Worlds Away

Worlds Away
New Suburban Landscapes

Walker Art Center

Edited by
Andrew Blauvelt

Available through D.A.P./Distributed Art Publishers, 155 Sixth Avenue, New York, NY 10013. www.artbook.com

Library of Congress Cataloging-in-Publication Data

Worlds away : new suburban landscapes / edited by Andrew Blauvelt.
 p. cm.
 Catalog of an exhibition at the Walker Art Center Minneapolis, MN, Feb.16-August 17, 2008 and at the Heinz Architectural Center, Carnegie Museum of Art, Pittsburgh, Penn., Oct. 4, 2008-Jan. 18, 2009.
 Includes bibliographical references and index.
 ISBN-13: 978-0-935640-90-8 (softcover : alk. paper)
 ISBN-10: 0-935640-90-8 (softcover : alk. paper)
 1. Suburbs in art—Exhibitions. 2. Suburban life in art—Exhibitions. 3. Art, American—20th century—Exhibitions. 4. Art, American—21st century—Exhibitions. I. Blauvelt, Andrew, 1964- II. Walker Art Center. III. Heinz Architectural Center.
 N8251.S56W67 2008
 704.9'4930774—dc22
 2007051213

Published on the occasion of the exhibition Worlds Away: New Suburban Landscapes, co-curated by Andrew Blauvelt and Tracy Myers, and organized by the Walker Art Center, Minneapolis, in association with the Heinz Architectural Center, Carnegie Museum of Art, Pittsburgh.

Walker Art Center
Minneapolis, Minnesota
February 16 – August 17, 2008

Heinz Architectural Center, Carnegie Museum of Art
Pittsburgh, Pennsylvania
October 4, 2008 – January 18, 2009

The exhibition is made possible by generous support from John Taft.

The exhibition catalogue is made possible by a grant from the Andrew W. Mellon Foundation in support of Walker Art Center publications.

Designers: Andrew Blauvelt and Chad Kloepfer
Editors: Pamela Johnson and Kathleen McLean
Publications Manager: Lisa Middag
Image Production: Greg Beckel
Indexer: Kathleen Preciado

Printed and bound in Belgium by die Keure.

Contents

Foreword

While discussing the exhibition concept of Worlds Away: New Suburban Landscapes with the show's organizing curators, the Walker's Andrew Blauvelt and the Carnegie's Tracy Myers, I was reminded of a striking work of art by Canadian artist Jeff Wall from the late 1990s. His photograph A Villager from Aricakoyu Arriving in Mahmutbey-Istanbul, September 1997 depicts a lone man walking along the periphery of a city, where the natural landscape meets the edges of industry and vast urban sprawl. Off in the distance, punctuating the skyline on the other edge of town, sits a row of freshly constructed suburban tract homes. One after the other, these mundane structures seemed fairly predictable in their boxlike configuration and massive proliferation. Yet something was not quite right about this picture. Closer inspection of the skyline revealed an array of spindly towers and turrets atop the cookie-cutter houses. These dwellings in the suburbs of Istanbul represented a surprising collision of cultural idioms and styles, a strange fusion of traditional Islamic architecture and American tract housing. I was deeply troubled and conflicted by what I deemed the promulgation of a less favorable aspect of American culture on such a striking, distinctive, and magical historical city.

As this work of art within the context of an exhibition shook the foundation of many key assumptions I held, both about the identity of suburbia and the differences between East and West, it also underscored the idea of suburbia as a specifically American phenomenon in its origins and its particular cultural idiom and practice. These origins—the values and assumptions that underlie their development as well as their subsequent transmutations, permutations, and failures—are the raw subject matter explored by the artists, architects, and authors associated with Worlds Away. Its curators have brought together a rich array of artworks, architecture, and thinkers who provocatively question commonly held assumptions about the myths, demographic composition, existence, and sustainability of the contemporary suburban landscape.

While this exhibition may represent one of the first major examinations of both the art and architecture of the American suburb, it does not arrive at the Walker without precedent. Writing in a 1980 issue of Design Quarterly entitled simply "Suburbs," Lois Craig, who taught for many years at the School of Architecture and Planning at MIT, argued presciently for a reevaluation of this maligned form of life. Since so many of our judgments and opinions about suburbia have been influenced by a plethora of images drawn from popular culture—film, television, and literature, in particular—Craig begins there: "A human settlement is a place on the land and in the mind. In both instances the images we have are social products. It is a common assumption that these images are not so important since we have before us the objects. . . . But until we examine the visual sources of our prejudices we will neglect one of the most powerful influences on our judgments and choices. This effort requires continuing reference to models both as conceived and as built, to test myth against life."

Some may wonder why an urban arts center such as the Walker would be interested in exploring suburbia. The ideas of city and suburb are more often succinct attitudes than distinct places. Indeed, it is difficult to untangle the suburban from the urban as cities are now understood as entire metropolitan areas and regions. When the Walker moved to its Lowry Hill location in the nineteenth century, downtown Minneapolis seemed distant. The residential neighborhoods that dominate South Minneapolis were suburban in a certain moment in urban history, their distance to the city core compressed by the expansion of railway lines and trolleys. Today, the Walker resides in a much larger place in an interconnected network that spans the local and the global, the urban and the suburban. In fact, about a quarter of our visitors—a figure similar to the number of Minneapolis city residents—come from suburban communities in the seven counties surrounding the Twin Cities, places where about 2 million of the area's 2.6 million people live.

The Minneapolis-based McKnight Foundation, a long-term supporter of the Walker and other area cultural institutions, recognized the increasing disparity between urban and suburban arts funding in its 2002 study, A New Angle. Arts Development in the Suburbs. The report noted that it was not only a matter of greater funding to support the arts in urban, suburban, and rural areas, but also a matter of changing attitudes held by both city dwellers and suburbanites themselves about the presumed lack of cultural interest and arts participation. In many ways, this exhibition was born out of a similar desire to rethink prevailing assumptions about suburbia as well as myths about its homogenous composition and lack of cultural authorship and spectatorship.

Worlds Away is particularly "Walker" in its multidisciplinary focus—reflected in its gathering of diverse artists and media in the galleries and the variety of writers and topics in this accompanying catalogue. Given the ambitious scope of the subject matter, it is fitting that the contemporary American suburb is examined through so many different artistic lenses and temperaments: candid portraits of big box shoppers, aerial views of our ever-changing exurban landscape, the ingenuity displayed in the transformation of former shopping malls, the imaginative transformation of and reverence for the banal and quotidian, and the desire to create new opportunities and architectures for social engagement and interaction.

This project also exemplifies the collaborative spirit of the Walker, the result of both internal and external partnerships. The Walker's education and community programs department and the Teen Arts Council in particular, with the assistance of the new media department, spearheaded the effort to expand the exhibition perspective by inviting the public to create personal video clips about their suburban experiences—a selection of which appears in the gallery and all of which can be viewed online. These efforts explore the new social technologies of the Internet—tools that enable people to share their work and knowledge with others. The exhibition itself is the result of a curatorial collaboration with the Heinz Architectural Center at Carnegie Museum of Art in Pittsburgh. The Walker and the Carnegie have enjoyed both formal and informal exchanges over the years involving both exhibitions and staff. In this regard, I would like to thank Richard Armstrong, director of the Carnegie, for his unwavering support of this project since its inception. The exhibition's co-curators, Andrew Blauvelt and Tracy Myers, have been exceptional collaborators, not only with each other and with staff at their respective institutions, but with the impressive array of art, architecture, film, and cultural historians and critics as well as the participating artists and architects whose voices and perspectives enhance this publication.

We are grateful to John Taft, long-standing Walker board member, whose generous support made this exhibition possible. It is a pleasure that we are able to include several artists who make their home in Minnesota, including photographers Chris Faust, Laura Migliorino, and Angela Strassheim and landscape architect Shane Coen and his firm, Coen+Partners. I would also like to thank the many lenders of works to the exhibition, a complete list of which appears on page 331 of this catalogue. In particular, I would like to acknowledge several close friends of the Walker who have graciously lent works to the exhibition: current board member and former president and chair of the Walker's board of trustees, Ralph Burnet, and his wife, Peggy; board member Peter Remes and his wife, Annie; and long-time friends and contributors to the Walker, Kimberly and Tim Montgomery, and Jennifer and Charlie Phelps.

Finally, I would like to thank all of the artists and architects for their provocative work, speculative visions, and engaging insights. By turning their eye toward the suburban conditions they variously depict, they actively deny the false notion that such spaces and lives are not worthy of aesthetic consideration. Their projects, as Craig noted, exist "to test myth against life."

Olga Viso
Director, Walker Art Center

Acknowledgments

Worlds Away: New Suburban Landscapes would not be possible without the participation and cooperation of many individuals who collectively helped realize the exhibition, its related programs, and this accompanying publication.

First and foremost, I extend my deepest gratitude to the more than thirty artists and architects who provided the creative energy necessary to realize the works we have assembled for this project.

I am indebted to the catalogue's essayists and contributors—John Archer, Robert Beuka, David Brooks, Robert Bruegmann, Julia Christensen, Beatriz Colomina, Ellen Dunham-Jones, Malcolm Gladwell, Louise A. Mozingo, Virginia Postrel, Denise Scott Brown, Katherine Solomonson, Robert Venturi, and Holley Wlodarczyk—for their insightful and provocative contributions, which expand the intellectual discourse on suburbanization.

The ability to assemble such a diverse range of projects would not have been possible without the generosity of those galleries, collections, and institutions willing to share their works with a larger public. The names of all lenders to the exhibition can be found on page 331. I would like to acknowledge those individuals and organizations that helped facilitate the loan of artworks for the exhibition: Allison Alter, Green Van Doren Gallery; Kristen Becker, associate director, Luhring Augustine, New York; Peggy and Ralph Burnet, Wayzata, Minnesota; Julie Casemore, Stephen Wirtz Gallery, San Francisco; Heather Darcy, Mixed Greens, New York; Beth Rudin DeWoody, New York; Kristina Ernst, gallery manager/director, and Erica Samuels, Bellwether, New York; Lisa Sette Gallery, Scottsdale, Arizona; Denise MC Lee, senior associate, SITE Environmental Design, New York; Richard Lidinsky, Sarah Walzer, and Teena Carlos at Perez Projects, Los Angeles; MARCH, New York; Marcello Marvelli and Sonel Breslave at Marvelli Gallery, New York; Max Protetch Gallery, New York; Kimberly and Tim Montgomery, Edina, Minnesota; Jennifer Case Phelps, Burnet Gallery, Chambers Hotel, Minneapolis; Peter and Annie Remes, Wayzata, Minnesota; Lee Stoetzel, director, The West Collection, Oaks, Pennsylvania; Anthony Terrana, Boston; and Kathryn van Voorhees, LTL Architects, New York.

I wish to express my appreciation to Carnegie Museum of Art for its role in the development of the exhibition. Richard Armstrong, the Henry J. Heinz II Director, enthusiastically supported the collaboration for the richness of content and potential for provocation that the resulting synergy might afford. The brainstorming session in July 2006 that initiated the partnership was generously funded by the Heinz Endowments and organized by Tracy Myers, curator of architecture at Carnegie Museum of Art's Heinz Architectural Center, which is supported by the Drue Heinz Trust. The liveliness of the dialogue at that session owed much to the intellectual generosity of its participants: architects Ellen Dunham-Jones, Kelly Hutzell, Paul Lewis, and Rami el Samahy; historians Robert Bruegmann and Matthew Lassiter; graphic designer Brett Yasko; and Marilyn Russell, chair and curator of education at Carnegie Museum of Art. Tracy Myers worked with me to identify fresh, innovative architects whose investigations and commissions could be refashioned for the exhibition and functioned as gadfly in the evolution of the architects' presentations. Contracting of these presentations was carried out under the meticulous supervision of Maureen Rolla, deputy director, and with the assistance of Martha Schloetzer, departmental assistant in the Heinz Architectural Center. Monika Tomko, head registrar, ably arranged for the packing and transportation of the architectural projects.

At the Walker Art Center my gratitude goes to former director Kathy Halbreich for her early support of this collaborative venture and to chief curator Philippe Vergne and members of the visual arts department for providing important counsel and valuable information during the exhibition's development. I would like to thank Olga Viso, the Walker's new director, who embraced the project and provided enthusiastic continuity in its realization. Visual arts administrator Lynn Dierks ably tackled the complexities of

exhibition planning and its tour and somehow found time to assist with picture research. My sincere appreciation to visual arts fellows Rachel Hooper and Shasha Liu and design fellow Jayme Yen for their invaluable support, research, and contributions to the project.

Walker registrar Elizabeth Peck expertly managed the handling of art and oversaw the complex coordination of shipping works from across the country and between the two institutions. Cameron Zebrun, director of program services, and lead technician Doc Czypinski, as well as the entire talented exhibitions team at the Walker, attended to the various details and demands of preparing and installing the works with their usual expertise and professionalism.

I would like to thank Sarah Schultz, director of education and community programs, and Robin Dowden, director of new media initiatives, and their staffs for their assistance in expanding the interpretative reach of the exhibition. In particular, Sarah Peters, associate director of public programs, with Allison Herrera, program manager, helped envision and manage the public programs; and Christi Atkinson, associate director of education and community programs, Witt Siasoco, teen programs manager, and the Walker Teen Arts Council collaborated with new media designers Justin Heideman and Brent Gustafson to solicit videos about life in Twin Cities suburbs from urban and suburban residents and get that work online.

Mary Polta, chief financial officer, kept the project moving forward on solid footing, while Christopher Stevens, development director, Marla Stack, director of special projects fund-raising, and Scott Winter, director of the annual fund, and their teams helped make the project a fiscal reality. Phillip Bahar, director of public relations and marketing, and his staff—Adrienne Wiseman, associate director of marketing, and Matt Peiken, staff writer and magazine managing editor—ensured that the exhibition would find its audience. Karen Gysin, associate director of public relations, with the assistance of Reid Selisker, public relations coordinator, got the word out to publications near and far.

Finally, I extend my deep gratitude to my inspired staff in the design and editorial departments for indulging me in this effort. Kathleen McLean and Pamela Johnson edited this publication with a keen attention to detail and sense of order. Lisa Middag, publications manager, kept the whole catalogue on track, while Greg Beckel ensured the quality of the images. Chad Kloepfer, senior graphic designer, worked tirelessly and collaboratively with me to design this book, resisting the temptation of the subject's supposed banality and envisioning instead a colorful panoply.

Andrew Blauvelt
Design Director and Curator, Walker Art Center

Preface

Worlds Away and the World Next Door

Andrew Blauvelt

My father's kindness was as pure and indifferent as a certain kind of saint's.

My father did not have a passion for his giving; it came from him, perhaps after much spiritual calculation, as a product might come from a conveyor belt.

The houses in this suburb were built the same way. As many as a hundred a day were begun between 1950 and 1952, more than five hundred a week. No two floor plans were built next to each other; no neighbor had to stare into his reflection across the street.

Teams of men built the houses.

Some men poured concrete into the ranks of foundations from mixing trucks waiting in a mile-long line. Other men threw down floors nailed with pneumatic hammers, tilted up the framing, and scaled the rafters with cedar shingles lifted by conveyor belts from the beds of specially built trucks.

You are mistaken if you consider this a criticism, either of my father or the houses.
— D. J. Waldie, Holy Land: A Suburban Memoir, 1996

Sometime during the past fifty years, the United States became a suburban nation. Although the 2000 census confirmed that more Americans live in suburbs than in central cities or rural areas *combined*, the increasing isolation of the city became glaringly obvious in both the 2000 and 2004 presidential campaigns when maps charting the voting results county by county revealed a cascade of red flowing from the urban periphery into the surrounding countryside. The assumption that urban cores voted Democratic (blue) and suburban areas Republican (red) was evident in the last presidential election where ninety-seven of the one hundred fastest-growing counties voted for the GOP candidate. However, it's not only the quantitative but also the qualitative measures that prove the suburb no longer lives in the shadow of the city. Long dominated by the city as its normative measure, today's suburbia marches on, trying to leave the polis in its wake.

Suburbia has always existed as a quasi-autonomous space, away from but always near the city. The *suburbium* of ancient Rome was the hillside area below the city, a place for exiled odious activities and disenfranchised people. The idea of the suburbs as a desirable place to live began more than two hundred years ago as living apart from the turmoil and challenges of the city fused with the growing appreciation of living with nature in general and the romanticism of the pastoral in particular. The twentieth-century suburb presented a viable "third way" for living, an alternative to both the great cities of America's industrial age and the ancestral farms and small towns of its agrarian past. The postwar suburb offered a new lifestyle with a path to home ownership in the kind of place that anticipated America's postindustrial destiny and decentralized millennial

lifestyles. These suburbs nevertheless remained dependent on the city for their very definition and economic vitality. In more recent times, however, the suburb has attained a new level of autonomy from the city, and in most cases eclipsed it to become a more vibrant place for economic development and growth. In fact, the relationship between city and suburb seems secondary to the competition between older, first-tier and newer, outer-ring suburbs—suburbia's suburbs. This process of constant expansion outward from the city core when seen in the long view of history discloses the simple truth that today's suburb is tomorrow's urban fabric. Each successive layer adds another facet to suburban history and American mythology, as David Brooks argues in his essay, "Our Sprawling, Supersize Utopia" (page 26).

The American suburb represents something of a paradox, since its very definition hinges on both its physical proximity to as well as its cultural distance from the city. The mutually dependent relationship between city and suburb is the product of both historical origins and contemporary necessity. City dwellers and suburbanites need each other to reinforce their own sense of place and identity despite ample evidence that what we once thought were different places and lifestyles are increasingly intertwined and much less distinct. The revenge of the suburb on the city wasn't simply the depletion of its urban population or the exodus of its retailers and office workers, but rather the importation of suburbia into the heart of the city: chain stores and restaurants, downtown malls, and even detached housing. If the gift of urban planners to suburbia was the tenets of the New Urbanism, it has been regifted, returned to cities not as tips for close-knit communities but as recipes for ever more intensive consumer experiences.

Suburbia has returned to the city just as most suburbs are experiencing many of the things about city life it sought to escape, both positive and negative: congestion, crime, poverty, racial and ethnic diversity, cultural amenities, and retail diversity. At the same time, cities have taken on qualities of the suburbs that are perceived as both good and bad, such as the introduction of big box retailing, urban shopping malls, and reverse suburban migration by empty nesters, who return to the city to enjoy the kind of life they lived before they had kids to raise. For every downtown Olive Garden there seems to be an Asian-fusion, chef-driven restaurant opening in a strip mall; for every derelict downtown warehouse there is an empty suburban office building waiting to be converted into lofts; the Mall of America is the largest shopping center in the nation, but SoHo may be the largest open-air retail neighborhood in the country; and everywhere in between we have Starbucks. What was once the generic and banal architecture of the commercial strip has been transformed into the branded retail environment of today. More merchandise is available to more people in more places, a point Virginia Postrel makes in her essay, "In Praise of Chain Stores," in which she also challenges the idea that local flavor is dependent only on mom-and-pop stores (page 70).

●

While the definition of a suburb is vague, varied, possibly even moot, the concept of suburbia remains potent—less a matter of propinquity and more a state of mind. The suburbs have always been a fertile space for imagining both the best and the worst of modern social life. On the one hand, the suburbs are portrayed as a middle-class domestic utopia, and on the other as a world of unrelenting homogeneity and stifling conformity. Most of what we think we know about suburbia has been shaped by its portrayal in various media—film, music, literature, and television in particular—where it has been depicted alternately as an idyllic setting for family life in TV sitcoms, for instance, and a dysfunctional landscape of discontent in Hollywood movies. In a more recent

11

twist, these separate qualities are combined in a dualistic whole: the pleasant veneer of suburbia masks its unsavory core. Robert Beuka explores one of the more potent tropes of suburban life as it is depicted in cinema: the surveillance and entrapment of suburbia's subjects in his essay, "The View through the Picture Window" (page 89). Just as the quintessential picture window can function to frame the view outside as well as the lives inside the home, similar depictions of suburbia can be read both ways. If suburbia conjures a safe haven of neighborliness for some, that same image of familiarity is viewed as an alienating place for others.

Despite voluminous critical condemnation, the contemporary suburb remains surprisingly unconsidered, at least on its own terms. The reasons for this oversight are tied to perceptions of suburbia's supposed cultural inferiority and persistent mythologies that reinforce partial, outdated, or stereotypical ideas that often present it in static, monolithic terms. The subject itself, however, has been in a state of perpetual change: from early streetcar suburbs and postwar, sitcom-style bedroom communities to the more self-contained citylike suburbs of the late twentieth century, such as the postindustrial technoburb, with its new office parks and high-tech research campuses, or today's boomburbs, whose explosive growth rivals the size of adjacent cities and suburbs. As the suburban landscape evolved over the last century, its demographic composition has also changed. The mid-twentieth-century image of largely white, prosperous, middle-class, two-parent families as the predominant household of suburbia has been transformed. Contemporary statistics reveal a different picture: more ethnic minorities (27 percent), including many new immigrants, make their homes in suburbia; households without children now comprise a plurality of suburban occupants (29 percent); and, for the first time, there are about one million more people living in poverty in the suburbs than in the city.

Despite the real or perceived challenges of living in suburban environments, demand for such places will not diminish. Even the latest round of burb-bashing, a variation of the "love-the-sinner, hate-the-sin" approach that casts sprawl as the dangerous by-product of suburbanite lifestyles, is unlikely to stem the tide. This is not to say that the impact of climate change or $5-a-gallon gasoline won't affect suburban development any less than it will urban lifestyles. The problem with so many end-of-suburbia theses is that they forget the most powerful thing about suburbia—its symbolism and the idealism associated with it. What might be surprising to critics of suburbia is not that most people choose to live there, but that they do so contentedly. Despite decades of trying to apply urban theory and assumptions onto suburban scenarios, it seems far more likely that suburbia itself will adapt and evolve accordingly. The ecological angle is but the latest variation on arguments against suburbia, as Robert Bruegmann makes clear in his essay, "Learning from Sprawl," which chronicles the successive waves of criticism about sprawl over the last century (page 257).

The suburb is, if not in vogue again, at least in the news more often. There is no shortage of topical subject matter confronting the contemporary American suburb—from the geo-marketing strategies that merged demographic profiles such as the soccer mom and NASCAR dad with electoral politics to suburban neighborhood campaigns to ban the construction of out-of-scale monster homes. In terms of economic resources, there is the resource disparity between prosperous boomburbs and declining, older suburbs or the allocation of state funding among cities, suburbs, and rural areas. In the case of housing, there is the lack of convenient, affordable homes for the service industries that suburbs demand, which spurs the creation of suburban plantations, or recent debates about moratoria on cul-de-sacs. There are also issues about movement within and between suburbs: the "roads versus rails" debates about the efficacy of highway construction

and mass-transit alternatives; the lack of roadway or sidewalk connections between residential and retail areas; or the creation of the gated communities that purposely restrict access to certain neighborhoods.

Newspapers and magazines now extol the virtues of suburban life, shocked to find among the tract homes and strip malls signs of civilization: gourmet restaurants, fashionable boutiques, rehabbed mid-century ramblers, and glimpses of urban life such as people of color walking around "lifestyle centers," places that look much like the city's new downtown. In what may appear to some as either a sign of the Apocalypse or the ultimate marker of neighborhood gentrification, depending on one's perspective, gays and lesbians can be found living openly in suburban locales, often raising children. Although denied to television viewers, the filmed but unaired reality series *Welcome to the Neighborhood* pitted various types of families against each other to win a new house. The fact that a white, gay couple with a child of color was victorious by winning the votes of their future white, Christian neighbors would have exploded some stereotypes held about suburbia even as it confirmed others.

●

As America's cities shrink and its suburbs swell, the distance between them widens, creating not so much an unbridgeable gulf but rather a vast traversable landscape that pushes the limits of the daily automobile commute. Today's suburban expansion is not only the horizontal expansion we associate with tract-housing developments and the outward spread of leapfrogging suburban settlements, but also the upsizing of the individual elements of suburbia itself: its houses, schools, churches, and malls, not mention its cars, meals, and, well, bodies too. This suburban expansion represents the kind of bigness you can't ignore anymore, because it is no longer just happening over *there*, on the fringe moving away from you. Its scale is now competing for your limited tax dollars, impinging on your own sense of propriety, and intruding on your own backyard. While the stylistic form of the suburban house has remained fairly constant over the twentieth century, its physical size has not. The average American home has grown from more than 900 square feet in the 1950s to 1,500 square feet in 1970 to more than 2,400 square feet in 2005. At the same time, the average lot size has shrunk and the average family size has fallen. This seeming paradox can be explained, in part, as a factor of bigger kitchens, family rooms, master bedroom suites, walk-in closets, and spa baths; separate bathrooms and bedrooms for each child; new spaces such as media rooms and home offices; bigger garages for additional, larger cars—not to mention the increasing price of land and less time to maintain lawns for children who are more likely to play inside.

Given these long-term trends, one might have expected that more philosophical and aesthetic attention would be paid to grappling with upsizing. Although there have been numerous articles and debates about the particular objects of bigness and their social implications—McMansions destroying neighborhood character; McDonald's caloric counts and childhood obesity; Hummers and the nexus of oil consumption, the Iraq War, and patriotism—these almost always posit bigness as the result of excessive consumption, lack of self-control, and moral fallibility. If these articles and debates do stray into aesthetics, bigness is often portrayed as alienating, inauthentic, uncontrollable, and placeless. Suburbia and sprawl, in particular, are characterized as uncontainable, a classic description of giganticism—out of scale with nature and out of context with, and thus overwhelming, its surroundings. Two prominent thinkers representing both ends of the scale spectrum are Rem Koolhaas, globe-trotting architect and theorist of such topics as Junkspace and

the Generic City, and residential architect and lifestyle author Sarah Susanka, the force behind the ethos of "not-so-big" houses, books, and lives. Even with these extreme ideologies, bigness has yet to find its own poetic dimension.

Despite its cultural impact and ubiquity, the American suburb has remained, until fairly recently, an elided subject in the cultural work of artists and architects. The close historical connection between the city and art and artists undoubtedly accounts for some of this omission. One expects to find both art and artists in the city—in downtown museums, galleries, and studios: culture and cosmopolitanism go hand in hand. For those artists who have addressed the suburbs, it has ranged from a kind of incidental backdrop for other subject matter to a central element of their work. As more and more people, including artists, are born, raised, and live in suburbia, their distance and relationship to it will be different—perhaps closer, perhaps more conflicted—than an earlier generation who were viewing it as essentially outsiders, albeit with a strong eye and curiosity. The signs, symbols, and imagery of suburbia have been particularly resonant in artists' work of late, suggesting, as the work in this exhibition does, that a landscape once seen as bereft of possibilities instead holds opportunities for creative engagement.

The built environment of suburbia has been the subject of numerous architectural critiques over the past fifty to sixty years. Mostly written with derision and scorn, these criticisms have been framed within the prevailing image of suburbia as a space of relentless visual monotony. An early exception was the research by architects Robert Venturi and Denise Scott Brown on the American suburb. Beatriz Colomina interviews these pioneering architects about "Learning from Levittown," their 1970 Yale studio, a "remedial project for architects" (page 49). Aside from some early twentieth-century concepts, many architects have simply opted out of practical engagement with transforming suburbia, with the possible exception of those involved in New Urbanism, an attempt to ameliorate aspects of sprawl with more pedestrian-friendly, higher-density, mixed-use, and community-oriented designs. As Ellen Dunham-Jones notes in her essay, "New Urbanism's Subversive Marketing" (page 147), the designs of New Urbanism are often dismissed by progressive architects because the resultant forms are too traditional and nostalgic and therefore inauthentic. However, as she notes, the recourse to traditional styles is often strategic, a way of masking the more difficult aspects of such proposals (such as living on smaller lots, with poorer people, and alongside businesses). Dunham-Jones provocatively asks: "Is it too much of a stretch to present the New Urbanists as subversive radicals? Are their interests in the suburbs, marketing, and development practices just too middle class, too bourgeois to drive real change?"

Unfortunately for architecture, suburbia has become a place to avoid rather than one to engage. In turn, the general absence of design professionals—whether by choice or circumstance—from the development equation has resulted in the continued proliferation of unimaginative buildings and landscapes that typically have no relation to each other or their contexts. Less than 10 percent of built residential structures are the direct result of an architect's design. While public and commercial structures have more architectural involvement, the majority of such buildings conform to a narrow range of standard predetermined forms. An important exception to this rule was the invention of the postwar corporate campus; if not situated in the suburbs, it at least drew upon a similar pastoral symbolism. Louise A. Mozingo follows the evolution of this emergent typology in her essay, "Campus, Estate, and Park: Lawn Culture Comes to the Corporation" (page 177). Public acknowledgment of and debate about suburban growth and its broad consequences have expanded greatly in the past decade, and advocacy of such ameliorative strategies as sustainability or green design, and nonexclusionary zoning practices or mixed-use development has moved

architecture and planning issues to a higher level of general recognition in this country than ever before. In spite of, or perhaps because of, the absence of signature architecture, suburbia is perhaps the most popularly successful of imagined utopian communities.

•

Whether in art or architecture, the suburbs seem to lack authorship in a general cultural sense—the suburban landscape simply unfolds ex nihilo—out of nowhere and out of nothing. This lack of identity is born out of a lack of history. Suburban time is thus strangely suspended, literally an arrested development frozen in its initial phases of construction: no wonder most people conjure an image of suburbia as a series of new housing starts and barren landscapes. Holley Wlodarczyk surveys the various uses of photography to record these processes of transformation and demonstrates that because they are focused on an early moment in the life cycle of suburbia, they do not typically provide any evidence of either human settlement, aspiration, or inhabitation (page 101).

The inability to situate a suburban aesthetics or to develop a language and theory to assess suburban forms as anything but an aberrant urbanism is clearly one of the crucial hurdles in constructing a more objective and less judgmental approach. The continued reliance on urban theories, assumptions, biases, and practices as a lens for viewing suburbia only compounds the problem. Another difficulty in developing a suburban aesthetics is the issue of popular taste. Most forms of criticism and artistic practice cannot perceive suburbia without the posture of ironic distance or cynical dismissal. As John Archer argues in his essay, "Suburban Aesthetics Is Not an Oxymoron" (page 129), the conventional assumption that suburbia represents an empty, thin, and inauthentic form of consumption—a paucity of experience—is contradicted by the richness of suburbia's symbolic universe, an experience lived by its occupants rather than viewed by its critics.

•

Suburbia inaugurated new forms of shopping, including such early typologies as the strip mall and the regional shopping center. The strip mall is a by-product of zoning codes that encourage businesses to cluster along busy thoroughfares and an evolution of small-town main streets and business districts. Fostered by favorable changes to tax codes and other financial incentives, regional shopping centers grew at an accelerating rate in the 1960s and 1970s after the introduction of climate-controlled malls and carefully planned circulation routes. The first such modern indoor shopping mall was Southdale Center, which opened in 1956 in Edina, Minnesota, and was designed by Victor Gruen. As Malcolm Gladwell reminds us in his essay, "The Terrazzo Jungle," Gruen didn't simply design a building: he invented a new archetype (page 216). Originally envisioned as town squares, malls did at least become public gathering places and some do hold civic events. In 1992, the country's first megamall opened—the Mall of America in Bloomington, Minnesota—with 4.2 million gross square feet and more than five hundred retail stores. A plan was recently floated for Mall of America II, next door to the original, which would have not only more stores, but also a series of proposed amenities such as hotels, restaurants, recreational spaces, and a performing arts center. This suggests that a mix of entertainment destinations and tourism (a large percentage of shoppers are from out of town) are necessary components for retail growth. Beginning in the 1960s, the advent of discount retailing and its expansive warehouse space doubling as a sales floor created the big box store as a rival to both specialty shops and department stores. Because of competition from big box and chain stores, the regional shopping mall has fallen into disfavor, replaced by power centers, or collections of big box stores, each existing autonomously in one large development.

Contemporary suburban retail has experienced both tremendous growth and new challenges. A major issue is the proliferation of abandoned and dying malls. "Greyfield Regional Mall Study," a 2001 report, concluded that 7 percent of the regional malls in the United States were abandoned sites and another 12 percent were in decline, approaching closure. The same situation now faces communities with defunct big box stores, a condition elucidated by artist Julia Christensen, who is interviewed about her experiences documenting the myriad reuses of such spaces (page 209). The adaptive reuse of such derelict sites has become an important ameliorative strategy. The recent interest in situating big box stores in urban locations has created an opportunity to rethink the large footprint, horizontal orientation, and parking schemes of such venues for both urban and suburban locations. Another important development within the world of suburban retail is the increasing interest in mixed-use development, with residential living spaces above street-level shops and second-floor office and business spaces.

•

The advent of suburbia was dependent on the expansion of transportation networks. In the nineteenth century, the extension of railway and streetcar lines fueled growth outside the urban core. The modern American suburb's development has been intimately connected to the expansion of the federal interstate system and its introduction in and around major metro areas. It is impossible to conceive of suburbia without this transportation network and the automobile culture it both serves and encourages. Not surprisingly, the suburban landscape is constructed to be viewed from an automobile—positioned perpendicular to the flow of traffic are the long, low-slung strip malls, with power centers, shopping malls, and housing developments located just off and alongside major highway interchanges. Not only has transportation defined the patterns of growth, but it has also contributed to some of the most vexing problems confronting suburbia, including traffic congestion and increased commuting times, not to mention the ecological impact of roadway construction and the consumption of fossil fuels. But just as the single-family detached home offers a symbolic ideal, the roadways serving suburbia and connecting large parts of our vast country also serve as compelling tropes—symbols of independence as well as catalysts for new forms of carchitecture: the drive-in movie and church, the drive-thru restaurant and bank, or even the defunct drive-by Fotomat booth. So powerful is the influence of the automobile that it has even upstaged the suburban house, moving the garage from the rear or side of the home to the front, producing snout houses and Garage Mahals. No longer merely the repository for a car, the garage has become a fabled place of homeowner ingenuity—from the invention of the personal computer and the cardiac pacemaker to the formation of numerous garage bands.

•

This exhibition is not intended as a primer on the latest statistics about suburbia or a history of it. Rather, it features the work of artists and architects who, without that burden, have imaginatively considered the subject: drawing inspiration from, provoking discussion about, and casting either an appreciative or critical eye on an environment that, for better or worse, constitutes an ever-larger portion of our world. This accompanying catalogue, with its essays, interviews, architectural projects, and artworks, sketches the possibilities for a future suburban aesthetics. In doing so, it offers a way of seeing and connecting these culturally distant realms. The oft-claimed alienation of the suburbs and the supposed close-knit communities of the city are both myths—convenient stories we tell about the other in the hope that the world next door will be kept worlds away.

Introduction

A Conversation with Andrew Blauvelt and Tracy Myers

Katherine Solomonson, August 23, 2007

Andrew Blauvelt and Tracy Myers are co-curators of the exhibition Worlds Away: New Suburban Landscapes. Blauvelt is design director and curator at the Walker Art Center, Minneapolis. Myers is curator of architecture at the Heinz Architectural Center, Carnegie Museum of Art, Pittsburgh.

Katherine Solomonson teaches in the School of Architecture at the University of Minnesota, where she also serves as an associate dean of the College of Design. Her teaching and research focus on the history of American buildings, landscapes, cities, and suburbs.

Katherine Solomonson: What brought about this exhibition and the collaboration between you and your institutions, the Walker Art Center and the Heinz Architectural Center?

Andrew Blauvelt: It's really the result of several factors. An earlier Walker exhibition I had curated, *Strangely Familiar: Design and Everyday Life*, was about designers and architects looking at everyday situations, rituals, and materials and transforming these into a new kind of condition. It was modeled on an avant-garde position of transformation—the shock of the new, the spectacular out of the quotidian. I was thinking of exploring the opposite: the shock of the familiar. The suburbs are ubiquitous and the most familiar of spaces, although they are little understood. This exhibition complements what I'm trying to do with architecture and design in general at the Walker, which is to look at topics that are just off center to the professions, more marginalized.

Tracy Myers: My undergraduate degree is in government and economics, with an urban studies focus, and my graduate education is in art and architectural history. I'm engaged with the "real world" of architecture through my involvement in a community development company, so there's a kind of mélange of interests. About five years ago, I became aware of a project by LTL Architects called *New Suburbanism* (page 161) that looks at the big box as an opportunity to restore the section to suburbia by using it as a platform, literally, for the construction of a complex residential condition. That project was seminal for my thinking about suburbia; it just stuck. Andrew's and my interests are complementary in looking alternately at the large scale and the finer grain, and in a way, that's how you have to look at suburbia. It's not as monolithic as I had thought.

KS: You're dealing with two different institutions, and you've come to this from different perspectives. In rich collaborations, you reach a point you never would have alone. How have your own ideas come into dialogue with one another?

AB: To start, I wasn't interested in doing an exhibition in which suburbia would be the brunt of all criticism. I wanted a more realistic and more balanced approach.

KS: The word "realistic" or "real" comes up periodically in the prospectus you sent me. I have a sense of where you're going with this, but I was wondering if you could talk about what you mean by "real" and "realistic" perspectives.

AB: The "real" is proposed as the inverse of the imaginary. The imaginary suburbia refers to its mythological construction through the media, film, literature, magazines, self-promotion, and marketing. What is the reality behind all of these myths? And the mythology itself has included both utopian perspectives and dystopic representations. Negotiating those two extremes is a way of constructing a kind of reality. There are, of course, different versions of reality, I understand that, but what people understand to be true about suburbia is different—if you look at the statistics, if you see what is happening on the ground—versus the kind of picture you get in the media or in the galleries.

TM: Or in academia.

AB: Or in architecture.

TM: My mantra is that more than half the country lives in suburbs; the suburbs are not going to go away, so rather than demonizing them, maybe there are ways to bring some better qualities to them through the practice and thinking of architecture. I've tried to step back from the normative position that suburbs are beyond redemption, because while the people who live in suburbs might not articulate what they like about them in the terms that are familiar to architects, critics, and curators, every condition has something of value in it. Andrew is coming to the point of the real, and I'm working beyond the real, or something that is prospective as opposed to representing the current reality. I think that's a point of convergence for us.

AB: You still have all three positions about suburbia out there: the apologists for suburbia, the promoters of suburbia, and the critics of suburbia that extend way back into urban history. The subject of suburbia is a moving target—the suburbs are dynamic and change over time. And this is probably why you'll never get agreement about them.

TM: Exactly. The demographers, the federal government—nobody seems to be able to agree on what the word "suburb" means. Statistical studies use the words "urban" and "suburban" in the same sentence to refer to the same conditions. There are different types of suburbs, so we finally had to agree that we weren't going to pin down a definition.

KS: The fact is that suburban conditions have always been quite diverse. There are particular stereotypes and myths about suburbia that obscure that diversity. One thing that strikes me about what I'm seeing in your choices for the exhibition is that you're actively exploring the diversity of those conditions. I appreciate your decision not to lock into a tight definition of what suburbia actually is. At the same time, there are underlying assumptions behind the choices you made for this exhibition. So what kind of things were you looking for, beyond people engaging the real conditions of suburbia or the diversity of suburbia?

TM: I think we don't want the show to appear to be a bunch of architectural projects surrounded by artworks. What is it that we want people to know or understand or question when they

leave this exhibition? That is the question that drives me in developing an exhibition. What do I want people to know? Which is, of course, rather presumptuous.

AB: Well, I might have a low bar. [laughs] I would hope that visitors, if they are typical urban dwellers who think of suburbia as that place out there where "those" people live, might take away a different perspective on it, and vice versa. Perhaps the suburban resident who doesn't quite see all the issues and problems happening in his or her environment would gain that perspective.

TM: If they look at the world differently—even if it's not tomorrow, but five years from now—and say, "I remember a thing I saw at this exhibition," then that is success to me. So I don't think it's setting a low bar to really challenge people's assumptions.

AB: True. I think a lot of visitors might actually be nostalgic because so many people have been born and raised in suburbia. America is a suburban nation now. So what would that evoke in someone? Would they run screaming, or would they embrace "the good old days"?

KS: To what extent does the exhibition engage with a nostalgic point of view?

AB: The exhibition might induce some nostalgia; visitors might say, "Yeah, I remember growing up in the burbs." But a lot of nostalgia is actually created through the media too, through film—and many people think of suburbia through that framework.

TM: Or television.

KS: Exactly. So you also said you see that in some of the art. Could you talk about that?

AB: Gregory Crewdson, for instance, is using film actors and actresses whom you might recognize from movies set in suburbia (pages 86–88). He's a photographer, but the work is very filmic. His scenes become a kind of mise en abyme—a picture within a picture—when you're seeing the person from a film and this photograph, and you think, "Wait a minute, isn't that so-and-so the actor?" It induces a certain kind of reverie.

TM: In a certain sense, that's the physical analogue to the intellectual framework of the exhibition: What am I looking at? What's the intellectual construct that has built up around ideas of suburbia and what is the real condition? Implicitly or explicitly, that's the central question the exhibition poses.

KS: Talk about cultural constructs and representations versus the real condition. You have many examples of the way that people are reimagining suburbia, not so much as a revelation of the real condition but as a dialogue with it, I think. What is it that the artists and architects can show us that demographers and scholars might not?

AB: It's the old cliché, but a picture is worth a thousand words. The symbolism around an image or around a building is so much stronger. Images tend to be more specific, and that carries with it much more baggage, while statistics and theories seem more abstract to most people.

TM: Surely people pass in their grocery store, or at the gas station, the new suburbanite: the immigrant, the African American family, or the Indian family, or whomever. But it might not really register. Although I don't believe that artistic representation of something necessarily endows it with additional value, the fact that an artist pays attention to suburbia might cause a visitor to stop and say, "Wait a minute. If this is important or interesting enough for an artist to be exploring it, or for an architect to be thinking about it, then it must be meaningful, and maybe I need to stop and think about my own situation, my own neighborhood, my own environment."

KS: And beyond that, you have work here that represents a rich critique. In what ways do you see the exhibition exploring, for example, the increasing cultural diversity of suburbia?

AB: Artist Laura Migliorino, who lives here in Minneapolis, travels past suburban development every day and was intrigued because she watched the sprawl happen—it just follows you to your workplace, down the highway, and it evolves over the years (pages 33–37). And then one day she decided to explore it. She started asking to photograph people there, and was surprised by the diversity she found. Some of that diversity is due to the fact that most immigrants used to settle in urban areas, in the city, which was the traditional place because it was the most convenient and cheapest place to live. Today, the settlement pattern is very different—now it's suburban—and for different reasons.

TM: It's also where the jobs are. Most of the job growth since the 1980s has been in the suburbs.

AB: And when you don't have great public transportation, you have to live closer to work. Some of that might be fueled by basic housing needs. If you have an Asian immigrant culture that is based around multigenerational family life, and the family is all living under one roof (or wants to), then the house type that you're looking for might be a first-ring suburban house. It's a larger structure, there are many bedrooms, and it's at a price point that is more affordable.

TM: Or people might build another structure on their property to accommodate multigenerational families or multiple individuals, not related, living within one house. One of the interesting things is that many of the conditions people thought they were leaving behind in the city now occur in older suburbs. Infrastructure is getting old, taxes are going up, and immigration is increasing density and diversity. In some places, this has led to overt hostility—it's upending all the expectations of people who moved to the suburbs thirty or forty years ago.

KS: There are also the retail battles. If you're going to fashion a new retail district in a culturally diverse suburb like Fremont, California, which has become an ethnoburb with large Chinese and Indian populations, what kind of retail will there be? Will there be a diverse range of restaurants and grocery stores, or will it be anchored with big box retail or national chains? There was some tension over this a few years ago. But then there's architect Teddy Cruz . . .

AB: I was also going to bring him up because he offers a good example of how looking at patterns of habitation and dwelling in Tijuana might affect suburban development in San Diego and vice-versa (page 120).

TM: He's very interested in not eradicating, or obliterating, the local immigrant culture's particular practices and traditions, but rather allowing the architecture to respond to them and privilege them. As someone who is involved in community development, I know how very complicated it can be, and the thing that most fascinates me about Teddy's work is the process-based nature of it. And this is what makes it so challenging to represent: he describes it as triangulation among the citizens, the architects, and the city government, trying to convince the city to accommodate these situations that fall outside the mental framework of what is an appropriate way to live, or what is an appropriate way to build. It's multigenerational; it celebrates communal living outdoors. Some of the other architectural projects in the exhibition are actually rather neutral in the way they incorporate thinking about changing demographics. They're not so much responding to a specific kind of population as they are responding to a specific physical and economic condition.

KS: Why do you think that is?

TM: Well, mostly it's a matter of the scale of the condition those particular projects address: a dead mall, for example, or a larger exurban situation rather than a single residence. These are theoretical projects that could be realized.

AB: They tend to be pragmatic, yet visionary. And they're not formally driven, which doesn't mean that they look bad! It's thinking about occupiable space, rather than simply the purity of space, for example.

TM: Another thing about the architectural projects is their incremental nature, as in the proposals of Lateral Architecture (page 235) and Interboro (page 225). I think this marks a big change in architectural thinking; whether or not it filters through the profession in general remains to be seen. Both of those projects accept given conditions and propose changes that either respond to those conditions and make lemonade out of lemons, as it were, or in some other way try to massage the condition.

AB: It's very tactical, looking for opportunities when or where you can. Lateral Architecture, for example, examines the space between big boxes in what are called power centers and ways that it can be occupied or programmed differently. It's not Victor Gruen's utopian vision of the regional shopping mall. In fact, Interboro studied the activity patterns of a dead mall. The mall is not truly dead because people are still there; not a lot of people, of course, but it's more about a mall's afterlife, or half-life, while it is in economic transition.

TM: And some of the mall activity is very illicit. Recognizing that fact is a much more realistic way of thinking about any kind of change than trying to completely transform something.

KS: Another thing that strikes me with somebody like Teddy Cruz is that he is opening up opportunities for others to continue to transform the landscape.

AB: Exactly. He's ceding control, or perhaps better, creating a framework. It's not about mastery. You create a structure, and allow it to evolve and develop on its own terms. As an architect you have to be okay with that, but it demands a strong framework.

TM: The subtext is not the typical attitude that drove modernist planning: "This is all wrong. We have to change it." Lateral and Interboro are saying, "Okay, the status quo might not be great, but this is what it is. What can we do with it, rather than trying to transform the attitudes that led to this situation?" I think that's pretty radical, actually.

KS: It raises the issue of critique from the outside in as opposed to the inside out—about artists and architects who might have grown up in suburbia, who might be living in suburban conditions, engaging with them as they're producing and examining the increasing complexity of their reactions to suburbia. Are you still seeing a cultural vanguard's reaction very much from the outside?

AB: The cultural vanguard's negative critique of suburbia, I believe, forms the normative position on suburbia. However, lived experience and firsthand knowledge of the place can produce more nuanced or complex, and even contradictory, reactions.

TM: A ghost in the room, of course, is the New Urbanism (page 282).

KS: I was going to ask you about that. Why is it absent from the exhibition?

TM: I'm sure this question of New Urbanism will be raised. I don't think that New Urbanism can be considered to be cutting-edge thinking at this point; it's so entrenched. There's the issue of New Urbanism really being New Suburbanism, because for the first ten years it was all little Smurf villages being built in cornfields.

KS: But New Urbanism didn't start out to be monolithic, either. New Urbanism and neo-traditionalism became conflated.

TM: All the projects we included are thinking more imaginatively about the conditions to which many New Urbanist responses have become, for whatever reason, formulaic. So these are projects that are just taking a different tack. We agreed from the beginning that this was not going to be a historical show, or that it would document every condition or idea. But I'm perfectly comfortable with not including New Urbanism because I just think it's time for other ideas to be presented.

AB: I think some of the issues would come up anyway, the base issues—not classic solutions of New Urbanism, but the problems they're trying to solve: land and energy resources, transportation issues, notions of community. The conflation of New Urbanism and neo-traditionalism is absolutely true. Of course, the whole justification is that . . .

TM: That's what people like.

AB: Yes, the people's choice, populist tastes. It's a double-edged sword. I always joke that suburbia is the only successful architectural utopia—it just wasn't authored by architects. This populist reduction has to do with class and cultural capital, but it also has to do with all sorts of factors that go into any complex system.

KS: It has to do with zoning, economics, and federal policy too. Moving on, I also wanted to ask how photographers are responding to existing suburban conditions.

AB: The artists are observing what is at hand. We tend to think of art within an urban mindset: the city, bohemia, Paris, New York.

KS: Both as subject and as site of production.

AB: Yes. It's about the artist and where they're working, what they're drawing upon as subject matter and inspiration. So you have painters such as Sarah McKenzie, who is living in Colorado and literally painting what she was seeing out her window (page 113). And if you've been in Denver, you know the explosion of housing all across the countryside there—that's what she painted. And you can see that approach across so many different artists in the exhibition. That's what was around them, and what they grew up with; it becomes source material. This is a little bit different than an earlier generation of artists such as Dan Graham (pages 38–39), Ed Ruscha (pages 193–197), or Robert Smithson, who viewed suburbia more as outsiders.

Another example is Matthew Moore, who studied sculpture and whose family operated a farm in Arizona (pages 252–256). He returned there and creates land-based projects, for instance, by growing different crops on parcels of farmland acreage to re-create the image of houses or the housing subdivision that will or might occupy these places. The projects are documented from the air. He has a really interesting, conflicted relationship with this process of suburban development. Some of his farmland has been sold off to a developer, but he went to city hall to obtain their plans, and he literally grew them. What's more destructive: agricultural or residential development? They're both damaging ecologically, but what's truly worse? If you're in Phoenix, it might actually be agriculture. As a farmer, he's dealing with that sort of conflict too, but he's also complicit in that cycle, and he understands that.

KS: If one of the goals here is to raise questions, what kinds of issues do you find photographers exploring?

AB: It depends on the photographer. Brian Ulrich has more of a critical take on suburbia that is born out of a larger engagement with issues of consumer culture (pages 232–234).

He makes these amazing portraits of shoppers whom he photographs largely in big box stores, but he also has a parallel set of images that have to do with thrift stores—the economy of resale and the economy of conspicuous consumption. He takes these photos in IKEA, Home Depot, Target, Lowe's, and so on. They remind me of Post-Impressionist paintings—like Manet's bartender, whose expression of urban ennui is recalled in some of Ulrich's portraits, a kind of suburban ennui. Is this our shock? Is it shocking to see this beautifully composed portrait of someone pushing a cart through Costco? Maybe those things aren't related, but it suggests that this is *our* millennial moment.

KS: I was wondering, too, about changing visual strategies. You're dealing with this expansive landscape. One strategy you talked about was the aerial view, and then there are panoramic views that try to capture the expansiveness. But there are also a few photographers you've selected who really close in and restrict our vision so that we don't get that sense of spatial expansion. What are some of the other strategies people are using?

AB: Ulrich has to photograph in what is in legal terms private property—the big box and the mall. He sometimes uses a range-finder camera so he can just glance down to see the frame. It's candid, so he gets a natural reaction. It's also about what you photograph. Larry Sultan, who created a series of photographs called *The Valley*, about the adult-entertainment film industry housed in the San Fernando Valley, gives us a glimpse of what we may not be aware of, or dare not see (pages 126–128).

TM: Or Stefanie Nagorka building sculptures in the aisles of a Home Depot (pages 202–205). There are interesting layers there: art in Home Depot; Home Depot as the source for material that can be made into an object of aesthetic pleasure, contemplation, or provocation.

KS: It's also potentially a commentary on the notion of people going into Home Depot and getting their materials to create aesthetically satisfying environments for themselves.

AB: This discussion reminds me of Julia Christensen, who documents how defunct big box stores are being reused (pages 206–208). I asked her what advantage she has as an artist versus an architect or a planner (page 209). Her answer was that she does not arrive with an agenda—a statistical imperative, a particular architectural interest—but really tries to connect with people about how they understand what they're doing. In her work, the range of reuse is amazing—former big boxes that are now megachurches, or even the Spam Museum.

TM: The architectural form that comes from a similar point of view is FAT (Fashion Architecture Taste) (page 43). Sean Griffiths, who is one of the partners, has observed very honestly that architects typically bring their elitist taste to their projects. FAT's work is really meant to subvert that notion and embrace the taste of the people for whom they're building or whom they're studying. For example, FAT was asked by a newspaper in London a few years ago to design a suburban house for a dysfunctional family. [laughter] Which is not to imply that all suburban families are dysfunctional, but rather to acknowledge that families are imperfect. In other projects, they have taken the bric-a-brac, the tchotchkes, and the do-it-yourself architectural styling of families and incorporated them into their design rather than neutralizing them and saying, "You don't need one hundred cows. You've got to get those out of here, it ruins our aesthetics!"

KS: They design so those one hundred cows can be on display?

TM: Yes. They're very indebted to Robert Venturi and Denise Scott Brown for inspiration in terms of assumptions about quality and taste (page 49). They're indebted to the idea

that any critique of suburbia is really about taste: suburban taste—lawn jockeys and the perfectly trimmed hedge, "carpenter Gothic" architectural details.

KS: So do you find a sense of irony in FAT?

TM: No, their attitude isn't cloying or overly self-conscious. I think it is genuine appreciation for that which others find somehow objectionable.

KS: Another ghost in the room is the argument that suburban ways of living simply are not sustainable. Issues of sustainability seem not to be explicitly present here, or are they?

TM: They're not explicitly addressed. I'm not sure it was necessarily a conscious decision. When I was first thinking about the exhibition, this was absolutely something I was going to explore, all these strategies for remediating suburban conditions.

AB: Some of the projects do engage with ecological issues, but in different ways. It wasn't primary, but the Coen+Partners project for Mayo Woodlands has land conservation in its genesis (page 173). It's also about erasing or remediating the typical cul-de-sac layout they inherited from an aborted development plan for the site.

TM: There's densification—someone like Cruz, who's looking at a mixed-use program.

KS: I found it intriguing to see the SITE projects in this particular context, especially the parking lot that becomes the roof of the store (page 78). Talk about changing ways of reading images! When you think about storm-water-runoff issues today, and so on, it becomes powerful in a different way.

AB: Any meaningful examination would have to study both cities and suburbs, and their respective and cumulative environmental impacts: the electrical consumption associated with city living or house and lot sizes—suburban lawns, because of their size, may have more green potential versus the asphalt jungle and the heat-island effects from cities; or other factors, such as commuting and telecommuting. Basically put, there are challenges to sustainability in both cities and suburbs, and because it affects both environments and lifestyles, it could be its own show.

KS: For this exhibition then, it seems that rather than calling out sustainability as a separate issue, you've threaded it through the whole show—which seems a good thing, if you consider that to be effective, sustainability needs to infiltrate design, not to mention our thinking.

AB: Our approach was: suburbia exists and persists. It's a dominant reality, so what can be done within that context? People contend that the end of suburbia will be caused by rising energy prices—oil shortages and higher gas prices. Historically, this is not true. The largest expansion of suburbia was in the 1970s during that energy crisis.

TM: Americans are not going to give up their cars.

AB: Or where they want to live. So there's nothing particularly logical about one thing leading to another. The very latest spin on this end-of-suburbia thesis is the subprime lending collapse combined with higher energy prices. I don't think this is going to doom suburbia, either.

KS: You do have some architecture projects from the 1970s and 1980s, but why is it that you're mostly finding artists discovering suburbia sooner? Or is that really true?

AB: For the sake of disclosure I should note that the exhibition does not include the work of many photographers who did document the suburban landscape in the 1980s. That could be a show in and of itself. I think it's a missing component within suburbia for so many decades—the lack of architectural engagement, whether by choice or circumstance. It simply did not happen as much.

TM: That lack of engagement on the part of architects is particularly paradoxical, given the history of American suburbs. Some of what are now recognized as the country's great architectural innovators—A. J. Davis, Frederick Law Olmsted, Clarence Stein and Henry Wright, Frank Lloyd Wright—theorized about, or were involved in, the design of early suburbs. And as Kate mentioned in another conversation, there are any number of architect-designed gas stations, corporate office parks, as well as the occasional architect-designed suburban house. But in the past fifty years, it's only the New Urbanists who have seriously looked at suburbia per se—and generally, they've assumed a tabula rasa rather than dealing with suburbia on its existing terms. I think a lot of this has to do with architecture schools. I don't know of any architecture program with a component that examines suburbia on an ongoing basis. Carnegie Mellon University, for example, has an urban lab—a fifth-year urban design studio—but it is very seldom organized around a suburban site.

KS: We actually have one at the University of Minnesota, the Metropolitan Design Center [formerly the Design Center for the American Urban Landscape]. By the late 1990s, most of their work was looking at first-ring suburbs, and they organized a conference called Reframing Suburbia that John Archer and I were involved in, which brought planners, policymakers, and design professionals together with academics in history and cultural studies, among others.

TM: But that's certainly not the norm. It's especially interesting in light of the fact that most Americans live in suburbs and most college students are coming from there. Most architecture schools are perpetuating architects' interest in the city by offering urban design labs, but not really looking beyond that. Public officials also need to start thinking of suburbs as areas to be designed—to which some conscious notion of organization should be brought. City officials are just now starting to understand that good design is good business, and that having an architect involved in a project might be more expensive up front, but it could yield dividends in the end. So there's also that policy component to the explanation of why architects haven't been invited to the table very often. Architects need to understand that these places have value, and they need to be engaged by those who are in a position to make a difference in those landscapes.

AB: There is huge potential because suburbia is an area where habitation patterns, technologies, and societal expectations are changing. It might be the last architectural frontier.

KS: I think the lack of engagement by architects is embedded in attitudes within the profession, because it's basically not the sort of landscape that offers those heroic opportunities.

AB: True, but perhaps it's time to embrace suburbia's antiheroic opportunities.

Our Sprawling, Supersize Utopia

David Brooks

David Brooks is a <u>New York Times</u> columnist. His books include <u>On Paradise Drive: How We Live Now</u> <u>(And Always Have) in the Future Tense</u> (2004), and <u>Bobos in Paradise: The New Upper Class and How</u> <u>They Got There</u> (2001).

We're living in the age of the great dispersal. Americans continue to move from the Northeast and Midwest to the South and West. But the truly historic migration is from the inner suburbs to the outer suburbs, to the suburbs of suburbia. From New Hampshire down to Georgia, across Texas to Arizona and up through California, you now have the booming exurban sprawls that have broken free of the gravitational pull of the cities and now float in a new space far beyond them. For example, the population of metropolitan Pittsburgh has declined by 8 percent since 1980, but as people spread out, the amount of developed land in the Pittsburgh area increased by nearly 43 percent. The population of Atlanta increased by 22,000 during the 90's, but the expanding suburbs grew by 2.1 million.

The geography of work has been turned upside down. Jobs used to be concentrated in downtowns. But the suburbs now account for more rental office space than the cities in most of the major metro areas of the country except Chicago and New York. In the Bay Area in California, suburban Santa Clara County alone has five times as many of the region's larger public companies as San Francisco. Ninety percent of the office space built in America by the end of the 1990's was built in suburbia, much of it in far-flung office parks stretched along the Interstates.

These new spaces are huge and hugely attractive to millions of people. Mesa, Ariz., a suburb of Phoenix, now has a larger population than Minneapolis, St. Louis or Cincinnati. It's as if Zeus came down and started plopping vast developments in the middle of farmland and the desert overnight. Boom! A master planned community. Boom! A big-box mall. Boom! A rec center and 4,000 soccer fields. The food courts come and the people follow. How many times in American history have 300,000-person communities materialized practically out of nothing?

In these new, exploding suburbs, the geography, the very landscape of life, is new and unparalleled. In the first place, there are no centers, no recognizable borders to shape a sense of

geographic identity. Throughout human history, most people have lived around some definable place—a tribal ring, an oasis, a river junction, a port, a town square. But in exurbia, each individual has his or her own polycentric nodes—the school, the church and the office park. Life is different in ways big and small. When the New Jersey Devils won the Stanley Cup, they had their victory parade in a parking lot; no downtown street is central to the team's fans. Robert Lang, a demographer at Virginia Tech, compares these new sprawling exurbs to the dark matter in the universe: stuff that is very hard to define but somehow accounts for more mass than all the planets, stars and moons put together.

We are having a hard time understanding the cultural implications of this new landscape because when it comes to suburbia, our imaginations are motionless. Many of us still live with the suburban stereotypes laid down by the first wave of suburban critics—that the suburbs are dull, white-bread kind of places where Ozzie and Harriet families go to raise their kids. But there are no people so conformist as those who fault the supposed conformity of the suburbs. They regurgitate the same critiques decade after decade, regardless of the suburban reality flowering around them.

The reality is that modern suburbia is merely the latest iteration of the American dream. Far from being dull, artificial and spiritually vacuous, today's suburbs are the products of the same religious longings and the same deep tensions that produced the American identity from the start. The complex faith of Jonathan Edwards, the propelling ambition of Benjamin Franklin, the dark, meritocratic fatalism of Lincoln—all these inheritances have shaped the outer suburbs.

●

At the same time the suburbs were sprawling, they were getting more complicated and more interesting, and they were going quietly berserk. When you move through suburbia—from the old inner-ring suburbs out through the most distant exurbs—you see the most unexpected things: lesbian dentists, Iranian McMansions, Korean megachurches, outlaw-biker subdevelopments, Orthodox shtetls with Hasidic families walking past strip malls on their way to shul. When you actually live in suburbia, you see that radically different cultural zones are emerging, usually within a few miles of one another and in places that are as architecturally interesting as a piece of aluminum siding. That's because in the age of the great dispersal, it becomes much easier to search out and congregate with people who are basically like yourself. People are less tied down to a factory, a mine or a harbor. They have more choice over which sort of neighborhood to live in. Society becomes more segmented, and everything that was once hierarchical turns granular.

You don't have to travel very far in America to see radically different sorts of people, most of whom know very little about the communities and subcultures just down the highway. For example, if you are driving across the northern band of the country—especially in Vermont, Massachusetts, Wisconsin or Oregon—you are likely to stumble across a crunchy suburb. These are places with meat-free food co-ops, pottery galleries, sandal shops (because people with progressive politics have a strange penchant for toe exhibitionism). Not many people in these places know much about the for-profit sector of the economy, but they do build wonderful all-wood playgrounds for their kids, who tend to have names like Milo and Mandela. You know you're in a crunchy suburb because you see the anti-lawns, which declare just how fervently crunchy suburbanites reject the soul-destroying standards of conventional success. Anti-lawns

look like regular lawns with eating disorders. Some are bare patches of dirt, others are scraggly spreads of ragged, weedlike vegetation, the horticultural version of a grunge rocker's face.

Then a few miles away, you might find yourself in an entirely different cultural zone, in an upscale suburban town center packed with restaurants—one of those communities that perform the neat trick of being clearly suburban while still making it nearly impossible to park. The people here tend to be lawyers, doctors and professors, and they drive around in Volvos, Audis and Saabs because it is socially acceptable to buy a luxury car as long as it comes from a country hostile to U.S. foreign policy.

Here you can find your Trader Joe's grocery stores, where all the cashiers look as if they are on loan from Amnesty International and all the snack food is especially designed for kids who come home from school screaming, "Mom, I want a snack that will prevent colorectal cancer!" Here you've got newly renovated Arts and Crafts seven-bedroom homes whose owners have developed views on beveled granite; no dinner party in this clique has gone all the way to dessert without a conversational phase on the merits and demerits of Corian countertops. Bathroom tile is their cocaine: instead of white powder, they blow their life savings on handcrafted Italian wall covering from Waterworks.

You travel a few miles from these upscale enclaves, and suddenly you're in yet another cultural milieu. You're in one of the suburban light-industry zones, and you start noting small Asian groceries offering live tilapia fish and premade bibimbap dishes. You see Indian video rental outlets with movies straight from Bollywood. You notice a Japanese bookstore, newspaper boxes offering *The Korea Central Daily News* and hair salons offering DynaSky phone cards to Peru.

One out of every nine people in America was born in a foreign country. Immigrants used to settle in cities and then migrate out, but now many head straight for suburbia, so today you see little Taiwanese girls in the figure skating clinics, Ukrainian boys learning to pitch and hints of cholo culture spreading across Nevada. People here develop their own customs and patterns that grow up largely unnoticed by the general culture. You go to a scraggly playing field on a Saturday morning, and there is a crowd of Nigerians playing soccer. You show up the next day and it is all Mexicans kicking a ball around. No lifestyle magazine is geared to the people who live in these immigrant-heavy wholesale warehouse zones.

You drive farther out, and suddenly you're lost in the shapeless, mostly middle-class expanse of exurbia. (The inner-ring suburbs tend to have tremendous income inequality.) Those who live out here are very likely living in the cultural shadow of golf. It's not so much the game of golf that influences manners and morals; it's the Zenlike golf ideal. The perfect human being, defined by golf, is competitive and success-oriented, yet calm and neat while casually dressed. Everything he owns looks as if it is made of titanium, from his driver to his BlackBerry to his wife's Wonderbra. He has achieved mastery over the great dragons: hurry, anxiety and disorder.

His DVD collection is organized, as is his walk-in closet. His car is clean and vacuumed. His frequently dialed numbers are programmed into his phone, and his rate plan is well tailored to his needs. His casual slacks are well pressed, and he is so calm and together that next to him, Dick Cheney looks bipolar. The new suburbs appeal to him because everything is fresh and neat. The philosopher George Santayana once suggested that Americans don't solve problems; we just leave them behind. The exurbanite has left behind that exorbitant mortgage, that long commute, all those weird people who watch "My Daughter Is a Slut" on daytime TV talk shows. He has come to be surrounded by regular, friendly people who do

not scoff at his daughter's competitive cheerleading obsession and whose wardrobes are as Lands' End-dependent as his is.

Exurban places have one ideal that soars above all others: ample parking. You can drive diagonally across acres of empty parking spaces on your way from Bed Bath & Beyond to Linens 'n Things. These parking lots are so big that you could re-create the Battle of Gettysburg in the middle and nobody would notice at the stores on either end. Off on one side, partly obscured by the curvature of the earth, you will see a sneaker warehouse big enough to qualify for membership in the United Nations, and then at the other end there will be a Home Depot. Still, shoppers measure their suburban manliness by how close they can park to the Best Buy. So if a normal healthy American sees a family about to pull out of one of those treasured close-in spots just next to the maternity ones, he will put on his blinker and wait for the departing family to load up its minivan and apparently read a few chapters of *Ulysses* before it finally pulls out and lets him slide in.

You look out across this landscape, with its sprawling diversity of suburban types, and sometimes you can't help considering the possibility that we Americans may not be the most profound people on earth. You look out across the suburban landscape that is the essence of modern America, and you see the culture of Slurp & Gulps, McDonald's, Disney, breast enlargements and "The Bachelor." You see a country that gave us Prozac and Viagra, paper party hats, pinball machines, commercial jingles, expensive orthodontia and Monster Truck rallies. You see a trashy consumer culture that has perfected parade floats, corporate-sponsorship deals, low-slung jeans and frosted Cocoa Puffs; a culture that finds its quintessential means of self-expression through bumper stickers ("Rehab Is for Quitters").

Indeed, over the past half century, there has been an endless flow of novels, movies, anti-sprawl tracts, essays and pop songs all lamenting the shallow conformity of suburban life. If you scan these documents all at once, or even if, like the average person, you absorb them over the course of a lifetime, you find their depictions congeal into the same sorry scene. Suburban America as a comfortable but somewhat vacuous realm of unreality: consumerist, wasteful, complacent, materialistic and self-absorbed.

Disneyfied Americans, in this view, have become too concerned with small and vulgar pleasures, pointless one-upmanship. Their lives are distracted by a buzz of trivial images, by relentless hurry instead of contemplation, information rather than wisdom and a profusion of unsatisfying lifestyle choices. Modern suburban Americans, it is argued, rarely sink to the level of depravity—they are too tepid for that—but they don't achieve the highest virtues or the most demanding excellences.

These criticisms don't get suburbia right. They don't get America right. The criticisms tend to come enshrouded in predictions of decline or cultural catastrophe. Yet somehow imperial decline never comes, and the social catastrophe never materializes. American standards of living surpassed those in Europe around 1740. For more than 260 years, in other words, Americans have been rich, money-mad, vulgar, materialistic and complacent people. And yet somehow America became and continues to be the most powerful nation on earth and the most productive. Religion flourishes. Universities flourish. Crime rates drop, teen pregnancy declines, teen-suicide rates fall, along with divorce rates. Despite all the problems that plague this country, social healing takes place. If we're so great, can we really be that shallow?

Nor do the standard critiques of suburbia really solve the mystery of motivation—the inability of many Americans to sit still, even when they sincerely want to simplify their lives. Americans

are the hardest-working people on earth. The average American works 350 hours a year—nearly 10 weeks—more than the average Western European. Americans switch jobs more frequently than people from other nations. The average job tenure in the U.S. is 6.8 years, compared with more than a decade in France, Germany and Japan. What propels Americans to live so feverishly, even against their own self-interest? What energy source accounts for all this?

Finally, the critiques don't explain the dispersion. They don't explain why so many millions of Americans throw themselves into the unknown every year. In 2002, about 14.2 percent of Americans relocated. Compare that with the 4 percent of Dutch and Germans and the 8 percent of Britons who move in a typical year. According to one survey, only slightly more than a quarter of American teenagers expect to live in their hometowns as adults.

What sort of longing causes people to pick up and head out for the horizon? Why do people uproot their families from California, New York, Ohio and elsewhere and move into new developments in Arizona or Nevada or North Carolina, imagining their kids at high schools that haven't even been built yet, picturing themselves with new friends they haven't yet met, fantasizing about touch-football games on lawns that haven't been seeded? Millions of people every year leap out into the void, heading out to communities that don't exist, to office parks that are not yet finished, to places where everything is new. This mysterious longing is the root of the great dispersal.

●

To grasp that longing, you have to take seriously the central cliche of American life: the American dream. Albert Einstein once said that imagination is more important than knowledge, and when you actually look at modern mainstream America, you see what a huge role fantasy plays even in the seemingly dullest areas of life. The suburbs themselves are conservative utopias, where people go because they imagine orderly and perfect lives can be led there. This is the nation of Hollywood, Las Vegas, professional wrestling, Elvis impersonators, *Penthouse* letters, computer gamers, grown men in LeBron James basketball jerseys, faith healers and the whole range of ampersand magazines (*Town & Country, Food & Wine*) that display perfect parties, perfect homes, perfect vacations and perfect lives.

This is the land of Rainforest Cafe theme restaurants, Ralph Lauren WASP-fantasy fashions, Civil War reenactors, gated communities with names like Sherwood Forest and vehicles with names like Yukon, Durango, Expedition and Mustang, as if their accountant-owners were going to chase down some cattle rustlers on the way to the Piggly Wiggly. This is the land in which people dream of the most Walter Mitty-esque personal transformations as a result of the low-carb diet, cosmetic surgery or their move to the Sun Belt.

Americans—seemingly bland, ordinary Americans—often have a remarkably tenuous grip on reality. Under the seeming superficiality of suburban American life, there is an imaginative fire that animates Americans and propels us to work so hard, move so much and leap so wantonly.

Ralph Waldo Emerson once wrote that those who "complain of the flatness of American life have no perception of its destiny. They are not Americans." They don't see that "here is man in the garden of Eden; here, the Genesis and the Exodus." And here, he concluded fervently, will come the final Revelation. Emerson was expressing the eschatological longing that is the essence of the American identity: the assumption that some culminating happiness is possible here, that history can be brought to a close here.

The historian Sacvan Bercovitch has observed that the United States is the example par excellence of a nation formed by collective fantasy. Despite all the claims that American culture is materialist and pragmatic, what is striking about this country is how material things are shot through with enchantment.

America, after all, was born in a frenzy of imagination. For the first European settlers and for all the subsequent immigrants, the new continent begs to be fantasized about. The early settlers were aware of and almost oppressed by the obvious potential of the land. They saw the possibility of plenty everywhere, yet at the start they lived in harsh conditions. Their lives took on a slingshot shape—they had to pull back in order to someday shoot forward. Through the temporary hardships they dwelt imaginatively in the grandeur that would inevitably mark their future.

This future-minded mentality deepened decade after decade, century after century. Each time the early settlers pushed West, they found what was to them virgin land, and they perceived it as paradise. Fantasy about the future lured them. Guides who led and sometimes exploited the 19th-century pioneers were shocked by how little the trekkers often knew about the surroundings they had thrown themselves into, or what would be involved in their new lives. As so often happens in American history, as happens every day in the newly sprawling areas, people leapt before they really looked.

Americans found themselves drawn to places where the possibilities seemed boundless and where there was no history. Francis Parkman, the great 19th-century historian, wrote of his youthful self, "His thoughts were always in the forest, whose features possessed his waking and sleeping dreams, filling him with vague cravings impossible to satisfy."

Our minds are still with Parkman's in the forest. Our imagination still tricks us into undertaking grand projects—starting a business, writing a book, raising a family, moving to a new place—by enchanting us with visions of future joys. When these tasks turn out to be more difficult than we dreamed, the necessary exertions bring out new skills and abilities and make us better than we planned on being.

And so we see the distinctive American mentality, which explains the westward crossing as much as the suburban sprawl and the frenzied dot-com-style enthusiasms. It is the Paradise Spell: the tendency to see the present from the vantage point of the future. It starts with imagination—the ability to fantasize about what some imminent happiness will look like. Then the future-minded person leaps rashly toward that gauzy image. He or she is subtly more attached to the glorious future than to the temporary and unsatisfactory present. Time isn't pushed from the remembered past to the felt present to the mysterious future. It is pulled by the golden future from the unsatisfactory present and away from the dim past.

There's a James Fenimore Cooper novel called *The Pioneers*, in which a developer takes his cousin on a tour of the city he is building. He describes the broad streets, the rows of houses. But all she sees is a barren forest. He's astonished she can't see it, so real is it in his mind already.

Mentality matters, and sometimes mentality is all that matters. The cognitive strands established early in American history and through its period of explosive growth—the sense that some ultimate fulfillment will be realized here, that final happiness can be created here, that the United States has a unique mission to redeem the world—are still woven into the fabric of everyday life. The old impulses, fevers and fantasies still play themselves out amid the BlackBerries, the Hummers, the closet organizers and the travel-team softball leagues.

Suburban America is a bourgeois place, but unlike some other bourgeois places, it is also a transcendent place infused with everyday utopianism. That's why you meet so many boring-

looking people who see themselves on some technological frontier, dreaming of this innovation or that management technique that will elevate the world—and half the time their enthusiasms, crazes and fads seem ludicrous to others and even to them, in retrospect.

We members of this suburban empire still find ourselves veering off into world crises, roaring into battle with visions of progressive virtue on our side and retrograde evil on the other, waging moralistic crusades others do not understand, pushing our movie, TV and rock-star fantasies onto an ambivalent and sometimes horrified globe.

This doesn't mean all Americans, or even all suburban Americans, think alike, simply that there is a prevailing current to national life that you feel when you come here from other places with other currents. Some nations are bound, in all their diversity, by a common creation myth, a tale of how they came into being. Americans are bound, in all our diversity, by a fruition myth.

Born in abundance, inspired by opportunity, nurtured in imagination, spiritualized by a sense of God's blessing and call and realized in ordinary life day by day, this Paradise Spell is the controlling ideology of national life. Just out of reach, just beyond the next ridge, just in the farther-out suburb or with the next entrepreneurial scheme, just with the next diet plan or credit card purchase, the next true love or political hero, the next summer home or all-terrain vehicle, the next meditation technique or motivational seminar; just with the right schools, the right moral revival, the right beer and the right set of buddies; just with the next technology or after the next shopping spree—there is this spot you can get to where all tensions will melt, all time pressures will be relieved and happiness can be realized.

This Paradise Spell is at the root of our tendency to work so hard, consume so feverishly, to move so much. It inspires our illimitable faith in education, our frequent born-again experiences. It explains why, alone among developed nations, we have shaped our welfare system to encourage opportunity at the expense of support and security; and why, more than people in comparable nations, we wreck our families and move on. It is the call that makes us heedless of the past, disrespectful toward traditions, short on contemplation, wasteful in our use of the things around us, impious toward restraints, but consumed by hope, driven ineluctably to improve, fervently optimistic, relentlessly aspiring, spiritually alert and, in this period of human history, the irresistible and discombobulating locomotive of the world.

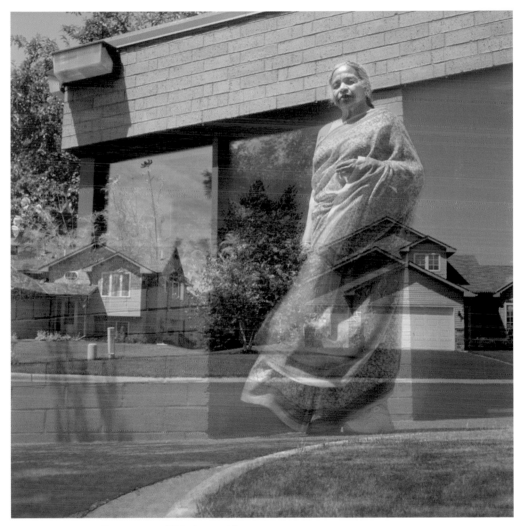

Laura E. Migliorino *Chicago Avenue* 2007 (cat. no. 46)

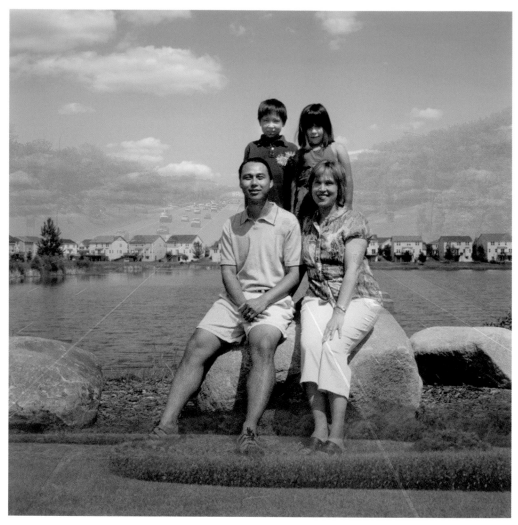

Laura E. Migliorino *Goodhue Street* 2007 (cat. no. 47)

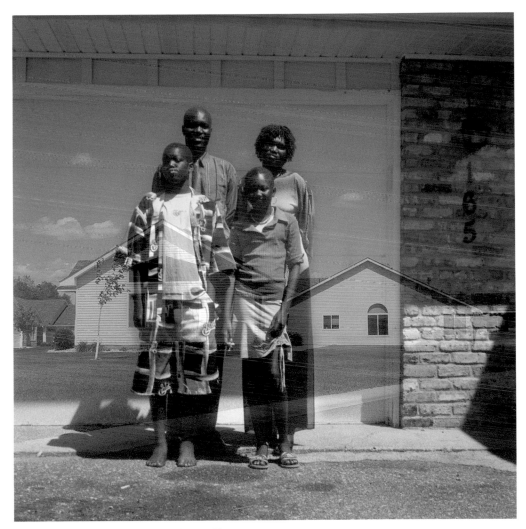

Laura E. Migliorino *Egret Street* 2006 (cat. no. 45)

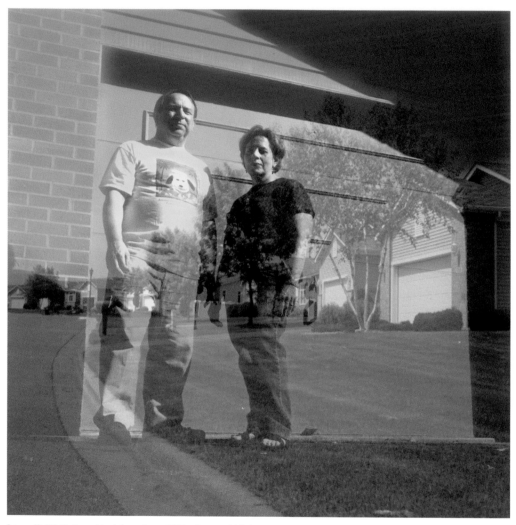

Laura E. Migliorino *Mendelsson Lane* 2006 pigmented ink-jet on canvas

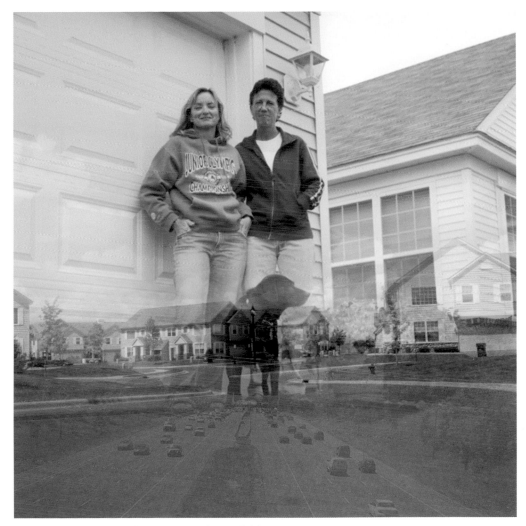

Laura E. Migliorino *Oakbrook Way #2* 2007 pigmented ink-jet on canvas

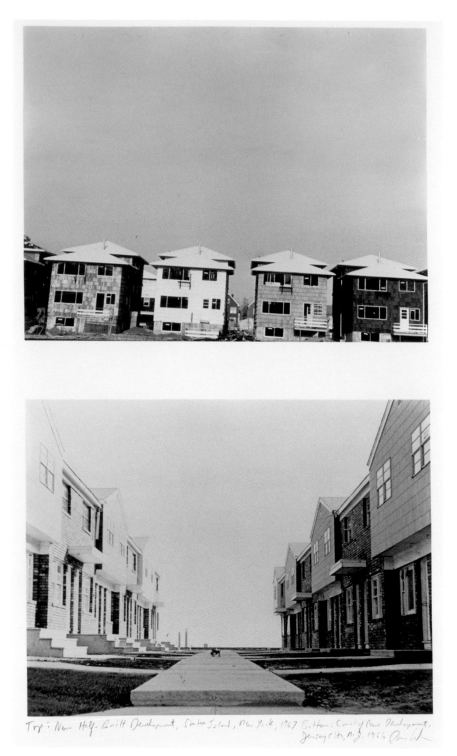

Top: New Half-Built Development, Staten Island, New York, 1967 Bottom: County New Development, Jersey City, N.J. 1966 Dan Graham

Dan Graham *Homes for America* 1966–1967 (cat. no. 33)

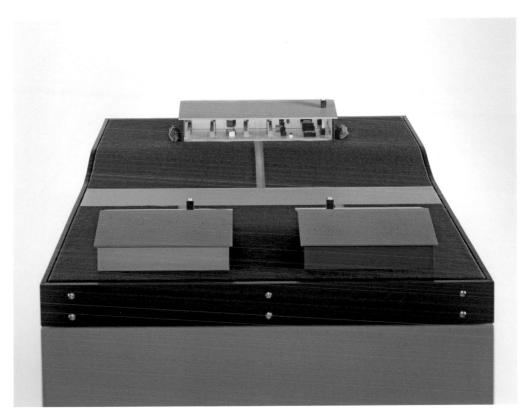

Dan Graham *Alteration to a Suburban House* 1978/1992 (cat. no. 34)

Floto+Warner *(Reindeer)* 2004 (cat. no. 30)

Floto+Warner *(Santa Claus)* 2004 (cat. no. 31)

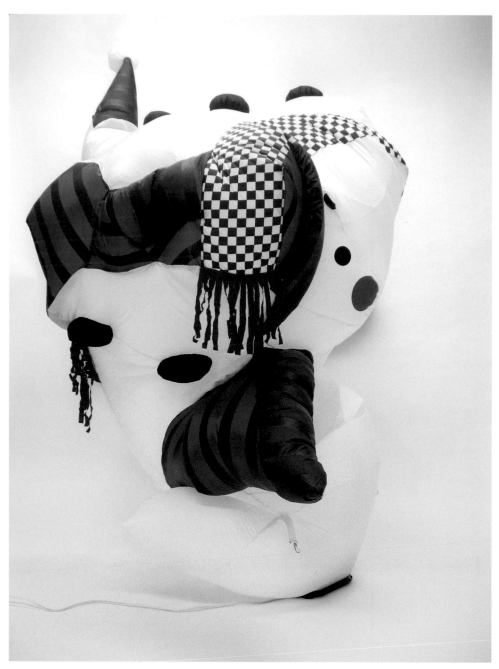

Floto+Warner *(Snowman)* 2004 (cat. no. 32)

Hoogvliet Heerlijkheid

2001–present

FAT (Fashion Architecture Taste)
Sean Griffiths, Sam Jacob, Charles Holland

Founded at the end of the fifteenth century and given political autonomy in the early nineteenth century, the town of Hoogvliet was incorporated into Rotterdam—the industrial and commercial heart of the Netherlands and the world's largest port— in 1933. Since that time, Hoogvliet's development has been closely tied to the fortunes of its principal industrial tenant, Shell Petroleum. Although it experienced substantial growth following World War II, the town suffered several setbacks beginning in the 1970s that ultimately led to debilitating physical, racial, and cultural division. Industrial depredation of the environment, together with several accidents and explosions at Shell plants, eroded the city's image and set off a cycle of commercial disinvestment and residential flight to outlying, lower-density areas. Automation of the petroleum industry resulted in a steep decline in the number of jobs in Hoogvliet, while the closing of Shell plants on Curaçao and Aruba in 1985 triggered an influx of Antillean, Cape Verdean, and Surinamese immigrants seeking employment. Unemployment and the familiar cycle of poverty, deterioration of the physical environment, crime, racial isolation, and collective despair culminated in a determination by various planning bodies in the late 1990s to remake Hoogvliet into a suburb of Rotterdam.

Through a coincidence of vision and a strong collective will, a progressive local politician and a group of architectural activists called Crimson Architectural Historians successfully pressed for a new model of reinvention that, rather than relying on the common process of wholesale demolition and reconstruction, encouraged imaginative interventions of widely varying scales that respond to the community's desires and exploit its surviving richness. The name of the overall Hoogvliet renewal project, WiMBY!—Welcome into My Back Yard!—reflects a philosophical commitment to countering the attitude of divisiveness that pervaded the town.

FAT's project, *Hoogvliet Heerlijkheid*, is a "summer village" and "hobby park," the components of which were defined through a process of close engagement with the community's residents. FAT and Crimson discovered an eccentric variety of users, including, among others, retired dockworkers who build and demonstrate model boats, pigeon-racing aficionados, players of panna football (a Surinamese variant of soccer that can be likened to arena football), a group that wanted to start an arboretum, teens who disassemble and reassemble motorcycles as a hobby, and groups of single Antillean mothers in search of space for socializing. Although the specific program evolved over a period of four years, FAT's first job was to create an architectural vocabulary that communicates what the community feels about itself and how it sees itself. Unabashed admirers of the work of Robert Venturi and Denise Scott Brown, FAT shared with Crimson an affinity for a kind of populist language "capable of expressing nostalgia, sentiment, conviviality, and a longing for a better world." Architecturally, these notions are articulated through diagrammatic forms with easily recognizable associations, the use of brilliant color, and treatment of the principal building as a layered billboard.

Hoogvliet Heerlijkheid eventually will comprise a multifunctional community hall (the "Villa"), a "hobby hut" for the model-boat builders, an arboretum, an ecology playground, and a variety of lampposts, park furniture, bridges, and additional huts. It is hoped that by collecting a wide range of activities, the park will become the locus of a civic spirit: a place in which racial and social barriers might dissolve and a sense of community emerge. Completion is expected in 2008.

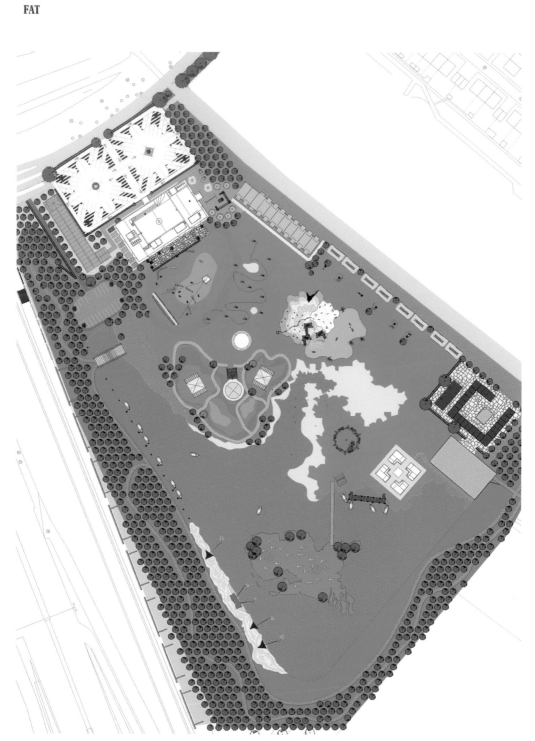

Early site plan

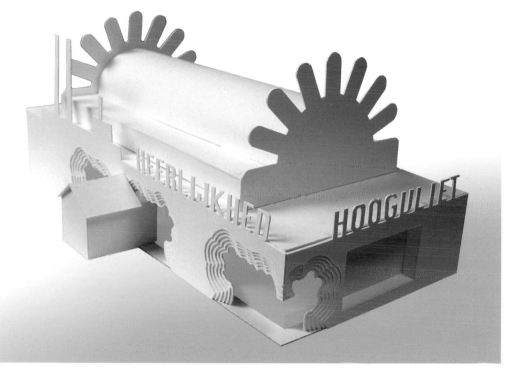

The Villa

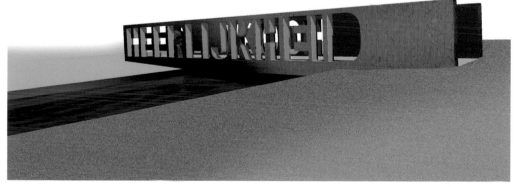

Heerlijkheid bridge

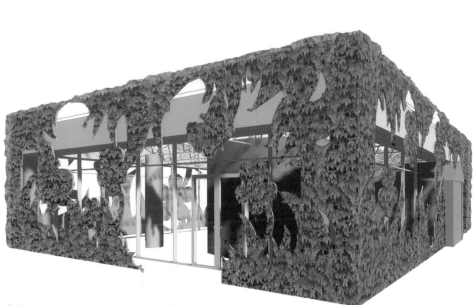

Early proposed arboretum, pet cemetery building

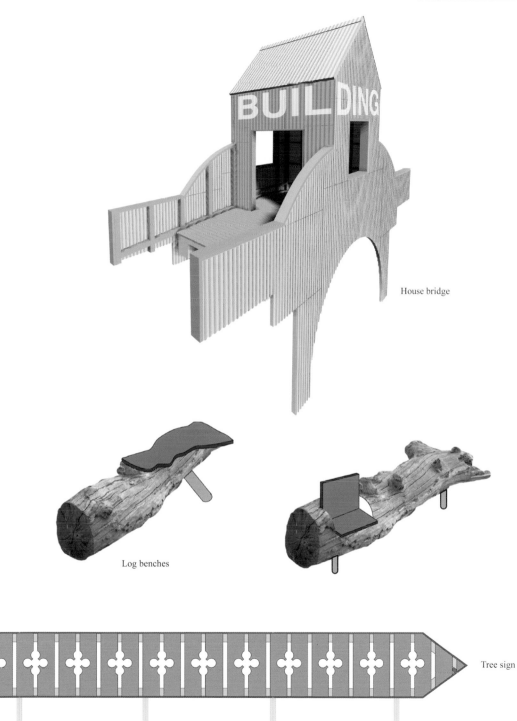

House bridge

Log benches

Tree sign

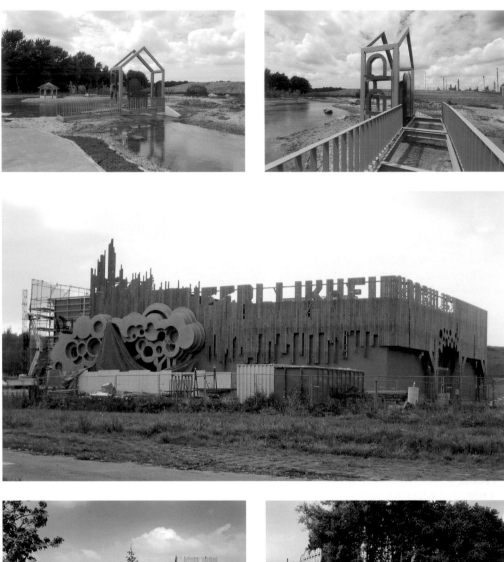

Hoogvliet Heerlijkheid under construction 2007

Learning from Levittown

A Conversation with Robert Venturi and Denise Scott Brown

Beatriz Colomina, October 9, 2007

Robert Venturi and Denise Scott Brown are founding principals of Venturi, Scott Brown and Associates (VSBA), an award-winning architecture and planning firm. Robert Venturi is the author of <u>Complexity and Contradiction in Architecture</u> (1966), which received the AIA's Classic Book Award. Scott Brown, Venturi, and Steven Izenour are the authors of the seminal book <u>Learning from Las Vegas</u> (1972/1977). In 2007, Venturi and Scott Brown were honored with the National Design Mind Award, Cooper-Hewitt, National Design Museum, New York.

Beatriz Colomina is professor of architecture and founding director of the Program in Media and Modernity at Princeton University. Her latest book is <u>Domesticity at War</u> (2007).

"We shall be more interested in what people make of their housing than in what architects intended them to make of it. We shall be more interested in the iconography of 'Mon (split-level, Cape Cod, Rancher) Repos' than in the iconography (<u>or</u> structure) of the Dymaxion house or Fallingwater. We shall be more interested in the marketing of industrialised house components than in their design. This is not a course in Housing, but an examination of the field from an action-oriented and architectural point of view, designed to make a subsequent, deeper study of housing more meaningful. We shall not be involved in civic or community action to do with housing in this studio, but in learning what is needed to make our professional contribution to this action more relevant." — Denise Scott Brown, "Remedial Housing for Architects," studio brief, 1970

Beatriz Colomina: Following your "Learning from Las Vegas" studio at Yale, which resulted in the famous book *Learning from Las Vegas*, you conducted a less well-known studio called "Remedial Housing for Architects or Learning from Levittown." Could you tell us about your impetus to study American suburbia and Levittown at that moment in 1970?

Denise Scott Brown: The idea of looking at suburbia derived from many strains of thought, but a great number came from the social sciences I studied during my city planning education at Penn. Some planning faculty showed unremitting scorn for architects, primarily for the scorn they in turn showed for the everyday environment and the architecture of suburbia. It so happened that the urban sociologist-planner, Herbert Gans, moved

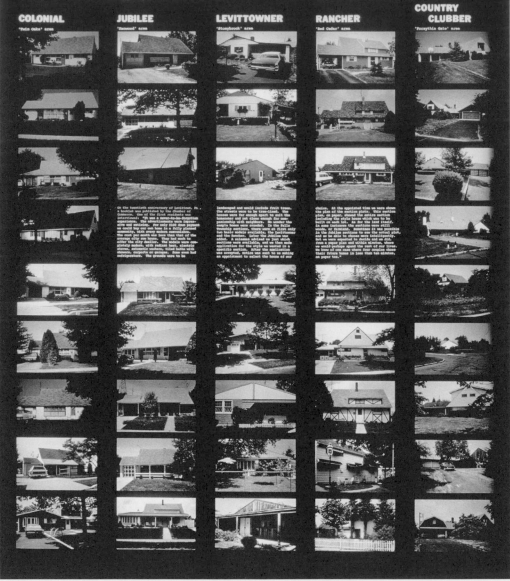

fig. 1 Analysis of alterations to and variations of Levittown house styles

to Levittown as a participant-observer in that new community during the course I took with him when I first got to Penn in 1958. We visited him there. In planning school we saw all around us evidence of harm that architects had brought about in urban renewal, dreadful stories of what happened to low-income people as a result of housing that was built to look like the social housing of Europe but in fact housed the rich. We were surrounded by that critique as Penn social-scientist planners admonished us that we should be more open-minded if we wanted to be city planners who did not do harm.

I came out of the New Brutalism in England and the social upheaval of the 1950s there, where the same questions were asked by architects and others. They said, "We've made mistakes in moving bombed-out people from the East End of London into the new towns, and destroying their social fabric." But my African experience had already harshly underlined cultural differences, particularly between popular, folk, and dominant cultures. So the African and English stories were in my mind very strongly when I got to America. Here I learned the issues more broadly, particularly from Gans, himself a German refugee who had lived in England before coming to America. A famous English postwar study of social and kinship patterns in the London East End was on his reading list, and he had written a book on the effects of urban renewal in the West End of Boston. Then, from the East End and West End he moved, literally and conceptually, to Levittown and later to developing his ideas on popular and high culture.

Robert Venturi: There is irony about this ideal form of social housing. The European continental idea of housing as high-rise buildings in a park, the Ville Radieuse of Le Corbusier, was imposed in American cities where, as Jane Jacobs indicated, it had little to do with Americans' notions of community. Even I, when I was young and working for Oskar Stonorov, was in on the design of a high-rise public housing project, which forty-five years later was destroyed because it was not appreciated. In America, the idea was to live in a suburb; and there was no proletarian class; even the poor hoped to come up in the world and live in the ideal suburb. So this imposition of the European socialist idea on the American working class or lower-income people—this whole thing was full of ironies, and that's what made us say, "Let's look at what people want to live in."

DSB: And there were other reasons. There were many nonarchitects in planning school in the 1960s because there was so much federal money available for urban renewal. So our faculty and our student body contained both architects and nonarchitects, and there was frequently warfare between them. The architects were horrified to hear some professors say, "You should go look at the automobile cities of the Southwest. You can't afford to ignore them. They are a trend that's logical in terms of the technology of movement today, and you need to be open to these things and understand them." So when I moved from teaching at Penn to teaching at the University of California, it was partly for that reason. But there was the influence of Pop artists as well, who were also finding inspiration in popular culture. We were fascinated and inspired by them.

RV: We forget now how much suburbia was despised at the time by the idealists. A busload of students came up from Columbia to attend the jury at the end of the Learning from Levittown studio, to boo, boo, boo. Robert Stern, now dean of Yale's School of Architecture, was there at the time, and Vincent Scully was on the faculty. They had been very friendly and agreeable to us before this, but they were against Las Vegas and Levittown. What we were doing was extremely unpopular.

DSB: The notion of permissiveness was important in planning then. Planners were taught to be open to different stimuli; not to say, "This one's wrong, that one's right," but rather, to reserve judgment at first, to make subsequent judgments more sensitive. In the late 1960s I wrote an article, "On Pop Art, Permissiveness, and Planning," in which I used the photographs of Ed Ruscha as my example of how urbanism and the Pop Art movement could be linked. I think I was one of the first people to publicize Ed Ruscha, and he was grateful. When we stopped in Los Angeles with the students on our trip to Las Vegas, he gave us a party in his studio.

RV: There is the irony also that classic European modernists in the early twentieth century acknowledged the significance of American industrial vernacular architecture, and essentially based the architectural vocabulary of modernism on American factory systems. But they wouldn't consider the next American generation's commercial or residential vernacular.

BC: In that sense, it can be said that you were a modernist, too, in claiming that it was also necessary to look at the vernacular next door, at the suburban houses of Levittown, for example, or the commercial street. But why Levittown? Were you interested because it was unique or because it was generic?

DSB: Because, like the Strip, it was an archetype. You couldn't say the Las Vegas Strip was generic, but it was the most extreme example. There are many merchant builders in America, and most do fewer than a hundred houses a year. After World War II, moderately priced housing was built in Philadelphia by private-sector developers, but it was row housing. Levitt built single-family, detached housing in suburbia. He was bigger and better organized, and he understood that industrialization didn't necessarily mean making housing in a factory. It could mean vertical integration of the construction process and rationalizing the timing and procedures of development as much as planning the house itself. Rather than thinking of high-tech housing, he thought of procedures. To improve his distribution systems, he acquired many of the elements of a construction industry. And he did introduce technological innovations in the house but without making it "modern"—things still looked colonial or whatever, but they were constructed more cheaply. Levitt listened very carefully to what people wanted. He would hang around the model homes to overhear visitors' remarks—that was his market analysis—then he worked by trial and error. He'd build six houses and see how they went; if sales were good, he'd try more. His thought was in advance of other merchant builders and took directions that seemed to us to be correct.

RV: Levittown was based on the automobile culture. Levittowners could afford cars and didn't depend on buses, trains, and trolleys. Another condition we enjoyed investigating was how people decorated their houses on the outside. Soon after they moved in, a lot of variation and individual expression appeared on the house fronts and in the yards ⬛fig. 1⬛.

DSB: This was a continuation of our interest in the symbolism of Las Vegas. Another route to Levittown took us from the commercial areas we'd been studying into the residential subdivisions nearby. A further influence was Sybil Moholy-Nagy, who recommended that architecture students investigate merchant builders' housing. We also did content analysis, looking at "literatures" ⬛figs. 2–4⬛. A literature could be a Disney Daisy Duck cartoon, or TV ads and sitcoms, or articles in *Popular Mechanics* magazine and home builders' journals. We analyzed all these for their housing con-

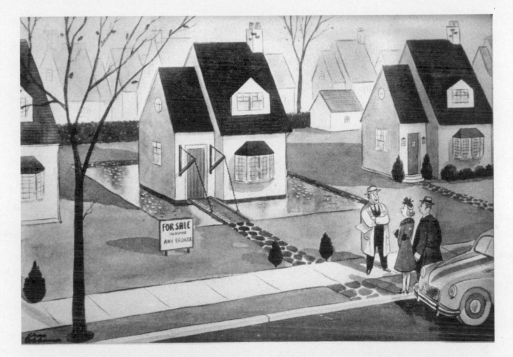

figs. 2–4 Printed ephemera about suburban houses used for content analysis in the "Learning from Levittown" studio

tent, the idea being that their interpretation of housing differed from those found in, for example, the architectural journals. The aim was to help give students a broader view on housing. And we didn't look only at Levittown. We considered various other forms of housing, including public housing.

BC: Yes, we noticed that. In fact, it seems that the first impulse of the studio was what you called "Remedial Housing for Architects," and that Learning from Levittown was an afterthought. We noticed in the studio brief that "Learning from Levittown" was added in Denise's handwriting to the original title. What did you mean by "remedial"? Is it remedial education for architects or is it remedial as in architecture that fixes a problem?

DSB: Remedial for us architects. That was the title I first gave it. It came out of taking housing courses in planning school and encountering wholly different subject matter from that considered in architecture school—housing economics and sociology, for example. Even our ideas of function required reconsideration. Instead of thinking of it in an early modernist sense, we needed to redefine it for our different era, and to include social, economic, and symbolic demands among those to be understood.

RV: The idea of symbolism is most important. That's what we, as well as a few others, brought back into architecture. It had been expressly thrown out by the modernists, although it was readmitted on the sly in the symbolic industrial vocabulary they employed.

BC: Did you think of Learning from Levittown as the direct follow-up to Learning from Las Vegas in the sense of going from studying the symbols in the strip to studying the domestic symbols of the American suburban house?

DSB: Yes. But we studied more than symbolism. The stress on symbolism hurt our career. It made people say, "All they think of is symbolism. They are superficial people because everyone knows that symbolism is superficial." Among artists we found sympathy for our interest in symbolism, but when we introduced our ideas on commercial symbolism and popular culture, Bob and I became unpopular with architects. I was passionately involved in our reassessment of symbolism, but I was interested too in what Peter Smithson called "active socioplastics." It had to do with understanding the way people really live, particularly with the life on the streets of London's East End. Peter had tried working with sociologists to translate these ideas into designs for new social housing, but he had given up. He felt the sociologists would have to extend their field before he could work with them. I began to feel that he was wrong, that we architects for many reasons were the ones who had to find a way to translate social information into physical terms. So that's what we've done as designers—tried to find ways of giving physical form to the social, economic, functional, and symbolic patterns of our client's program.

RV: And we considered the idea of electronic technology. It is important to acknowledge that we are no longer [living] in the age of industrial technology.

BC: The studio looked at Levittown houses and the changes that owners had made on them, but mostly from the outside. In that sense, it can be said that you were treating houses as media, as billboards, in a kind of echo of Las Vegas.

RV: The modernists were saying we design from the inside out. We said you design from the outside in as well as the inside out.

BC: Both Learning from Las Vegas and Learning from Levittown were studios, and the brief of both studios had the same structure. In which way was the teaching technique differ-

ent in Learning from Levittown? Did you learn something from the Learning from Las Vegas studio that you then applied to Levittown?

DSB: Those two studios were part of a series of, I think, eleven that I've given over my career, about half of them in urban design and planning.

RV: Together we gave a studio at Rice and three at Yale.

DSB: Their structure came from Harvard, via my Penn studio critic and advisor, David Crane. I'd not seen studios like his before, because in architecture studios people worked individually, often competitively, and there was neither an organized research phase nor a discussion of getting from research to design. These and the research-design relationships we set up came from years of experience in planning school, where the poor architects were often lambasted by faculty who said, "You did a ritual dance called research, then you closed that book and went on to your favorite activity, design, taking no note whatsoever of the research." So we were always asking ourselves how to make the one flow into the other. When planning the Yale studios, I told myself "These are not planning students; I can't try for the overall comprehensive integration of everything that I attempted with planning students." But I still wanted to give them an understanding of the breadth of everything, so I introduced lecturers for some subjects, while the students worked themselves on others. We tried hard to tune the subject matter to their interests. Both studios had to be very controversial, because in the 1960s if you weren't "agin' the government" in some way, forget it. And if your aim was to get students to read, you had better find something they really needed to read in order to do their design work or they wouldn't read it. So I tried to design problems that would fascinate them, and at the same time make them need information and learn how to go get it. All my studios had that aim, but the "Learning from" and those that followed were looser and freer than the earlier ones.

RV: The heads of the schools weren't very happy about what we did. Even Charles Moore was unhappy, although you think of him as connecting with the everyday environment. What did he say once at some conference? "I did not learn anything from Las Vegas."

DSB: On the other hand, Yale let us absorb all the students' credits for the semester into the studio. This meant that the reading and research had to give them the equivalent of about four courses.

BC: A semester seems like a very short time for such complex research. Did you ever consider repeating the subject, doing Learning from Levittown again, for example?

DSB: That would be boring. The fun is that you're entering a new subject, a new adventure, with fifteen eager collaborators. But I'd love to see further research, not repetition, done on this subject, and am very happy you are doing it.

RV: We were thinking of writing a book called *Learning from Levittown*, but our architectural partner John Rauch said, "Let's not do it." He had a point. We had spent so much time writing *Learning from Las Vegas* that it interfered with our work as architects. It was important to us that we were architects as well as writers, thinkers, and academics. I think it was in 1972 that I gave up teaching. I decided I couldn't do both. In the old days you could, but now things have become so complex that if you do both, you don't do a good job of either, and it becomes superficial. A lot of people still do both, but I didn't think I could.

BC: 1972? So after the studio from Levittown, you never taught again?

RV: I have not taught since then. I've lectured a lot.

DSB: Another thing: those two studios were almost all research. Dean Holmes Perkins criticized me at Penn for stressing research in studio. He said, "You can't take these students away from their first love—design." So, in the Las Vegas studio, when they got back from Las Vegas, I said, "We're going to do a design." The theory was, and I agree with the theory, that you do a design as part of the research. Design is seen as a particular way of bringing information together that can tell you what other information is needed. So design is a heuristic for research, not only the other way around. Therefore, I gave them a four-day sketch design. They called it "That busywork Denise is giving us." For architecture students to call a design "busywork" was very funny. The Levittown studio ended with some fun, free-floating designs. They did marvelous jobs on those, but they spent only three weeks.

BC: Only three weeks for design? Denise, you come from planning, and planning studios, as you said, are always about collaborative research on the city. How about you, Bob? You come into this from the world of architecture, which is all about objects. Was there a connection between research and design studios in your background? For example, when you went to Rome, you did a lot of research.

RV: In Rome I did research in a sense by looking, traveling, absorbing. I summed up my experience in *Complexity and Contradiction in Architecture*. I found that I had to write. I consider myself essentially an architect, but as a young architect, I couldn't get my ideas down through building because I didn't have the opportunity. I did not have the connections to get good projects, and what I did build was not that likeable; not many people wanted it. So in order to accommodate myself and not feel too frustrated, I described my ideas in writing.

DSB: Bob had ways of doing research that I think came from his historical studies, and to some extent from Labatut, his teacher at Princeton. He used a comparative method. He'd say, "Let's look at the architecture of vast space everywhere, at Versailles, on the expressway, and on the Strip." Or, "Let's look at pleasure architecture. What are its innate characteristics? What makes a pleasure environment, in the Middle East, in Europe, and in Las Vegas?" That kind of analysis was a huge addition to our studio research topics.

RV: It is important to mention how grateful I am to have been a student at Princeton in the mid-1940s. At that time, the great schools of MIT and Harvard did not look at history. For them, history started with the modernist movement and would evolve from there. Princeton was the one place where you could be a modernist who looked at history. That was fortunate for me, because I always loved history and historical architecture and felt inspired by it. For me, connecting with the historical past enriched what we were doing now.

BC: I think one of the most interesting things about your practice is the way in which you have reinforced the idea that the designer is a researcher and a communicator. In fact, much of your research is about architecture as a form of communication. What would you say about the suburbs and communication today?

DSB: You mean latter-day suburbs since our study?

BC: Yes.

RV: We haven't kept up. We are repelled by McMansions—we're utter snobs about that.

DSB: We're saddened by the latter-day Las Vegas, by its Disneyfication.

BC: But it's interesting that you went back to Las Vegas and did a subsequent study that analyzed Las Vegas in that sense, demonstrating how it had changed so much from the 1970s, and how it was no longer about symbols but about scenography. Did you ever consider going back to Levittown and thinking about how it has changed in the last few decades?

DSB: It would be very fascinating to do that, because suburbia is really changing enormously. I have watched some outskirts of Philadelphia develop as a mish-mash between housing and office parks, with perhaps a little New Urbanism seeping in at the seaming of the two. But I haven't been able to follow it systematically. We're too old. We'll be the critics, but someone else needs to do it.

RV: We're fascinated by a parallel direction, the taking over of industrial loft buildings and making them residential. We're sympathetic to that, and intrigued by it. I love industrial lofts. I feel they, along with industrialized symbolic signage, are great building types of the twentieth century.

DSB: And then there's edge city—the vastly dense sprawl you get in Dade County and around Washington, D.C., and maybe Boston—I think it's an order we haven't understood yet. I don't know whether the studies of it are well based or what its future patterns will be, and I haven't seen a studio take it on. It would be a very big task.

RV: We have not kept up with the idea of the suburb and how it deals with community and how it connects with the commercial. And we don't have any specific ideas. We do think a lot of New Urbanism tends to be sentimental picturesque. How well it works, I'm not sure.

BC: Do you consider Learning from Levittown an unfinished project? Or did you get to test these ideas in your practice? Do you regret never completing the book? What was the relationship between the Learning from Levittown studio and the office at the time?

DSB: It's a shame we couldn't write the book. Other people have threatened to do it. Working today, they'd need to see our study as history and take the research further in different directions. A young architect, Steven Song, is writing an essay called, "Renovating the Decorated Shed." The theme is that much has changed in the world of electronics and today, if you can use an iPod or make private cell-phone calls in a public place, then architects must once again reconsider and redefine subjects such as flexibility and the differences between public and private, updating what we did in the 1960s and 1970s. These conditions aren't exactly new, there was always private life in public places (and vice versa) but certainly electronics are affecting the architectural conditions we described, and it's very good to see the discussion take that direction.

BC: I'm fascinated that your studios are not only based on research but that they can turn into books. Did you already have this idea while you were doing the Learning from Las Vegas studio or did it happen afterwards, perhaps when you were doing Learning from Levittown?

DSB: While teaching, I felt I was involved in professional rather than academic education, and I scorned the maxim "publish or perish." To digress a moment: I practice architecture and planning and teach architects, urban designers, and city planners, but some people forget that I'm an architect. I was angry the other day when someone said, "She's a sociologist." I'm not. I use sociological material for architectural purposes. That's what professional practice requires. So my teaching includes helping students use academic information for design purposes. At Penn I gave a course on theory of architecture, city

planning, and landscape, in which part of my job was to teach a seminar that helped make lectures given by various faculty members relevant to students' problems in the first-year design studio. To do this, I gave small design research topics in building types and structures, and I recommended as sources books such as *The Minor Architecture of Venice*. For each study I asked a series of questions that would guide them in linking their research to their design. For a row housing project I asked, "How do you get the impression of privacy even if you can't have the reality? And how do you get light deep into the center of a row house plan?" They also were supposed to do reading, but I began to realize that if I didn't ask the right questions, they wouldn't do the reading. This seminar helped to prepare for some study topics in the "Learning from" studios. I got accustomed, too, to writing in connection with designing.

RV: The theory course I gave in the early 1960s at Penn was the result of a specific request to me by Holmes Perkins. I replied, "I've never taken a theory course, I've never heard of a theory course in architecture." Later I asked him, "Holmes, were there any theory courses elsewhere in the academic world at that time?" "No," he said. "Yours was the first one." That's very funny because he was a Harvard Bauhaus guy. But I think he asked me because he knew that I was the only one around at the time who was a modern architect and a studio teacher who had some knowledge of history, which derived, as I said, from my unique Princeton background and my particular interest.

BC: But the particular idea of making a book out of the research of a studio—was there any precedent for this?

DSB: Some architecture faculty used studios to promote and publish their ideas on design, and perhaps some out of UC Berkeley on research. By 1968 we had already written two articles on Las Vegas. I had wanted to run a studio on Las Vegas when I was teaching at UCLA and was planning it as my next project, but instead, I started teaching at Yale with Bob. Then I thought, "Why not do it at Yale?" Once we had done it, and because we had two articles and all our written and mapped studio material, it seemed a very good idea to compile it into a book.

BC: Toward the end of *Learning from Las Vegas*, there is already a hint of Learning from Levittown in a section of the book with a title I love, "From La Tourette to Levittown." You talk about how modern architects "who can embrace vernacular architecture remote in time and place reject the current vernacular of the merchant builders like Levittown and the commercial vernacular of Route 66." So it is as if you conceive of these two vernaculars, the public and the private, in tandem, and you cannot separate them. Were you thinking about the commercial and the domestic vernacular in parallel?

RV: I think we started thinking about the commercial first, and we evolved that from Denise's past work. Then it went to the residential, to the suburb, and in that move we were influenced somewhat by Gans. At the time I was thinking, "I want to look at what I hate, because I'm going to learn from that." There really was a problem with the modern. There was this irony that modernism said, "Get rid of this horrible École des Beaux-Arts background. Throw that out." But modernism had really become like the École des Beaux-Arts in the sense that it had a very narrow, overly idealistic vision.

DSB: The course I took with Gans was in 1958. In 1960 I wrote a term paper for David Crane on merchant builders, and I was totally intrigued by Southern California, single-family, detached, rural-scale, urban-suburban housing. So I had been interested in both for a

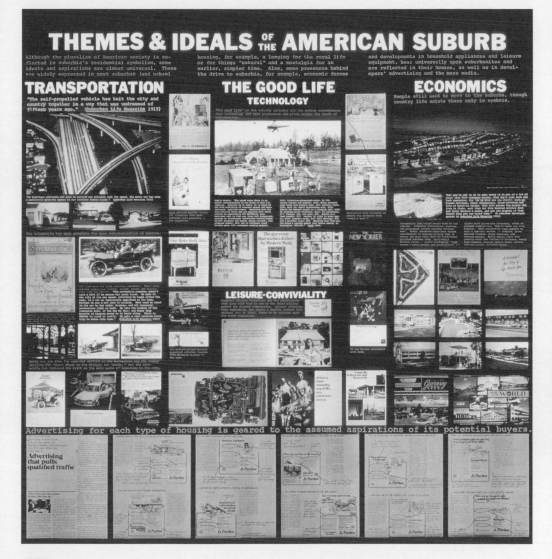

fig. 5 *Themes & Ideals of the American Suburb* (detail)

long time. On the other hand, the realization that the big, striking signs of Las Vegas had a parallel in the smaller imagery of Levittown came later.

BC: This late part of *Learning from Las Vegas* where you refer to Levittown could also be seen as an anticipation, a preview of something to come, in the same way that at the very end of *Complexity and Contradiction in Architecture*, you wrote that "Main Street is almost all right," in a way anticipating *Learning from Las Vegas*. Is Levittown almost all right?

RV: Yes, especially when you consider what the Levittown inhabitants do to it, which is to individualize it.

BC: The studio looked at Levittown houses and the changes that people made to the exteriors. It's interesting that you also asked students to look at the way in which houses were represented in television commercials, home journals, car advertisements, *New Yorker* cartoons, films, and even soap operas. So the house is a form of media and the media is full of houses. What is the relationship between the suburbs in the streets and the suburbs in the media?

DSB: That's a great question for research. Thinking on our feet, houses in the media are there for many purposes, including to sell things. We investigated the media as an alternative filter—not the architect's—on the reality of housing. We put our own mesh on reality, and we see what we want to see. People in marketing use their mesh. How do you sell pickles to a housewife? You give her a very beautiful kitchen, and there she is on the TV screen, holding the pickle jar with the kitchen behind her. Marketers have to work out what would be looked upon as a beautiful kitchen by their pickle customer. In the studio, we explored the lifestyles around housing of very low-income people as well as the different lifestyles and markets within middle-income groups, and we documented the information in illustrated matrices figs. 6–7 . One student read forty-four books on sociology to make her matrix. She couldn't find color pictures of very low-income lifestyles, so she used black-and-white ones from news stories and charity brochures. Color infuses her matrix as income rises. We were trying to learn about society and to teach ourselves that our mesh was not the only one.

RV: Although we haven't studied it or thought about it much, we find Main Street and the Strip of the recent past more likeable emotionally and aesthetically than McMansions and malls—the manifestations of current suburbia.

DSB: We don't go there much.

BC: So there is not so much to learn from the current suburbia?

RV: Maybe if we were a generation later, we might learn. I think we do have a kind of snobbery.

BC: We have noticed an enormous number of titles in your work that start with the word "Learning": *Learning from Las Vegas* and "Learning from Levittown," of course, but also "Learning from Pop," "Learning from Brutalism," "Learning from Hamburgers," "Learning from Lutyens," "Learning from Brink," "Learning from Philadelphia," "Learning the Right Lessons from the Beaux Arts," "Learning the Wrong Lessons from the Beaux Arts," "Co-op City: Learning to Like It," even "Learning from Everything," in your Spanish book, *Aprendiendo de todas las cosas*. It's a lot of learning. What is the meaning of the word for you?

RV: I think it's absorbing the culture that you are in, and connecting with it. In the early days

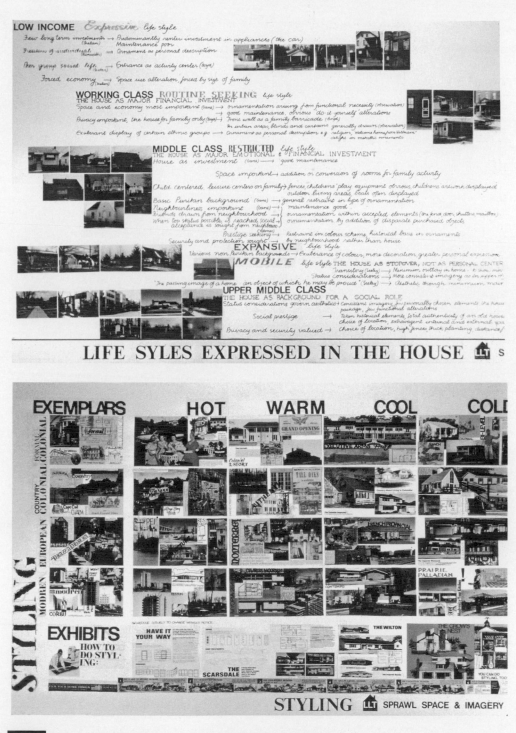

of modernism, architects said, "The current culture is no good. We are revolutionaries." I think we are saying, "Evolution is as significant as revolution." There are moments when revolution makes sense, and there are moments when evolution is right. And when you are indulging evolution, you want to absorb what's there to evolve from and out of.

DSB: Every study we do, whether for an architecture project, a campus plan, or a city, starts with a "Learning from" study—you could say adventure. We try to do it very early in the project; to make ourselves super sensitive to vibes as we first encounter the environment we'll be working in and on.

RV: And we acknowledge what we think we'll evolve from and revolt against.

BC: I'm very interested in this insistence on "learning," because again, it emphasizes the idea that your mode of operation as architects is as researchers.

RV: We do research because we think the idea of evolving from as well revolting against is significant. Revolting, for us, derives from acknowledging what is evolving. So we revolted against the modernist aesthetic of minimalism and purity partly as a result of appreciating the evolving quality, the freedom and excitement, of the everyday landscape.

BC: So, revolting and learning, the ugly and the ordinary. The research of "Learning from Levittown" materialized in the exhibition *Signs of Life: Symbols in the American City* figs. 8–9 at the Renwick Gallery in Washington, D.C., in 1976, where you put together the signs and symbols of the commercial strip and the home to bring together *Learning from Las Vegas* and "Learning from Levittown."

RV: For the home section, we learned from Ray and Charles Eames, who were unusual for that era in that they lived in a modern house, but it was cluttered. Then we loved looking at the Victorian aesthetic—especially the cluttered Victorian house. We said, "All these small objects can be significant, can be beautiful, can enrich your life, your memories. Hey, let's go back to an aesthetic of anti-minimalism, of clutter if you will, and let's look at the everyday." So we showed photographs of the cluttered facades and interiors of three houses. In the ranch house, for example, word balloons like those in comic strips refer to the pseudo-Chippendale chair or the modern radio and acknowledge that many associations are connected with these elements.

BC: How would you describe the relationship between the research in the studios and the exhibition? Were the students involved in some way in the exhibition? What was the role of Steve Izenour, who had had such a big part in *Learning from Las Vegas*?

DSB: Steve Izenour had been our student at Penn and was our student assistant for *Learning from Las Vegas*, but not Levittown. He felt it would be logical to go on to the symbolism of Levittown, but he didn't work on the studio because by then he was working in our office. As to the show, Joshua Taylor, director of the National Collection of Fine Arts, approached us to design the Smithsonian Institution's bicentennial celebration. *Signs of Life* was his title. I think the Smithsonian was getting interested in non-minimalist exhibition design. He knew about us, and the kinds of things we might do—perhaps, too, because he had been at Princeton with Bob. The show had three foci: the city, the strip, and the house. We had to build the city exhibit from scratch. For the others, we didn't directly use the work of the students, but our themes were basically those we had evolved with them. We commissioned photographs and gathered hundreds of illustrations like those we'd collected in the studio from magazines and other sources. Then we used them in making big illustrated panels on chosen subjects. Our exhibits were

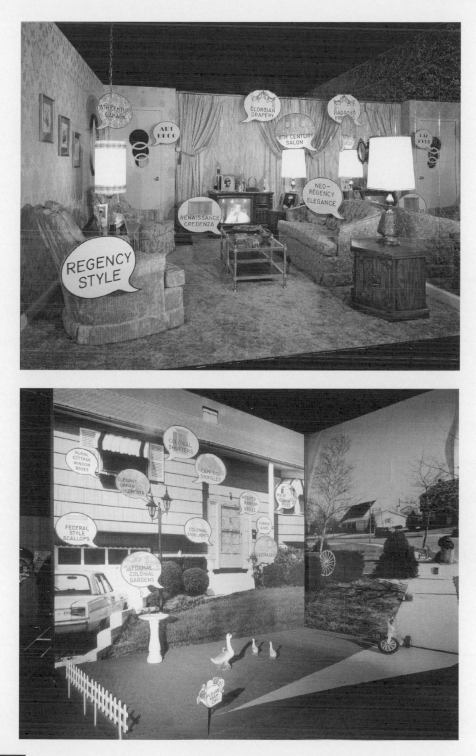

Installation views of South Philly row house interior (top) and suburban house facade and front yard (bottom) in the exhibition *Signs of Life: Symbols in the American City* 1976

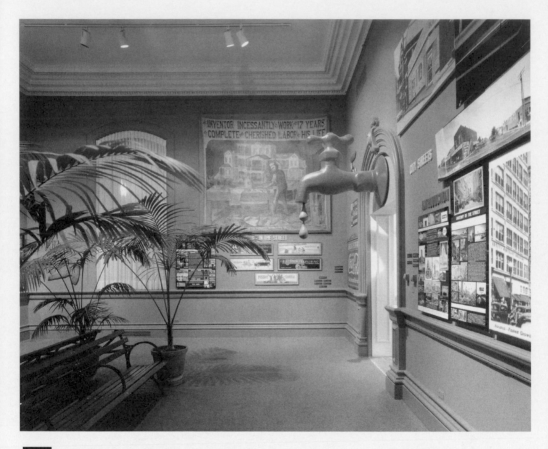

fig. 10 Installation view of the city room in the exhibition *Signs of Life: Symbols in the American City* 1976

far from minimalist, but they were disciplined. To present "far too much" information, we treated each panel like a newspaper, with strong headlines, subtitles, and text. Some photographs and models were huge, like the billboard that stretched the length of a wall, or that wonderful Styrofoam faucet with the water droplets fig. 10 . Steve Izenour had a major role in the conception and implementation of the show. And he, more than the Smithsonian, was its organizational arm. He got all the stuff, supervised its production and erection, and did extra fund-raising. All of us did the research, designed the layouts, and wrote the texts.

BC: In the studio brief of "Learning from Levittown" you said to the students, "Do for housing what [Claes] Oldenburg did for hamburgers." What did you mean? What would be the equivalent in architecture?

DSB: I was thinking of Oldenburg's soft sculpture, particularly his soft hamburger. If he had a way of artistically interpreting a hamburger, we as architects should be able to artistically interpret a suburban house.

RV: We loved him and learned from him.

BC: But how do you translate that in architecture? Is the Levittown house a hamburger that through some artistic, or in this case architectural, intervention gets to be seen in a different light?

DSB: Our students' response to the problem was to design a huge blowup of a Levittown house, then to divide it into four or five apartments for low-income people. For another problem, I said, "Think of the possibility of integrated residential areas where family incomes range widely but where we might be pretty certain that everyone has suburban values." How could we insert low-income housing into this suburbia without threatening people living there? So students tried to design housing that looked like the suburban houses nearby, but was in fact made of smaller houses put together.

BC: As architects you were interested in Pop Art, and at the same time, some artists were interested in popular architecture and studying the American vernacular. Ed Ruscha's photographs of the Strip in Los Angeles were, of course, a very important reference in *Learning from Las Vegas*. Were you also aware of Dan Graham's *Homes for America*? He photographed the facades of New Jersey tract houses and the additions that owners have made to them.

DSB: And he takes their theme as an inspiration for his artistry.

BC: Dan Graham began *Homes for America* fig. 11 in 1966. It was published in *Arts* magazine in 1967. The parallel with your work is very interesting because Graham was also fascinated, and still is, with the little transformations that people make to their houses, particularly the decorations Italian Americans add, such as madonnas on the lawn. There is a clear parallel between his work and yours at that time, but there doesn't seem to have been any awareness of this coincidence either way.

DSB: We didn't know too much about him then. I suspect he may have heard or read Herb Gans, because Gans talked about how he could recognize an Italian American's house in Levittown from its wrought ironwork.

RV: That's interesting, the ethnic symbolism.

BC: "Remedial Housing for Architects or Learning from Levittown" was both architecture and planning, but you did the studio in the School of Architecture at Yale at a time of enormous tension between both programs. In fact, historically it coincides with the

Dan Graham *Homes for America* 1971 lithograph on paper

separation of planning and architecture in many schools. What did it mean to be in the middle of this? What was the context at Yale at that time?

DSB: Penn was where I was really held in tension, not Yale. At Yale there were some interesting planners, but they weren't social revolutionaries like Paul Davidoff. In fact, I introduced Paul to Yale. He lectured there for a while, but there was no tension between architecture and planning around us—perhaps because we spent our days in studio and saw few others. But during the semester I began to wonder how these Yalies could deal with this material when they weren't taking any planning courses at all. Perhaps it was a later era, or perhaps they were just more generally educated than the young urban designers I dealt with at Berkeley or Penn—had more under their belt from undergraduate school.

RV: What about the influence of Vincent Scully at Yale? The significance of modern planning was in the air via his extremely popular and influential course on modern architecture, but it didn't really help to orient students in our direction.

DSB: Yalies who took Scully's course gained a sense of the change of ideas with time and shifting circumstances. So they could be more sophisticated clients than many. Also, Scully was deeply involved with social planning for the Hill Community in New Haven, and he was very aware of himself as someone who had won a scholarship to Yale.

BC: You have such warm feelings for Scully, and of course he was and still is so important at Yale. Why do you think he was so negative toward the Levittown studio?

DSB: Vince's son, our good friend, was in the Las Vegas studio, and that blunted his criticism a little, but with the Levittown studio it all came out. His complaints were a mixture of "You have to maintain standards, this is not art," and, unspoken, "Where is this woman leading this man?"

RV: It's been a back and forth, but he's been very good to us.

DSB: To you!

Sara Stevens (SS, student): Between "Learning from Las Vegas" and "Learning from Levittown," you taught a studio at Rice [University] and you looked at the Westheimer commercial strip in Houston as well as at housing—apartment buildings that come up later in a Levittown studio piece. I am wondering if the studio you taught at Rice led you from what you had been doing with the Las Vegas studio toward the Levittown studio?

RV: I think it did, yes, because it did connect to the more typical and ordinary landscape as opposed to the sort of hyper-exaggerated landscape of Las Vegas, even the earlier Las Vegas. So I think that was influential and it was a wonderful studio, but it did irritate a lot of the other people on the faculty. We were controversial.

DSB: We analyzed the Westheimer strip as a sequence of events. I had already looked intensely at 1960s suburban group housing in Los Angeles, which was a stage set, where secretaries sunned themselves around the young executives at the pool, and the place was called something like the Taj Mahal. Even more so in Houston, they built housing environments for the newcomers who were flooding the city and who wanted what Colin Rowe called an instant "décor de la vie," meaning a setting for themselves against which they could form a social life. You could choose among amazingly different backgrounds.

SS: When you taught the studio at Yale in the spring of 1970, the Black Panther trials were going on and there were riots in the city of New Haven, so there was a lot of social unrest. The fire in the school of architecture happened about the same time as well. Could you speak generally about the immediate context of New Haven at that moment?

DSB: The first studio was taught in the architecture building. The second had to be moved owing to the fire. But we were more involved with social unrest and the social-planning movement in Philadelphia than at Yale. At the office, in parallel with the Las Vegas studio, we were running an advocacy planning project, fighting an expressway on behalf of communities on South Street. Given their subject matter, the issues to be tackled, and the mandate to be open to other people's values, we felt that the thrust of both projects in Philadelphia and Las Vegas concerned both social justice and aesthetic excitement. (And we had the joy of flying Alice Lipscomb, matriarch of the South Street low-income Hawthorne community and leader of our community, to New Haven to lecture on housing to our Levittown studio. She held them spellbound for five hours.)

RV: My mother was a Socialist, which is unusual for an American at that time. So I had that in me in the first place as I grew up.

DSB: In planning school, because I sat cheek by jowl with the social planners, I was the one they attacked. But I loved and respected people like Paul and Linda Davidoff, so this was very challenging for me. The rest of the architecture school went along its merry way. Even [Louis] Kahn said, "How can you believe in the sociologists when they believe in 2.5 people?" Yet I believe Lou's experience of working with social planners in Philadelphia in the 1940s made his work different from that of his followers. In any case, that ardent social-physical debate was what I was coming from, and I wasn't going to leave half the argument out.

Gina Greene (student): I'm curious about why you were interested in suburban architecture at a particular historical moment when it seemed that urban centers were such an object of focus in the late 1960s. Was there something specific that made you want to turn away from focusing on the urban?

DSB: We didn't turn away. In the 1960s, 1970s, and 1980s we worked continuously for small, generally low-income communities as architects and advocate planners. From 1968 to 1972, mainly as volunteers, we helped South Street's inner-city communities first stop the expressway and then make their own plans.

RV: In Las Vegas, we were into urbanism very much, of course.

DSB: Gans' move from the West End to Levittown was a departure from the traditional urban approach of his mentors, but he felt profound social changes were happening for large populations in the new lower-middle class suburbs, and he influenced us. However, we continued social and physical planning for little towns and inner-city areas until, under Nixon and Reagan, reduced funding caused urban-planning agencies to become haunted houses. The planners left, and the young architects and young lawyers who remained spent their time on aesthetically based design guidelines. I couldn't get the data needed to do the responsible planning Davidoff would have called for, and we lost so much money making a plan for downtown Memphis that I felt I could no longer do that to our firm. I may be the last person alive to use Paul's social-planning methods, but I apply them now to campus planning.

RV: I think you could say that suburbia *is* urban. It's low-density urbanism, but it is urban.

DSB: Our community and campus plans are seldom published. If you use the fine-grained data that goes with low-income and inner-city situations, it doesn't show up clearly where architects publish. Since the early 1960s, we've been doing the kind of mapping that

is now suddenly fashionable in architecture. I believe most architects use it to evolve urban sculptural shapes, but for us it's a design tool. We try to go from social forces to physical forms via an analysis of the social and physical patterns in maps.

Diana Kurkovsky (student): I guess this is a wrap-up question. I was wondering what you learned from the "Learning from Levittown" studio, what were your surprises and disappointments, what did you discover that you didn't expect to see there, and how did everything you learned influence your attitudes toward housing and your subsequent work?

RV: One sad answer is that we have not had the chance to work on a Levittown-inspired project. Developers don't come to us for housing. Occasionally we do individual houses, but that's entirely different. So we have not had a chance to be stimulated into thinking about suburbia further, by dealing with the realities of the subject as designers.

DSB: It's hard to decide what we learned from Levittown. It was easier with Las Vegas. When people first asked, "Just what did you learn?" it puzzled us. I finally grew impatient and said, "What did you learn from the Parthenon?" The next answer I gave was, "See what we do to see what we learned." The next, mainly from Bob, was, "We basically learned about symbolism." But we also learned how to put active socioplastics on the ground. And there is a piece of the answer I haven't covered yet. It concerns thinking in the 1960s about complex systems, particularly in the field of regional science. From them, I began to learn some basic ways of going from forces to form, and I've followed their methods ever since — including in Las Vegas, where we mapped land uses and activity distributions across the city and eventually inside the casino complexes. This showed us that, despite their seemingly huge variety, they all worked by the same system, and that was very meaningful to us. Now we say we do land-use and transportation planning inside buildings. So a combination of Gans and the systems planners helped us get by Smithson's problems with active socioplastics and move from forces to form.

RV: Or we could say we went from complexity and contradiction to complexity and perversity. [laughs]

BC: Thank you very much.

RV: Thank you for the lovely questions.

This interview is part of an ongoing research project on the studio "Remedial Housing for Architects or Learning from Levittown" run by Denise Scott Brown and Robert Venturi at Yale University in 1970. The research team, led by Beatriz Colomina, includes students in the PhD program in Architecture and the Media and Modernity program at Princeton University: Pep Aviles, Gina Greene, Urtzi Grau, Joy Knoblauch, Diana Kurkovsky, Daniel Lopez-Perez, Joaquim Moreno, Enrique Ramirez, Rafico T. Ruiz, Molly Wright Steenson, and Sara Stevens.

In Praise of Chain Stores

They aren't destroying local flavor—they're providing variety and comfort

Virginia Postrel

Virginia Postrel is an <u>Atlantic Monthly</u> contributing editor and author of the books <u>The Substance of Style: How the Rise of Aesthetic Value Is Remaking Commerce, Culture, and Consciousness</u> (2004) and <u>The Future and Its Enemies: The Growing Conflict Over Creativity, Enterprise, and Progress</u> (1999).

Every well-traveled cosmopolite knows that America is mind-numbingly monotonous—"the most boring country to tour, because everywhere looks like everywhere else," as the columnist Thomas Friedman once told Charlie Rose. Boston has the same stores as Denver, which has the same stores as Charlotte or Seattle or Chicago. We live in a "Stepford world," says Rachel Dresbeck, the author of *Insiders' Guide to Portland, Oregon*. Even Boston's historic Faneuil Hall, she complains, is "dominated by the Gap, Anthropologie, Starbucks, and all the other usual suspects. Why go anywhere? Every place looks the same." This complaint is more than the old worry, dating back to the 1920s, that the big guys are putting Mom and Pop out of business. Today's critics focus less on what isn't there—Mom and Pop—than on what is. Faneuil Hall actually has plenty of locally owned businesses, from the Geoclassics store selling minerals and jewelry, to Pizzeria Regina ("since 1926"). But you do find the same chains everywhere.

The suburbs are the worst. Take Chandler, Arizona, just south of Phoenix. At Chandler Fashion Center, the area's big shopping mall, you'll find P. F. Chang's, California Pizza Kitchen, Chipotle Mexican Grill, and the Cheesecake Factory. Drive along Chandler's straight, flat boulevards, and you'll see Bed Bath & Beyond and Linens-N-Things; Barnes & Noble and Borders; PetSmart and Petco; Circuit City and Best Buy; Lowe's and Home Depot; CVS and Walgreens. Chandler has the Apple Store and Pottery Barn, the Gap and Ann Taylor, Banana Republic and DSW, and, of course, Target and Wal-Mart, Starbucks and McDonald's. For people allergic to brands, Chandler must be hell—even without the 110-degree days.

One of the fastest-growing cities in the country, Chandler is definitely the kind of place urbanists have in mind as they intone, "When every place looks the same, there is no such

thing as place anymore." Like so many towns in America, it has lost much of its historic character as a farming community. The annual Ostrich Festival still honors one traditional product, but these days Chandler raises more subdivisions and strip malls than ostrich plumes or cotton, another former staple. Yet it still refutes the common assertion that national chains are a blight on the landscape, that they've turned American towns into an indistinguishable "geography of nowhere."

The first thing you notice in Chandler is that, as a broad empirical claim, the cliché that "everywhere looks like everywhere else" is obvious nonsense. Chandler's land and air and foliage are peculiar to the desert Southwest.

The people dress differently. Even the cookie-cutter housing developments, with their xeriscaping and washed-out desert palette, remind you where you are. Forget New England clapboard, Carolina columns, or yellow Texas brick. In the intense sun of Chandler, the red-tile roofs common in California turn a pale, pale pink.

Stores don't give places their character. Terrain and weather and culture do. Familiar retailers may take some of the discovery out of travel—to the consternation of journalists looking for obvious local color—but by holding some of the commercial background constant, chains make it easier to discern the real differences that define a place: the way, for instance, that people in Chandler come out to enjoy the summer twilight, when the sky glows purple and the dry air cools.

Besides, the idea that America was once filled with wildly varied business establishments is largely a myth. Big cities could, and still can, support more retail niches than small towns. And in a less competitive national market, there was certainly more variation in business efficiency—in prices, service, and merchandise quality. But the range of retailing *ideas* in any given town was rarely that great. One deli or diner or lunch counter or cafeteria was pretty much like every other one. A hardware store was a hardware store, a pharmacy a pharmacy. Before it became a ubiquitous part of urban life, Starbucks was, in most American cities, a radically new idea.

Chains do more than bargain down prices from suppliers or divide fixed costs across a lot of units. They rapidly spread economic discovery—the scarce and costly knowledge of what retail concepts and operational innovations actually work. That knowledge can be gained only through the expensive and time-consuming process of trial and error. Expecting each town to independently invent every new business is a prescription for real monotony, at least for the locals. Chains make a large range of choices available in more places. They increase local variety, even as they reduce the differences from place to place. People who mostly stay put get to have experiences once available only to frequent travelers, and this loss of exclusivity is one reason why frequent travelers are the ones who complain. When Borders was a unique Ann Arbor institution, people in places like Chandler—or, for that matter, Philadelphia and Los Angeles—didn't have much in the way of bookstores. Back in 1986, when California Pizza Kitchen was an innovative local restaurant about to open its second location, food writers at the L.A. *Daily News* declared it "the kind of place every neighborhood should have." So what's wrong if the country has 158 neighborhood CPKs instead of one or two?

The process of multiplication is particularly important for fast-growing towns like Chandler, where rollouts of established stores allow retail variety to expand as fast as the growing population can support new businesses. I heard the same refrain in Chandler that I've heard in similar boomburgs elsewhere, and for similar reasons. "It's got all the advantages of a small town, in terms of being friendly, but it's got all the things of a big town," says Scott Stephens, who

moved from Manhattan Beach, California, in 1998 to work for Motorola. Chains let people in a city of 250,000 enjoy retail amenities once available only in a huge metropolitan center. At the same time, familiar establishments make it easier for people to make a home in a new place. When Nissan recently moved its headquarters from Southern California to Tennessee, an unusually high percentage of its Los Angeles–area employees accepted the transfer. "The fact that Starbucks are everywhere helps make moving a lot easier these days," a rueful Greg Whitney, vice president of business development for the Los Angeles County Economic Development Corporation, told the *Los Angeles Times* reporter John O'Dell. Orth Hedrick, a Nissan product manager, decided he could stay with the job he loved when he turned off the interstate near Nashville and realized, "You could really be Anywhere, U.S.A. There's a great big regional shopping mall, and most of the stores and restaurants are the same ones we see in California. Yet a few miles away you're in downtown, and there's lots of local color, too."

Contrary to the rhetoric of bored cosmopolites, most cities don't exist primarily to please tourists. The children toddling through the Chandler mall hugging their soft Build-A-Bear animals are no less delighted because kids can also build a bear in Memphis or St. Louis. For them, this isn't tourism; it's life—the experiences that create the memories from which the meaning of a place arises over time. Among Chandler's most charming sights are the business-casual dads joining their wives and kids for lunch in the mall food court. The food isn't the point, let alone whether it's from Subway or Dairy Queen. The restaurants merely provide the props and setting for the family time. When those kids grow up, they'll remember the food court as happily as an older generation recalls the diners and motels of Route 66—not because of the businesses' innate appeal but because of the memories they evoke.

The contempt for chains represents a brand-obsessed view of place, as if store names were all that mattered to a city's character. For many critics, the name on the store really *is* all that matters. The planning consultant Robert Gibbs works with cities that want to revive their downtowns, and he also helps developers find space for retailers. To his frustration, he finds that many cities actually turn away national chains, preferring a moribund downtown that seems authentically local. But, he says, the same local activists who oppose chains "want specialty retail that sells exactly what the chains sell—the same price, the same fit, the same qualities, the same sizes, the same brands, even." You can show people pictures of a Pottery Barn with nothing but the name changed, he says, and they'll love the store. So downtown stores stay empty, or sell low-value tourist items like candles and kites, while the chains open on the edge of town. In the name of urbanism, officials and activists in cities like Ann Arbor and Fort Collins, Colorado, are driving business to the suburbs. "If people like shopping at the Banana Republic or the Gap, if that's your market—or Payless Shoes—why not?" says an exasperated Gibbs. "Why not sell the goods and services people want?"

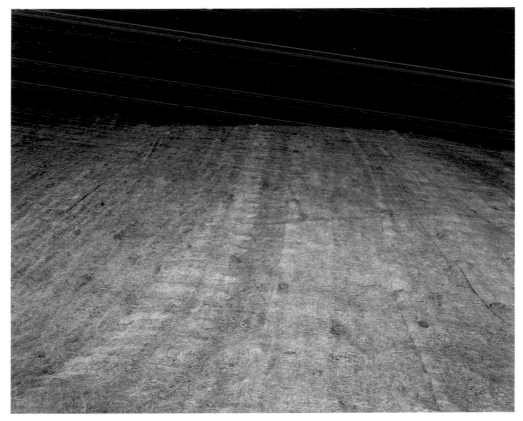

Michael Vahrenwald *Grey Slope, Wal-Mart, Bloomsburg, PA* from the series *Universal Default* 2005 chromogenic print

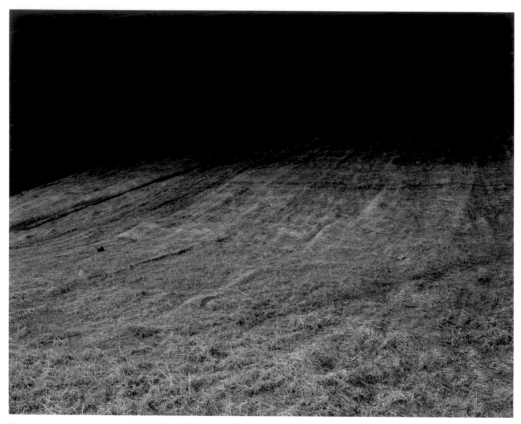

Michael Vahrenwald *Straw Hill, Wal-Mart, Bloomsburg, PA* from the series *Universal Default* 2005 (cat. no. 78)

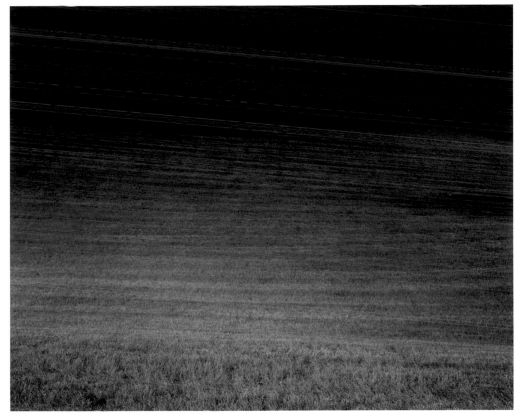

Michael Vahrenwald *Stepped Hill #2, East Greensbush, NY* from the series *Universal Default* 2006 chromogenic print

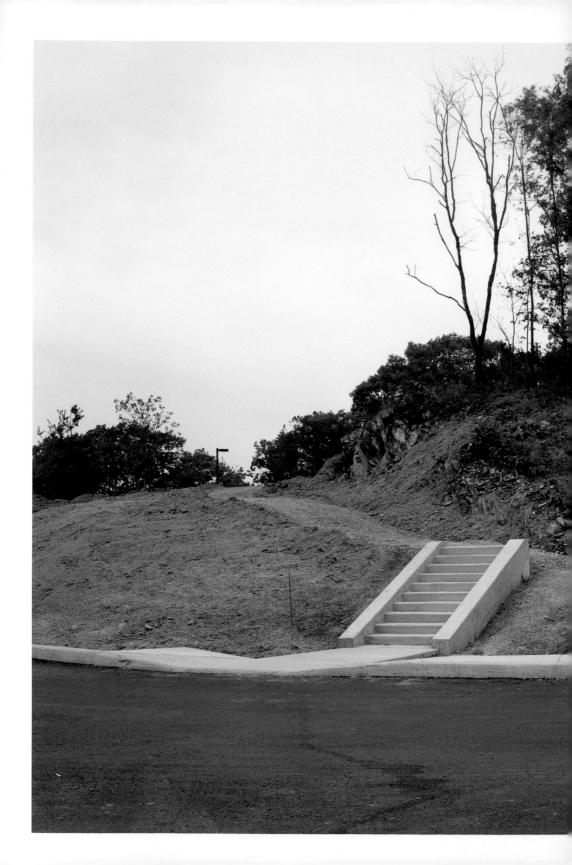

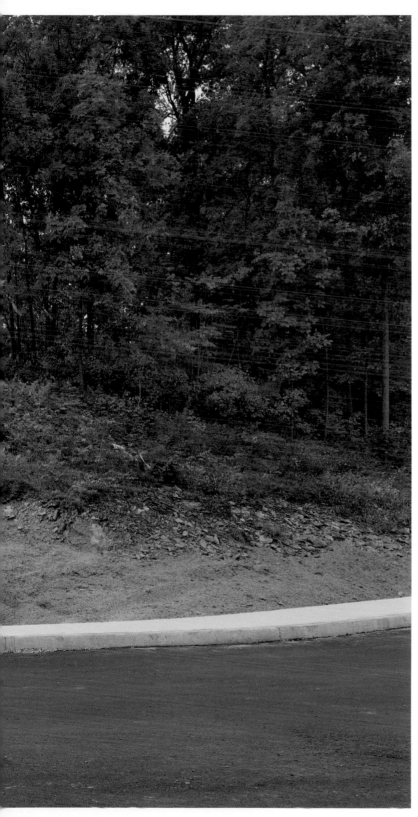

John Lehr *Poughkeepsie, NY* 2005 (cat. no. 38)

Parking Lot
Showroom

1976

SITE

Parking Lot Showroom is an unbuilt design for a Best Products retail showroom that proposes to roll the central section of a parking lot over the building, consuming it in a casual flow of undulating pavement. The entire surface of both parking lot and showroom roof would be covered with asphalt poured over a concrete supporting structure. This design is a complete inversion of the traditional relationship between architecture and site. What is traditionally regarded as a building and its immediate surroundings would become integrated to a degree where it would no longer be possible to discern where one began and the other stopped—suggesting that architecture need not necessarily be an object distinct from its context.

Consistent with SITE's other Best Products showroom designs, this concept utilizes the materials and circumstances inherent in the commercial strip. In this case, two universal elements—the parking lot and retail warehouse (rhetorically condemned as eyesores by purist designers)—are transformed into conditions of visual fantasy. The structure expresses the iconography of non-iconography in that it implies the elimination of architecture altogether, not as a final requiem but as a beginning. Additionally, the idea is a further exploration of SITE's intention to reverse the relationships between art and architecture and to expand the definition of both as they relate to public experience.

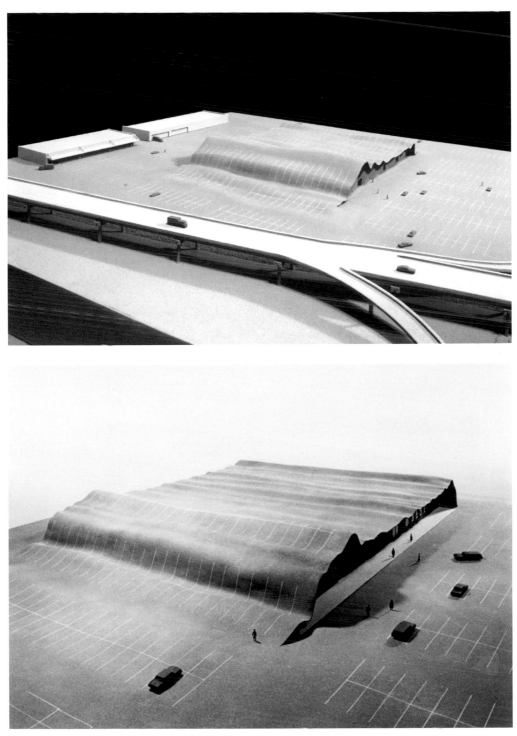

Parking Lot Showroom, Best Products, Inc., Dallas, TX 1976 (cat. no. 62)

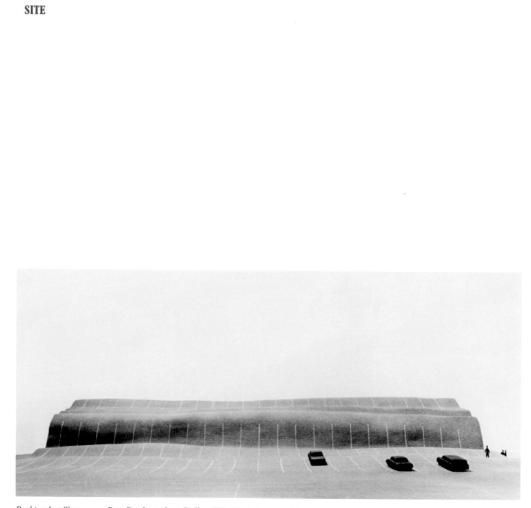

Parking Lot Showroom, Best Products, Inc., Dallas, TX 1976 (cat. no. 62)

Ghost Houses

1979

SITE

Most of SITE's buildings and environmental projects endeavor to preserve popular typologies as a means of increasing the communicative potential of the design. In the case of *Ghost Houses*, the typical developer-built, construction-company-designed suburban tract-housing community is an archetype that has been retained without changing its essential configuration. For all intents and purposes, each member of the community will be living in identical dwellings—the only difference will be in terms of an inversion of materials.

For example, shingle-style houses will be produced in cement and asphalt, stone-surface houses will be produced in cast latex rubber, and brick houses will be built with Cor-Ten steel instead of masonry. Because each structure will appear to be one material and will actually be built in another, the identity of the houses will be based on illusions of reality. It is intended that the entire community will acquire a ghostlike appearance as these houses proliferate and as it becomes increasingly difficult to discern actual materials from simulated ones. In time, members of the community might become active participants in a game of illusion and begin transforming all objects, every fixture, each surface into an alternative material. As this evolution continues, an entire new concept of shelter and tools may evolve—function and use itself may change with the advent of objects such as asphalt window-panes and rubber screwdrivers.

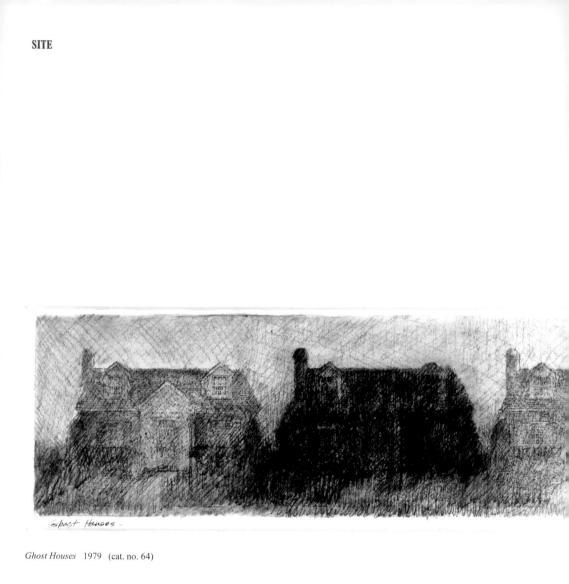

Ghost Houses 1979 (cat. no. 64)

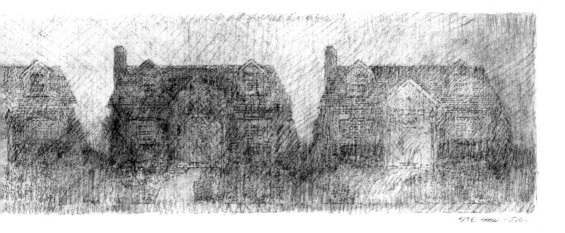

SITE SHAW - J.W.

Ghost Houses 1979 (cat. no. 63)

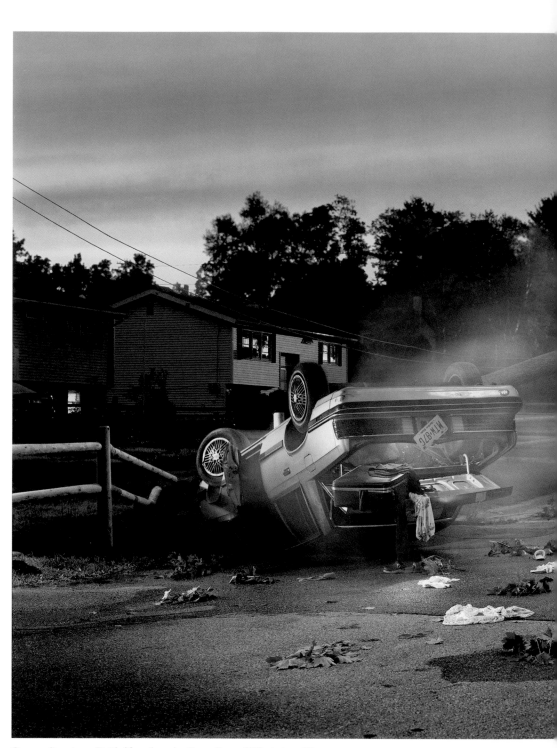

Gregory Crewdson *Untitled* from the series *Dream House* 2002 (cat. no. 15)

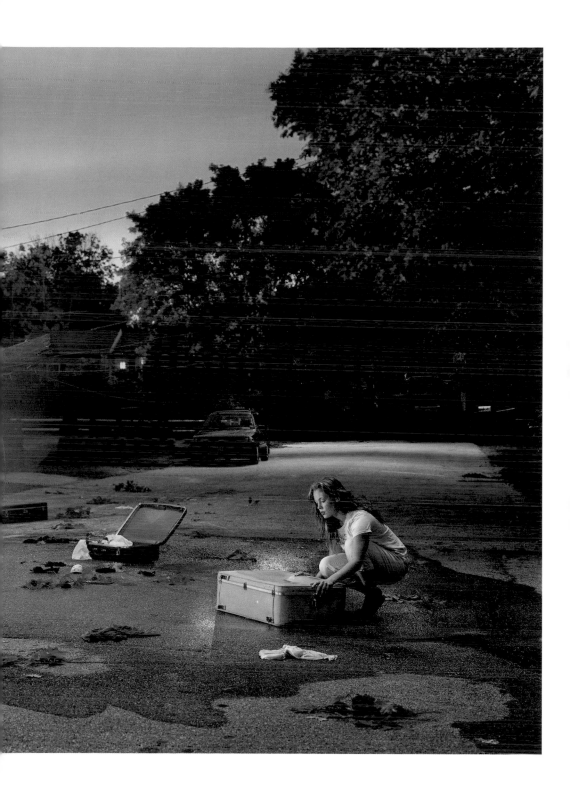

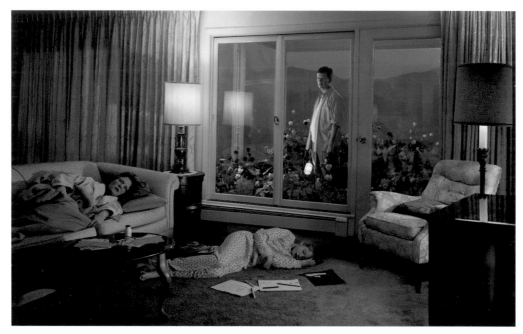

Gregory Crewdson *Untitled* from the series *Dream House* 2002 (cat. no. 16)

The View through the Picture Window

Surveillance and Entrapment Motifs in Suburban Film

Robert Beuka

Robert Beuka is associate professor of English at Bronx Community College, City University of New York. He has published articles on classic and contemporary Hollywood cinema as well as nineteenth- and twentieth-century American fiction and cultural studies. His first book, SuburbiaNation (2004), examines the depiction of the suburbs in American film and fiction.

One of the surprise hit films of 2007 was a teen horror movie called *Disturbia*, a *Rear Window*-esque thriller about a boy who witnesses the sordid doings of his neighbors through the bedroom window of his suburban home. As the title suggests, the movie offers an over-the-top view of the anxieties of contemporary suburban life. The protagonist, a teenager named Kale, is confined to house arrest as a result of a violent outburst at school. He gets in the habit of peering out the window at his neighbors, and what he sees is unsettling, to say the least. DreamWorks Pictures initially promoted the film with the tagline, "*Disturbia*: The quieter the street, the darker the secrets." Subsequently, the distributors shifted to an even more lurid promotional catchphrase: "Every killer lives next door to someone." Their idea of exposing the darker side of suburbia seems to have had its appeals, since D. J. Caruso's *Disturbia* ranked as the number one film in America for several weeks. Indeed, the success of the film would seem to indicate that its critique of life in the contemporary suburbs is hip, fresh material.

Or is it? A look back through films about suburban life over the past few decades reveals that a movie such as *Disturbia* is, in fact, following an ingrained tradition of critique. In contrast to the rosy depiction of suburbia on network television from the 1950s onward, the suburbs have fared far worse on the big screen. In the 1950s, in the midst of the great middle-class migration to suburbia, films such as *The Man in the Gray Flannel Suit*, *No Down Payment*, and *All That Heaven Allows* countered television's glowing image of suburban life by presenting the suburbs as an alienating environment. Movies from the 1960s and 1970s, from *The Graduate* to *The Stepford Wives*, painted the suburbs as an artificial, entrapping world. Even the 1980s, the decade that gave us any number of carefree suburban teen movies, also saw the ascent of the "slasher-next-door" genre of suburban horror film. Additionally, seemingly innocuous 1980s films such as *The 'burbs* and *Little Shop of Horrors* indirectly raised the issue of racial and ethnic intolerance in suburbia. More recently, *The Truman Show* (1998) metaphorically painted suburbia as a prison house of surveillance, while the celebrated 1999 film *American Beauty* portrayed the suburbs as the site of isolation, materialism, family dysfunction, voyeurism, violent outbursts, and drug dealing, with a murder thrown in for good measure.

Robert Beuka

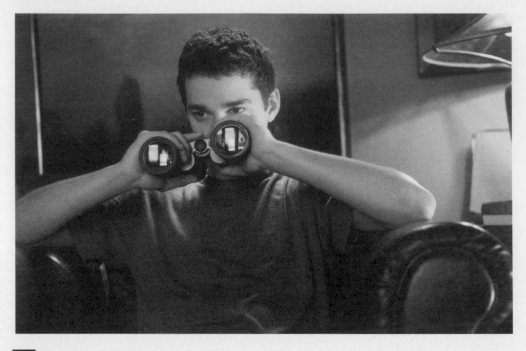

fig. 1 **A closer look**
Kale Brecht, *Disturbia*'s protagonist, uncovers suburbia's dark secrets. ©DreamWorks/Christopher B. Landon/
Carl Ellsworth/Jim Page

What these cinematic depictions of suburban life reveal, particularly through their repeated emphasis on visual scrutiny, vulnerability, and entrapment, is our continued cultural ambivalence about life in suburbia—an environment that has, over the past sixty years, evolved from a revolutionary, insurgent landscape into the predominant environment of most Americans.

A basic starting point for this discussion is the idea that there is something a little distorted about the depiction of the suburbs that we see in a movie such as *Disturbia*. As I have argued, the suburban environment is often portrayed and understood in exaggerated terms; suburbia is the kind of place that tends to get alternately attacked and defended—overly idealized on the one hand, and demonized as embodying the worst aspects of our culture on the other.**1** Both of these visions of suburbia—the utopian and the dystopian view, we might call them—seem clearly to be oversimplified understandings of this important American environment. Where do we go to get a sense of the roots of this distorted view of life in suburbia? There are worse places to begin than the advent of the mass-

produced suburban development town, as seen in the founding of Levittown, New York, in 1947.

It seems all but impossible to overstate the historical importance of Levittown to life in the twentieth century. Both practically and symbolically, it marked the beginning of the era of mass suburbanization in the United States in the postwar years, an era that forever altered the way we think about physical space in this country. The uniform landscape of identical single-family homes and plots immediately became invested with a deep symbolic significance. On the one hand, the lower costs resulting from William Levitt's mass-production techniques allowed for a generational move to this new landscape, in the process creating a massive new middle class in America. In this sense, suburbia became recognized as the new promised land of the American dream.**2** On the other hand, social critics worried from the start about the physical homogeneity of the new suburban towns, fearing that places like Levittown would foster a similar sort of social and cultural homogeneity.**3** Racially restrictive selling practices undercut the utopian view of community the new towns seemed

90

fig. 2 Hometown blues
George Bailey of *It's a Wonderful Life* must learn to accept his small-town existence. ©Paramount Pictures/Frank Capra/ Frances Goodrich/Albert Hackett/Jo Swerling/William Hornbeck

to offer, and the individuals who did move to the new suburbs also had to cope with a sense of isolation, and the need to build communities from the ground up.

These realities of life in postwar suburbia also formed the fodder for the cinematic representations of these new places. Consider, for example, a film that one might not immediately associate with the suburbs—Frank Capra's holiday classic, *It's a Wonderful Life*. Released in December 1946, just over a year after the end of World War II, *It's a Wonderful Life*, despite its nostalgic tone and its sense of optimism, is a film that expresses a profound trepidation over the future of the small-town landscape in the postwar era. This becomes apparent through the manipulation of the image of the town throughout the film, as protagonist George Bailey comes to inhabit both the traditional small town, Bedford Falls, and the dark urban nightmare world of Pottersville. In the contraposition of these two visions of the same town, the film expresses a sense of anxiety over the direction in which the small-town landscape is evolving.

Historically, there was good reason for this concern over a landscape in transition, as the identity of the American small town was very much up in the air in this period. While the first half of the twentieth century saw increasing urbanization across America, the time of this film's release also coincided with the beginning of a massive boom in new housing starts and the emergence of the suburban landscape.4 This was about the time that ground was broken on Levittown, an event that signaled the coming age of suburbia. And in its own way, *It's a Wonderful Life* carefully addresses the emergence of the suburban landscape: the distinctly suburban-looking development of Bailey Park, which represents the future of Bedford Falls, also serves—through the subplot of Mr. Martini's move there—as a central symbol in a larger thematic linking of new home construction and ownership with the rebuilding of traditional community values. Indeed, insofar as Capra's film focuses on matters of town- and community-building, it stands as a sort of primer on the potential for creating old-fashioned "small-town" communities in newfangled landscapes.5 In this sense, *It's a Wonderful Life* offers us an early glimpse of the utopian vision of suburbia that would be picked up by television sitcoms in the 1950s and 1960s. Nonetheless, even with its ringing endorsement of these new suburbs,

Capra's film also constantly reminds the viewer of Bailey's sense of being trapped in this town, prefiguring the entrapment themes to be found in subsequent suburban fiction and films.

Surely one of the dominant images of suburban life we have had from our popular media comes from television situation comedies of the 1950s and early 1960s. On programs such as *Father Knows Best*, *Leave It to Beaver*, *The Donna Reed Show*, and others, the new suburban life was depicted in optimistic terms as family-centered and rich with community ties. As Nina Leibman has argued, the rise of these suburban sitcoms helped facilitate the psychic as well as physical mass migration to the suburbs.6 In the process, such programs created an image of the contented, white, solidly middle-class family that continues to be associated with suburban America.7 In effect, these shows created what Lynn Spigel has aptly termed a "fantasy of antiseptic electrical space," fostering a simulated sense of community between the viewer and on-screen counterpart.8 But if television helped to contribute to the image of suburbia as the new home of the middle-class American dream, feature films tended to show a different side of the story. Sometimes the critiques of the move to suburbia were lighthearted, as in the 1948 film *Mr. Blandings Builds His Dream House*, starring Cary Grant. Here the move from the city to exurban Connecticut was shown to be fraught with perils and annoyances; nonetheless, all works out well in this benign satire. The 1956 film *The Man in the Gray Flannel Suit*, adapted from Sloan Wilson's novel and featuring Gregory Peck, depicts life in the suburbs as well as the climb up the corporate ladder as alienating experiences for the protagonist. Other films of this era, such as Martin Ritt's *No Down Payment* (1957) and Douglas Sirk's *All That Heaven Allows* (1955) paint an even darker picture of suburbs as repressive and even dangerous places.

In comparing depictions of the suburbs on television programs and in movies of the immediate postwar years, we may begin to see how the popular media and arts had a hand in shaping the utopia/dystopia binary that seems to continue to influence our thinking about suburbia even today. In contrast to the image of contented family and community life portrayed in network television's image of suburbia in the 1950s and 1960s, big-screen portrayals of the suburbs were characterized by their darker subjects: isolation, entrapment, anxiety, and the breakdown

fig. 3 **The posh prison**
The Graduate's Ben Braddock and Mrs. Robinson feel trapped in the affluent suburbs. ©Studio Canal Image

fig. 4 **Love object**
Joanna Eberhart, protagonist of *The Stepford Wives*, being watched. ©Palomar Pictures/William Goldman/Timothy Gee

of the family. Such themes were to become increasingly apparent in suburban films of the 1960s. Consider, for example, Mike Nichols' 1967 film *The Graduate*, with Dustin Hoffman, Katharine Ross, and Anne Bancroft. Though the movie is most likely remembered for its wit, its sense of sexual and romantic adventurousness, and its sound track, *The Graduate* is also an interesting critique of the imprisoning suburbs. The main conflicts of the film center around the rebellion of the protagonist, Benjamin Braddock, a recent graduate from a prestigious university "back East," against the conventional suburban existence of his parents.

From the opening credits, which feature Ben being carried along an airport moving sidewalk with a blank look on his face, until the final shot of the film, which shows Ben and Elaine Robinson being driven back into the suburbs sitting at the rear of a city bus, the suburban lifestyle of the older generation is depicted as a trap for the protagonist.9 The root causes of this sense of entrapment are summed up most succinctly by a guest at Ben's graduation party, Mr. McGuire, who corners him by the backyard pool in order to advise him on future career plans. Suggesting that Ben think in this regard of "just one word: *plastics*," McGuire unwittingly offers up the very metaphor used by young people to characterize his generation, whose lifestyle is seen as materialistic and contrived, a plastic existence reflected most clearly in their choice of landscape. It is not insignificant that McGuire's weighty if brief pronouncement is delivered poolside, for the shimmering backyard pool is used here, as it is in so much of the fiction and film of suburbia, to symbolize not only the materialism, but also the superficial, self-destructive narcissism of the suburban dream.

Indeed, McGuire's praise of plastics sets the tone for the film, establishing what will become the dominant theme: Ben's search, at the dawn of his "manhood," for an identity apart from what he sees as the constricting, spirit-crushing world of his parents' suburbanite generation. Note that at the time of this film's release, the suburban lifestyle, promoted since the early 1950s as the embodiment of the American dream, was under a broader generational attack. Consider the representation of suburbia in popular songs such as Malvina Reynolds' "Little Boxes," made a hit by Pete Seeger in 1962, and Gerry Goffin and Carole King's "Pleasant Valley Sunday," a big hit for the Monkees in 1967.

Both songs critiqued the homogeneous landscape of the suburbs, and both tied this criticism to a view of suburban residents as sheltered, phony, materialistic, and trapped in a closed-off world. Echoes of this critique can be found in *The Graduate*'s portrayal of the relationship between Ben and Mrs. Robinson, characters who share a similar predicament. Like Ben, Mrs. Robinson finds herself imprisoned within the confines of her suburban world. When she reveals to Ben that she was once a university art major, but now knows "nothing" about art, Mrs. Robinson hints at the larger sense that her life has lost direction as she has come to find herself trapped in the stultifying role of upper middle-class suburban housewife. As Ethan Mordden aptly notes, Mrs. Robinson's essential problem is that she has "grown old and beyond happiness in a suburban Californian nowhere," a fact that makes her represent, for Ben, the futility and self-destructiveness of suburban adulthood.10

●

The depiction of the entrapment of the suburban housewife was taken a step further in Bryan Forbes' 1975 science-fiction satire *The Stepford Wives*, an adaptation of Ira Levin's novel. The film portrays the move of the Eberhart family from a New York City apartment to a house in the upper-middle-class suburb of Stepford, Connecticut. Stepford, as the viewer eventually learns, is a fantasy world of patriarchal control, a place where the men of the town have devised a process of replicating their wives in android form. Perfect physical copies of the eliminated women, the manufactured Stepford wives exist solely to serve the wishes of their husbands, combining sexual subservience with a boundless devotion to and love of housekeeping. That the film is specifically situated in the suburbs is no coincidence, for as Betty Friedan had demonstrated over a decade earlier in her 1963 book *The Feminine Mystique*, the growth of the suburbs in the postwar period coincided with a rigorous cultural positioning of females into a domesticated role, a phenomenon tied to fears over women's increasing social autonomy and influence during the war years.

In the first shot of the film, Forbes shows protagonist Joanna Eberhart lingering for a final few moments in the now-empty apartment. Here, tight, eye-level shots emphasize the angular lines and the sense of snug comfort that characterize the small urban space, and it is from Joanna's perspective

that the viewer takes in the apartment she is preparing to leave. In contrast, after the family's drive north to the suburbs, we eventually see Joanna entering the Stepford house for the first time, alone. The cinematography emphasizes the protagonist's insignificance: in a shot from high atop the grand staircase to the second floor, Joanna is pictured standing in the foyer of what seems an immense house, looking bewildered and, by virtue of the camera angle, small and isolated. The change in perspective between domiciles signals Joanna's shift from subject to object. Upon her displacement to the suburban sphere, she enters a world where women quite literally become objectified, and the camera work suggests the extent to which she will become the object of increasingly intense observation by the men of Stepford.

Indeed, much of the film emerges as a case study in the psychosexual dynamics of *looking*, of the positioning and pleasurable manipulation of fetishized sexual objects.11 Time and again throughout the course of the narrative, we see the women of Stepford positioned by the male gaze: The "converted" wives are subject to intense surveillance at a neighborhood cocktail party; Joanna attends a meeting of a men's association, only to find that this seeming step toward equality only provides a means for their intense scrutiny of her; and, most tellingly, the power of the male gaze affords the men the ability to create visually perfect replicas of all of the "Stepford wives." In fact, the only element missing from the android re-creations is the eyes, so the "replacement" process only becomes complete after the eyes of the victim have been transplanted to her replacement, in the final and ultimate theft of female vision and, by extension, subjectivity.

Through this ongoing play with the power dynamics of the male gaze, Forbes conveys an image of the suburb as an intensely *visual* landscape, a terrain marked by a compromised subjectivity brought about by the breakdown of distinctions between public and private spaces. In this regard, the film conforms to our ingrained cultural image of the suburb. For both the architecture and landscape of the suburb—where "picture windows" eliminate the distinction between inside and outside, and where separate but contiguous lawns replace urban and rural privacy with the illusion of shared, neighborly space—highlight the visibility of its residents. What is distinctive about Forbes'

handling of this issue is his consistent focus on surveillance and control in suburbia. The key to the oppressive gender relations the film depicts, this surveillance motif also sets a pattern that has resurfaced in a number of recent suburban films, from *The Truman Show* to *Disturbia*.

The idea of the danger of life in the suburbs, some sort of threat lurking or watching next door, which we see in *The Stepford Wives*, would also feature in different sorts of suburban films in the 1980s. On one hand, the slasher genre of horror film, epitomized by the *Halloween* and *Nightmare on Elm Street* franchises, was predicated on a fear of the unknown, deranged small-town neighbor. These movies—like the recent *Disturbia*—seem to play on a traditional notion of suburban homogeneity and blandness, deriving their shock value from the specter of the terrifying bête noire lurking behind the manicured hedges. As in *The Stepford Wives*, these films show the very design of suburbia implicated in the horrors that transpire, not merely through an implied incongruity between the manicured landscape and the malevolence lurking within, but also through the interchangeability of homes, which provide hiding places for the perpetrator, but seemingly no escape for the victims. This key motif of suburban horror is summed up in a bit of dialogue from *Halloween* (1978), when the residents of suburban Haddonfield are described as "families, children, all lined up in rows, up and down these streets . . . lined up for a slaughterhouse."

Other films of the 1980s and 1990s indirectly addressed another type of suburban fear of the unknown—the resistance to racial and ethnic difference in suburbia. Comedies such as *The 'burbs* (1989) and *Little Shop of Horrors* (1986) offer different takes on suburban bias. In the former, a lighthearted suburban satire, a group of cul-de-sac neighbors unite in their paranoid resistance to a new, noticeably different family on the block; in the latter, the depiction of postwar white flight to the suburbs provides a stark counterpoint to an otherwise fluffy musical comedy. Reginald Hudlin's 1990 movie *House Party* approaches this issue from a different angle, portraying the suburbs as a forbidding world of control and discipline, monitored by seemingly constant police surveillance. Essentially a teen comedy in the manner of such 1980s films as *Sixteen Candles* and *Risky Business*, *House Party* tracks the adventures of a group of

fig. 5 Time out of joint
The Truman Show's Truman Burbank and his "wife" in his 1950s-style sitcom world. ©Paramount Pictures/Andrew Niccol/
William M. Anderson/Lee Smith

African American teenagers as they set out to throw the party of the year.

The action transpires across a socioeconomically diverse urban setting that ranges from lower-class public-housing projects to one character's home in a wealthy suburban enclave of the city. Police surveillance is confined to the more upper-class neighborhoods. In the several scenes that transpire in housing projects, the police are not to be found anywhere, while a darkly comic moment in the narrative finds a character in a working-class black section of the city phoning the police for assistance and being left to utter, "911? Yeah, I'll hold." The protagonist of the film finds himself harassed and accosted by the police every time he sets foot in the elite part of town, as does his father, who eventually snaps back at the officers: "I know why you stopped me. I know why. 'Cause I'm a poor black man and y'all just wanna bust my black ass." To this, one cop responds, "No, no; you look suspicious," while the other adds, "Yeah, you look suspicious, and you definitely look black." Cautioning him, "Watch your attitude," the cops drive off, but not before they have underscored a

message the film as a whole presents about race and landscape: upper-class, suburban environments remain under the watchful, domineering eye of white authority.

Recent years have seen a spate of films about the suburbs, and these depictions have maintained established trends. While lighthearted comedies of manners continue to spoof suburban sensibilities, "serious" films such as *Pleasantville*, *The Truman Show*, and *Happiness*, all released in 1998, have continued to offer variations on the critique of suburbia as dystopia discussed thus far. If anything, the portrayal has become darker. *Pleasantville* and *The Truman Show* share common ground, as they both invoke 1950s television sitcom life as a metaphorical model against which they judge life in the contemporary suburbs. This coincidence provides evidence of the enduring impression created by the fictional televised image of suburbia from the 1950s. Indeed, one can trace the persistence of this image through many other suburban movies of recent years, ranging from time-travel films such as the *Back to the Future* series and the suburban comedy *Blast from the Past* (1999)

97

fig. 6 **Through the picture window**
American Beauty is the latest in a line of suburban exposé films. ©DreamWorks/Alan Ball/Tariq Anwar/Christopher Greensbury

to Todd Haynes' *Far from Heaven* (2002), a self-consciously anachronistic remake of Sirk's *All That Heaven Allows*.

In *The Truman Show*, protagonist Truman Burbank, played by Jim Carrey, slowly comes to learn that his idyllic suburban life, which revolves around his home, wife, and friendly neighbors, not only seems to be the stuff of network television, but in fact is so [fig. 5]. As Truman eventually discovers, every aspect of his life is controlled by the omnipotent television director Christof, who each night broadcasts to fifty million viewers worldwide his creation, a program chronicling Truman's "real life" called "The Truman Show." The aptly named protagonist (a would-be "true man" who finds himself instead controlled by the world of studio television, long centered in and around Burbank, California) eventually escapes his imprisoning suburban "world," presumably bound for someplace where he can be a true man. Left behind at the end of the film is a vision of the suburb as not only an artificial by-product of television culture but also as a prison, a (nearly) inescapable grid of preprogrammed behavior.

While the storyline of *The Truman Show* might not be entirely original (as fans of science fiction writer Philip K. Dick's 1959 novel *Time Out of Joint* might argue), the film does offer an updated take on classic suburban surveillance and entrapment themes. The film's depiction of the omnipotent Christof and his televised creation not only anticipates the "reality television" craze that has since made this sort of entertainment commonplace, but also points toward the more pervasive spread of surveillance and tracking mechanisms throughout contemporary culture.12 Moreover, the environmental critique of the film takes on added depth and currency by virtue of having been shot on location in Seaside, Florida, the crown jewel of the contemporary New Urbanism architectural movement, a neo-traditional urban-design philosophy centered on planned communities and described by its leading practitioners as an antidote to suburban sprawl. The ironies abound: director Peter Weir's choice of the master-planned, presumably post-suburban town of Seaside as the physical setting to depict his make-believe suburban sitcom set, which in turn was meant to mirror old-fashioned American sub-

urbia, suggests a metatextual commentary on traditionalism, nostalgia, and planned community that is potentially explosive, but accessible only to viewers aware of Seaside's history and philosophy.

Indeed, in its emphasis however heavy-handed—on control and imprisonment masquerading as old-time community, *The Truman Show* evokes not only the neo-traditionalist ethos of the New Urbanism, but also the thinking behind the other major development in suburban design in recent decades, the gated-community movement. Truman's soundstage world, in other words, bears some uncomfortable philosophical similarities to contemporary suburbia, a fact that lends added weight to his entrapment and eventual escape, as well as the viewer's voyeuristic involvement in both.

Whereas *The Truman Show* employs a televisual metaphor as a means of portraying a world of total control, the other major suburban commentary film of recent years, Sam Mendes' *American Beauty* (1999), depicts a modern suburbia that is, in many ways, out of control [fig. 6]. An updated rendering of all the classic motifs of fear and loathing in the suburbs, *American Beauty* undertakes the now-predictable gesture of looking beneath the veneer of suburban affluence to find the decay within. Of the many traditional critiques of suburban life offered in the film, the strongest is the issue of family discord and breakdown. This is shown not only through the dysfunctional relationships between parents and children, but also through the fractured marriage of protagonists Lester and Carolyn Burnham. While Carolyn's obsessive concern with appearances and success fits her for the stock role of materialistic suburbanite (or, as her husband calls her, a "bloodless, money-grubbing freak"), Lester rebels against the world of appearances, and his rebellion costs him his life. We are forewarned of his demise when the film opens with his own *Sunset Boulevard*-esque posthumous voice-over, which, not insignificantly, plays against an aerial shot of Lester's suburban neighborhood. Since the days of Levittown's founding, the aerial view of the suburban development has been used as a visual symbol of suburban homogeneity and all the anxieties that go along with it. This shot is repeated at key turning points of the narrative and again at the end of the film, tying Lester's fate clearly and specifically to his position as a suburban head of household.13

As in *The Truman Show*, once again we see surveillance and voyeurism as keys to the depiction of a fractured suburban community. Lester's young neighbor, Ricky Fitts, is fascinated with spying on his surroundings and neighbors, filming them through his bedroom windows with a hand-held digital camera. Ricky's voyeurism, his gaze through the picture window, recalls a grand theme of suburban fiction and film, but with an ironic contemporary twist. His use of modern technology to aid in his surveillance allows Ricky, ultimately, to document simply the banality of his world, best captured in his artistic rendering, in digital video, of a plastic garbage bag floating through the streets of his suburban town. As critic Marcel O'Gorman notes, in addition to Ricky's video camera, other technologies such as telephones, pagers, and even a two-way speaker system at a drive-thru restaurant all function as spying devices in the film. The logical effect of this atmosphere of relentless surveillance, as O'Gorman notes, is the desire, on the part of a number of characters, to transgress or escape the controls placed upon them.14 For Lester, a classic example of the beleaguered, entrapped suburban male character, these transgressions lead to his death. This fate reveals the conservative nature of the film's critique. Following an established tradition of cinematic representations of suburbia, *American Beauty* suggests that Lester's suburban trap is total and inescapable.

His death, brought on by his failure to conform to modes of behavior appropriate to his "place" in life, points toward the most interesting, and perhaps most conflicted, aspect of *American Beauty*: its treatment of the suburban landscape. After the film completes its unqualified condemnation of life in contemporary suburbia, Lester's final voice-over, played over another aerial shot of the town, exhorts viewers to "look closer" and find the beauty in life—even, one is led to believe, in so depressing, dysfunctional, and imprisoning an environment as the suburb. It is an ambivalent close, to say the least—but in that sense, it underscores the ambivalent depiction of suburbia (paradise or prison house?) that we have been grappling with in our popular culture for more than half a century.

Notes

1. For a fuller discussion of this thesis, see Robert Beuka, *SuburbiaNation: Reading Suburban Landscape in Twentieth-Century American Fiction and Film* (New York: Palgrave Macmillan, 2004).

2. David Halberstam in *The Fifties* (New York: Fawcett Columbine, 1993) notes that the mass-production techniques of Levitt and similar firms can be thought of as not only a response to the growth of the middle class and their subsequent need for housing, but indeed as a force behind the growth of the new middle class itself: "These techniques made it possible to provide inexpensive, attractive single-unit housing for ordinary citizens, people who had never thought of themselves as middle-class before," 132. For more extended discussions of Levittown's history and its cultural significance, see Barbara M. Kelly, *Expanding the American Dream: Building and Rebuilding Levittown* (Albany: State University of New York Press, 1993) and Rosalyn Baxandall and Elizabeth Ewen, *Picture Windows: How the Suburbs Happened* (New York: Basic Books, 2000).

3. Sociologist David Riesman, for example, in his influential 1950 work *The Lonely Crowd* (New Haven, Connecticut: Yale University Press) argued that postwar culture was becoming increasingly "other-directed," with the focus on the maintenance and progress of the group rather than the individual, a phenomenon that manifested itself in the conformity and classlessness of suburban living. William H. Whyte, in *The Organization Man* (Garden City, New York: Doubleday Anchor, 1956), advanced a related argument, considering the many ways in which organizational/corporate structure shaped the individual and society in the postwar years. Included is a section on the nature of suburban living, with a particular focus on social dynamics in the suburb of Park Forest, Illinois.

4. For a thorough discussion of the postwar housing boom, see Kenneth Jackson, *Crabgrass Frontier: The Suburbanization of the United States* (New York: Oxford, 1985), chapter 13, 231–245. The sheer numbers of new housing starts are indicative of the landscape revolution under way at this time. As Jackson notes, "Single-family housing starts spurted from only 114,000 in 1944, to 937,000 in 1946, to 1,183,000 in 1948, and to 1,692,000 in 1950, an all-time high," 233.

5. In an interesting article that presents a contrasting view, Patrick J. Deneen, in "Awakening From the American Dream: The End of Escape in American Cinema?" from *Perspectives on Political Science* 31.2 (Spring 2002): 96–103, argues that the success of Bailey Park will eventually lead to the loss of the old-fashioned sense of community in Bedford Falls: "Bailey Park is not a community that will grow to have a form of life and communal interaction similar to that in Bedford Falls; instead, George Bailey's grand social experiment in progressive living represents a fundamental break from the way of life in Bedford Falls, from a stable and interactive community to a more nuclear and private collection of households that will find shelter in Bailey Park but little else in common," 98. This argument, while potentially compelling, seems to be based on the erroneous claim that "the development is empty, devoid of human presence. The residents of this modern development are presumably hidden behind the doors of their modern houses," 98. Bailey Park only actually appears in one scene, a sequence where it appears that a great number of neighborhood residents turn out to welcome the Martini family into their new home.

6. Nina Leibman, *Living Room Lectures: The Fifties Family in Film and Television* (Austin: University of Texas Press, 1995).

7. As Dana Heller argues in *Family Plots: The De-Oedipalization of Popular Culture* (Philadelphia: University of Pennsylvania Press, 1995), suburban family sitcoms tended to "naturalize" the white, middle-class suburban experience, serving as models of "familial normalcy" (45), idealized visions of what suburban middle-class family life ought to be like.

8. Lynn Spigel, *Make Room for TV: Television and the Family Ideal in Postwar America* (Chicago: University of Chicago Press, 1992), 111.

9. Director Mike Nichols held out little hope for the fate of his young protagonist, asserting to *New York Times* critic Leslie Aldrige that the romantic plot of Ben and Elaine served to set a "trap" for Ben, and that ultimately, in his opinion, Ben would "end up like his parents." See Glenn Man, *Radical Visions: American Film Renaissance, 1967–1976* (Westport, Connecticut, and London: Greenwood Press, 1994), 47–48.

10. Ethan Mordden, *Medium Cool: The Movies of the 1960s* (New York: Knopf, 1990), 180–181.

11. See Laura Mulvey's groundbreaking essay of feminist film theory, "Visual Pleasure and Narrative Cinema," in *Feminism and Film Theory*, ed. Constance Penley (New York: Routledge, 1988), 57–68, for her discussion of how classic Hollywood cinema appeals to the fetishizing, scopophilic gaze of the male viewer.

12. For an interesting discussion that connects *The Truman Show* to modes of surveillance in modern life, see J. Macgregor Wise, "Mapping the Culture of Control: Seeing through *The Truman Show*," *Television & New Media* 3.1 (February 2002): 29–47. This article uses Gilles Deleuze's theories about the "society of control," which he laid out in the essay "Postscript on Control Societies," to explicate issues raised by *The Truman Show*. The essential point is that the movie demonstrates how we have moved from a more traditional society of discipline, characterized by surveilling and punitive forces centralized in specific locations and authoritative bodies, to one of control, where surveillance and tracking are so pervasive as to make self-control internalized and to leave no room for escape. Truman, the would-be "true man," is nonetheless so positioned by forces of spying, control, marketing, and manipulation, let alone by the unseen eye of millions of viewers worldwide, that he is unable to have an authentic life as a "real" individual outside of this context. Read in this manner, the film serves as a metaphor for our own late-capitalist "information age" of surveillance, tracking, and assessment, and its ironic (and capitalistic) celebration of the "individual."

13. Shirley Law, "Looking Closer: Structure, Style and Narrative in *American Beauty*," *Screen Education* 43 (2006): 123–129. Law notes that this repeated aerial shot "tightens slightly each time it appears and thus double codes the tension that is building in the narrative," 125–126.

14. For this interesting discussion of the omnipresence of modern surveillance systems in this film, see Marcel O'Gorman, "*American Beauty* Busted: Necromedia and Domestic Discipline," *SubStance* 33.3 (2004): 34–51.

Intermediate Landscapes

Constructing Suburbia in Postwar American Photography

Holley Wlodarczyk

Holley Wlodarczyk is a PhD candidate in comparative studies in discourse and society at the University of Minnesota, where she teaches courses in film, television, and cultural studies. Her current research is centered on representations of suburbia in American visual culture.

Representations in the visual culture of suburbia have often been concerned with its status as a landscape in transition. Since photographers first turned their cameras toward the suburban landscape, a number of them have focused on scenes depicting various stages of construction, especially residential subdivisions and tract homes. While still unfinished and uninhabited, these vistas connote the movement or tension between our concepts of nature and culture, the beautiful and the banal, the wilderness of frontiers and the domesticity of home. Critical use and reception of these kinds of suburban views quite often serve as photographic evidence of undesirable phenomena such as urban sprawl, documenting the commonly destructive and wasteful processes used to transform the land from a perceived natural or pastoral condition into a homogenous built environment that lacks either aesthetic or productive value. As art, such photographs do more than simply record historical changes in land-use patterns. They participate in framing—visually and intellectually—our understanding of suburbia as a cultural as well as physical landscape, one that is often treated with indifference or derision in contemporary discourse. A brief survey of construction photographs made, exhibited, and published over the past several decades can illustrate how and why certain images validate—or even help to construct—more commonly negative views about suburbia in American culture, despite the fact that a growing and diverse majority of the population chooses to live there.

Mass consumption is as much a factor as mass production in critical accounts of national building trends. Despite historical scholarship tracing the origins of suburbia to late seventeenth- through mid-nineteenth-century philosophical, economic, social, and architectural transitions in the United States and abroad,[1] the term more popularly evokes the middle-class, mass-produced developments of the postwar era as the progenitors of contemporary American suburbia. While the rapid growth of such suburbs following World War II was met with enthusiasm from a burgeoning, upwardly and outwardly mobile consumer society,[2] increasingly high-profile, large-scale developments across the country almost immediately elicited strong disapproval from a broad range of critics. Photography played an important yet complicated role from the start, illustrating both positive and negative aspects of such rapid market growth.

Aiding in the promotion of new home building practices and products, aerial photos offered newly empowered consumer-citizens encouraging views of plentiful, modern housing stocks equal to the task of satisfying long-suppressed desires and demands, especially following decades of Depression-era hardship and wartime sacrifice. New suburbs were seen here by many as not only a practical solution to a national housing shortage and uncertain peacetime economy, but also the potential fulfillment of more abstract and personal longings, such as self-determination and socioeconomic security. Yet while young couples and growing families may have seen only the promise of their own individualized American dream-come-true in *one* of the seemingly endless expanse of detached, single-family homes, the uniformity and scale of the view made possible by such images also practically illustrated aspects of such construction and consumption practices that architectural and social critics felt deserved their collective scorn.

William Garnett's iconic 1950 aerial series documenting various stages in the construction of Lakewood, California, is perhaps one of the earliest and best-known examples of this dual function. figs. 1–2 Initially commissioned by the developers to promote both sales within the subdivision and, like Levittown on the East Coast, the efficiency of its revolutionary application of mass-production techniques to on-site home building, these same photographs have been often reproduced as visual proof of everything that was and is wrong with the modern suburb. While the scale and method of building these homes provides a visually interesting, almost abstract pattern from the air, 3 it is precisely these factors of scale and method that soon caused the widest and most enduring concern warranting public reassessment of the social, aesthetic, and environmental costs of the emerging suburban landscape on the ground.

As these concerns gained more traction in both the academic and popular press, certain trends in home building and town planning were viewed from an evolving political perspective that seemed to value more than just maintenance of the capitalist economy or possessive individualism. Focus on the "potential" represented in such imagery shifted from individual gain to collective loss. For example, in Adam Rome's 2001 *The Bulldozer in the Countryside*, the author begins his study of the relationship between postwar suburban sprawl and the rising environmental movement with a discussion of the changing role of these (in)famous images in American visual culture. Though they were widely reprinted since their initial marketing usage, Rome points out that "by 1970, however, the Garnett photographs had become symbols of environmental devastation," beginning with their republication in Peter Blake's 1964 *God's Own Junkyard: The Planned Deterioration of America's Landscape*, as "a biting pictorial attack on 'the planned deterioration of America's landscape.'"4 The progress once suggested by such construction photographs was quickly recaptioned and reread by postwar critics like Blake as destruction and decline, and the language accompanying such images—terms such as "sprawl" and "wasteland"—made the association quite clear for viewers and readers alike.5

Photography continues to be used to support environmental criticism as well as analysis of the socioeconomic system that encourages further development on urban fringes. In the 2004 collaboration between urban historian and architect Dolores Hayden and aerial photographer Jim Wark, the full-color aerial images in *A Field Guide to Sprawl* illustrate the evolving "vocabulary of sprawl," including terms such as "boomburb," "privatopia," "sitcom suburb," and "snout house." As with the Garnett images produced more than a half century earlier, any photograph's viewing context can greatly change the meaning derived from it, regardless of the photographer's original intent—or commission—in making it. Yet such views in and of themselves allow us to quite literally "look down on" the expanding suburban landscape, a position supported by Hayden's brief text, clarifying the "smart growth" agenda the photographs are meant here to serve.

Another contemporary aerial photographer, Alex S. MacLean, has been straddling the commercial/critical fence in his own work, producing images for a variety of public and private concerns while also compiling effective projects with regard to provoking a more thoughtful discussion—and application—of planning and building practices. Though MacLean's 2003 book, *Designs on the Land: Exploring America from the Air*, takes a broader look at the continuum of the built landscape from urban centers to pristine forest, desert, and ocean, several of his notable suburban photographs draw our attention to the dramatic pace and scale at which land is still being converted, giving viewers

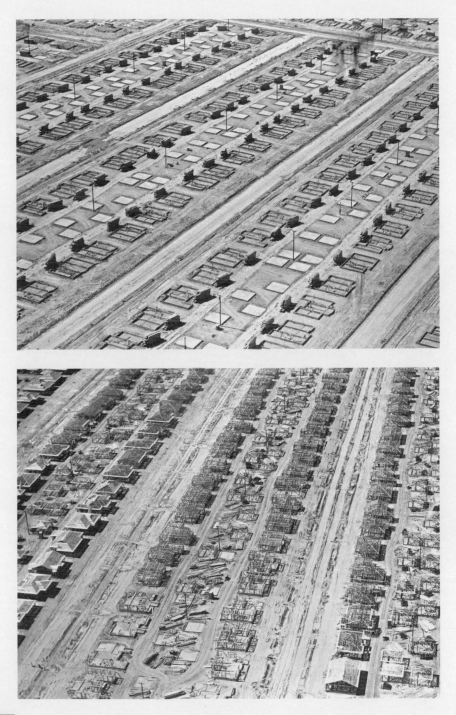

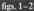 figs. 1–2 William Garnett Aerial views of new house development in California's Lakewood Park 1950

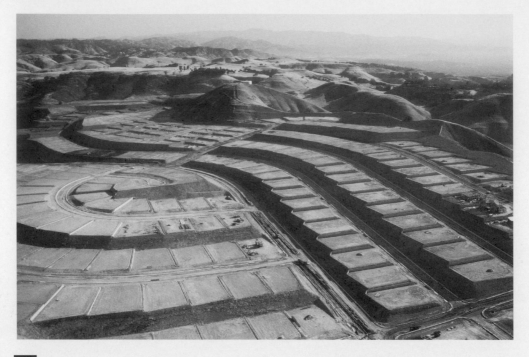

fig. 3 Alex MacLean *Los Angeles, California. Plots for hillside housing* 1989 35mm Kodachrome film

a sense of the "before" and "after" all in the same image.6 In this photograph, we get a bird's-eye view of one of the methods and geographic settings of contemporary suburban construction projects. California hillsides are here flattened to create more accessible and traditional housing sites fig. 3 . Meanwhile, in other suburban construction photographs in this collection, an imposed urban grid suggests the geometrically ordered landscape soon to be built up on the floor of a flat West Texas desert valley, a new Arizona subdivision fills in quadrants of a larger-scale agricultural grid, and two stages of cul-de-sac development lie in stark contrast, indicating the piecemeal construction—and habitation—of new houses and neighborhoods. Our own perspective while driving by or walking through such communities-in-progress could never capture the combined reach and impact of each individual house, driveway, or street on the larger landscape, yet this is precisely the point of view we are most often limited to in our daily visual lives, no matter what environment we personally inhabit—urban, suburban, or rural. Through such distanced and high-angled views, we can escape our customary terrestrial-based focus on individual properties, as

experienced either individually (house and yard) or sequentially (longer street views). Even so, the meaning of these and similar aerial suburban photographs is not fixed, but rather firmly *suggested* by both their visual content and published context.

James Corner describes MacLean's images as "a particularly emphatic double reading on the perverse expansionism of modern development and infrastructure across otherwise endless territory."7 The phrase "otherwise endless territory" is especially significant if we understand—or desire—cities to be bounded, contained, and somehow manageable. If, in fact, suburbia is extending or transgressing a physically or conceptually established city limit, its incursion into the countryside can be seen as dangerously uncontrollable. Suburban sprawl, as a product of urban growth, is thus aligned against un- or underdeveloped territory, and is usually the less-valued quantity in such a cultural dichotomy that opposes natural to man-made landscapes. Yet in opposition to the "city" proper, suburbia—when seen as a hybrid of "natural" and "cultural" landscapes—is often devalued by critics who envision urban centers as more purely or honestly belonging to the latter cat-

egory. As a third or middle term in such aesthetic and environmental discourses, suburbia is quite often denigrated for the very hybridity that makes it appealing for many potential and actual residents. Construction images are central to the visualization and documentation of suburban hybridity as process as well as product, the means by which suburbs bridge and encompass both the city and the country in their making.

From this perspective, we have the opportunity of seeing suburbia as more than a disruption in conventionally conceived landscapes. As another author argues, "MacLean is not concerned with the traditional opposition of city and countryside," but rather with this "cultural continuum" in which "fields and woods, villages and roads, suburbs and cities only have meaning as part of the landscape insofar as they reveal connections between people and the organization of space which either favors these connections . . . or results in their break-up and loss."[8] MacLean explains that he likes "shooting borders, when two different things come together." But our understanding of those borders, while potentially influenced by such dramatically distanced views as made available through aerial photographs, is nonetheless still dependent upon our own positioning within this physical and cultural landscape continuum. For example, from the perspective of the urban dweller in a city center, the wilderness is quickly moving farther away with each new fringe development. Yet, from the vantage point of a new homeowner on the outer suburban edge, that same wilderness is brought closer to daily life than ever before. And if we can *see* that expanding suburban stretch as part and parcel of the city, rather than as a repudiation of or escape from it, then the man-made and the natural might indeed conceptually "come together" here, on this "middle ground."

Countering the possibility of such a compromise, urban-based visual *and* verbal discourses often frame the "problem" of suburban sprawl as something done by "others." Looking back to the early seventies, various art photographers, such as those involved in the New Topographics movement,[9] were contributing to and complicating the debate, as did Robert Adams in *What We Bought—The New World: Scenes from the Denver Metropolitan Area, 1970–1974*. The title of this book implicates "us" in this evaluative process, so that from the very start "we" are asked to question our own level of participation—as individuals and as a society—in building, buying, viewing, and criticizing this type of suburban fringe development. Despite the invitation posed by the title, however, most of what has been written about the photographs within frame them predominantly as critiques of suburbia and suburbanites, mostly for destroying or defacing nature. For example, Adams' project has been described as capturing ". . . what was done to Denver during a period when the region's natural beauty and thriving economy spurred massive growth. Denver residents who, in Shakespeare's phrase, 'loved not wisely but too well,' destroyed much of what had drawn them there. . . . Adams captures the beauty of the Rockies, the banality of subdivisions, and the windblown trash in the weedy margins—the only true border left between wilderness and the built environment."[10]

•

In this description, however, an interesting equation is suggested between the city of Denver and the surrounding wilderness: the "thriving (urban) economy" and the "region's natural beauty" are both causal factors, and the suburb as "trashy" and "weedy" borderland is seen as a negative effect of both. These suburbs-under-construction are characterized as somehow *other* than city or nature, a moving line that divides rather than connects different social and physical landscapes on a continuum of domestication and habitation.

While borders between the natural and built environments are central to many of Adams' photographs, transformation of the larger landscape is more subtly suggested in two particular photographs in which, as viewers, our focus is directed toward a "frame within the frame." fig. 4 Here a nearby suburban vista is seen through a picture-window-sized opening in an unfinished wall, creating a view that contains and merges the natural and the man-made even while the light effects visually disrupt the wood frame, allowing a bleed between inside and out. In another similar construction image, we are invited to look into the chasm of a newly dug basement that punches a hole in the physical fabric of the landscape, reversing the "build-up" effect of both distant mountain range and nearby berm. Meanwhile, the planks in the foreground and partially completed structure behind promise that this negative space will soon be contained and made positive, an object rather than an absence to behold. In contrast to aerial pictures by Garnett and

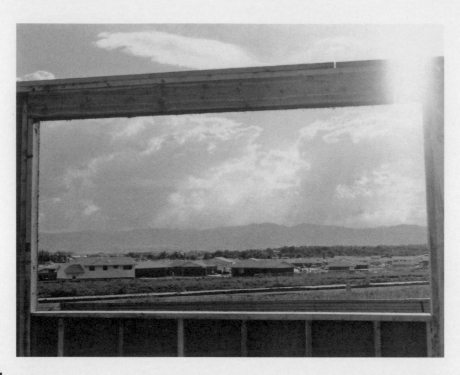

Robert Adams *Colorado, ca. 1973*, plate 128 from the monograph *What We Bought—The New World: Scenes from the Denver Metropolitan Area, 1970–1974* 1995

Lewis Baltz *Prospector Village, Lot 85, looking West*, no. 14 from the series *Park City* 1979 gelatin silver print

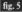

MacLean, these images do not so much shock us with the massive scale of building sites or methods; rather, they give us the opportunity to temporarily inhabit these spaces on a more human scale—at a time before the transformative labor and litter of the construction process is obscured by the clean, finished product of suburbia, and before the next finished house or street obscures our view of the frontier beyond.

Lewis Baltz's work, in many ways similar to that of Adams', records the play between boundaries in *Park City*, whereby pristine landscape, partially built houses, and construction debris are featured in almost equal measure. As seen in one photograph from the series fig. 5, the corner of a finished house and landscaped backyard are separated from the undeveloped hillside by an intermediate construction zone full of discarded materials. While a contrast is drawn between the built and unbuilt areas, the starkness of that contrast might be visually minimized with the removal or erasure of the scar that divides them. The illusion of seamlessness between suburb and wilderness can, theoretically, be more easily maintained when we are not so directly confronted with evidence of the transformation—for while cities and farms are also man-made environments, there is nevertheless something jarring about the suddenness of a new suburb being constructed outright, as well as the ever-mobile yet strikingly visible line denoting this temporary boundary in such photographs.

Part of the critique engendered by such images that "make us see" what is usually covered up and built over quite quickly, is the commodification of the landscape. Marvin Heiferman describes Baltz's "barren landscapes" as "achingly beautiful . . . eyewitness accounts of building starts and human achievement from the dead zone called success" wherein "things get built, things get sold, things get better; that's how the narrative is supposed to play."11 Yet photographs, and particularly art photographs such as these, participate in their own form of appropriation, turning the perceived "ugliness" of such transitional suburban spaces and processes into aestheticized views for a different type of consumption, especially when exhibited in (urban) art galleries and related photography books. While Heiferman promotes Baltz's role as a witness to the social and physical transformation, noting that he "sees landscape turn into real estate," Baltz's own photographic process and product converts landscape—both natural and built, contained and contrasted in the same image—into fine art and cultural critique, discourses that have only rarely viewed suburban expansion as a positive enterprise.

While the catalogue of complaints against suburbia includes a variety of social and cultural ills, including the perennial favorites of conformity and banality, these are often read into the built landscape, especially as represented in construction photographs. The continued consumption of wild or rural land is often translated as loss of natural variety and pastoral visual interest when compared to the national palette of similarly finished suburban houses and subdivisions. Whether in fine art or popular media such as film and television, our dominant cultural narrative appears to confirm that there is nothing "unique" or "interesting" to see in the suburbs; that, in fact, if you've seen one you've seen them all. Yet in each photographer's respective interpretation of suburbia, we expand not only the terms of critique, but also our understanding of how these paradigms are produced and reproduced, and *perhaps* why we, as a society, seem to prefer a daily, lived landscape that bespeaks a certain amount of similarity and regularity. For as a commodity, we cannot ignore the relationship of economics and aesthetics that continues to influence how suburbs are built, marketed, and bought by an ever-growing segment of the American public, a majority that has come to expect certain visual and practical amenities in their new homes, no matter where they are built.

The monumental means by which recent suburban construction in the desert states integrates and alters the landscape in this way is evident in Steven B. Smith's *The Weather and a Place to Live: Photographs of the Suburban West*, demonstrating the westward migration of not only people, but of a technologically enabled, consistent aesthetic paradigm. His perspective in making these photographs is shaped by his experience working in construction—building the same kinds of houses he once found so "ugly" in Baltz's *Park City*. Yet in Smith's work, the construction of individual houses and neighborhoods is less significant than the manipulation of the larger landscape supporting and surrounding them. The ground is variously moved away and pinned down—as is evident in these two respective images figs. 6–7 . There is a shift from the surface "scrape and build" methodology, depicted decades earlier in Garnett, Adams,

and Baltz, **12** to Smith's images of immense, major earthworks that alter the very shape of the land—a process made both necessary and economically feasible by the sheer extent of how far suburbia has already stretched into the apparently untamed hills and recesses of the Western frontier.

To achieve and maintain the desired effect of living in a natural environment, while not sacrificing the convenience and stability of traditional suburban community development, an ever-greater level of control must be exerted over the newly domesticated landscape. Smith's photographs directly reference that interplay, highlighting the fact that suburban growth and expansion can be understood not only in spatial terms—its linear or radial progression outward from the city—but also in the context of the changes in physical, technological, and cultural process that create continually new hybrid forms of natural/man-made landscapes. In her introduction to the book, Maria Morris Hambourg writes that while "Smith could have recorded a failure of the imagination or the ruin of desert ecologies . . . he was after something much more interesting and amorphous—an intersection of human, climatic, and geographic realms as yet without a name." She notes, though, that the label "suburbia" is "inadequate" since "Smith's subject . . . in its totality, is a vision of the future of our planet, of the time when man-made environments no longer just spread out in widening circles around cities and encroach like weeds along the highways, but hold sway everywhere."**13**

Despite the decades-long outcry from artists, academics, planners, and social critics, suburbia remains ubiquitous as a landscape type and sociocultural ideal in the late twentieth and early twenty-first centuries and, as such, we need to take better account of our own individual and collective connections to and investments in it. As literal borderlands through which a construction paradigm is further realized nationally (and internationally), despite regional and local conditions, it is possible to read such images of wide-scale suburban expansion as indicative of a cultural preference for a domestic environment that promises the positive attributes of a merged and imagined country and city, without the commonly assumed negatives of either. Yet by narrowly focusing on suburbia as a "moving border" in image and rhetoric, we lose sight of that "intersection" whereby connections are made rather than severed. That this continues

to be, however, the preferred approach to assessing the suburban fringe in American culture may have as much to do with the spatial as critical position of those performing the critique.

While many of the photographers discussed thus far have focused on the relationship between expanding suburbia and previously rural or undeveloped lands, only a few have entered the suburbs with their cameras and acknowledged their mostly urban vantage points and intellectual investments. After making a career out of photographing the changing cityscape of Chicago, Bob Thall admits in the introduction to *The New American Village* that he was attracted to what he "initially perceived to be the extreme banality of a place such as Schaumburg," a new suburb on the edge of the city that functions as a city unto itself. He candidly admits that "whether we city folk like these places or not, we think we know what they are and, to some degree, we take them for granted."**14** In addition to the expected shots of suburban houses and neighborhoods under construction, other images record Schaumburg's commercial and industrial landscapes. As a result, residential construction is seen in the larger context of Thall's project—in relation to urban spatial and economic expansion. Suburbia in this respect cannot as easily be regarded—and dismissed—as a place completely divorced from the city center, or to which many escape in search of a more natural landscape and lifestyle. Thall also captures the compromise between the natural and man-made worlds in the small but highly ironic details of that expansion, as seen in a momentarily treeless strip of blacktop, lined by a few partially constructed houses, named "Deep Woods Lane." This is a landscape not yet inhabited, or even yet inhabitable, but one being physically and culturally constructed to appeal to future residents desiring what they perceive to be the best of both worlds. This is a decidedly new space, yet one that continues to at least reference much older concepts of nature *and* culture, country *and* city.

As viewers, however, it is admittedly difficult to approach such suburban images without regard for our own residential histories *or* knowledge of the developmental histories of the spaces in question. Accompanying Thall's provocative images, his text informs us of the interpretive struggles faced by those occupying oppositional poles in this landscape continuum. While recalling a conversation with a friend that resulted in an argument

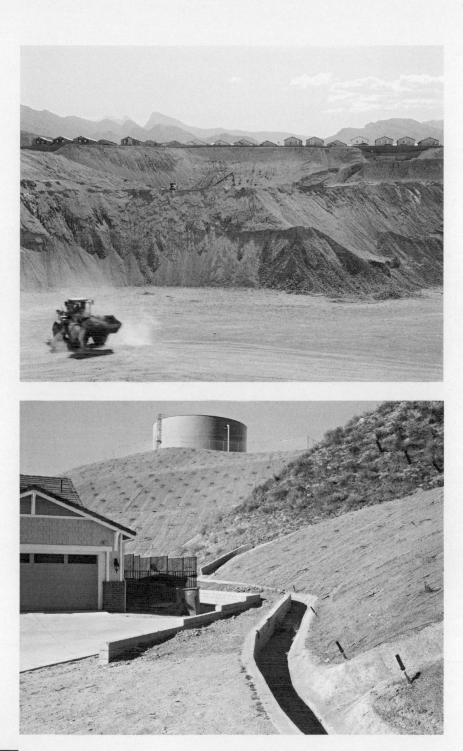

figs. 6–7 top to bottom: Stephen B. Smith *North Las Vegas, NV* 2003; *Santa Clarita, CA* 2001 ink-jet prints

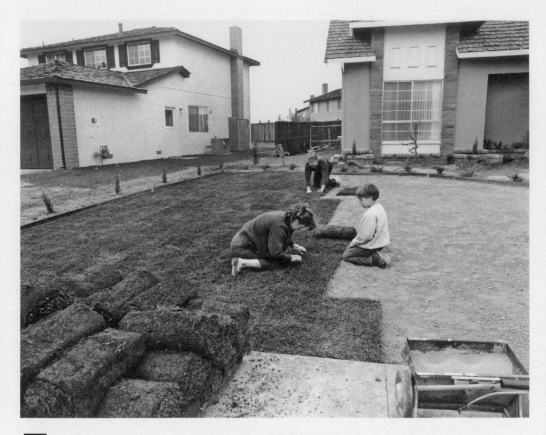

fig. 8 Bill Owens *I bought the lawn in six-foot rolls. It's easy to handle. I prepared the ground and my wife and son helped roll out the grass. In one day you have a front yard.* 1972 black-and-white photograph

"about my place in the city versus his new place in the suburbs," Thall noted that it was "interesting that neither of us mentioned the most common objection to new suburban sprawl. the destruction of what was there before the developers arrived."15 Cleared long ago, like much of the land immediately surrounding Chicago and other Midwestern cities, this new suburban development cannot necessarily be characterized as despoiling a pristine wilderness. But neither do Thall and his friend romanticize it in terms of a lost pastoral ideal, nor bemoan the loss of otherwise productive agricultural land.

Their exchange is centered on the present quality of life one could expect to find in city and suburb respectively, particularly concerning social configurations and cultural opportunities assumed inherent in each landscape. Progress, in terms of its direction and location, becomes a multifaceted and fluid term open for debate. Thall's textual account here frames his images with open acknowledgement of competing place-based visions—urban versus suburban, and, specifically, urban photographer versus suburban resident. In addition to insights gleaned from his own interaction with suburbanites, Thall also reminds his readers/viewers that: "It may be that the developers, residents, and corporate owners of the new American village have gotten exactly what they want"; that like "all such rare complete triumphs, the victors are left to consider not the limits of their effort but the quality of their original vision."16

Yet, despite the apparent homogeneity of suburban design and construction, there is not and has never been one singular "vision" of suburbia. It is constantly mediated and amended, as is our understanding of "the city" or "the country." And while the preceding construction photographs document as well as critique aspects of planners' and builders' original designs for and implementation of such intermediate landscapes, they do not tell us much, if anything, about how they continue to change and be perceived as they are lived in, *and* as the border between city and country moves on beyond them. For example, Garnett's mid-century images of a quickly transformed environment persist forever as they were; and while they may elicit vastly different responses from viewers today, they do not inform us of the changes that have undoubtedly occurred in Lakewood since the development was first built and the photographs were first published well over a half-century ago. The processes of construction, while historical, are almost rendered ahistorical when reproduced without a social context of habitation and modification. These suburban views are effectively frozen in time before they are actually lived in, and therefore more easily viewed objectively as landscapes, rather than subjectively as "homescapes."

Unlike these and the many other unpopulated photographs of suburbs in the process of being built, several of the images originally made by Bill Owens in the early seventies and republished in 1999 17 take us to a suburban landscape both visualized *and* lived as a dynamic social landscape, where construction is as much a sociocultural operation as a transformative physical one. He presents us with an environment in which each unfinished house is being made *for someone*, and where family members participate in the actual work required to make this once-barren space a livable home by planting their own lawn as a group activity ⌷fig. 8⌷. The differences in approach and effect between Owens and the other photographers considered here potentially lie in his relationship to the places—and the people—photographed.

As a photojournalist for a local newspaper, Owens was neither a casual visitor nor a disinterested observer documenting this emerging suburban landscape. He lived and worked there, witnessing the transformation from within. Rather than drive by and anonymously photograph suburban scenery in the midst of change from the natural to the cultural, Owens was invited into people's homes and received their participation in completing the project. He recorded their thoughts about their own environments and their experiences of the product, in addition to the appearance of the process. And while claiming the requisite objectivity of his profession, each individual image (and his project as a whole) is nonetheless subjectively recording and communicating his and his subjects' personal visions of how suburbia—at this particular time and place—fits into and functions in the ever-changing landscapes between country and city.

In consideration of the more than half-century of postwar suburban construction photography, the work of Owens offers us a relatively unique viewing position—one that incorporates the personal concerns of suburban residents along with the more traditional emphasis on landscape art and photography's codes and conventions. While Garnett's photographs may have sold many a suburban tract

house, the images of MacLean, Adams, Baltz, and Smith may have shown us the dramatic conversion of suburban landscapes, and Thall's text may have expressed the subjective view of a suburban dweller, only Owens' combined images and text communicate what "suburbia" might have meant to people who bought, labored, and lived in suburban homes in this critical period in which both the construction and cultural paradigms gained and maintained ascendancy. In equal parts journalistic, portrait, and landscape art, these images occupy a temporal as well as spatial position usually ignored by both builders/marketers, who wish to sell a product or ideal, and by artists/critics, who wish to comment on a process or trend. The few photographs emphasizing the physical construction of suburbia included in Owens' project punctuate the more social interactions between residents—the building of home, family, and community that suburbia is ideally meant to accommodate. These images function more in the capacity of representing that physical *and* cultural continuum compared to the temporary transitional boundary of isolated construction photographs that exclude the human in terms of labor, habitation, or aspiration. The intermediate landscape of suburban construction photographs is certainly one of hybridity, but that characterization should be considerate of the physical transformations in our environment as well as the means and meanings with which we all come to terms with the expanding sociocultural landscape of suburbia.

Notes

1. See, for example, John Archer, *Architecture and Suburbia: From English Villa to American Dream House, 1690–2000* (Minneapolis: University of Minnesota Press, 2005).

2. For more on postwar suburban development in this context, see Lizabeth Cohen, *A Consumers' Republic: The Politics of Mass Consumption in Postwar America* (New York: Vintage Books, 2003).

3. In addition to their publication as marketing materials and critical historical documents of postwar suburban growth, Garnett's photographs have also been recognized as having artistic merit, despite the perceived banality of their subject matter. For example, two of Garnett's images were included in Volker Kahmen's 1973 publication, *Art History of Photography* (originally published in German).

4. Adam Rome, *The Bulldozer in the Countryside: Suburban Sprawl and the Rise of American Environmentalism* (New York: Cambridge University Press, 2001), 1–2. In his assessment of the public's increasing awareness of the value of open green space in

new development, Rome further notes that by the mid-1960s and 1970s, "attacks on the bulldozer were supported by stark aerial photographs of the construction of subdivisions," 151.

5. Blake refers to contemporary usage of "the great suburban sprawl" before briefly explaining the postwar "bureaucratic strait jacket on design" that "gives Suburbia its 'wasteland' appearance." Peter Blake, *God's Own Junkyard: The Planned Deterioration of America's Landscape* (New York: Holt, Rinehart and Winston, 1964), 17.

6. Alex S. MacLean, *Designs on the Land: Exploring America from the Air* (New York: Thames & Hudson, 2003).

7. James Corner, "The Aerial American Landscape," in MacLean, 11.

8. Gilles A. Tiberghien, "Learning from MacLean," in MacLean, 150.

9. The 1975 exhibition and catalogue that gave this movement its name, *New Topographics: Photographs of a Man-altered Landscape*, organized by the International Museum of Photography at George Eastman House in Rochester, New York, included photographic works by Robert Adams, Lewis Baltz, Bernd and Hilla Becher, Joe Deal, Frank Gohlke, Nicholas Nixon, John Schott, Stephen Shore, and Henry Wessel, Jr.

10. Eric Fredericksen, "Bought and Sold," *Architecture* 91, no. 7 (July 2002): 31.

11. Marvin Heiferman, "Great Pictures, Mean World," in Lewis Baltz, *Rule without Exception* (Des Moines: University of New Mexico Press in association with the Des Moines Art Center, 1990), 14–17.

12. A similar type and scale of enterprise is evident in many of MacLean's images, but in Smith these changes are viewed from a much more terrestrial position, as part of the landscape rather than dislocated above it.

13. Maria Morris Hambourg, in Steven B. Smith, *The Weather and a Place to Live: Photographs of the Suburban West* (Durham, North Carolina: Duke University Press, 2005), 6–7.

14. Bob Thall, *The New American Village* (Baltimore: Johns Hopkins University Press, 1999), 6.

15. Ibid., 4.

16. Ibid., 19–20.

17. Bill Owens, *Suburbia* (New York: Fotofolio, 1999/first edition 1973).

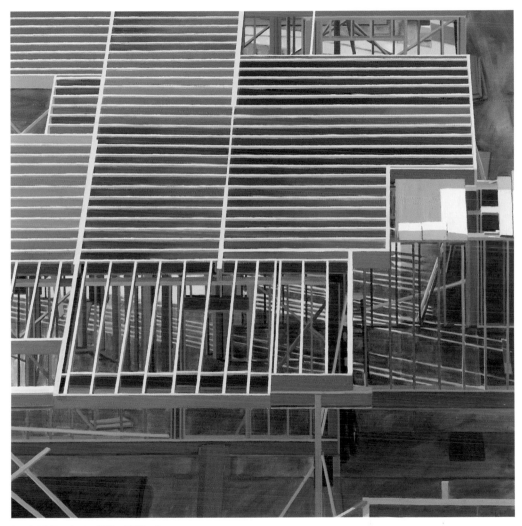

Sarah McKenzie *Build Up* 2005 oil on canvas

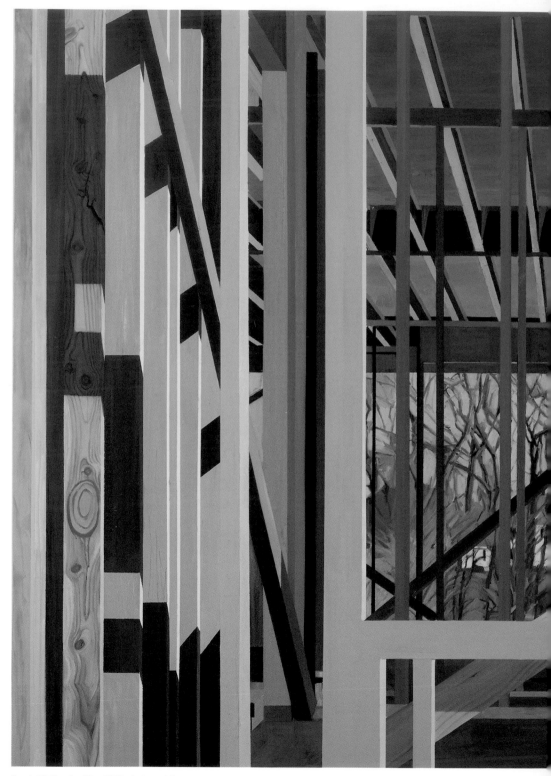

Sarah McKenzie *Site* 2007 (cat. no. 44)

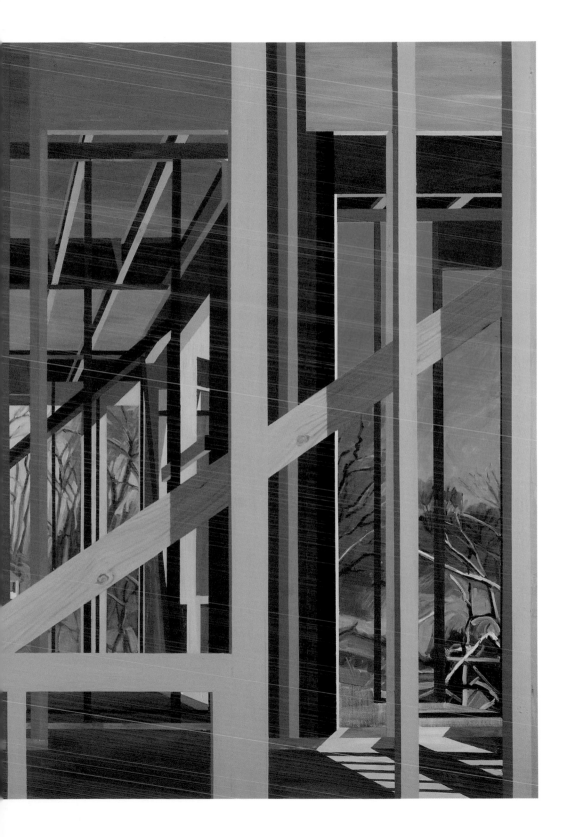

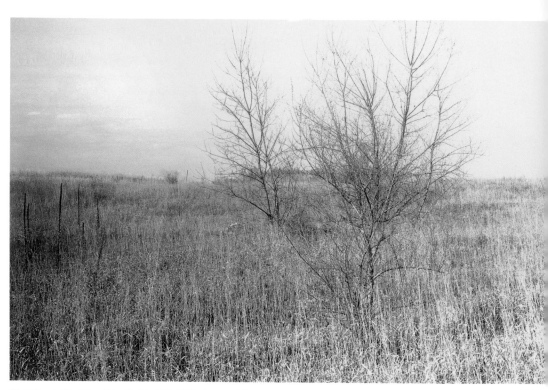

Chris Faust *The Edge, Eden Prairie, MN* 1990 (cat. no. 24)

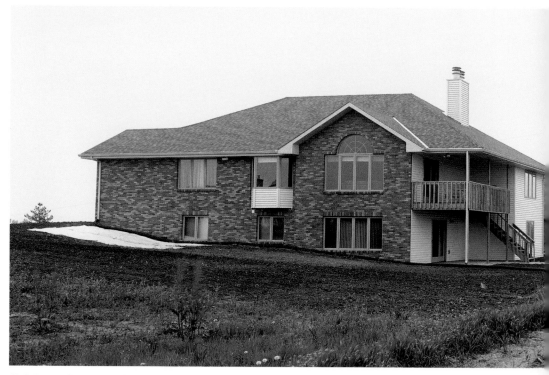

Chris Faust *The Edge, Lincoln, NE* 1993/2007 (cat. no. 29)

Chris Faust *Bankrupt Developer Homes, Apple Valley, MN* 1991 (cat. no. 25)

Chris Faust *Veneer of Greenness, Woodbury, MN* 1992/2007 (cat. no. 26)

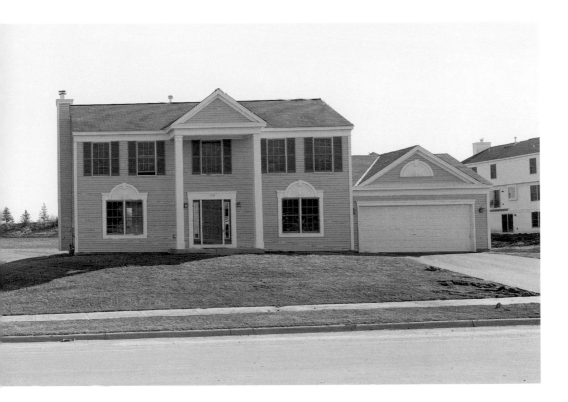

Cross-Border Suburbias

2008

Estudio Teddy Cruz

The border between the United States and Mexico at the San Diego/Tijuana checkpoint is the most trafficked in the world. Approximately sixty million people cross annually, moving untold amounts of goods and services back and forth. It is here that the perennial alliance between militarization and urbanization is reenacted and epitomized by the post–September 11 solidifying of the border wall that divides these cities, further transforming San Diego into the world's largest gated community.

By zooming into the particularities of this volatile territory and by traveling back and forth between these two border cities, we can expose landscapes of contradiction where conditions of difference and sameness collide and overlap. At no other urban juncture in the world does there exist such economic disparity, from the wealthy communities and expensive real estate of suburban San Diego to some of the poorest settlements in Latin America, located barely twenty minutes away from Tijuana's southern fringes. A series of under-the-radar, two-way border crossings— north to south and south to north—suggest that no matter how high and long the wall becomes, it will always be transcended by migrating populations and the relentless flow of goods and services. This flow is manifested, in one direction, by the informal land-use patterns and economies produced by migrant workers moving from Tijuana and into San Diego. But, while the "human flow" travels northbound in search of dollars, "infrastructural waste" moves southbound to construct an insurgent, cross-border urbanism of emergency.

North to South: A Suburbia Made of Waste
San Diego's Levittown Is Recycled into
Tijuana's Slums

Southern California's first ring of suburbanization, its Levittown, is being dismantled as new and large McMansion subdivisions replace these older suburbs. But Levittown's debris is being recycled to build the new periphery of Tijuana.

Mexican builders, for example, recuperate postwar bungalows that are slated for demolition in San Diego. These small migrant dwellings are brought to the border on wheels, imported into Tijuana, and assembled above one-story steel frames. The elevated suburban houses define a space of opportunity beneath them that, in time, will be filled with more house, a taco stand, a car repair shop, or a garden.

The leftover parts of San Diego's older subdivisions, standard framing, joists, connectors, plywood, aluminum windows, and garage doors are being disassembled and recombined twenty minutes away, on the other side of the border. Born of housing shortages, social crisis, and emergency, these parts are reassembled into fresh scenarios in Tijuana's outskirts, creating a housing urbanism of waste. Recycled rubber tires are cut and folded into loops, clipped and interlocked, and stacked and filled with earth, creating a system that forms a stable retaining wall, while discarded wooden pallets create an armature awaiting cladding and other surfaces imported from San Diego. Here, on Tijuana's fringes, countless new spatial opportunities open suburban housing to the unpredictability of time and programmatic contingency.

South to North: A Suburbia Made of Nonconformity
Tijuana's Encroachment into San Diego's Sprawl

While discarded rubber tires, garage doors, pallet racks, and disposable houses flow southbound to construct an urbanism of emergency, immigrants flow north to one of the strongest economies in the world, the state of California, with the assurance that such economic power still depends on the cheap labor only they can provide—a supply-and-demand logic.

As the Latin American diaspora travels north, it inevitably alters and transforms the fabric of San Diego's subdivisions. Immigrants bring with them diverse sociocultural attitudes and sensibilities regarding the use of domestic and public space as well as the natural landscape. In these communities, multigenerational families shape their own programs of use, taking charge of their own microeconomies in order to maintain a standard of living for their households, generating nonconforming uses and higher densities, all of which reshape the fabric of the residential neighborhoods where they settle. Alternative social spaces begin to spring up in large parking lots—informal economies such as flea markets and street vendors appear in vacant properties, and housing additions in the shape of illegal companion units are plugged into existing suburban dwellings to provide affordable living. Together, these "plug-in" programs and informal architectures suggest that the higher pixilation of Tijuana's three-dimensional and multicolor zoning is crossing the borderline and forming an archipelago of difference within the sea of homogeneous sprawl that defines San Diego's periphery.

Tijuana Project
Manufactured Sites: A Maquiladora-produced Frame Is the Micro-Infrastructure for Housing in the Informal Urbanism of Tijuana

Estudio Teddy Cruz is currently working on a maquiladora-produced prefabricated frame that can act as a hinge mechanism to mediate the multiplicity of recycled materials and building systems brought from San Diego and reassembled in Tijuana. By giving primacy to the layered complexities of these informal sites over the singularity of the object, this small piece is also the first step in the construction of a larger interwoven and open-ended scaffold that helps strengthen an otherwise precarious terrain, without compromising the temporal dynamics of these self-made environments. By bridging the planned and the unplanned, the legal and the illegal, the object and the ground, as well as man-made and factory processes of construction, this frame questions the meaning of manufacturing and housing in the context of building community.

San Diego Projects
Living Rooms at the Border and
Senior Housing with Child Care

Community agencies such as Casa Familiar, in the suburban neighborhood of San Ysidro, are an example of the social service organizations that have been engaging and managing the shifting cultural demographics caused by immigration within many older suburban neighborhoods in the United States. In the past five years, we have designed a micropolicy with Casa Familiar that can act as an informal process of urban and economic development for the neighborhood and empower San Ysidro to become a developer of alternative dwelling prototypes for its own housing stock.

Working with the premise that no advances in housing design in the United States can occur without advances in its housing policy and subsidy structures, our collaboration with Casa Familiar has been premised on shaping counter-political and economic frameworks, which in turn yield tactical housing projects inclusive of these suburban neighborhoods' nonconforming patterns of mixed-use and density. In San Ysidro, housing is dwelling in relationship to the social and cultural program managed by Casa Familiar and thus will not be simply "units per acre" spread indifferently across the territory, but rather a density measured in "social exchanges per acre."

The two small projects that emerge from Casa Familiar micro-policy propose the tactical interweaving of dwelling units and social-service infrastructure to transform suburban parcels into systems that can anticipate, organize, and promote social density. Casa Familiar injects microeconomic tactics, such as "time banking" through sweat equity, to produce alternative modes of affordability (barter housing units, exchange of rent for social service, etc.). In parcels where current regulation allows only a single use, we propose five different uses that support one another, suggesting a model of social sustainability for suburban enclaves—one that conveys density not as bulk, but as social choreography and neighborhood collaboration.

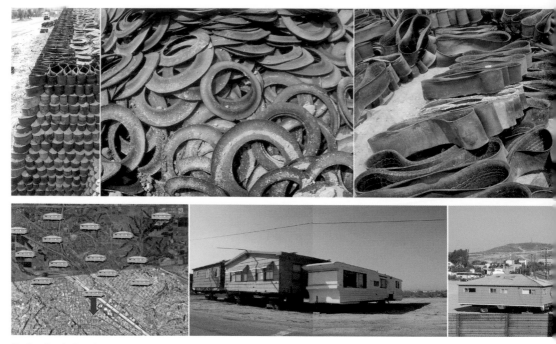

North to South: San Diego's Levittowns are recycled into Tijuana's slums

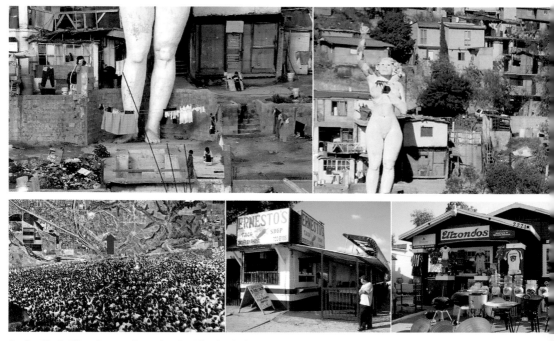

South to North: Tijuana's encroachment into San Diego's suburban sprawl

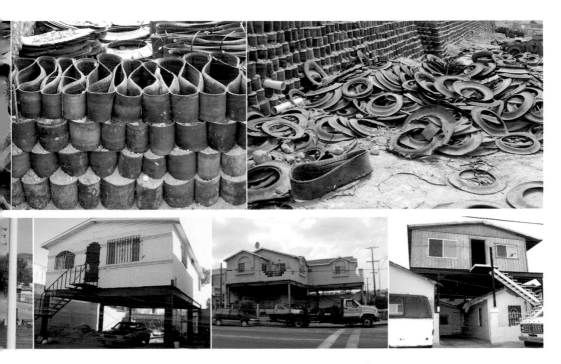

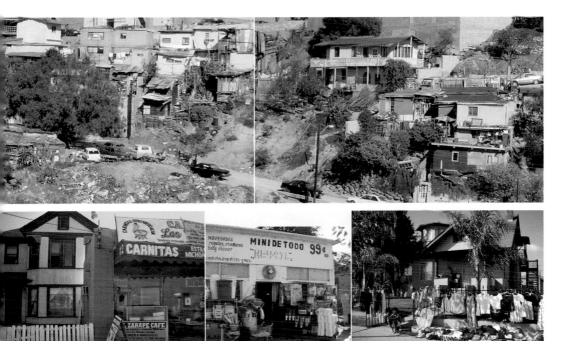

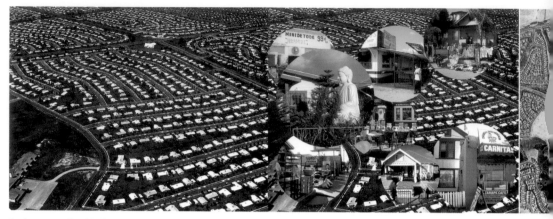

Levittown retrofitted by immigrants: San Diego's first ring of suburbanization is pixilated with difference

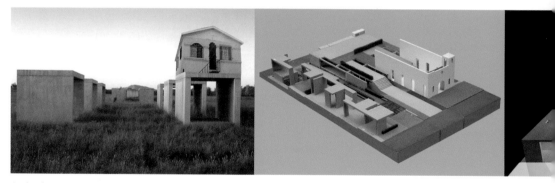

A mix of programs—affordable and senior housing, a central market, community garden, and child care—for suburban San Diego

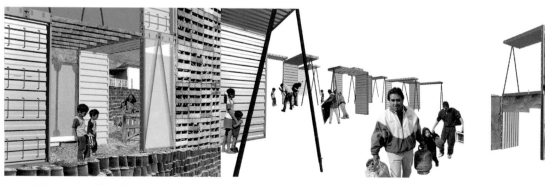

A maquiladora-produced frame becomes the micro-infrastructure for housing in the informal urbanism of Tijuana

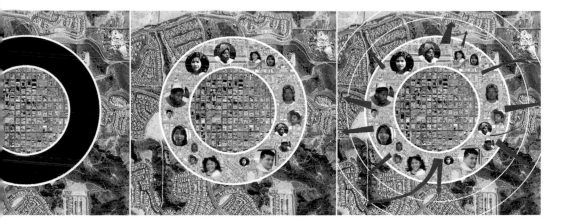

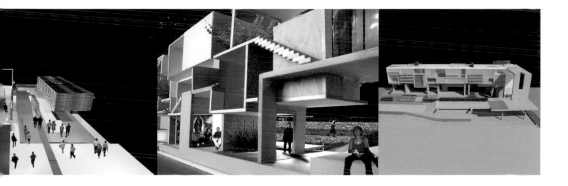

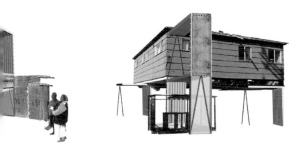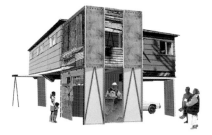

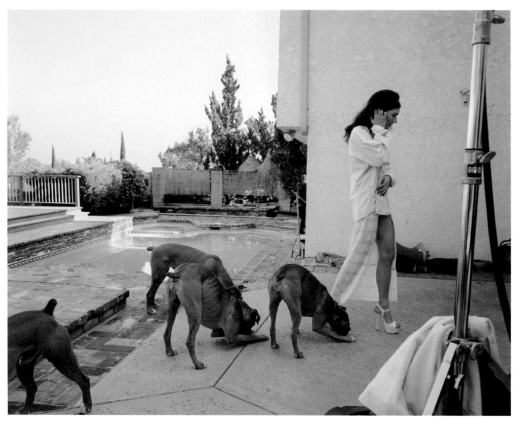

Larry Sultan *Boxers, Mission Hills* 1999 (cat. no. 75)

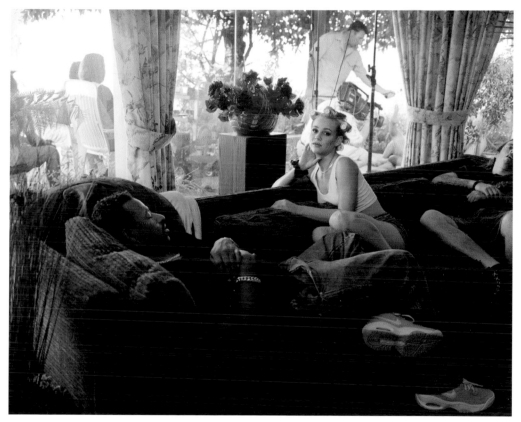

Larry Sultan *Tasha's Third Film* 1998 (cat. no. 74)

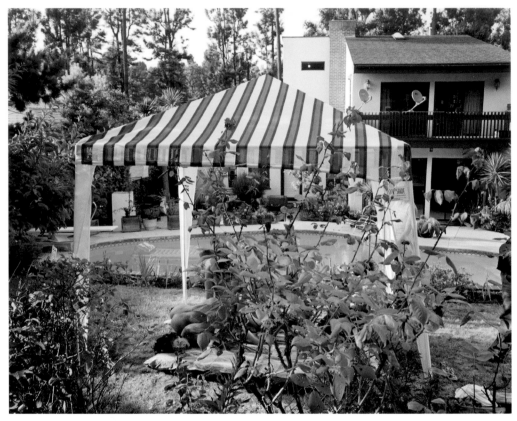

Larry Sultan *Cabana* 2000 chromogenic print

Suburban Aesthetics Is Not an Oxymoron

John Archer

John Archer is chair of the Department of Cultural Studies and Comparative Literature at the University of Minnesota, where he teaches a course titled Suburbia. His most recent book, <u>Architecture and Suburbia</u> (2005), explores the historical relation between the single-family house and the rise of modern suburbia over the past three centuries.

Little boxes on the hillside,
Little boxes made of ticky-tacky,
Little boxes on the hillside,
Little boxes all the same.
There's a green one and a pink one
And a blue one and a yellow one,
And they're all made out of ticky-tacky
And they all look just the same.

Conventional wisdom often recognizes these lyrics—Malvina Reynolds' 1962 acerbic critique of suburban tract housing in Daly City, California—as epitomizing America's exasperation with the ever-growing expanse of suburbia.1 Not only do the lyrics deride mass-produced housing as fostering homogeneity and conformity, but they also disparage the aesthetics of these houses, both individually and as an ensemble, in abject terms. Reynolds' critique continues to be well-known nearly a half century later, having been popularized in the 1960s by folk singer and activist Pete Seeger, and most recently adopted as a theme song for the suburban dark-comedy television series *Weeds*.

Reynolds was hardly alone in her assessment of suburbia. Just the previous year, urban critic Lewis Mumford had similarly bewailed the homogeneity and aesthetic vacuity of suburbia as:

a multitude of uniform, unidentifiable houses, lined up inflexibly, at uniform distances, on uniform roads, in a treeless communal waste, inhabited by people of the same class, the same income, the same age group, witnessing the same television performances, eating the same tasteless prefabricated foods, from the same freezers, conforming in every outward and inward respect to a common mold, manufactured in the central metropolis.2

In 1964 Ada Louise Huxtable decried the "regimented hordes of split-levels lined up for miles in close, unlovely rows." And in that same year, Peter Blake's book *God's Own Junkyard* vilified suburbia's "interminable wastelands dotted with millions of monotonous little houses on monotonous little lots and crisscrossed by highways lined with billboards, jazzed-up diners, used-car lots, drive-in movies, beflagged gas stations, and garish motels." Blake acknowledged little, if any, hope for aesthetic redemption: "In today's Suburbia, it

is virtually impossible to create outdoor spaces of *any* character."3

This concerted spate of critiques, reacting to the proliferation across America of mass-produced tract housing over the previous decade and a half, and setting the tone for the critique of suburbia ever since, is hardly without irony. Here, on the eve of the widespread civic unrest of the 1960s, and the profound social, cultural, and political changes that ensued, the aesthetic establishment circled the wagons against suburbia, outlining a conservative dogma that continues to shape the way in which academic and professional critics try to get us to think about suburbia today.4 For while the 1960s ushered in an era of populist, antiestablishment reform (much of which has been reversed by ensuing waves of conservatism) and precipitated far-reaching changes in popular culture, the critique of suburbia has maintained its disdain for the working-class and petit-bourgeois tastes of those who choose, and prefer, to live in developer-built, mass-marketed, tract-house environments.

The conservatism of the 1960s complaints is more evident in light of their origins in more than two centuries of vilification of suburbs, dating to the historical beginnings of modern suburbia in eighteenth-century England. Lines published in 1754 in one popular periodical, for example, denounced, in terms very similar to Malvina Reynolds', the unsophisticated, underfinanced, and underlandscaped sort of "box" that people with no taste were building on the outskirts of London:

> A little country box you boast
> So neat, 'tis cover'd all with dust;
> And nought about it to be seen,
> Except a nettle-bed, that's green;
> Your Villa! rural but the name in,
> So desart, it would breed a famine.5

A century later, New York architect William Ranlett wrote in similarly derogatory terms about the suburbs of his own time. Starting from the premise that cities are to be apprehended in terms comparable to a work of art—a genteel aesthetic stance in its own right—he found that American suburbs were little more than visual blight: "The suburbs of our cities are, generally, like a shabby frame to a fine picture. . . . [T]hey are put up in a hurry by careless speculators, and very little regard is paid to their externals." At the end of the twentieth century, the

refrain was still the same: speaking acerbically, yet in tune with many in the design establishment, James Howard Kunstler described "the building of suburbia" as "a self-destructive act," a "tragic process" that "is bankrupting us economically, socially, ecologically, and spiritually," "not merely the symptom of a troubled culture but in many ways a primary cause of our troubles." A good portion of the blame is directed at the aesthetic "banality" of suburbia: "a fake fanlight window in a tract house is the supposed solution for the problem of a house designed and built without affection for nobody in particular. A Victorian street light is the supposed cure for overly wide, arbitrarily curvy streets that are poorly defined by tract houses."6

Persistent Precepts

Despite the historical persistence and consistency of critiques such as these, mocking uniformity, sneering at shoddy construction, and decrying the absence of taste (or worse), a substantive history of suburban aesthetics—the criteria according to which society has judged the design and appearance of suburban dwellings and landscapes—remains to be written.7 Although such a history is not possible here, a preliminary survey of the popular and professional literature on architecture, landscape, planning, and urban/suburban design of the past two-and-a-half centuries does yield four key precepts that have persisted over the history of suburbia.

First, a common factor in assessing the relationship between dwelling and landscape is picturesque design—adopting the English landscape aesthetic known as the picturesque, or at the very least acknowledging an overt pictorial relationship between the dwelling and "nature." Second, design is recognized as a didactic instrument that is available for improving the morality, taste, and welfare of the populace. Third, preference is best given to the neighborhood or community, not the parcel of private property, as the principal aesthetic object. And fourth, an authoritative role in the evaluation and practice of urban/suburban design ought to be reserved for the professional planner and designer.

Yet despite (or perhaps because of) sprawling developments across the United States and the globe that defy these principles, there is scant counterdiscourse that explores the sorts of aesthetic—pragmatic, everyday, bourgeois, self-oriented, and identity-centered—that do prevail in this *terra abdicata*. Before turning to the grounds and

fig. 1 Short Hills, New Jersey, panorama and vignettes, from *History of Essex and Hudson Counties, New Jersey* (1884), by William Shaw

substance of such aesthetics, however, a closer look at the currently dominant discourse will help to clarify the comparatively elite and intangible premises on which the debate has been conducted so far.

Picturesque Composition

The earliest, and perhaps foremost, of these precepts governing the production of suburbia originated in the eighteenth-century English landscape aesthetic of the picturesque. Tellingly front and center in William Ranlett's mid-nineteenth-century comment that suburbs should serve as a "frame to a fine picture," the picturesque stemmed from mid-eighteenth-century efforts of English landscape gardener Capability Brown and artist and essayist William Gilpin, among others, to make the natural landscape, whether as fashioned by gardeners or as perceived by spectators, conform to the same rules of pictorial composition that informed the canvases of then-esteemed landscape painters Claude Lorrain and Nicolas Poussin. Brown recast the terrain of large estates by creating country landscapes that were in effect pre-framed pictorial compositions, ready for apprehension by the viewer as static pictures. At the same time, Gilpin, seeking a structured method for tourists to apprehend the beauties of Britain's natu-

ral landscape and historical ruins, transformed the touristic experience into a series of encounters with overtly pictorial compositions. He accomplished this by addressing each scene of landscape-cum-ruins not as something to be observed directly, but rather to be viewed through an amber-tinted oval piece of mirror called a "Claude glass." This lenslike object rendered the subject in a manner ostensibly comparable to the paintings of Claude or Poussin, which at that time generally were seen through a layer of old, and therefore yellowed, varnish. Landscapes consequently were experienced at one remove, excluding the observer from the composition by means of the implied, or sometimes explicit, frame.

Thus, picturesque nineteenth-century suburbs such as Llewellyn Park, New Jersey, or Short Hills, New Jersey, were extolled as much for their pictorial aesthetics as for their physical comforts and amenities. In 1884 *Lippincott's Magazine* rhapsodized that Short Hills "is scene-painters' architecture in an opera village," while essayist Alfred Matthews, praising the siting of houses in the landscape, wrote that "each group reveals harmony, and every house gains something from its neighbor as well as from the broad picture formed by natural surroundings."[8] fig. 1 More than a century later, the same effect

THE neglected home, where the child grows up without knowledge of order or correct system; tools and vehicles exposed to all kinds of weather, rusting and falling to pieces from inattention.

THE home of neighbor Thrifty, where the children learn habits of neatness, economy and good management; there being a place for every implement when not in use, and each kept where it belongs.

fig. 2 The neglected home, and the home of neighbor Thrifty, from *Peale's Popular Educator and Cyclopedia of Reference* by Richard S. Peale, circa 1860s

continues to be emulated, in real estate Web sites and marketing brochures that frame idyllic visions of carefree and labor-free pastoral tranquility, and even in promotional prose that, as it typically encourages us to think back to a time when life was simpler and more wholesome,9 also appeals to our memory stock of images by Norman Rockwell and Currier & Ives. This pictorializing imperative is presently epitomized in its utmost form by Hiddenbrooke, a development in Vallejo, California, which is marketed as fashioning in three dimensions the romantic-pastoral vision of Cotswold-like cottages seen in the work of artist Thomas Kinkade, even though by all accounts the development bears almost no resemblance to the paintings.10

Moral Efficacy

Of equal interest to American architects, almost since the founding of the republic, has been the didactic and instrumental capacity of design to influence the moral character of the population. Houses long have been understood to have a close relation to the personality and character of those who lived within: the taste with which a dwelling was designed and furnished would have a corresponding effect on the character of the resident. Thus, as early as 1821 Timothy Dwight observed that "Uncouth, mean, ragged, dirty houses" produce "coarse groveling manners," while beauty can set "coarse society" on the road "towards improvement." At mid-century John Bullock proposed in *The American Cottage Builder* that the proper design of country residences could reduce the number of young men who "precipitate themselves into the dissipated and vitiated follies of a city life." Likewise, Alexander Jackson Downing, the preeminent American architect of the time, declared that "in this country . . . we have firm faith in the *moral* effects of the fine arts. We believe in the bettering influence of beautiful cottages and country houses." And in the mid-1860s, J. J. Thomas wrote that "[a] house is always a teacher; it may become an agent of civilization. While builders minister to deceit and vanity, those vices will prevail; when their works embody fitness, truth and dignified simplicity, these republican virtues will be firmly rooted in the nation. Few are aware how strong an influence is exerted by the dwelling on its inhabitants."11 [fig. 2]

In 1852 Philadelphia architect Samuel Sloan even made a case for good design as a general patri-

otic resource, contending that by erecting "elegant buildings, . . . [t]hus does the national character become infused with refinement." And the influential feminist and reformer Catharine Beecher, in her 1869 tract *The American Woman's Home*, stressed that "the aesthetic element" of dwelling design could have a distinctly positive effect on younger members of the household as well as contribute to the education of all in "refinement, intellectual development, and moral responsibility."12

By the end of the nineteenth century, along with the rise of civic and municipal reform movements, reform-minded architects and planners began to extol the moral efficacy of aesthetics on a civic scale. As Richard E. Foglesong has shown, planners associated with the early-twentieth-century City Beautiful movement eagerly advocated aesthetics as a medium of benevolent social control, such that "control by design experts" ultimately could overcome many deficiencies of the market system in fashioning urban space. More generally, as Foglesong notes, turn-of-the-century City Beautiful aesthetics sought to transform the entire city plan into a physical apparatus for legitimating civic ideals—a plan that, at a time of large-scale immigration, could inculcate in the citizenry a respect for country, American culture, and capitalism.13

Thus, Charles Mulford Robinson's 1903 treatise, *Modern Civic Art, or the City Made Beautiful*, promoted a form of "civic art" that "stands for more than beauty in the city. It represents a moral, intellectual, and administrative progress as surely as it does the purely physical." Indeed, municipal aesthetics bore an efficacy that bordered on the eugenic: "[a]s this environment is lovely and uplifting, or mean and depressing, as it feeds or starves the brains and spirits whose outlook upon earth it compasses, it may be supposed to influence the battle, to help the forward or retrograde movement of the race." Or as Frank Koester wrote in 1912, tying together aesthetics, nationalism, and morality: "The superior appearance, beauty and harmony of the city will develop artistic taste and will result in increased civic pride and patriotism. This is turn affects the character of the individual favorably, improving moral conditions."14 By the 1950s and 1960s, considerable concern had arisen over the pernicious effects that suburbia was having on American morality, epitomized perhaps in *No Down Payment*, John McPartland's 1957 tale of

alcoholism, infidelity, and abuse. As late as 1979, Jonathan Kaplan's film *Over the Edge* purported to show the corrosive effects that master-planned communities might have on their youth. In recent decades, the discussion of morality has shifted from an interest in suburbia's good or bad effect on the individual to an emphasis on suburbia's effects on a broader scale, as an engine of sprawl. Dolores Hayden's comments on sprawl, although they do not specifically refer to suburbia, succinctly epitomize the opinions of many. Sprawl, she writes, is "socially destructive. It intensifies the disadvantages of class, race, gender, and age by adding spatial separation. Sprawl is politically unfair as well as environmentally unsustainable and fiscally shortsighted."15

Community

An abiding challenge to those who would deploy design as a means of inculcating morality has been the long-standing, uncomfortable tension in American culture between community interest and the private rights of individuals and their property. Designers and critics have long struggled to balance these competing interests and values. Yet in the early decades of the twentieth century, buoyed by the spirit of municipal reform, many came to the conclusion that to prioritize community benefit over private interest was the best way to serve the interests of all. Robinson, in a remark subsequently repeated by many of his contemporaries, set the tone of the discussion in 1903: "The exterior of your home, said Ruskin, is not private property." For although Robinson recognized the need to balance "civic art" with the "rights of privacy," he argued that in some situations the whole could be aesthetically more efficacious than the sum of its parts: "the individual residents . . . are to be encouraged . . . to co-operate, that there may be a harmonious result and that each effect may be heightened by its neighbours."16

Much the same attitude informed the writing of urban planner Thomas Adams, the first manager of Letchworth Garden City and later director of the Regional Plan Association of New York. In 1934 Adams argued that in order "to improve public taste . . . [i]ndividualism must be controlled"—hastening to add, in tacit acknowledgment of the growing menace posed by the USSR, that this could be accomplished "without the aid of communistic government and architecture." Rather,

perhaps presaging popular enthusiasm for communities governed by private homeowners' associations later in the twentieth century, he proposed that individualism be harnessed not by state or municipal authority, but instead privately, "through cooperative action" in the form of "associations of individuals."17 And despite (or perhaps because of) the inexorable, ongoing privatization of the American landscape over the rest of the twentieth century, community has become an increasingly common consideration in the planning and marketing of new developments. Commonly proceeding from the unstated presumption that there has been a drastic loss of community in American life, advertisements for new developments ask readers to imagine or recall a time when community flourished—a time and tradition that the new development promises to restore. As a marketing brochure for Clover Field, a development in Chaska, Minnesota, put it in 2005:

> The community of Clover Field is reminiscent of an age when picket fences and front porches lined the streets, neighbors gathered in the town square and in their front yards, and children walked to school. Life was a little simpler. The neighborhood was a place where you felt at home.
>
> Older neighborhoods hold a timeless appeal. They awake fond memories of a simpler way of life. Gathering with friends and neighbors on a warm spring day. Sitting on the front porch watching the stars flicker on a summer night. Riding bikes through newly fallen leaves to the corner grocery store. Or, walking to school in the season's first gentle snow. It's a way of life missing in many new subdivisions but the cornerstone of the area's newest neighborhood development—Clover Field.18

Professional Authority

Long before the invention of modern suburbia, architects commonly insisted that, because of their training and expertise, all matters of building design should be entrusted to them in order to secure the greatest public and private benefit. This sort of self-interest also figured regularly in the writings of nineteenth-century architects who designed for the suburban residential market. City Beautiful planners, however, reached further, making centralized aesthetic control a crucial factor in the larger

134

enterprise of civic reform. Robinson lamented, for example, that as a city grows, "There is immense scope for the poor taste of untrained individualism." He expected that the public instead would appreciate "the value of an authoritative aesthetic control," and presumably accede, gratefully, to its imposition. Thomas Adams focused more directly on the sorts of buildings that traditionally would have been designed and built by small contractors or owner-occupiers, particularly since they constituted an ever-increasing portion of the urban/suburban landscape. Plainly mistrusting their builders' capacity to conform to an appropriate aesthetic, he recommended large-scale professional intervention: "Until the public obtains a greater appreciation of architecture, too many buildings will continue to be designed by untrained men, and until more architects are employed to design the smaller buildings, which constitute the greater part of cities, the standard of civic architecture will be low."[19]

In short, from the nineteenth century to the early twenty-first, architects and planners have promoted the *instrumental* capacity of the built environment, by *aesthetic* means, to shape the consciousness and material life of those who encounter it. As the expansion of America's urban peripheries began to accelerate, first in the 1890s with the expansion of streetcar lines, and again in the 1920s as automobile ownership became widespread, advocates of municipal improvement were optimistic that prescriptions such as those offered by Robinson and Adams would help to tame and order the all-too-rapidly growing suburban landscape. Their exemplary visions of aesthetically managed landscapes, actively contributing to the welfare of residents and community, remained influential, and were largely realized in a number of prominent suburban projects, such as Radburn, New Jersey (1929); Greenbelt, Maryland (1937); Reston, Virginia (1964); Columbia, Maryland (1964); Jonathan, Minnesota (1967); and The Woodlands, Texas (1972).

Yet, by and large across American society, as suburbia expanded ever more rapidly in the decades following World War II, public interest in planning and design as instruments of civic and social improvement faded, and support for control over neighborhood design through municipal (rather than private) means likewise all but disappeared. Nevertheless, simultaneously there was a complementary rise in the popularity of *private*

developments that do incorporate a comprehensive, professionally crafted aesthetic into an overall master plan, the maintenance of which is assured through design regulations and behavior codes enforced by private homeowner associations. But even as master-planned communities (MPCs) have become a leading type of residential development in the United States, the aesthetic imperative has subtly and profoundly changed. Promotional materials for MPCs still boast design features that are consistent with precepts recommended by early twentieth-century planners—affording picturesque engagement with nature, offering neighborhood layouts and amenities that are conducive to wholesome family and community life, and providing covenants, codes, and restrictions (CC&Rs) that have a cachet of professional erudition. Yet compared to the first half of the twentieth century, two differences also stand out. First, all the advantages of these design strategies accrue to, and are enjoyed in, the private, not public, realm. And second, as justification for the expense and for limitations to personal freedoms that these strategies require, a quantitative standard is introduced: property values, which thus become the primary register in which these benefits are valued, not infrequently more so than lifestyle, aesthetics, or community.[20]

Still, whatever the aesthetic regime a given master-planned community may adopt, the net effect is that suburbia in general is, to many eyes, an aesthetic hodgepodge: countless private enclaves, legally and aesthetically self-contained, which compete with an even greater number of unregulated tract developments, as well as lot-by-lot developments of individually designed houses. The result is that, on balance, suburbia still profoundly disappoints the critics. Many identify master-planned communities as particularly blameworthy—for withdrawing beauty and community from the public realm, both as amenities and as matters of public concern, and for repressing freedom and diversity through CC&Rs that strictly limit opportunities for individual expression and distinction. The large-scale, long-term result is neither social improvement nor community. Other critics find little more aesthetic merit in most master-planned communities than in suburbia at large—which, they argue, is still regimented, repetitive, bleak, and decidedly unpicturesque. Visually, as well as in terms of such factors as

navigation and transportation, they find suburbia incoherent—a problem, they suggest, that begs the intervention of professional authority.

In sum, over the past century the distance between the critical establishment and run-of-the-mill suburbia remains in many respects unchanged. Nevertheless, suburbia itself has changed profoundly, not only demographically but also in other significant respects: as the physical fabric of suburbia consists ever more of manufactured products and marketable commodities, its relation to the lives of its inhabitants and to the culture at large has been transformed. In order to better understand the nature and function of aesthetics in present-day suburbia, it is necessary to explore the relationship of this transformation to broader aspects of American culture and everyday life.

Mass Production and the Loss of Selfhood

At the outset of the twentieth century, houses generally were one-off products, built separately and individually, or perhaps occasionally in small series by small-scale entrepreneur builders. A given house could be regarded as a work of craft, which often was presumed to have the potential to embody the character and facilitate the personal interests of the person or family who inhabited it.[21] As the manufacturing economy became more sophisticated, however, more and more aspects of the house-building process became mechanized and standardized, thus diminishing the individuality of each house, theoretically reducing its capacity to suit the individual resident, and becoming more of a mass commodity. Sears Catalog Homes, shipped as ready-to-assemble kits from 1908 to 1940, were one harbinger of change. Sinclair Lewis' lamentation in *Babbitt* (1922) on the evils of standardized housing production vividly captures the disappointing shift in what a homeowner could expect from a house, epitomized in this excerpt describing George Babbitt's bedroom: "It was a masterpiece among bedrooms, right out of Cheerful Modern Houses for Medium Incomes. Only it had nothing to do with the Babbitts, or anyone else. . . . In fact there was but one thing wrong with the Babbitt house: It was not a home."[22]

A generation later, in the late 1940s and 1950s, the mass-production processes that built Levittown, Lakewood, Park Forest, and other large-scale tract developments accelerated this transformation

of dwelling into commodity. And as Americans became more mobile due to freeways, expanding employment opportunities, and rising affluence, they moved more frequently, rendering the house even less befitting as an anchor of self and identity. Simultaneously, the housing-construction industry has become a major economic sector unto itself, and real estate has become as much a financial and marketing product as it is an apparatus for dwelling.[23] Probably the most concerted criticism of these postwar changes has been found in the medium of popular music, which condemns suburbia in terms far more acerbic than Sinclair Lewis used. From "Pleasant Valley Sunday" (Monkees, 1966) and "Subdivision Blues" (Tom T. Hall, 1973) to "Subdivisions" (Neil Peart, 1982) and "The Valley of Malls" (Fountains of Wayne, 1999), the message is that life and soul have been sucked out of suburbia.

While a common factor in critiques from *Babbitt* to the present day is the loss of selfhood, the underlying basis for these critiques almost always focuses on how, and from what, suburbia is made: specifically, standardized, mass-produced materials, marketed in terms (such as "Cheerful Modern Houses for Medium Incomes") that stereotype rather than individualize the resident. "Suburban Home," released by the Descendents in 1982, is quintessential:

> I want to be stereotyped
> I want to be classified
> I want to be a clone
> I want a suburban home.[24]

Even as twentieth-century American popular culture, especially since the 1960s, witnessed extraordinary shifts in the understanding of selfhood (as it turned more privatized and narcissistic), Americans were loath to relinquish the long-standing presumption that a bond prevailed between dwelling and identity—that the house was a material register of selfhood.[25]

Nevertheless, the nature of that relation between dwelling, identity, and selfhood had changed in three crucial ways. First, houses were no longer individually designed and built; purchasers no longer could expect that such a mass-produced product could be a "personal" fit to the life of any given individual. Second, houses were designed to suit specific marketing categories of consum-

ers, such as "Medium Incomes" in Babbitt's day, or "Kids & Cul-de-sacs," which currently is one of sixty-six clusters in Claritas Corporation's PRIZM NE marketing system. Third, the general mobility of the American population, and the ease with which purchasing and selling houses has been made possible by modern financial instruments and government organizations (such as the growth of thirty-year mortgages following World War II, the FHA and its insured housing loan programs, and the Federal National Mortgage Association), have rendered the act of purchasing of a house, and living in it, ever closer to being just another act of consumption. In short, the standardization and commodification of the house led many to doubt its capacity to serve adequately as a register of individualized American selfhood.

Diminished Community, Absent Authenticity

Such profound changes in the ways that suburban housing was produced, marketed, and utilized were paralleled by a related cultural shift: as modern industrial, economic, and political relations have contributed to a progressive erosion of community in American society, critics likewise identified a corresponding vitiation of *authenticity* in social and personal relations. In 1887 German sociologist Ferdinand Tönnies penned a pioneering analysis of this fissure as a structural product of modern, industrial-capitalist society. He differentiated *gemeinschaft*, a comparatively traditional, long-standing form of community based on shared values, familial ties, and customs of mutual dependence, from *gesellschaft*, a form of community that individuals in a privatized, competitive society construct explicitly to facilitate mutual cooperation in the pursuit of self-interest.26 As Tönnies noted, interpersonal ties in *gesellschaften* ordinarily are much weaker, and more impersonal, than in *gemeinschaften*, since they are formed artificially around specific interests, rather than constantly generated, through custom and tradition, across multiple interests among the population at large. The rise of *gesellschaften* thus bespeaks citizens' growing alienation under modern forms of industrial capitalism. Members of industrialized societies are no longer part of a feudal order where everyone's place is fixed in a complex, often hierarchical social fabric, but rather cast as individuals, all given the responsibility of forging their own identities and relationships. There are

positive advantages to this more autonomous status; nevertheless it also has the capacity to alienate individuals from the common interests of other citizens and society at large.

Tönnies' account of economic and social alienation, further developed in the social criticism of Max Weber in the 1920s and by members of the Frankfurt School in the 1940s, blossomed after World War II into a withering critique of the role of industrialized mass production—not least in the form of tract housing—in undermining American society and culture. Sociologist David Riesman's 1950 book *The Lonely Crowd* sharpened the critical polemic, arguing that the rise of individualist consumerism only directed Americans' loyalties away from community and toward a selfish, careerist alliance with corporate interests. William H. Whyte's 1956 book *The Organization Man* echoed much the same fear. In 1957, Riesman's essay "The Suburban Dislocation" became one of the earliest, and most trenchant, condemnations of the mass-produced tract suburb. He warned of the "loss of human differentiation," of "aimless" uniformity and conformity, and of privatization and isolation, especially for women.27

An ensuing generation of critics refocused the question from the loss of community to the loss of authenticity, focusing not simply on American suburbs but on Western urbanism in general. Architects searched distant portions of the globe for structures that might be more demonstrably authentic, as for example Bernard Rudofsky did in the exhibition *Architecture without Architects* that he curated at the Museum of Modern Art in 1964 to 1965, and in a catalogue published under the same title. A decade later geographer Edward Relph, arguing for an "unselfconscious and authentic experience of place as central to existence," chronicled the decline in the very possibility of authentic places in post-Renaissance Western architecture. In what amounted to a funeral for authenticity, Relph declared "that inauthenticity is the prevalent mode of existence in industrialised and mass societies," and charged that "mass values and impersonal planning in all their social, economic, and physical forms are major manifestations of such inauthenticity."28

A number of critics offered a narrower critique, however, identifying the accelerating abandonment of America's cities in favor of suburbia, and the

escalating presence of commodities in American's everyday lives as synergistically contributing to a diminution of authenticity in modern life. Returning to Babbitt, for example, T. J. Jackson Lears pointed to suburbanite George Babbitt's realization that standardized, mass-produced products precluded, in Babbitt's words, the "joy and passion and wisdom" that he had sought in life—a life journey that Lears described as a "search for the lost springs of authentic being," a "quest for authenticity that comes to nothing."29 Stewart Ewen, writing in 1989, echoed the title of Riesman's 1957 essay in defining "the central experience of urbanization and modernity" as a "cultural dislocation." At a time of accelerating flight to the suburbs, Ewen did not implicate suburbia explicitly in this disruptive process; yet by tying it to a prevailing malaise over the decline of cities, he left little doubt as to where the perpetrators went and what enticed them to leave. Specifically, those abandoning the cities for suburbia were happily indulging in various forms of commodity consumption that eroded "authentic" culture and replaced it with an ersatz selfhood or, as Ewen put it, a "commodity self," a mere "dream of identity" fashioned, but never delivered, by advertising.30 In a 1980 essay, architectural historian Adrian Forty and architect Henry Moss singled out one of the more prominent ways in which this manifests itself in suburbia, namely the assortment of quasi-vernacular and quasi-historical style choices which, as marketed to suburban house buyers, not only attempt to camouflage the standardized and mass-produced nature of suburban tract housing, but also fashion an ostensible "scenery of permanence" and myth of authenticity for those who live there.31

Assessments such as these by Lears, Ewen, and Forty and Moss, that twentieth-century technologies of mass production, marketing practices, and advertising afforded only simulacra of identity, found ready acceptance among erudite critics of suburbia as well as throughout American popular culture. Of the considerable body of twentieth-century literary fiction and film that is set in suburbia, a remarkable portion is devoted to much the same theme, the alienation and inauthenticity that pervade suburbia. Novels and films from Babbitt (1922) and The Man in the Gray Flannel Suit (novel by Sloan Wilson, 1955; film, 1956) to Independence Day (Richard Ford, 1995) and American Beauty (directed by Sam Mendes, 1999), all foreground

the estrangement of their central characters from a world that is ever more artificial, corporate, and regimented.32 Indeed, for many critics of modern capitalist and consumer society, suburbia became Exhibit A, not only because so much of it was mass-produced and mass-marketed, but also because so much of it appeared to subscribe to an ersatz aesthetic, mindlessly forgoing authenticity.

Critiques such as these, however, paid little attention to the lives and practices of the real people who lived there; for those who did pay close attention, such as Herbert Gans, who published The Levittowners in 1967, and Bill Owens, whose collection of photographs titled Suburbia appeared in 1973 (page 110), the findings often were astoundingly different. Far from sterile and conformist, suburbia harbored people with rich and diverse cultures, who employed the physical housing apparatus in a host of original, personal, and indeed authentic ways.

Objects and Identity

Central to the process by which housing contributes to the articulation of selfhood and identity is the larger role that objects in general serve in human consciousness and daily life. A rich academic literature has explored the production and consumption of goods in human society, and demonstrates how they are in general instrumental to the very real articulation of identity, selfhood, and the relation of self to society. Early in the twentieth century, scholars of structural anthropology and sociology such as Émile Durkheim and Marcel Mauss identified the significant role of gifts and other objects in articulating the bonds and ranks that tie individuals and larger social groups together. In 1979 Mary Douglas and Baron Isherwood extended the analysis to a deeper level, writing that consumption of goods "is a ritual process whose primary function is to make sense of the inchoate flux of events." A critical factor in that process of stabilization is a meaningful built environment: dwellings do not simply protect against the elements, they also constitute an organizing apparatus that through practical, symbolic, and aesthetic means anchors and negotiates the constantly changing relations between self and the world. "Consumption goods," as Douglas and Isherwood put it, "constitute the very system itself."33

Focusing more closely on the relation between objects and selfhood, marketing researcher Russell

Belk states that "our possessions are a major contributor to and reflection of our identities": through investing energy in producing and using objects, they become part of the self.**34** Geographer David Harvey views the process in much the same fashion, but more broadly, focusing on the construction of place: here "material, representational, and symbolic activities"—including what people do with objects—"find their hallmark in the way in which individuals invest in places and thereby empower themselves collectively [and, one might add, personally] by virtue of that investment."**35** Put another way, what people do with objects, and the meanings that people invest in objects, are fundamental to the articulation of selfhood. Goods and all the things we do in the process of consuming them fashion not only the very structure of everyday life, but selfhood itself.

In the mid-nineteenth century, well before the widespread mechanization of standardized products, American architects and intellectuals understood this instrumental relationship between goods and selfhood. And many of them identified the house as the premier apparatus by which the resident could fashion the many dimensions of selfhood. As the popular and influential preacher Henry Ward Beecher wrote in 1855:

A house is the shape which a man's thoughts take when he imagines how he should like to live. Its interior is the measure of his social and domestic nature; its exterior, of his esthetic and artistic nature. It interprets, in material forms, his ideas of home, of friendship, and of comfort.

And despite the concerns of many that mass-produced tract housing and commodity culture have eviscerated dwellings of any capacity for meaningful articulation of identity,**36** the notion of an instrumental relation between house and selfhood still retains considerable credence. As critic Michael Sorkin has remarked, "We trust home to be aid and comfort to individuality," and we place full confidence in the "idea of the home as the preserve of the personal, the terrain of our individuation."**37** And as historian Andrew Hurley observed in 2001, in a conclusion that applies to housing and retail goods alike, those who make use of a given product are not bound by the meanings attached to the marketing of the product. "Contemporary advertisers and retailers pitch their products, not to middle-class families, but to individuals as cultural free agents. Commodities once promoted as instruments of family cohesion and cultural amalgamation are presented as mediums of self-expression and personal transformation."**38** Or as architect Sara Selene Faulds puts it, "Our homes provide us with a freedom for personalization of those special places which we nurture into being, and which, in turn, nurture us. It is in our homes that we are best able to display for others our interests, fantasies, aesthetics, and images of self."**39**

From Standardization to Distinction

Despite the confidence of commentators such as those above that dwellings and their contents readily serve as instruments for fashioning selfhood and identity, there are many who argue, to the contrary, that standardization, mass production, and mass marketing have left suburban housing capable of articulating little more than stock designs, stereotypes, and clichés. Such might be the case if the only way in which to make use of an object were as it originally was intended, or the only way to understand an object was in the way it originally was advertised. But once the product is made part of the purchaser's home, use and significance are open to change: depending on how it is situated and employed, it becomes part of the apparatus by which the residents fashion their own specific interests and daily lives.

As marketing researchers Richard Elliott and Kritsadarat Wattanasuwan have shown, individuals are not confined to the range of meanings and uses that marketers attach to their products. Rather, in articulating selfhood through the practices of daily life, consumers bring with them the potential to "ascribe different and inconsistent cultural meanings" to all sorts of products. Advertisements don't transfer meaning directly to consumers. Instead, consumers are aware of the meanings that they are being "sold," and that they also are able to vary, multiply, ignore, and undercut those meanings, depending on their own interests and circumstances.**40** This applies equally to the production and consumption (or habitation) of suburbia. The house, contents, and yard are in great measure an assemblage of standardized, industrially produced, mass-marketed products; but far from being prisoners of the menu, those who actually live there are engaged every day in a careful and deliberate

process of selecting and fashioning their material surroundings into an apparatus of selfhood and identity. The ways in which a house is finished and furnished, and the ways in which particular features and spaces are used, maintained, and modified, continually fashion a pragmatic apparatus that binds together the resident's dreams, values, and everyday life. For although elements such as pristine lawns, pedimented porticoes, wood-grain metal siding, great rooms, master suites, multi-paned sash windows, reproduction furniture, and reproduction artwork may be stock products, even clichés, they are also essential instruments of social signification, making multiple statements about social class, economic class, taste, style, identity, heritage, security, and so forth, thus fashioning a rich and complex selfhood.41 As architect Peter Kellett shows, even in barrios and other informal settlements, the physical attributes of homeplace, fashioned by whatever means and in whatever materials may be available, still "relate to issues of identity, economic and social positions: in short, a person's place in society." "Through the processes of occupation, construction and habitation," he writes, the dweller "is actively reconstructing her place in the world."42

Indeed, far from the presumption that standardized products standardize the users, the trend is very much the opposite. Today the social world is increasingly organized according to the logic of differential distance, which is to say that differences are signs of distinction. In an early exploration of this phenomenon, sociologist Pierre Bourdieu's book *Distinction* examined the specific tastes and aesthetic practices that people employ in pursuing individual distinction—a means of differentiating themselves from others in order to establish their position vis-à-vis the various levels and echelons of society.43 Much the same thing occurs in American suburbia: distinction is achieved not only by living in a certain place (e.g., by owning a house in a community with a certain cachet) but also by distinguishing oneself within that community (e.g., by having the showiest plantings, or the most accurately restored historic exterior). Distinction does not necessarily imply substantial outright difference. For example, in a neighborhood of houses that are all similar to each other, distinction may not be a matter of using a paint color that noticeably differs from all the others, or having a unique addition; rather, it may well be a matter of using a

combination of paint colors that is the most tasteful within the local palette, or making additions that coexist most peacefully with the surrounding structures and landscape.

In this way the housing market, instead of surrendering to the tyranny of standardization, is expanding the available means by which individual owners can shape their material surroundings and simultaneously fashion aesthetic statements that suit and express their own distinctive tastes and aspirations. As Witold Rybczynski details in the book *Last Harvest* (2007), the ever more ample option menus that builders offer their clients are a significant avenue of personal differentiation, serving to "give buyers the opportunity to personalize their homes."44 Features such as elaborate ceilings, skylights, additional rooms, fireplaces, chair rails, exterior stylistic packages (bungalow, Victorian, colonial, etc.), appliance packages, various window types, and different grades of trim, all are part of the ever-expanding range of products by which houses serve not simply as apparatuses of social signification (tying the owner to certain class echelon, for example), but also become instruments of personal distinction.

Some will argue that such products are not "genuine," or authentic, but rather a smorgasbord of ersatz veneers and simulacra, and therefore nothing of genuine distinction can result—that however the household is configured, all that it can amount to is imitative representation. But this, as with other arguments concerning authenticity, again denies the reality of everyday life as lived amidst, and through, commodities. A parallel argument denies *aesthetic* legitimacy in circumstances when multiple standardized units, especially those that may be obvious stereotypes or clichés, are employed. Yet to do so risks drawing a specious distinction between such techniques when they are employed under the aegis of "art" and their use in common everyday life. The work of Andy Warhol is a case in point. His serial repetition of mechanically reproduced images and objects readily captivated both the public and the art establishment—beginning, not incidentally, in the very same year that "Little Boxes" appeared. Warhol's own little boxes—his Brillo boxes (1964)—followed by Campbell's Soup cans (1968) and more, and his confidence that distinction, in the form of "fifteen minutes of fame," would accrue to everyman, were lasting and widely accepted statements of confidence in the aesthetic value of commodity culture.

But in the longer history of artistic production, Warhol was hardly a pioneer in the appropriating standardized elements to a larger whole. As Walter J. Ong has shown, the epic works of Homer survived from storyteller to storyteller in part because they were constructed from clichéd expressions and standardized themes, which rendered them sufficiently memorable to be learned and recited from one generation to the next. As Ong puts it bluntly, "Homer stitched together prefabricated parts,"**45** yet the aesthetic distinction of these poetic works has been an article of faith for centuries. In this light, the widespread censure of prefabricated suburbia appears ever more problematic. At best, it has all the trappings of a class-based critique: what is hallowed by the golden glow of history or by the prestige of the New York art scene is entirely acceptable, but when much the same process is found amongst the bourgeois (or nouveaux-bourgeois) masses, the establishment demurs. Yet in terms of performance as well as pragmatics, there is no intrinsic difference between Pop Art or Greek epic and what suburbanites do, on a daily basis, with their fifteen hundred square yards (about one-third acre) of distinction.

Thus in a culture such as ours that is centered not only on an economy of consumption, but also on delineating distinction, the vocabulary and syntax for articulating selfhood and identity are the object of considerable attention. Not only is there incentive for constant invention and innovation (products that instigate new activities, fashions, or styles, for example), and to devise products that may be readily individualized and customized, but there is also a corresponding incentive for marketing practices to address each person in terms that are as individualized as possible, and to offer new avenues to personal distinction as well. This approach characterizes the marketing of real estate as much as any other commodity, as is seen in the incorporation of several standard marketing practices into the marketing of real estate. These include market segmentation, lifestyle marketing, branding, and theming.

Prefiguring present-day marketers' interest in consumers' pursuit of distinction, marketing researchers of the 1960s began to identify a spectrum of "life style concepts" to help explain the social and psychological frameworks in which individuals tended to fashion personal identity and identify with particular social classes. In the 1970s, researchers expanded and refined this mode of analysis into a more refined methodology termed "market segmentation"; this in turn served as a crucial foundation for mass customization and personalized marketing, and it remains a predominant, ever more sophisticated apparatus for identifying consumers according to increasingly precise criteria. A key principle of market segmentation is that there is no "average" consumer. Rather, it is the differences among consumers that market-segmentation analysis seeks to elucidate: the more axes of difference, and the more degrees of difference along the scale of any given axis, the more highly differentiated (one could also say *distinguished*) is any consumer. And although it is generally not (yet) realistic for marketers to target any single individual, it can be highly effective to address specific consumers in terms that identify respects in which they already are differentiated from others, and in which a given product can conduce to even greater degrees of distinction. Claritas Corporation, working in this field of market segmentation since the 1970s, has developed the leading system for identifying, and marketing to, specific market segments, or clusters of individuals. Known by the acronym PRIZM NE, the system assigns Americans to fourteen groups that are further divided into a total of sixty-six clusters. Significantly, residential location (urban, suburban, or country/rural) is one of the two factors that are considered in PRIZM's top-level classification into groups, the other being income level, ranging from "affluent" to "downscale." Further refinements in residential location are part of the definitional framework for the sixty-six clusters—for example, cluster 34, "White Picket Fences."**46**

Developers and builders are keenly aware of these marketing conventions, and design their products accordingly to appeal to identifiable and thus receptive market segments. There is a risk that this can degenerate into a stagnating, circular process if developers and builders cease to refine their understanding of market segments, or search for new ones. If market segments are associated with specific types of housing, and builders simply replicate those specific types in order to appeal to the same market segments, there is little innovation—and what had been distinct, over time becomes commonplace.

In real estate, as with marketing in general, segmentation commonly focuses on *activities* rather than personality, although consumers'

"lifestyle attitudes" remain a central consideration.**47** The sorting and grouping of people according to lifestyle—practically speaking, a combination of activities, interests, and opinions—has been central to market segmentation since the beginning. As a standard text on the marketing of places states, "people are able to define where they live to work rather than where they work to live." Thus "places must learn to market to various individual life-styles."**48** Each of the PRIZM NE clusters is in large measure a lifestyle analysis, identifying specific lifestyle attributes, the popularity and unpopularity of which identify each given cluster. Thus in the "Middleburg Managers" cluster, college football ranks high (two and one-half times the national average) and pro basketball ranks low (less than a third of the national average), while in the "White Picket Fences" cluster, distinguishing lifestyle characteristics include owning a treadmill, dining at Carl's Jr., and subscribing to baby magazines.**49** Real estate developers and marketers correspondingly orient their projects around specific lifestyles, identifying a specific "target market" of consumers, assessing local competition for that market, developing a coordinated marketing campaign that features advertising in selected media, and furnishing a model home and its surrounding landscape with features intended to appeal to the prospective customer's lifestyle interests. Often marketing is less about the physical attributes of the home and site than about who and what the resident can become, given the opportunities afforded there. The following, for example, appears in a Web advertisement for Standard Pacific Homes in Fort Collins, Colorado: "Harvest is about so much more than houses. It's about creating a sense of community. It's about personal style and promising relationships, born of intricate planning and attention to detail. It's about connecting with people in a place where 'home' goes beyond the borders of your front lawn."**50**

Branding and theming are two interrelated techniques that are complementary to lifestyle marketing. Instead of addressing potential customers in terms of distinctive lifestyle attributes, developers and builders can also offer distinction on their own terms, through branding and marketing. Yet as marketing expert Mark Stevens put it, "until recently, builders had been brain-dead about branding"; few homebuilders put much effort into developing and maintaining a brand name. To do

so meant maintaining consistent, distinctive standards across regions and over time. But around 2000, builders began to realize the opportunities that branding could provide. For example, in 2002, Beazer Homes, as reported by real estate editor Pat Curry, headed down a path soon trod by many: the company realized that although it basically made good homes, "there was inconsistency between regions," and that "retaining the local names of the builders Beazer acquired diluted the firm's name recognition." By 2003 the company had not simply sharpened and consolidated its brand identity, but also shifted its marketing focus from near-meaningless terms such as quality and value to the particulars of the experience that customers would have in "buying, building, and owning a home." A similar rebranding at Epcon Communities adopted this strategy of "purposeful branding," focusing not simply on price or quality, but on the appeal to the customer of something more significant (or even distinctive). As the marketing director for Epmark Communities put it, "In any industry, the focus so often is on the product instead of the consumer. . . . If I'm focused on the consumer, I know I'm going to deliver a product that will satisfy the consumer." Thus a critical factor in home building is "that our customers have a great experience." As real estate branding expert David Miles asserts, branding is not only about "creating an experience" for the customer, but also about honing and refining that experience so that it will stand out as distinctive in the eyes of the consumer. As Curry notes, the process of developing a real estate brand "helps a company focus on what it does best and connect with customers who value that focus, instead of trying to be everything to everyone and not satisfying anyone."**51** In other words, the goal is to develop a distinctive brand, in anticipation of customers seeking that particular kind of distinction.

Probably the most publicized of recent housing brands is that announced in the *Wall Street Journal* in October 2005, the joint venture between KB Home and Martha Stewart, for whose "Martha" series of houses the marketing focus is suggestive of the customer's experience once moved in. As the *Journal* reports, "The houses are meant to evoke the bucolic splendor of prosperous suburbia," although, as the *Journal* also points out, there is a considerable difference between most KB homes and the "prosperous suburbia" of multi-acre lots from which Martha hails. Still, the fact that the KB homes are explicitly

"inspired" by three of Stewart's own houses points to a critical aspect of branding in a consumer society based on distinction. The KB home acts synecdochically because the customer does not purchase a real house owned by Martha Stewart, or even an entire facsimile. Nor can the "Martha" house render for the purchaser a lifestyle just like Martha's. Instead, there are specific elements and aspects of the KB home that correspond to Stewart's ideals and standards of domestic living, which then stand in for the whole. Both materially and aesthetically (notwithstanding those who would say inauthentically 52), purchasing a "Martha" house does, however, afford the resident at least some of the requisite apparatus for fashioning a lifestyle that is aligned to ideals and standards associated with Martha Stewart and the rest of her branded oeuvre. That association can be subtle and yet both significant and pragmatic, as Stewart indicated in a comment on her furniture collection that might equally apply to a "Martha" house: "When you're sitting on this couch, you don't know it's a Martha Stewart couch unless someone tells you. . . . But you can be sure it will last, it's well made, it's covered in beautiful fabric, it's comfortable and it fulfills the homeowner's dream of having a comfortable, practical, usable piece of furniture."53

Finally, just as Martha Stewart's branding goes hand in hand with lifestyle marketing, it also shares some characteristics with theming, a related marketing approach that, as Witold Rybczynski writes, "provides a coherent and instantly recognizable set of visual cues, to the home builders as the development is being created, and later to the people who live there."54 Frequently, theming is dismissed as inauthentic or shallow, particularly when it amounts to little more than a name such as "Mountain Estates" or "Eden Fields." But if the design of houses and surroundings maintains a theme of some aesthetic or cultural significance, or if a consistent design theme sustains elements of a certain lifestyle, the result is an apparatus that, aesthetically and materially, can augment residents' lives in practical and meaningful ways.

Conclusion

By the end of the twentieth century, suburbia became the place where more than half of all Americans live and work. Suburbia is where their lives are centered and where they select and fashion the surroundings in which they choose to live.

Suburbia also is a quintessential product of a mass-production economy, on a wide range of scales, from neighborhood and community, to house and yard, to the contents of the kitchen cabinets, the bedroom closets, and the entertainment center library. Everyday life is a constant process of engagement with mass-produced commodities. Critics of commodity culture argue that modern life is diminished owing to the demise of authenticity; but in actuality the expanding variety of commodities offers individuals (suburban and otherwise) increasingly rich opportunities to fashion lives that may fulfill their chosen ideals and standards, or may achieve desired degrees of distinction—or, equally valid, to accept and maintain the status quo.

As Margaret Crawford observes, "everyday space"—which I would argue includes the space of everyday life in suburbia—is not an "aesthetic problem" to be resolved by professionals, but rather "a zone of possibility and potential transformation." Unlike the New Urbanism, which she considers to be more of a design project that is "scenographic and image-driven in its production of familiarity,"55 everyday urbanism is a pragmatic process that encompasses the daily activities and the aesthetic conventions of the locality and the people who live there. As James Rojas has shown, the entire domestic apparatus, including house, yard, driveway, fences, sidewalks, and streets, is instrumental in the fashioning of everyday life. Focusing on the largely Mexican and Mexican American suburban district of East Los Angeles, he demonstrates how residents employ the building stock, much of which consists of small bungalows with fenced front yards, a shifting array of objects (signboards, tables, chairs, yard art, and so on), the presence of other people (vendors, musicians, visiting friends, passersby), and decorations (murals, graffiti), to fashion an aesthetically complex, vital daily existence.56

But everyday life is not simply a matter of the energy and creativity of a particular ethnic group. Even the banal is a legitimate aesthetic dimension of everyday life. As John Chase notes, "The stucco apartment box," despite its plainness, is well adapted in its own way to serve "the pragmatic and hedonistic character of Southern California."57

Everyday practices such as these are simultaneously material and aesthetic: furnishing a room, landscaping the yard, and preparing a meal, to give just a few examples, all involve the deployment of

material resources as an apparatus for conducting everyday life in a certain intended manner. They also employ resources in a manner that unapologetically accords with personal taste. Much of the recent concern over the appearance of suburbia arises from this privatization of aesthetics; that is, the concentration of aesthetic prerogative in the hands of individual homeowners, or in the hands of private developers—thus forgoing benefits oriented toward the public realm that reformers such as Charles Mulford Robinson advocated a century ago. In truth, the front lines in the battle between public and private interests in modern society have been centered in suburbia for centuries, and aesthetics constitute just one of the complex dimensions in which this battle continues to be fought.

Yet outright condemnation of any given aesthetic practice in suburbia just because it fails to conform to a larger public interest, or even because it is discordant with a preferred suburban aesthetic, is patently unfair. Suburban aesthetics are true to the conditions in which they operate—a culture in which the production of selfhood and identity is increasingly understood to be a private, individual endeavor. Aesthetics play an important and necessary role in this endeavor, not least in fashioning the framework of one's daily life. Understanding suburban aesthetics from this perspective neither discounts the importance of concerns over the fate of the public interest in modern society, nor does it pretend to apologize for aesthetic efforts that any given observer may find to be half-baked, tasteless, or worthless. But it does afford grounds on which to better understand the very real role that aesthetics play every day in fashioning the lived environment of suburbia.

Notes

I am greatly indebted to Holley Wlodarczyk for her research assistance with this project, and I am grateful for financial support from the Office of the Dean of the Graduate School of the University of Minnesota and the University of Minnesota McKnight Arts and Humanities Endowment.

1. Excerpt from "Little Boxes," words and music by Malvina Reynolds. Copyright 1962 Schroder Music Co. (ASCAP); renewed 1990.

2. Lewis Mumford, *The City in History* (New York: Harcourt, Brace & World, 1961), 486.

3. Ada Louise Huxtable, "'Clusters' Instead of 'Slurbs.'" *New York Times Magazine*, February 9, 1964, 37; Peter Blake, *God's Own Junkyard: The Deterioration of America's Landscape* (New York: Holt, Rinehart and Winston, 1964), 8, 20.

4. More recently, the term "sprawl" has been appropriated in the negative appraisal of suburbia, but often as not the specific faults and the proposed remedies are aesthetic. See, for example, Andrés Duany, Elizabeth Plater-Zyberk, and Jeff Speck, *Suburban Nation: The Rise of Sprawl and the Decline of the American Dream* (New York: North Point Press, 2000), and Dolores Hayden, *A Field Guide to Sprawl* (New York: Norton, 2004).

5. On the origins of suburbia in eighteenth-century England, see John Archer, *Architecture and Suburbia: From English Villa to American Dream House, 1690–2000* (Minneapolis: University of Minnesota Press, 2005).

6. William Ranlett, *The City Architect* (New York: De Witt & Davenport, 1856), 12. "Letter on the Villas of Our Tradesmen," *The Connoisseur* 1, no. 33 (September 17, 1754). James Howard Kunstler, *Home from Nowhere* (New York: Simon & Schuster, 1996), 17–18.

7. Emily Talen and Cliff Ellis have made a substantial contribution in "Cities as Art: Exploring the Possibility of an Aesthetic Dimension in Planning," *Planning Theory & Practice* 5:1 (March 2004): 11–32. Also see Archer, *Architecture and Suburbia*.

8. "Some Suburbs of New York," *Lippincott's Magazine* n.s. 8, no. 1 (July 1884): 23. Alfred Matthews, "Short Hills," in *History of Essex and Hudson Counties, New Jersey*, comp. William H. Shaw (Philadelphia: Everts & Peck, 1884), 709–710.

9. For an example, see the discussion on page 134 below of the marketing of Clover Field in Chaska, Minnesota.

10. Jeffrey Vallance, *Thomas Kinkade: Heaven on Earth* (Santa Ana, California: Grand Central Press, 2004), 121–140; Janelle Brown, "Ticky-tacky houses from 'The Painter of Light™,'" Salon.com, http://archive.salon.com/mwt/style/2002/03/18/kinkade_village/index.html, accessed May 13, 2007.

11. Timothy Dwight, *Travels; in New-England and New-York* (New Haven: Timothy Dwight, 1821), 2:494–495. John Bullock, *The American Cottage Builder* (New York: Stringer & Townsend, 1854), 223. Alexander Jackson Downing, *Rural Essays*, ed. George William Curtis (New York: Leavitt & Allen, 1857), 210. John J. Thomas, *Illustrated Annual Register of Rural Affairs, for 1864-5-6* (Albany: Luther Tucker & Son, 1873), 130. See also Sarah J. Hale, *Manners; or, Happy Homes and Good Society All the Year Round* (Boston: J.E. Tilton, 1868), 81; and Walter R. Houghton et al., *Rules of Etiquette*, 6th ed. (Chicago: Rand, McNally, 1883), 43.

12. Samuel Sloan, *The Model Architect* (Philadelphia: E.S. Jones, 1852), 10. Catharine Beecher, *The American Woman's Home* (New York: J.B. Ford and Company, 1869), 24–25.

13. Richard E. Foglesong, *Planning the Capitalist City* (Princeton: Princeton University Press, 1986), 134; see also 125, and in general chapters 4 and 5.

14. Charles Mulford Robinson, *Modern Civic Art*, 3rd ed. (New York: G.P. Putnam's Sons, 1909), 14, 17, 229. Frank Koester, "American City Planning," *American Architect* 102 (October 23, 1912): 141–146, http://www.library.cornell.edu/Reps/DOCS/koester.htm, accessed August 18, 2007. See also Robert Swain Peabody's remark that "a good and beautiful arrangement for a city . . . pays not only in the current coin of commerce but in the refinement, the cheerfulness, the happiness, the outlook on life of the poorest citizen." In defining city planning, Peabody quoted Arnold Brunner: "It means . . . elevation of the standard of citizenship." "Notes for Three Lectures on Municipal Improvements,"

Architectural Quarterly of Harvard University 1 (September 1912): 84–104, http://www.library.cornell.edu/Reps/DOCS/peabody.htm, accessed August 18, 2007.

15. Hayden, *A Field Guide to Sprawl*, 11.

16. Robinson, *Modern Civic Art*, 230, 234–235, 239–240. The passage referring to Ruskin is identical in the 1903 first edition.

17. Thomas Adams, *The Design of Residential Areas* (Cambridge, Massachusetts: Harvard University Press, 1934), 116–117.

18. Marketing brochure for Clover Field, Chaska, Minnesota (Legacy Communities LLC, 2005). On the importance of community in New Urbanist design, see Emily Talen, "The Social Goals of New Urbanism," *Housing Policy Debate* 13:1 (2002): 165–188.

19. Robinson, *Modern Civic Art*, 21. Adams, *The Design of Residential Areas*, 323.

20. Edward J. Blakely and Mary Gail Snyder, *Fortress America: Gated Communities in the United States* (Washington, D.C.: Brookings Institution, 1997). Evan McKenzie, *Privatopia: Homeowner Associations and the Rise of Residential Private Government* (New Haven: Yale University Press, 1994). Robert H. Nelson, *Private Neighborhoods and the Transformation of Local Government* (Washington, D.C.: Urban Institute Press, 2005).

21. Archer, *Architecture and Suburbia*.

22. Sinclair Lewis, *Babbitt* (New York: Harcourt, Brace, 1922), 14–15.

23. John Chase, *Glitter Stucco & Dumpster Diving* (New York: Verso, 2000), 207. Christopher B. Leinberger and Robert Davis, "Financing New Urbanism," *Thresholds* 18 (1999): 43–50.

24. "Suburban Home," by Tony Lombardo. Copyright 1982 Cesstone Music (BMI), c/o New Alliance Music (BMI).

25. The notion of the dwelling as a lifelong anchor of a given individual's identity was preeminent in eighteenth- and nineteenth-century architectural theory; see Archer, *Architecture and Suburbia*. After World War II, the notion has become ever more nostalgic; Gaston Bachelard's 1958 phenomenological analysis is perhaps the most eloquent postwar treatment of the subject: *The Poetics of Space*, trans. Maria Jolas (Boston: Beacon Press, 1994).

26. Ferdinand Tönnies, *Gemeinschaft und Gesellschaft* (1887), 2nd ed. revised and expanded (Berlin: K. Curtius, 1912). An example of *Gesellschaft* would be the labor union, formed for the purpose of advancing the employees' mutual self-interest against owners and management.

27. David Riesman, *The Lonely Crowd* (New Haven, Yale University Press, 1950), and "The Suburban Dislocation," *Annals of the American Academy of Political and Social Science* 314 (November 1957): 123–146.

28. Edward Relph, *Place and Placelessness* (London: Pion, 1976), 75, 81–82, 142.

29. T. J. Jackson Lears, *Fables of Abundance* (New York: Basic, 1994), 352.

30. Stuart Ewen, "Advertising and the Development of Consumer Society," in *Cultural Politics in Contemporary America*, ed. Ian Angus and Sut Jhally (New York: Routledge, 1989), 82–95; Stuart Ewen, *Captains of Consciousness* (New York: McGraw-Hill, 1977), 47; Stuart Ewen, *All Consuming Images* (New York: Basic, 1988), 103. Along similar lines, see also T. J. Jackson Lears, "Infinite Riches in a Little Room: The Interior Scenes of Modernist Culture," *Modulus* 18 (1987): 3–27,

and Christopher Lasch, *The True and Only Heaven: Progress and Its Critics* (New York: Norton, 1991). Edward Relph was among the earliest to treat authenticity in architecture and landscape in considerable depth, in *Place and Placelessness* (London: Pion, 1976).

31. Adrian Forty and Henry Moss, "The Success of Pseudo-Vernacular," *Architectural Review* 167:996 (February 1980): 73–78.

32. See Catherine Jurca's discussion of the "suburban jeremiad" in *White Diaspora* (Princeton: Princeton University Press, 2001).

33. Émile Durkheim, *The Elementary Forms of Religious Life* [1915], trans. Karen E. Fields (New York: Free Press, 1992). Marcel Mauss, *The Gift: Forms and Functions of Exchange in Archaic Societies*, trans. Ian Cunnison (New York: W.W. Norton, 1925). Mary Douglas and Baron Isherwood, *The World of Goods* (New York: Basic, 1979), 65, 72. Also see Rolland Munro, "The Consumption View of Self: Extension, Exchange and Identity," in *Consumption Matters*, ed. Stephen Edgell, Kevin Hetherington, and Alan Warde (Oxford: Blackwell, 1996), 255–256.

34. Russell W. Belk, "Possessions and the Extended Self," *Journal of Consumer Research* 15 (September 1988): 139, 144. See also Helga Dittmar, *The Social Psychology of Material Possessions* (Hemel Hempstead: Harvester Wheatsheaf, 1992). See also Walter Benjamin's remark that "ownership is the most intimate relationship that one can have to objects. Not that they come alive in him; it is he who lives in them." *Illuminations*, trans. Harry Zohn (New York: Schocken, 1968), 67. Also see Daniel Miller's discussion of consumption as integral to processes of personal distinction, including individuation. He argues that people appropriate objects—including those industrially manufactured—to "utilize them in the creation of their own image." Commodities thus play a role in the social positioning of the self: "the relation between [a given] object and others provid[es] a dimension through which the particular social position of the intended individual is experienced." *Material Culture and Mass Consumption* (Oxford: Basil Blackwell, 1987), 147, 175, 190.

35. David Harvey, *Justice, Nature, and the Geography of Difference* (Oxford: Blackwell, 1996), 323.

36. Henry Ward Beecher, "Building a House," *Star Papers* (New York: J.C. Derby, 1855), 285–292. Among the critics of suburbia who decry the sterility of mass-produced houses and their standardized contents, many point to the incapacity of formulaically replicated industrial products (e.g., "ticky-tacky boxes") to serve as an apparatus for individualizing identity. Such is the argument that, for example, undergirds Malvina Reynolds' critique:

> And the people in the houses
> All go to the University
> And they all get put in boxes,
> Little boxes, all the same.
> And there's doctors, and there's lawyers,
> And business executives,
> And they're all made out of ticky-tacky
> And they all look just the same.

(Excerpt from "Little Boxes," 1962.) Of course Reynolds' commentary also is an exemplary case of the determinist fallacy, suggesting that an architecturally regimented environment produces a regimented, homogeneous population, limiting the dimensions

in which residents can act, grow, and change. This seriously misreads (or, more accurately, simply disregards) the real lives that people live, and the agency that they have in deploying manufactured and mass-marketed products to articulate a meaningful fabric of everyday life, articulating selfhood and identity both personally and in relation to the larger community.

37. Michael Sorkin, *Exquisite Corpse* (London: Verso, 1991), 187, 193. See also Archer, *Architecture and Suburbia*, 303–311.

38. Andrew Hurley, *Diners, Bowling Alleys, and Trailer Parks: Chasing the American Dream in Postwar Consumer Culture* (New York: Basic Books, 2001), 333.

39. Sara Selene Faulds, "'The Spaces in Which We Live': The Role of Folkloristics in the Urban Design Process," *Folklore and Mythology Studies* 5 (Spring 1981): 54.

40. Richard Elliott and Kritsadarat Wattanasuwan, "Brands as Symbolic Resources for the Construction of Identity," *International Journal of Advertising* 17 (1998): 131–144, esp. 136–137.

41. See too Virginia Postrel's remark that "The seeming homogeneity of master-planned communities—the planning that gives them a bad name among intellectuals—turns out to be real-world pluralism once you realize that everyone doesn't have to live within the same design boundaries." "Home buyers select the design regime that fits their personalities and lifestyles." *The Substance of Style* (New York: HarperCollins, 2003), 151–152, 125.

42. Peter Kellett, "Constructing Informal Places," in *Constructing Place: Mind and Matter*, ed. Sarah Menin (London: Routledge, 2003), 90, 89.

43. Pierre Bourdieu, *Distinction* [1979], trans. Richard Nice (Cambridge, Massachusetts: Harvard University Press, 1984). See also these remarks by Bourdieu: "the social world presents itself, objectively, as a symbolic system which is organized according to the logic of difference, of differential difference." "*[D]ifferences function as distinctive signs* and as signs of distinction, positive or negative." Pierre Bourdieu, "Social Space and Symbolic Power," *Sociological Theory* 7:1 (Spring 1989): 14–25.

44. Witold Rybczynski, *Last Harvest* (New York: Scribner, 2007), 211–212.

45. Walter J. Ong, *Orality and Literacy: The Technologizing of the Word* (London: Methuen, 1982), 22–23.

46. Joseph T. Plummer, "The Concept and Application of Life Style Segmentation," *Journal of Marketing* 38 (January 1974): 33–37. Claritas' PRIZM NE system is the focus of Michael J. Weiss' two books on market segmentation, *The Clustering of America* (New York: Harper & Row, 1988) and *The Clustered World* (Boston: Little, Brown, 2000). See also page 142 below.

47. William Leiss, Stephen Kline, and Sut Jhally, *Social Communication in Advertising* (Toronto: Methuen, 1986), 125.

48. Philip Kotler, Donald H. Haider, and Irving Rein, *Marketing Places* (New York: Free Press, 1993), 304–305.

49. Michael J. Weiss, *The Clustered World*, 219. "2006 PRIZM NE Market Segmentation System," http://www.claritas.com/MyBestSegments/Content/tabs/filterMenuFrameWork.jsp?menuid=91&submenuid=911&page=../Segments/snapshot.jsp, accessed 16 August 2007.

50. "New Home Community in Fort Collins, Colorado: Harvest Single Family," iNest Realty Inc., http://www.internest.com/standardpacificfcl/standardpacificfcl7688.asp, accessed August 16, 2007. For a general introduction to the marketing of subdivisions, see Chapter 6 of Adrienne Schmitz, *Residential Development Handbook*, 3rd ed. (Washington, D.C.: Urban Land Institute, 2004).

51. Pat Curry, "Brand-New Way," *Builder Online* (October 1, 2006), http://www.builderonline.com/industry-news-print.asp?sectionID=96&articleID=376928, accessed 11 July 1007. As Curry also reports, a client told the general manager at Frey and Son Homes, "I can always tell which houses are yours because the backs are very distinctive." See also Michael Bordenaro, "The Brand Factor," *BigBuilder Online* (September 23, 2003), http://www.bigbuilderonline.com/Industry-news.asp?channelID=59§ionID=65&articleID=14030, accessed July 9, 2007.

52. Despite the ridicule that Martha Stewart's critics might feel that KB Home's "Martha" series invites, it is not credible that someone would buy a Martha Stewart–branded house and thereby expect to become Martha Stewart or "just like" her, to be her equal in some respect (such as status or prestige), or even to trade more than modestly on her cachet.

53. Margaret Lillard, "Dream Homes or Nightmare: A Whole Martha Stewart Subdivision," JournalStar.com (October 24, 2005), http://journalstar.com/articles/2005/10/24/business/doc-43596111c6a9a611995462.txt, accessed July 13, 2007.

54. Rybczynski, 152. Also see Mark Gottdiener, *The Theming of America* (Boulder: Westview, 1997).

55. Margaret Crawford, in Rahul Mehrota, *Everyday Urbanism* (Ann Arbor: University of Michigan, 2005), 19, 22.

56. James Rojas, "The Enacted Environment of East Los Angeles," *Places* 8:3 (Spring 1993): 42–53.

57. Chase, *Glitter Stucco & Dumpster Diving*, 3.

New Urbanism's Subversive Marketing

Ellen Dunham-Jones

Ellen Dunham-Jones is a modern architect, a New Urbanist, a scholar of sprawl and of contemporary architectural theory, and director of the architecture program at Georgia Institute of Technology. She is cowriting a forthcoming book titled Retrofitting Suburbs.

There are certain subjects that architectural discourse tends to avoid. These include: the suburbs, the middle class, marketing, and New Urbanism. Perhaps their associations with commerce, mass production, and business are what make them so distasteful to those who prefer to focus on architecture as an art practice. Architecture has always operated as both an art with an elite discourse, and as a service and trade with a more direct impact on public and private life. Architects have had to juggle their aspirations for their work's contributions to perceptions of the public good, with the necessities of meeting market demands. Robert Venturi and Denise Scott Brown's populist trading between high culture and low or pop culture is but one means of foregrounding, if not resolving, this inherent tension. Nonetheless, despite such examples, there is still tremendous resistance to cross-contaminating the worlds of contemporary theory (or high culture) and contemporary development, the everyday landscape of the suburbs, sprawl, the market, and the middle class. As someone who teaches contemporary architectural theory but lives with contemporary suburban development, I'm convinced both desperately need each other. I'm not sure if that makes me a populist or simply an architectural educator who wants to see her students more effectively realize their ideas, a citizen who wants to see more alternatives to the destructive aspects of sprawl, and an architect who is appalled that our discourse focuses on that minute percentage of construction that we're actually proud of and ignores the vast—and atrocious—majority of what we're building. So, as an urbanist, I'm on a mission to bring together designers, critical theory and public policy with the suburbs, sprawl, and real estate development.

Sprawl—A Populist Landscape?

The 2000 census confirmed that 50 percent of the U.S. population now lives in the suburbs. Frankly, one might have assumed it was even higher given that the suburbs have accounted for over 75 percent of construction over the past thirty years, and almost ninety percent today.[1] As home to the majority of the nation's baby boomers, the target market for all consumer goods—including housing—the suburbs have seen considerably more construction activity than rural areas or even the revived and gentrifying downtowns.[2] However, while new downtown office towers and high-rise condos are highly visible in situ and in the media,

147

Empty Nesters and Retirees	Traditional and Non-Traditional Families	Younger Singles and Couples
Metropolitan Cities	*Metropolitan Cities*	*Metropolitan Cities*
The urban establishment	Full-nest urbanites	Urban elite
Rowhouse retirees	Multi-cultural families	e-types
	Black urban families	Urban achievers
Small Cities/Edge Cities	Latino urban families	New bohemians
Middle-class move-downs	In-towners	Soul city singles
Active retirees		Young Latinos
Blue-collar retirees		
Hometown retirees	*Small Cities/Edge Cities*	
	Cosmopolitan families	*Small Cities/Edge Cities*
	Unibox transferees	Twentysomethings
Metropolitan Suburbs	Mainstream families	University/college affiliates
The social register	Smalltown downtowners	
Nouveau money	Newcomer Latino families	*Metropolitan Suburbs*
Post-war suburban pioneers	Around-towners	The VIPs
Affluent empty nesters		Fast-track professionals
Blue-collar button-downs		Suburban strivers
Middle-American retirees	*Metropolitan Suburbs*	Generation X
Grey-collar couples	Full-nest suburbanites	
	Kids 'r' us	*Agrarian/Rural*
Town & Country/Exurbs	Blue-collar families	PC pioneers
Mainstream retirees		
Retired miners and	*Town & Country/Exurbs*	
millworkers	Exurban elite	
	Full-nest exurbanites	
Agrarian/Rural	New-town families	
Back country seniors	Pillars of the community	
Rustic elders	Middle-American families	
Aging farmers	Young homesteaders	
Southern country seniors	Blue-collar ruralites	
Hardscrabble seniors	Military affiliates	
	Factory families	
	Norma Rae-Ville	
	Agrarian/Rural	
	Heartland families	
	Small-town families	
	Rustic families	
	Farmtown families	
	Rural families	

Note: Most market group names are unique to Zimmerman/Volk Associates proprietary target market methodology; the few groups with little or no data augmentation retain the Claritas PRIZM cluster names.

Target Market Groups

Zimmerman/Volk Associates conduct market research for New Urbanist projects. This is their list of the different target market groups for the different kinds of developments along the urban-rural transect.

the low-density spread of suburban development, most of it residential, has grown at a far faster, if stealthy, pace.3

The majority of commercial and retail space is also increasingly in the suburbs, not in the cities. Twenty-six percent of office stock was in the suburbs in 1979. By 1999, the suburbs accounted for 42 percent of office space—most of it in "edgeless" locations. New York and Chicago were the only metropolitan areas with the majority of office space located in their primary downtowns, while the majority of office space in Philadelphia, Atlanta, Washington, D.C., Miami, and Detroit was in their suburbs.4 The so-called "New Economy" is sometimes referred to as "the exit-ramp economy" since so much of it, like Silicon Valley, is based in suburban office parks. Similarly, the amount of retail square feet per person continues to climb in the United States, most of it in malls, strip malls, and big box power centers.5 In contrast to urban retail, these building types tend to be auto-dependent, short-lived, and require vast footprints.6

How is this ubiquitous landscape produced? It is an example of our highly specialized disciplines at work—each operating according to its own logic, more or less independently. This kind of development is in fact exactly what our regulations and our financing practices encourage. It usually begins with the transportation engineers laying out what they consider to be a rural road. (To this day, the infamous "Green Book" that dictates design standards for all U.S. Departments of Transportation, bases level of service on a sliding scale between access [for urban conditions] and mobility [for rural conditions], with little consideration of suburban conditions or pedestrians.) The assumption is that rural roads between cities should be designed to maximize traffic flow, so speeds are high, pedestrians are discouraged, and intersection intervals and curb cuts are limited. Walkability is not a factor to be considered in what is defined as a rural road. However, the new road's access to cheap land builds development pressures and the prospect of tax revenues. These in turn prompt local governments to grant commercial rezoning requests along the entire length of the new road. Then, the easiest thing for the developers to do is propose a stand-alone building that conforms to one of the 19 standardized real estate products regularly financed by the Wall Street Real Estate Investment Trusts (REITS)—the principal source of real estate financing today.7 The REITS do not care much about long-term value, let alone a building's contribution to local placemaking. They care more about predictable performance in the short term (so they can be traded on Wall Street just like pork bellies or any other commodity). Consequently, the more standardized the strip mall or self-storage facility or other single-use building, and the more well-known the lease holder (chain retailers are preferred over unpredictable mom-and-pop local stores), the easier it is to finance. The same logics apply to construction loans on residential development. The banks base their appraisals on comparables and extrapolations of existing trends. They will only loan money at good rates on building types that have already sold well. As a consequence sprawl continues to be monotonously reproduced as so many individual subdivisions plugged onto the supposedly rural arterial road. Eventually you end up with a traffic-clogged commercial strip. Since every trip now has to funnel through it, the road no longer functions well for the through traffic it was designed for or for the numerous destinations that now line its sides.

The litany of problems associated with this kind of growth are familiar: traffic, social segregation, lack of public space, jobs/housing imbalances, disinvestment in cities and first-ring suburbs, and unsustainable environmental impacts to wildlife habitats and air and water quality. A recent study by American Forests states that U.S. cities have lost 20 percent of their trees in the last ten years primarily to urban sprawl and highway construction.8 The low-density development pattern creates automobile dependence and has resulted in such dramatic increases in vehicle use that tailpipe emissions from automobiles have replaced smokestack emissions from factories as the principal source of leading toxic air pollutants in the United States.9 Similarly, runoff pollution from developed land is now the nation's leading threat to water quality.10 Almost one hundred American cities now suffer with chronic lack of compliance with Clean Air and Clean Water standards. And it is not only environmental health that is affected. Recent studies suggest a correlation between urban sprawl and human sprawl. Obesity is now an epidemic in the United States, and while much of it is caused by our eating habits, the physical form of our habitat is also an important factor.11 People living in suburban environments tend to lead extremely sedentary lives: they work in offices or learn in classrooms—

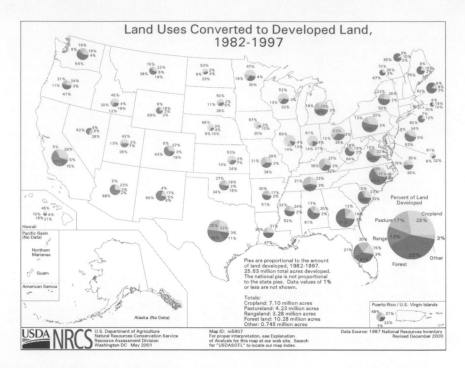

Land Uses Converted to Developed Land, 1982–1997

Between 1960 and 2000, urbanized population grew by about 80 percent and urbanized land area grew by 130 percent, resulting in urbanized land density dropping from 3,100 persons per square mile to 2,400. Between 1985 and 2001, America added 19 million housing units, but 8 million, or 40 percent of them, were on lots of more than one acre (U.S. Census, 1985 and 2001). And while population grew about 20 percent during this period, vehicle miles traveled increased more than 50 percent (Arthur C. Nelson, "Towards a New Metropolis: The Opportunity to Rebuild America," a discussion paper prepared for the Brookings Institution Metropolitan Policy Program, December, 2004).

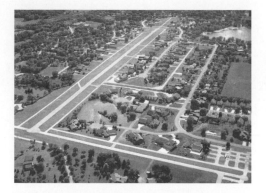

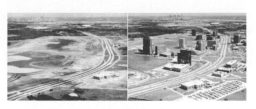

Residential Airport outside Chicago

There are approximately 400 residential airports in the United States, an extreme response to the long commutes mandated by residential developments that are now often 40 to 60 miles out from the urban core. This example, the Napier Aero Club on the outskirts of Chicago, has a modified Radburn plan with the runway down the center and streets wide enough to accommodate planes taxiing from driveways to the runway.

Las Colinas, Texas, 1976 and 1986

These images illustrate a typical growth pattern: a highway/ arterial intersection attracts fast-food restaurants, followed by a regional or strip mall and office buildings, then apartment complexes. There is a mix of uses, but the regulations require each to be on its own isolated pad, surrounded by its own parking, with relatively large distances between curb cuts. This particular case, the Las Colinas Urban Center, was designed with this pattern.

sitting, they drive everywhere—sitting, they watch many hours of television—sitting—and snacking. Despite the suburbs' reputation as a family-friendly healthy environment, people in cities tend to walk more and be healthier.

Despite all of the problems with sprawl, it remains the predominant model and is immensely popular. Is it therefore appropriate to conclude that this landscape is what "the people" want? Is this a populist landscape? I'll return to this question.

The Market and the Public Realm

In a very good analysis of discourse on "the every-day" and its recent popularity in architectural theory, Dell Upton proposes that everyday archi-tecture—with a little *a*—is the Other of high-design Architecture—with a capital *A*.12 To take this observation further, I would argue that sprawl, the bulk of contemporary building, is repressed in high-Architecture discourse. Why? Perhaps because it reminds us of our failures. Our failure to produce a popular modern urbanism other than sprawl 13 and our failure to convince "the peo-ple" that social progress is dependent, in part, on building "progressive" environments. While most architects remain motivated by a veiled Zeitgeist imperative that modern design is necessary to usher in progressive lifestyles and a progressive society, most consumers simply view modern versus tradi-tional as a decorating choice.14

Perhaps most of all, the suburbs remind archi-tects of our failure to convince the majority of the public of the value of Architecture, capital *A*, for their everyday lives and their personal investments. High-design Architecture is valued for the cultural message it sends about a place and is welcomed generally for culturally significant building types, but the evidence surrounds us that Architecture with a capital *A*, with intellectual thought about advanc-ing societal agendas, is not deemed a worthwhile investment for the majority of homes, office parks, retail strips, etc. Nor have architects' abilities to accommodate individual desires while contribut-ing to collective, communal interests been called upon in the design of sprawl. Does this mean that "the people" don't want a public realm? Don't care about design? Don't care about the environment? Don't care about community?

Homebuilding is a big business in the United States and, unlike in Europe, is almost entirely mar-ket-rate, with public subsidy coming in the form of after-sale tax deductions of mortgage interest. In 2003, 1.8 million new homes were constructed, the highest number in 25 years.15 Most of the contractors on those homes belong to the National Association of Home Builders, an organization that attracts 75,000 members to its annual convention. They come because, even more than the develop-ers or the designers, they want to know what "the people" want. Ultimately, it's the builders who have to sell the houses, and they cannot afford to be left holding unpopular designs. They rarely invite architects to show them what the architects think would be good design improvements. Instead, they invite the market researchers. What kind of designs and features sold the best last year and in what mar-kets? What do surveys of consumer preferences indicate will be next year's hot products? The results can have a profound influence, such that up to 30 percent of a year's new housing will be slight variations of a single winning floorplan presented at the previous year's homebuilder convention.

The homebuilders' surveys have consistently revealed a strong preference for "the American Dream," a single-family detached house in a traditional style on a relatively large lot. While American consumers have embraced contempo-rary designs for products like Nikes and iMacs, their architectural tastes remain very conserva-tive, especially those of middle-class homebuy-ers. They tend to look for traditional signifiers of status and stability, perhaps to compensate for the middle class' declines in both in recent decades,16 but certainly to aid in the resale value. The average American household moves every five to six years. While this might seem to support a willingness to experiment with modern, evolving styles, it has the opposite effect. Today's middle class, by and large, associates modern architecture either with office buildings, the poor, or the asbestos-filled tract homes their parents bought and lost money on. Instead, there is a marked preference for easy-to-sell conventional styles on the biggest house and the biggest lot one can afford.

Despite continued demand for "the American Dream," there is also growing recognition that each new house contributes to traffic and land con-sumption, and consequently, movements resisting growth have increased in popularity. Voters have significantly supported public investment in public transit and the protection of open space.17 Several pre–September 11 polls found that Americans

ranked traffic and urban sprawl as their number one local concern, tied with crime and ahead of jobs and education.18 Yet, at the same time, the market for low-density development continues to be strong. In essence, each individual wants everyone else to use transit and live in a condo and get off the road and out of their view of the countryside! Collectively, "the people" have clearly said that they do not want sprawl. However, their individual purchases continue to support it.

In fact, the entire industries of market researchers, contractors, and realtors have helped produce this landscape geared solely to the satisfaction of private desires. As a consequence we have been building pathetic public spaces that we collectively compensate for with fantastic, if also inherently compromised, private spaces. Instead of communal theaters and Olympic-size natatoriums, we get home entertainment systems and small backyard pools. Instead of the traditional "good" populist concerns with collective action for some notion of a public or common good, sprawl shows us the degree to which "what the people want" is no longer considered in collective, populist, or public terms. It is solely measured in terms of individual desires. In this sense, the market now substitutes for the public, and what "the people" want individually has been severed from what "the people" want collectively. Similarly, marketing has reduced any critical notion of counterpublics and multiple publics simply to "niche markets."

The marketing of this lifestyle presumes that "what people want" are "community" out their front door and "nature" out their back door. Joel Garreau facetiously claimed that one of the rules of contemporary development is to name your project after whatever species you have forever eradicated from the site: Eagle Ridge, Fox Run, Pin Oak Preserve.19 The references are almost exclusively to nature, or to quaint sounding British villages, but never to anything urban. Ever since Thomas Jefferson's anti-urban lauding of the gentleman farmer, Americans have historically been suspicious of cities. Despite our myths of melting pots, most individual homebuyers still think of "diversity," "density," "urban" and even "public" as dirty words or inferior categories. As a consequence, most developers, bankers, contractors, and even public planning boards strongly resist the factors that might mitigate sprawl such as mixed-use, mixed-income, transit, and compactness.

Suburban Cafe
The quality of what passes for public or civic space in sprawl is pathetically low and remarkably placeless. The joke is that you can only tell that you've entered a new town when the chain stores start repeating.

This situation puts architects and urban designers in a dilemma. Should they design for "the market" (individual interests) or for "the public" (collective interests)? Designers have long understood their obligations to both, to serve the individual client's needs while also contributing to generally accepted understandings of the public interest. But rarely have the two been so diametrically opposed. The benefits of sprawl accrue to individuals, while the costs are borne collectively by society. Given the strength of private property rights in the United States, and the minimal role of public development (except roadbuilding), there have been very few successful challenges to sprawl.

And yet, in fact there is a significant market for alternatives to sprawl. Several studies show that between 30 and 40 percent of homebuyers are frustrated with the lack of choices available to them.20 Although several American cities experienced revivals in the nineties, the residue of decades of disinvestment in cities has made most homebuyers reluctant to consider urban living. Limited to locating in the suburbs, their only choices have been varied flavors of single-use subdivisions—even though market studies show a sizable market willing to pay a 5 to 25 percent supplement for living in mixed-use, compact, walkable neighborhoods.21

New Urbanism: Alternative to Sprawl
Market demand combined with public interest in alternatives to sprawl is fueling interest in a new urbanism that reveals the market for urbanism

within the suburbs. A New Urbanism that recognizes that the suburbs are where the bulk of the market is, but that valorizes cities and urban living. A New Urbanism of transit-oriented development instead of park and rides, of neighborhoods instead of subdivisions, and of Main Streets instead of malls. A New Urbanism of mixed uses, mixed-building types, mixed-lot sizes, mixed incomes, multiple modes of transportation, and multiple interconnected street types. A New Urbanism that celebrates the public realm and trades large lots each with its own patio, pool, and swing set for nearby sidewalk cafes and neighborhood parks and playgrounds. A New Urbanism that reconciles both private and public interests, that is both marketable and mitigates sprawl. A New Urbanism that rejects ad hoc, incremental, low-density development in favor of regional planning that targets areas both for conservation and for higher-density growth including reinvestment in infill sites and central cities.

Unfortunately, according to the current system, such a New Urbanism is largely illegal and almost impossible to finance. The need for fundamental reforms to the current system, to at least allow for alternatives, prompted the formation of the Congress for the New Urbanism (CNU). It got started in 1989, when six architects got together who had been working at the scale of urban design.22 The meeting included Andrés Duany and Elizabeth Plater-Zyberk of Miami (the designers of Seaside, Florida, with its focus on community building around public spaces and streets designed like outdoor rooms), and Peter Calthorpe of San Francisco, with his strong interest in the environmental benefits of transit-oriented development. They recognized that they shared a common enemy: the regulations that reproduce suburban sprawl. In 1991 they invited 75 of their like-minded friends in related disciplines to meet, critique each other's work, and discuss their shared frustrations with contemporary development patterns. They decided to call themselves the Congress for the New Urbanism—a deliberate reference to the Congrès International d'Architecture Moderne (CIAM), in that they too planned to hold annual congresses and write a charter. However, their charter is aimed at replacing CIAM's modern urbanism with a New Urbanism (inspired by pre-CIAM planning) of healthy regions balancing growth and conservation; compact, mixed-use, mixed-income neighborhoods of walkable street networks with transit; and attractive, focal public spaces, including the streets themselves, framed by buildings that are responsive to place and climate. 23

CNU has been developing such a New Urbanism along three simultaneous trajectories. On the one hand, the members of the organization and staff have collectively been working on changing the systems that reproduce sprawl to allow for development that is more in keeping with public goals. They have written a charter with 27 principles and model codes; devised new transect-based standards for finer-grained linkage of land use, transportation, building types, and niche markets; engaged in educating diverse professionals involved in the built environment; and formed partnerships to influence policy with key federal agencies (HUD and EPA) and strategic organizations (AIA, AIAS, APA, ULI, Fannie Mae, USGBC, ITE).24 On the other hand, the members of the organization have been working as individual professionals designing and building over 600 New Urbanist developments. In the twelve years of CNU's existence, the projects have evolved from an initial focus on Greenfield TODs and TNDs, to greater concern with urban infill, brownfield, and grayfield projects (especially the more than 100 Hope VI public-housing projects that have been built according to New Urbanist guidelines) and increased attention to both regional design and environmental considerations. The obstacles to implementation remain significant, and most projects have suffered compromises along the way, often being forced to lower densities or limit the number of affordable-housing units. However, many of the projects have been extremely successful economically, improving the movement's reputation and opportunities. The third trajectory, the sharing of strategies and development of a transdisciplinary discourse, is also responsible for much of the evolution of New Urbanism. CNU is a forum, not a formula. In addition to the annual congresses, CNU now has a newsletter, awards program, regional chapters, and council meetings where projects continue to be presented and critiqued, successful and failed strategies are shared, design techniques honed, and ambitions ever elevated.

The New Urbanists' bold claims set them up for criticism, which has been ample and from both sides of the political spectrum. They have been criticized as naïve for enthusiastically presenting

Conventional Suburban Development versus Traditional Neighborhood Design

The average vehicle trips generated by a single family in a detached home are 10.1 per weekday. For people living in conventional suburban development, shown in the top half of this image, each trip has to travel on the high-speed arterial, with the effect of requiring that every one of those trips be made by car—using up resources, polluting the air, and isolating those who cannot drive. (The Surface Transportation Policy Project's recent report, "Aging Americans: Stranded Without Options," states that more than half of the non-drivers age 65 and over stay home because their transportation choices are limited.) Children in single-family houses are physically deterred from playing with their peers in apartment buildings, and mothers in minivans become chauffeurs clocking 30 percent more vehicle miles than men. In the traditional neighborhood design (TND), in the lower half of the drawing, uses are more inter-connected; traffic is distributed through an inter-connected network of slower, narrower, walkable streets, increasing safe mobility for nondrivers and the likelihood that at least some of those 10 trips will be made on foot or bicycle. By increasing walking, the TND also expands the possibility of neighborly interaction and connection to a wider range of people. The TND's combination of community building and environmental benefits distinguish it as an alternative to sprawl and a model for New Urbanism.

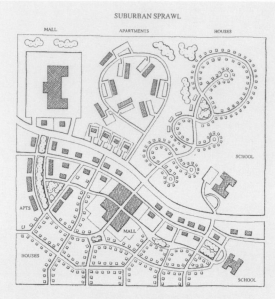

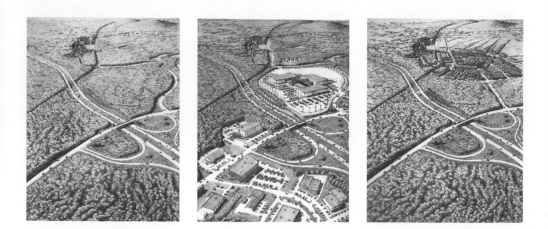

Alternative Development Scenarios

This sequence shows a typical beltway interchange (left), the kind of sprawl development that conventional regulations promote (center), and a New Urbanist alternative, had different regulations been in place (right). The New Urbanist development includes the same mix of uses as shown in the middle image but reconfigures them compactly as a town, extending, preserving, and reinforcing the existing village and making use of its position on a rail line to concentrate the new buildings into a transit-oriented development (TOD). The synergies between the different uses add value to each other and tend to hold that value longer, making them both more economically and ecologically sustainable while preserving far more open space.

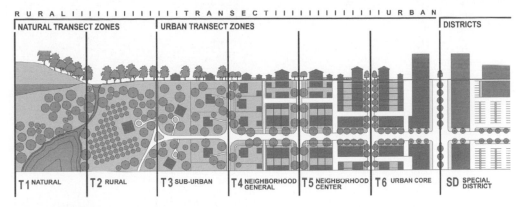

RURAL IIIIIIIIIIIIIIITRANSECTIIIIIIIIIIIIIIIURBAN

NATURAL TRANSECT ZONES			URBAN TRANSECT ZONES				DISTRICTS
T1 NATURAL	T2 RURAL	T3 SUB-URBAN	T4 NEIGHBORHOOD GENERAL	T5 NEIGHBORHOOD CENTER	T6 URBAN CORE		SD SPECIAL DISTRICT

The Urban-Rural Transect

Andrés Duany's diagram of seven zones along an urban-rural transect differentiates environments at the scale of the region or at the scale of a neighborhood. It serves as a New Urbanist placemaking and community-building tool for resisting the monoculture developments of crude land-use designations by linking finely graded zoning, street types, building types, and design guidelines to each other. The point is not necessarily to produce seamless gradations between transect zones, as the diagram implies, so much as to establish coherent differences between centers and edges such that a range of households and needs are both accommodated and interconnected.

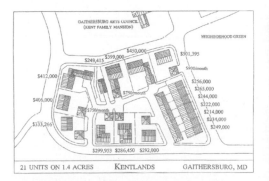

Mixed-Income, Mixed Building Types at Kentlands, Maryland

The original sale prices of new homes on a single block in Kentlands (a DPZ greenfield TND outside Washington, D.C.) demonstrate how mixed-lot sizes and building types that respond to their urban location can foster a much greater mix of incomes than typical same-lot size development. The large single-family homes on the north and west sides of this block sit on an "A" street facing a park and commanded prices approaching a half million dollars. The homes on the "B" street at the bottom of the slide averaged just under $300,000 on slightly smaller lots. The townhouses on the side street sold for $200,000 to $250,000, and the apartments above the accessory garages in the middle of the block rented for $750 per month. It is worth noting that all of the prices are approximately 12 percent more than neighboring subdivisions for comparable square footage and lot size, demonstrating that well-designed, community-oriented, and walkable mixed income actually increases property values.

Mixed-Income Public Housing in Cincinnati, Ohio

In its Hope VI campaign to deconcentrate poverty, the U.S. Department of Housing and Urban Development employed New Urbanist guidelines to redevelop 217 of the most blighted public housing projects, most of them '50s and '60s towers or barracks on urban superblocks. The redeveloped projects, like this one designed by Torti-Gallas CHK, combine undifferentiated market rate and publicly subsidized units and integrate them back into the existing neighborhood through reconnected street grids and compatible traditional architecture.

Ellen Dunham-Jones

New Urbanism as the free-market solution to all of the world's problems, or worse, as corrupted by the market, offering little more than aestheticized sprawl. Conservatives and libertarians bark at New Urbanism as socialist governmental interference with private property, while left wing academics decry New Urbanism's nostalgia for more unified, traditional communities as reinstalling the patterns of patriarchy, squelching the expression of dissent that is critical to democracy, and appealing to the worst kind of xenophobic populism.

The neo-traditional styling associated with both the architecture and the urbanism is particularly controversial, provoking deep feelings of connection amongst admirers and charges of Disneyfication and social regression from detractors. Ironically, the focus on the surface appearance of New Urbanism reveals how distant both traditional and modernist architects have become in terms of seeing architecture in relation to solving larger societal and placemaking issues. The leading New Urbanists use style very strategically, both to connect to popular, climate-appropriate, regional building traditions and to mask the more radical (and unpopular) aspects of their projects: mixed uses, mixed incomes, compact lots, and transit. In what could be seen as subversive marketing, New Urbanist projects tend to use pleasing, traditional, familiar, and unthreatening imagery precisely to build market acceptance of these progressive, public goals.**25** Is this nostalgia, or is it just a pragmatic way of overcoming suburban resistance to a more sustainable form of development? In the end, some of the high-design community's knee-jerk disdain for New Urbanism may be because it has picked up the modernist torch of social reform abandoned by today's neo-avant-garde. In addition to employing subversive marketing techniques, are the New Urbanists subversive modernists?

New Urbanists and Rem Koolhaas:
Subversive Marketing or Marketing Subversiveness?

Is it too much of a stretch to present the New Urbanists as subversive radicals? Are their interests in the suburbs, marketing, and development practices just too middle class, too bourgeois to drive real change? Rem Koolhaas studies suburbs, marketing, and development practices, too, and enjoys an avant-garde reputation. His writings on bigness and generic cities and his work on the *Harvard Guide to Shopping* are similarly concerned with

Prospect, Colorado
Approximately 60 percent of the New Urbanist communities in the United States are "greenfield" projects, meaning they are built on undeveloped, often rural, land. Regulatory obstacles and NIMBY ("Not in My Back Yard") resistance from neighbors make these projects much easier to develop than infill sites, and they are where the movement got its start. Masterplanned by DPZ, this greenfield TND outside Denver has more modernist architecture than most and ironic street names like "Incorrigible Circle."

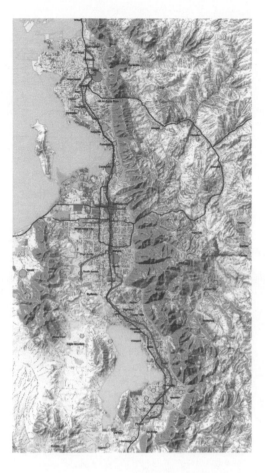

Envision Utah, Quality Growth Strategy—composite map
This regional design for accommodating one million additional people in Salt Lake Valley over 20 years demonstrates the New Urbanists' commitment to public participation and smart-growth principles. The plan, by Fregonese Calthorpe Associates, developed out of an extensive process of more than 600 community workshops, significant media coverage, and nearly 18,000 participants voting online for their preferred plan. The process educated the public to recognize the conflicts between the market's desires and the growth pressures from increased population as well as the need for trade-offs. The plan demonstrated that low-density sprawl would add over 400 square miles of urbanized land over the 20 years, while compact development would add 85 square miles. It succeeded in developing a regional consciousness and helped to build public consensus for acceptance of higher density, more transit, and transit-oriented development (TOD) in growth areas and stricter conservation rules to protect the mountain slopes from development.

the systems that reproduce contemporary development. He too is interested in architecture not just as an art practice, but as the intersection between art, business, money, and culture. His work engages this intersection at the elite levels of Prada and the Guggenheim, while the New Urbanists operate at the more everyday level of production builders and traditional ideas of civic art. But, both share an interest in the big picture behind the surface and beyond the more narrow concerns that have dominated architectural discourse. Both are bringing larger development patterns and processes into architectural discussion. Koolhaas, even more than the New Urbanists, recognizes the degree to which the market now substitutes for the public. However, it is difficult to draw connections between his research and his design work. Disdainful of moralizing positions, he deliberately refrains from making judgments about the effects of the market, preferring only to express a certain admiration for how its power and effectiveness have eclipsed that of architecture and planning. There is much the New Urbanists could learn from Koolhaas. His designs are formally more interesting than the New Urbanists' and juxtapose innovative forms with thrilling spatial manipulations, bold and intelligent graphics, and unconventionally used materials around circulation systems that privilege chance encounters and open-ended possibilities.[26] Yet, beyond a preference for an urbanism of dynamic juxtapositions, he deliberately avoids establishing a prescribed public agenda for his work.[27]

In comparison, if New Urbanism is nostalgic, it is not for the gingerbread architecture, but for an engaged public realm, for charrettes with public involvement, for public debates on laws, and at professional congresses. In the New Urbanist work, retail and shopping are vital to the mix but are still used to frame "civic" space, not to completely substitute for it.

Highly critical of sprawl and the systems that reproduce it, and eager to change those systems from within, the New Urbanists' strategies negotiate between the market and the public, between architecture (little *a*) and Architecture (capital *A*), and between serving "the people" and advancing "the discipline" of urban design. They operate mostly in the middle landscape of suburbia. As a middle course, New Urbanism is inherently not avant-garde (at the leading edge), although in my opinion, its quiet engagement in fundamentally

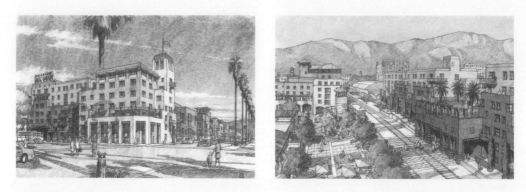

Del Mar Station, Pasadena, California
To reduce auto-dependency, New Urbanists encourage the sensitive integration of transit and new mixed-use development, as in this TOD designed by Moule & Polyzoides. The station welcomes users to Pasadena with a public plaza, retail, underground parking, and affordable housing whose varied massing establishes both private courtyards for residents and strong urban corners in scale with diverse existing conditions.

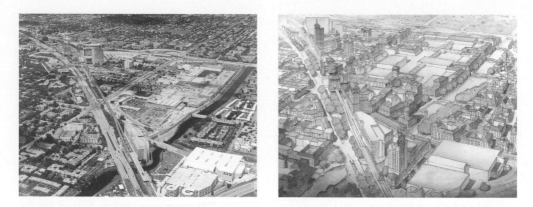

Kendall, Miami: Before and After
Municipalities in search of economic development solutions for dead or dying brownfields and grayfields often turn to New Urbanism. "Brownfields" are former industrial sites, and "grayfields" are suburban sites dominated by parking lots. This grayfield TOD, designed by Dover, Kohl & Partners and Duany Plater-Zyberk and under construction, inserts parking garages, a street grid, and mixed-use liner buildings into the parking lots separating an existing suburban office park and shopping mall. The new development provides a street face to these inward-oriented building types, makes walkable streets, and connects the neighborhood to the existing but neglected canal and a new rail station.

altering the laws, regulations, and financing practices that reproduce sprawl is both more radical and producing far more profound changes than the sexy restylings of most of our architectural elite. Interestingly, high theory and high design may also be moving towards middle grounds. The shift towards the post-critical, or what W. J. T. Mitchell, editor of *Critical Inquiry*, calls "Medium Theory," 28 as well as Koolhaas' middle course between the market and art practice, offer hope that more designers will begin to engage the suburbs, the market, the middle class and New Urbanism.

Adapted by the author from the book **What People Want: Populism in Architecture and Design** (2005), edited by Michael Shamiyeh; reprinted with permission from Birkhaeuser Verlag.

Notes

1. For more elaboration, see Ellen Dunham-Jones, "Seventy-Five Percent," *Harvard Design Magazine*, Fall 2000.

2. Of the $518.6 billion dollars of construction activity in the U.S. in 2003, $278.1 billion, or 54 percent was detached single-family homes, most of it suburban and very little of it designed by architects (source: McGraw Hill Dodge Construction.) However, there are signs of shifts back into urban areas and denser living patterns. The National Association of Realtors reported that in 2003, more condominiums sold than in any other year, sales volume is growing faster than single-family homes, and for the first time, the price midpoint for condos topped that of detached single-family homes. Reported by Thomas A. Fogarty, "Condo Sales Outrun a Fast Market," *USA Today*, February 17, 2004.

3. There are various ways of defining, let alone measuring, the extent of sprawl. The 1997 National Resources Inventory produced by the U.S. Department of Agriculture claims that between 1982 and 1997 the United States (minus Alaska) lost 24.8 million acres to development, the loss of rural land grew 34 percent and per capita land consumption increased 16 percent (accounting for 48 percent of the loss of rural land, with the other 52 percent attributable to population growth). The Massachusetts Audubon Society released a report in 2003, "Losing Ground: At What Cost?" that claims the state lost 40 acres per day to new development between 1985 and 1999. Nearly nine of every 10 acres lost went to residential development, with 65 percent used for low-density, large-lot construction. Jim Miara, quoting a study done by the *New York Times*, in "Visiting Sprawl," *Urban Land*, July 2001, p. 76, claims that 17,000 square miles of land that were rural in 1990 reached suburban or urban densities in 2000 (an amount more than twice the size of New Jersey). This rate of conversion is a slight decline from the 1980s.

4. Robert Lang, "Office Sprawl: The Evolving Geography of Business," October 2000, The Brookings Institution.

5. The U.S. currently has nine times more retail space per capita than it did in 1960. F. Kaid Benfield, Jutka Terris, Nancy Vorsanger, *Solving Sprawl: Models of Smart Growth in Communities Across*

America, (Washington, D.C.: Island Press, 2001), 99. Between 1992 and 1994, 55 percent of all new retail space in America came in the form of big box superstores; in 1994, 80 percent of all new stores fell into this category. Ibid., p. 59.

6. Malls and power centers typically require 50 to 80 acres and are built for a 5 to 15 year lifespan.

7. Christopher B. Leinberger & Robert Davis, "Financing New Urbanism," *Thresholds* 18 (Cambridge, MA: Massachusetts Institute of Technology, 1999). REITS limit their investment recommendations to 19 standard real estate products, 17 of which are explicitly stand-alone, sprawl contributors. Along with the secondary mortgage market's preference for uniform real estate products, this is one of the major factors figuring in the reproduction of sprawl.

8. Reuters, September 18, 2003, published in several newspapers, and reported on CNN.

9. Total vehicle use more than tripled between 1960 and 1995. Benfield, *Solving Sprawl*, 3.

10. Ibid.

11. There are several recent studies on this topic. See Howard Frumkin, Lawrence Frank, and Richard Jackson, *Urban Sprawl and Public Health* (Washington, D.C.: Island Press, 2004).

12. Dell Upton, "Architecture in Everyday Life," *New Literary History* 33 (2002): 709.

13. Ironically, sprawl's land-use pattern of functionalist single-use zoning connected by highways is a direct legacy of CIAM's Corbusian principles—perhaps the most repressed of modern architecture's legacies, and that with the highest impact.

14. For further elaboration of this point, see Ellen Dunham-Jones, "Stars, Swatches, and Sweets: The Role of Design in the Post-Industrial Economy," in *Thresholds* 15 (Fall 1997), Massachusetts Institute of Technology.

15. Maricé Chael, "The NAHB Builders Show: Reflections from Las Vegas," *The Town Paper* 6, no. 1 (Spring 2004), 10.

16. Since the 1960s, the middle class in the United States has lost the job security associated with their formerly unionized jobs, and as the rich have gotten richer and the poor have gotten poorer, according to an August 26, 2004 U.S. Census Bureau report, households with income between $25,000 and $75,000, adjusted for inflation in 2003 dollars, went from 51.9 percent of the population in 1980 to 44.9 percent in 2003 (Timothy Egan, "Economic Squeeze Plaguing Middle-Class Families," *New York Times*, August 28, 2004, p. A11). Since 2001, 4.3 million U.S. citizens have fallen below the poverty line, and median family income has dropped, ("Economic Reality Bites," editorial, *New York Times*, August 28, 2004, p. A26).

17. Despite the markedly divided presidential vote in the November 2004 election, support for mass transit and parks and preserves was both strong and bipartisan. Of the 50 transit ballot initiatives voted on across the United States, 39 were approved while 120 of the 161 land conservation measures passed.

18. Feb. 15, 2000 Press Release from the Pew Center for Civic Journalism, Washington, D.C. See also a September 2000 poll by Belden, Russonello & Stewart, commissioned by Smart Growth America, which found that 78 percent of the 1,007 adults in a geographically balanced poll support policies to curb sprawl. Available at http://www.smartgrowthamerica.com.

19. Joel Garreau, *Edge City, Life on the New Frontier* (New York: Doubleday, 1991).

20. The National Association of Realtors' 2001 "Community and Housing Preference Survey" found that one third of home-buyer

respondents have a strong preference for "New Urbanism" hous-
ing options, and up to half may be attracted to these options once
they see them. Similarly, the SMARTRAQ preferences survey of
1466 Atlanta metro-area residents found that approximately one
in three current inhabitants of conventional suburbs would prefer
to be living in a more walkable neighborhood; 53 percent prefer
connected streets and 3-mile drives over cul-de-sacs and 15- to
18-mile drives; and 56 percent would sacrifice having a larger
home if it means always having to drive, although 60 percent
would still prefer a detached single-family house over living in the
town center. L. Frank, J. Levine, and J. Chapman, *Transportation
and Land-Use Preferences and Atlanta Residents' Neighborhood
Choices—Implementing Transit Oriented Development in the
Atlanta Region,* Georgia Regional Transportation Authority
and Georgia Department of Transportation, Project CM-000-
00(339)m O.I. # 0000339 (2004).

21. Mark J. Eppli and Charles C. Tu, *Valuing the New Urbanism:
The Impact of the New Urbanism on Prices of Single-Family
Homes* (Washington, D.C.: ULI – The Urban Land Institute,
1999).

22. Dan Solomon, Elizabeth Moule, and Stefanos Polyzoides
were the other CNU founders at the meeting, invited by Judy
Corbett, head of the California Local Governments Commission.

23. I missed the first two congresses but have been to all of them
since. From 1996 to 2000, I was co-chair of the CNU Educators
Task Force, and I have been a member of the Board of Directors
of CNU since 2005. What I may lack in objectivity, I hope I make
up for in direct experience and knowledge of what the aims and
discussions have been about.

24. For more information, visit http://www.cnu.org.

25. New Urbanism also makes extensive use of "strategies of
mobilization," principally in the use of 7- to 10-day charrettes
involving stakeholders in the design of the project.

26. The multidirectional ramp at Koolhaas' Rotterdam
Kunsthalle or the intersecting movement systems in his master-
plan for Euralille are examples of what, in the context of this
conference, might be called "strategies of mobilization."

27. This could be understood as an effort to respect the mul-
tiplicity of publics using his spaces, but also likely stems from
his strong distrust of moralizing positions. See "Lite Urbanism,"
Rem Koolhaas and OMA, *S,M,L,XL,* (New York: Monacelli
Press, 1995).

28. W. J. T. Mitchell, "Medium Theory," *Critical Inquiry* 30,
no. 2 (Winter 2004).

New Suburbanism

2000/2004

LTL Architects
Paul Lewis, Marc Tsurumaki, David J. Lewis

New Suburbanism provocatively explores the possibility of creatively reconfiguring the popular desires that fuel contemporary suburban culture by combining the mini-mansion with the mega-store that exists to service and supply it, producing new efficiencies of land use, shared infrastructure, and reduced transportation without fighting the desires that feed the popularity of the quotidian suburb. In this speculative project, LTL imaginatively mitigates the extensive horizontal surface of suburban sprawl by introducing "section into suburbia," a gesture that opens the possibilities for new vertical connections.

In *New Suburbanism*, dwellings migrate to occupy the vast horizontal roofscapes of big boxes. The residential neighborhood above and the commercial zone below are physically separate and perceptually distinct, although each influences the other. The repetitive system of the big box store's open-span structure with aisles and storage racks dictates the logic of the new residential-commercial hybrid in two ways. Storage structures extrude through the inhabitable roof plane of the big box, delineating property divisions within an alternating pattern of houses and yards above and providing containers for the equipment and commodities of domestic life. The linear organizing system of the big box also reorients the standard relationship between house and yard, expanding the typically minimal zone of the side yard such that it becomes the primary exterior space. In a conventional house, the separation between the ornamental front yard and the private rear yard limits the size and utility of each, whereas in the LTL scheme, the continuous yard paralleling the length of the house allows for more varied functions and activities. The houses also tap into the extensive air-conditioning and heating systems of the big box, thus minimizing redundant mechanical systems.

Spatially, the New Suburbanist house re-accommodates existing desires by rethinking the suburban paradigm of horizontality. In a typical developer house, what LTL terms "figural commodity rooms"—formal living and dining rooms, master bedroom suites, media rooms, bathrooms—are conceived as independent objects isolated within the house plan, while more continuous public areas such as the foyer, kitchen, breakfast room, and family room are loosely treated as open-plan spaces. In *New Suburbanism*, the relationships between these types of rooms are not hierarchical, but reciprocal: the free-plan public spaces and the commodity rooms engage in a spatial push-and-pull, such that the location of one type in plan and/or section is contingent on the location of its countertype. Object rooms claim a parity of status with public spaces but do not relinquish their commodity or figural qualities.

The massive and overarticulated roof that visually dominates the typical suburban mini-mansion is reconceived as a solid insulating zone, hung from the big box's structural column grid and cocooning the private bedrooms and suites on the second floor. Volumes punched through the roof produce the requisite double-height spaces for grand foyers and living rooms, while stalactite-like forms descend from the ceiling to accommodate storage, fireplaces, and staircases on the first floor. The result is a spatial dynamic not achievable in the stilted plans of conventional suburban houses.

The vast parking lots of big box stores are reinvented as a multistory parking structure around a central sports field, creating a new and more efficient hybrid of the suburban activities of shopping, sport spectatorship, and even tailgate parties. In *New Suburbanism*, the multifunctional aspect of the big box construction system—once used only for warehouses and factories, but now adapted to build public libraries, schools, community centers, and gas stations—together with demand for housing means that the potential for the New Suburbanist coupling is enormous.

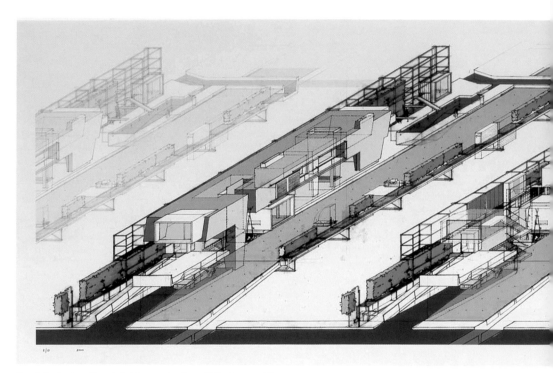

New Suburbanism, dissected oblique projections 2000 (cat. no. 39)

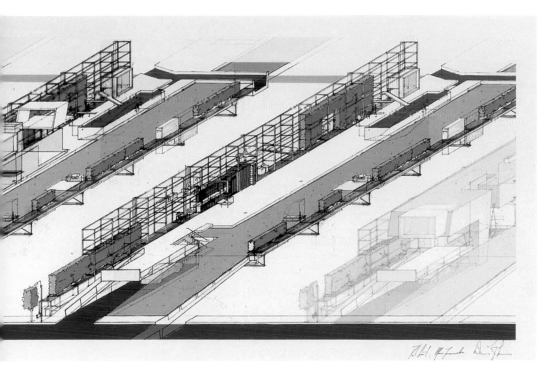

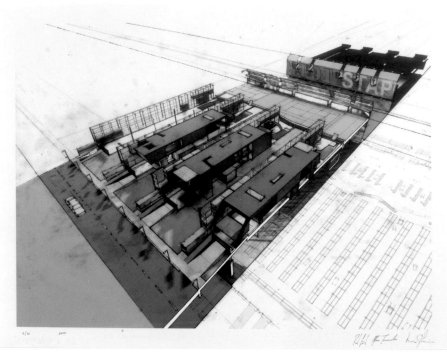

New Suburbanism; sectioned perspective (aerial) 2000 (cat. no. 40)

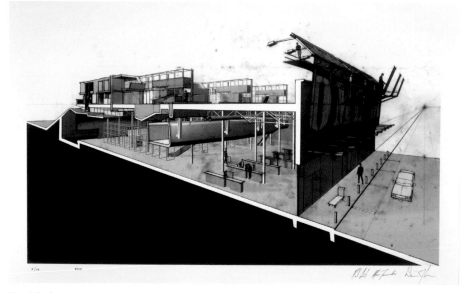

New Suburbanism; sectioned perspective (street) 2000 (cat. no. 41)

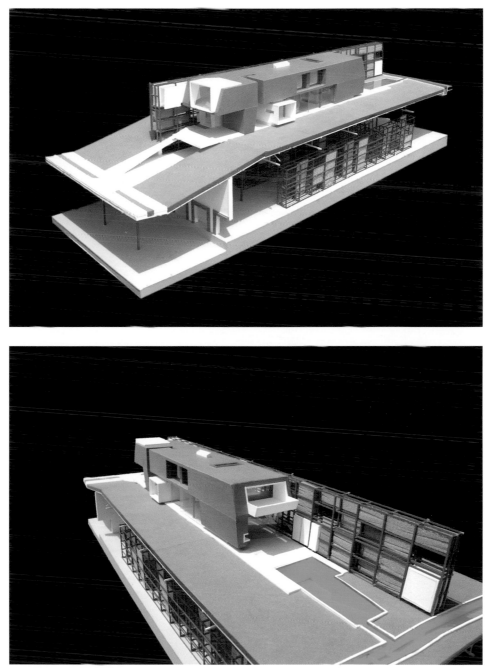

New Suburbanism, model 2000/2004 (cat. no. 42)

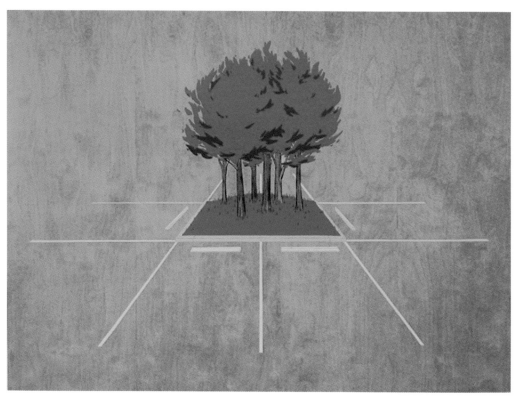

Chris Ballantyne *Untitled (Berm)* 2003 (cat. no. 1)

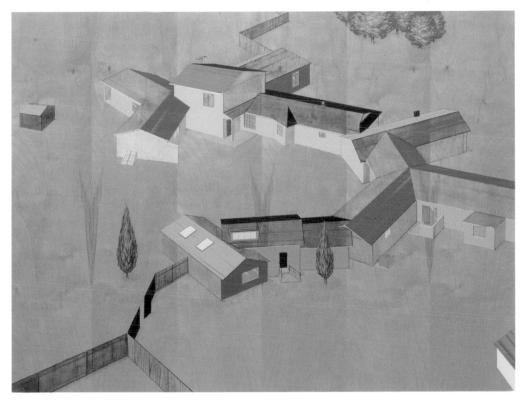

Chris Ballantyne *Untitled (Additions)* 2004 (cat. no. 2)

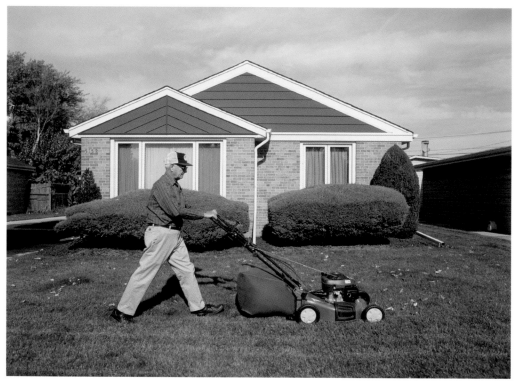

Greg Stimac *Mowing the Lawn (Oak Park, IL)* 2005/2006 ink-jet print

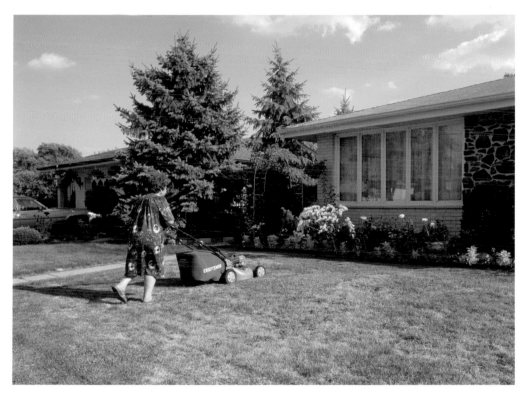

Greg Stimac *Mowing the Lawn (Oak Park, IL)* 2005/2006 ink-jet print

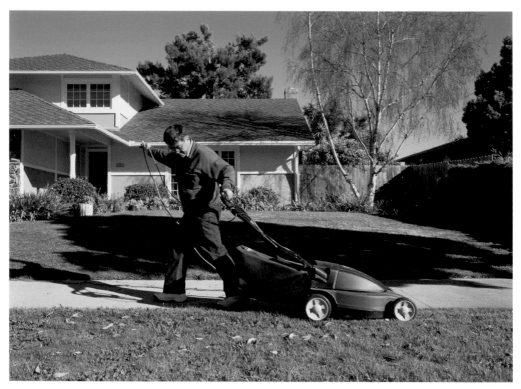

Greg Stimac *Mowing the Lawn (Goleta, CA)* 2005/2006 ink-jet print

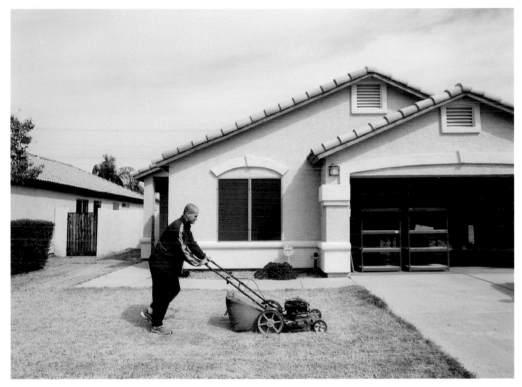

Greg Stimac *Mowing the Lawn (Chandler, AZ)* 2005/2006 (cat. no. 69)

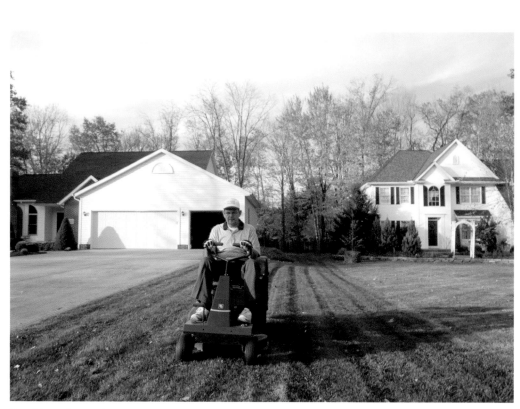

Greg Stimac *Mowing the Lawn (Mentor, OH)* 2005/2006 (cat. no. 70)

Mayo Plan #1

Reinventing a Midwestern Suburb

2002/2007

Coen + Partners
Shane Coen, Bryan Kramer, Stephanie Grotta, Nathan Anderson, Travis Van Liere

Mayo Woodlands is a residential development located in rural Olmsted County, southwest of Rochester, Minnesota. The site occupies 220 acres of farmland, meadows, and rolling woodland and faces typical suburban development pressures. Prior to Coen+Partners' involvement, the one-hundred-twenty-unit development was platted by an engineering firm following conventional subdivision patterns. The engineer's plat created a road system failing to respond to the land or the infrastructural precedents found within Rochester's turn-of-the-century neighborhoods. The density was a mathematical equation derived from the county's ordinances. Proposed houses were oriented around cul-de-sacs, and lots were sited haphazardly throughout the development, encroaching on microclimates better left as conserved open space. Standardized setbacks and right-of-ways were also used. The end result is an experience that neither fostered community nor created privacy.

The challenge was to transform a typical subdivision—complete with cul-de-sacs and overscaled lots—into a progressive statement for American suburbia, while working within a substantial series of constraints: all infrastructures, including lots, setbacks, roads, right-of-ways, and easements, were unalterable. Within these constraints our strategy was to overwhelm the engineered infrastructure, at minimum rendering it benign and at most integrating it as an essential part of the experience. The resulting master plan is an orthogonal system reclaiming the site, referencing the existing tree lines and original section lines of the farm, and invoking community within a previously placeless plan.

Our initial intervention erases all ill-conceived lot lines by blanketing the entire parcel with a tall grass monoculture. Through uniform height, texture, and color, the five-foot grasses reference the land's agricultural heritage as cropland. To reorient the lot and define the buildable footprint, orthogonal cutouts of each lot are made in the tall grasses. Each cutout is oriented to true north and maintains a fifteen-foot distance from all adjacent lot lines. These parameters allow the tall grasses to flow in and around each defined homestead, providing a new site vocabulary for the neighborhood independent of the engineered infrastructure. Additionally, red pine trees are planted in long bands stretching across the site, recalling the iconographic windrow found throughout rural America. These trees, in combination with low fences and walls, visually extend the proposed houses, direct residents to common open spaces, and connect neighbors rather than define property lines. The true east-west orientation of the pines, fences, and walls reinforces the most dominant existing natural and historical elements: the agricultural furrows and the wood's edge. The direction of these elements also dictates that the residential designs follow the site strategy by orienting all structures east-west while maximizing their southern exposure. The monoculture of tall grasses, windrows, fences, low walls, and residences, rather than the original meandering road system and cul-de-sacs, organizes the site and defines neighborhoods. The previously arbitrary road experience now provides a more compelling journey through a series of land-based corridors and rooms.

Although ownership of Mayo Woodlands changed prior to implementing all of our proposed site strategies, the project nevertheless remains an instructive case study for transforming typical suburban developments and new neighborhoods into progressive land-based designs. The critique inherent in this project is a rejection of an engineered solution, even while working within its substantial constraints, in favor of a design solution emerging from the land, the community, and responsible site use.

Predevelopment land with active
agriculture, prairie, and woods

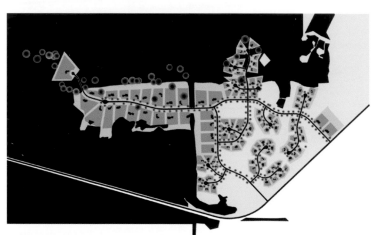

Existing conventional
subdivision plan

Planting native tall grass prairie
erases lot lines

To de-emphasize the cul-de-sacs, orthogonal "cutouts" in the prairie define residences

Red pine trees planted in an east/west orientation recall rural windrows

Low fences and walls placed in east/west orientation mark pedestrian paths

Prairie Group

Village Group

Woods Group

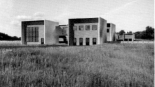

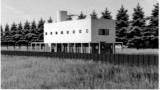

Campus, Estate, and Park

Lawn Culture Comes to the Corporation

Louise A. Mozingo

Louise A. Mozingo is an associate professor in the department of landscape architecture at the University of California, Berkeley. She was formerly an associate and senior landscape architect at Sasaki Associates. Her articles and reviews have appeared in such publications as Places, Landscape Journal, Journal of the History of Gardens and Designed Landscapes, Landscape Architecture magazine, Geographical Review, and the Journal of the Society of Architectural Historians.

Beginning in the 1940s, American corporate management built three new business landscapes at the urban periphery: the corporate campus, the corporate estate, and the office park. In edge-city conurbations they may appear chaotic, but they function as distinct niches of the corporate workplace, contrived with discernible intent. Though they are different in specifics, common motives have fashioned these suburban environments. The purported magic of gazing at greenness lies at these landscapes' conceptual core—magic credited with generating productivity, competitiveness, and public approbation fig. 1.

The emergence of suburban corporate landscapes was framed by the conceptual precedents of the public park and the residential suburb, both material results of what J. B. Jackson termed "lawn culture." By the late nineteenth century, the pastoral public park prevailed as an environmental ideal of the American landscape. Gently undulating grass, serpentine lakes, sinuous pathways, and leafy woodland groves provided urban dwellers a much sought after respite from the dense industrial city, presumably with salutary physical and moral effects as well. The application of this pastoral

ideal to residential districts by real estate speculators formed exclusive suburbs typified by open lot houses, coordinated infrastructure, limited building heights, and expansive, unfenced front yards presenting a continuous street-side landscape. Both the public park and the residential suburb conjoined gentility and greenery.[1]

The prevalence of automobile transportation that began the 1920s expanded the scale and scope of the suburbs, a process that accelerated after World War II. The ever sprawling suburbs encompassed other development types besides single-family housing: parkways, highways, strip shopping centers, drive-in movie theaters, and retail malls. The last suburban development types to crystallize (and the last to receive scholarly attention) are the interrelated corporate campus, corporate estate, and office park.

Corporate management initially built and occupied the *corporate campus*, a suburban workplace for industrial scientists. Modeled on the American university landscape, the corporate campus consisted of several office and laboratory facilities focused around an inner green or quadrangle. Inspired by the corporate campus, top management retreated

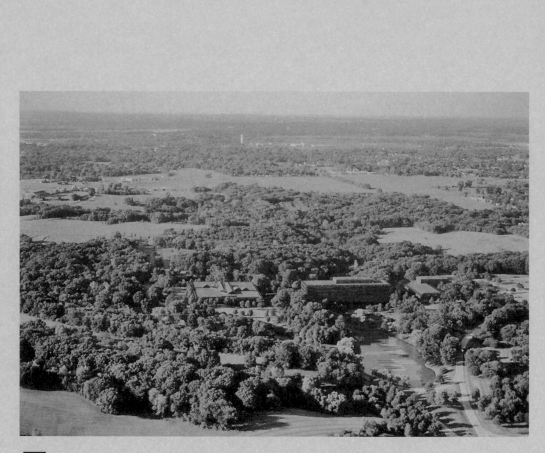

fig. 1 Aerial view of the Deere & Company Administrative Center, the quintessential corporate estate. The imposing corporate headquarters, inaugurated in 1964, sits in the center of 720 sylvan acres well outside the industrial downtown of Moline, Illinois.

from the city center to the *corporate estate*, distinguished by a conspicuously grand site, usually of at least two hundred acres, centered on an impressive office structure. Real estate entrepreneurs translated the most elementary attributes of the corporate campus and estate to develop the *office park*, which housed regional managers of national corporations, corporate support staffs, small local corporations, and service businesses.

Together these suburban landscape types served the ranks of white-collar employees of a new twentieth-century economic institution—the managerial capitalist corporation. Since the 1890s, corporate expansion had both required and been facilitated by a rational and professional management hierarchy, consisting of three specialized tiers: lower management, which oversaw production, sales, and purchasing; middle management, which coordinated the activities of lower management and implemented corporate strategies through finance, marketing, and research departments; and top management, which directed the activities of middle managers, allocated overall corporate resources, and plotted competitive strategies.[2]

Managerial capitalism was a necessary precursor to the relocation of corporate managers to suburban offices. One of the principal advantages of this rationalized hierarchy was the decentralization of business decisions, which provided the means to control and guide geographically distant parts of vast corporations. Economic expansion after World War II furthered the adoption and refinement of this management strategy. The differentiated corporate offices were a parallel manifestation of the specialization and decentralization that marked the suburbs as a whole. But in moving to the suburbs, these corporations did more: "greenery," as Jackson stated, is "a way of communicating with others." The new corporate management landscapes connoted both the "relaxation and sociability" of the public park and the "goodwill and approval" of the suburban front yard, and thus elided the actualities of profit-making American business.[3]

Motivations

The advent of suburban workplaces for corporate management resulted from either of two business strategies. In one, management separated from industrial production. When William Hewitt took over as president of the farm machinery giant Deere & Company in 1955, his initial and most decisive action was to remove his top management from the corporation's sprawling industrial swath along the Mississippi River in Moline, Illinois.[4] He transferred it beyond the city limits to a stunning headquarters nestled within 720 verdant acres. As *Fortune* reported in 1952, corporations were cleaving management from industrial sites "in the hope that this will reduce friction . . . between unionized workers and unorganized office personnel."[5] In the second strategy, corporations relocated away from urban downtowns. In the immediate postwar years, space tightened significantly in central business districts: office staffs doubled between 1942 and 1952, and each individual worker took up more space. In addition, efficient office organization now required flexible, expandable offices with movable partitions rather than fixed walls.[6] The dense, constricted downtown became untenable for rapidly expanding conglomerates such as General Foods, which had been a Manhattan resident since the 1920s.[7] After first seeking adequate space in Manhattan, General Foods exited to a custom-designed headquarters in Westchester County, twenty miles north, in 1954. It was the first of many *Fortune 500* companies to do so.

A peculiar postwar circumstance, civil defense, also spurred the corporate decision to relocate to the urban periphery. After 1949, as civil defense activities rapidly increased, corporate interest in suburban locations also sharply increased. As of 1952, out of twenty-two New York City companies that had consulted with an expert on land acquisitions in suburban Westchester County, each had "privately revealed that, among other things, it wanted to avoid target areas."[8] Among General Foods employees, the scuttlebutt was that the corporation had designed the complex to be used as a hospital in case of nuclear war.[9]

In addition to their presumed safety from atomic warfare, suburban sites allowed corporate managers an extraordinary degree of control over public access to their facilities. Buildings were distanced from public roads, fences discreetly secured sites, long driveways gave ample warning of approaching visitors, and guard houses vetted guests under the guise of giving friendly directions. For the many corporations undertaking military research and development, only ample suburban sites could offer these defensive layouts. By the 1960s, corporations had left behind Cold War concerns and instead were focusing on suburban sites

as insulated from disconcerting "urban unrest."10 Protective measures could be tied up in an appealing bucolic package, altogether less threatening and obtrusive than the urban fortresses that eventually housed some downtown corporations.

These new management landscapes fit hand in glove with the economic goals of the politicians, developers, and bankers in suburban jurisdictions. As *Business Week* reported of 1950s Westchester County, suburban office buildings solved the "threatening problem" that faced predominantly residential suburbs: "Residential areas don't pay their own way unless average [housing] valuations run high." For this, *Business Week* noted, "Office buildings look like a heaven-sent answer. They carry a big share of the tax load, but don't clutter up the countryside."11

The landscape provisions attached to these corporate workplaces made them palatable to well-to-do communities known for their idealized, and envied, suburban landscapes. Though power brokers welcomed corporate development, homeowners feared unsightly and noxious industry. Indeed, factories preceded corporate administration in the urban periphery by several decades. The need to distinguish between the environments of genteel white-collar management and gritty blue-collar industry necessitated corporate investment in a green surround. When Dr. F. B. Jewett, president of Bell Telephone Laboratories, had to convince local New Jersey politicians that his research campus (completed in 1942) would fit into the "high" suburban character of the nearby town of Summit, he repeatedly returned to the site design by the Olmsted Brothers, the esteemed firm of landscape architects founded by Frederick Law Olmsted and carried on by his sons.12 Universally, suburban authorities imposed height restrictions, limited uses to offices and research laboratories, and dictated the presence of enveloping landscape setbacks. What demarcated executive offices from production plants was not the appearance of the buildings, since from a disinterested perspective offices might look much like factories, but the presence of a generously designed and tended landscape.

Corporate management understood that a landscape surround could appease suburban residents but also, more generally, broadcast a positive public image. While closely controlling public access, corporations orchestrated engaging public prospects from the new parkways and highways that

usually flanked their facilities. The site designer of the forerunning General Electric Electronics Park, a 1948 corporate campus outside Syracuse, New York, along the New York State Thruway, promoted the "possibilities and advantages of 'site advertising'" in *Landscape Architecture* and described the importance of "the location, orientation, and treatment with respect to the abutting highway. Here will be our approach; here will be our advertising."13 Highly visible sites displayed impressive buildings and greenery to a ready audience of passing motorists and, in the process, an estimable depiction of the corporation itself.

Relatedly, large suburban properties yielded the idealized modernist design effect advocated by the architects employed by corporations in the 1950s. Groves of trees, glistening lakes, and rolling lawns buoyed gleaming buildings of glass standing free from the dictates of the street. The transparent curtain wall of modernist buildings demanded a suitable exterior panorama, for the entire wall was now window. Ultimately, the only acceptable view was either a dynamic city skyline or verdant pastures, one the purview of the downtown skyscraper, the other of the new corporate suburban landscape. As typified by the popular press's reaction to the 1956 Connecticut General Life Insurance headquarters in Bloomfield, Connecticut—an "important departure from the monolithic piles which corporations once favored," a "building with a future," and "one of the finest office structures in the country"—the summary effect of the lustrous architecture and lush landscape seized public attention fig. 2 .14

Corporate management justified the expensive suburban moves and elaborate landscape provisions as cost effective. Suburban pioneers consistently reported low rates of employee turnover. Management determined that suburban locations increased effective working hours because the convenience of integrated parking spaces captured the employee for the entire working day. The new workplaces discouraged out-the-door distractions and facilitated overtime by minimizing concern about mass transportation schedules and traffic congestion (at least initially).15

From the beginning, corporate management expected employees of "a better type" to be attracted by the suburban character and location of the new campuses, estates, and office parks.16 In 1967, *Fortune* minced no words: "New York is becoming an increasingly Negro and Puerto Rican

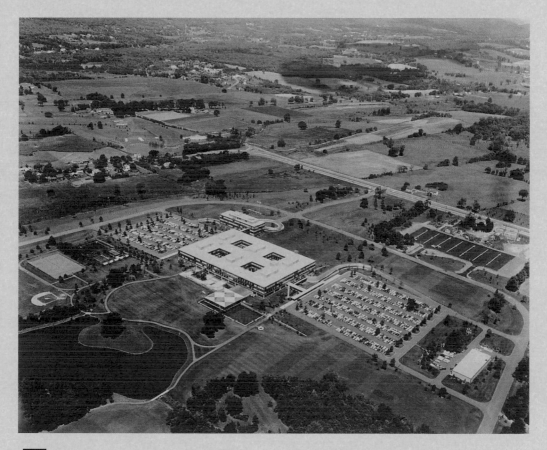

fig. 2 Aerial view of the 1956 Connecticut General Life Insurance headquarters designed by Skidmore, Owings and Merrill. On the expansive property outside of Hartford, Connecticut, the designers and their corporate patron achieved the modernist design ideal of a gleaming glass and steel building set amid a bucolic landscape.

city. Some companies are reluctant to hire a large proportion of Negro and Puerto Rican help."17 As characterized by a New York City Economic Development administrator to the *New York Times* in 1971, the "executive decision maker" lived in a homogeneous "ethnic and class community," while his urban employees came "from communities very different in class and ethnicity." The administrator bluntly continued, "It's an older generation in charge trying to reestablish a setting that seems to be more comfortable, more the old way."18

Corporate leaders also calculated that bucolic settings could grant their business a competitive edge. At the 1964 opening ceremonies, William Hewitt declared that the new Deere & Company Administrative Center would provide "additional inspiration to all of us to be bold, ingenious and creative, to use our imagination in new ways to keep John Deere out in front as a leader."19 Five years after occupation of the Administrative Center, a staff survey determined that employees overwhelmingly favored the resplendent site and landscape of the Administrative Center over all other elements of the headquarters. Attracting new high-quality personnel became easier, and want ads that included pictures of the center garnered notably higher response rates than those that did not.20

The corporate managers who developed the corporate campus, the corporate estate, and the office park were recasting the social engineering of the nineteenth-century public park and the residential suburb to serve corporate capitalism. The landscape designers of the General Electric Electronics Park described the purpose of the carefully composed trees, lawns, and lakes as the creation of a landscape "that bespeaks orderliness, spaciousness, and well-being."21 Corporations used the aesthetic, mental, and social effects attributed to the public park and the residential suburb to achieve operational efficiency, local acceptance, employee satisfaction, selective discrimination, and favorable self-representation.

The Corporate Campus

Corporations, and the designers they employed, devised the corporate campus because scientists conducting industrial research became crucial to corporate success. By 1940, companies angling to entice and keep scientists in a fiercely competitive labor market realized that the old industrial plants where scientists typically worked conveyed ever

less prestige; Americans in general regarded the landscapes of production with growing distaste.22 Nor did the factory environment continue to match the role that corporations envisioned for the corporate scientist. As the General Motors director of technical employment explained in an address to the American Association for the Advancement of Science in 1946, the scientist "is not recruited as a factory laborer" but rather "for development into a management position."23 For their part, scientists were wary of corporate strictures, and management needed to provide them with a setting that reflected and reinforced their comparatively independent operations. In 1955, *Business Week* concluded that the notable success of General Electric and Bell Labs in attracting and retaining scientists could first be accounted for because, "Work goes on in a campus-like atmosphere that the brainy youngsters seem to go for."24

The defining element of the corporate campus is a central open space that provides a visual focal point for the separate buildings that house administrative, office, and laboratory uses. Like a university campus, this pattern of landscape and structures accommodates complicated underground utility conduits, and in the years after the campus's initial construction minimizes disruption when, inevitably, incremental alterations and additions to buildings and infrastructure take place. The major driveways in the corporate campus begin at the gate or entry, course around the site's periphery, and connect several parking lots, usually one for each building; the encircling driveway pattern also provides essential truck access to each building, for the delivery of laboratory materials fig. 3 .

The Bell Telephone Laboratories, first proposed in 1930 and completed in 1942 on a 213-acre site in Murray Hill, New Jersey, was the model for all corporate campuses to follow, as *Fortune* later attested.25 Scientists worked in flexible modular laboratories provided with excellent experimental utilities. The three-story height limit, ample landscape setbacks, buried utilities, and specifically white-collar uses (all subsequently codified in unprecedented zoning restrictions) allowed the incursion of a corporate employment center into an exclusive residential suburb fig. 4 . Most important, Bell's "campus" initiated and integrated an industrial research culture that mimicked the university's encompassing landscape, prestige, and reputation for independent intellectual inquiry. Bell Labs is

fig. 3 Site plan by SWA Group of the IBM West Coast Programming Center in Santa Teresa, California. Completed in 1977, the plan iterates the concentric scheme of the corporate campus first developed in the 1940s: buildings clustered around a central open space serving as the campus focal point, parking lots ranged around the buildings, and an access drive encircling the entire site.

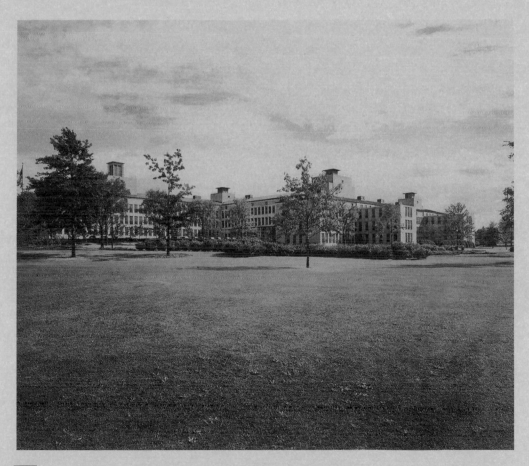

fig. 4 View of the first corporate campus, the Bell Telephone Laboratories in Murray Hill, New Jersey, completed in 1942. The landscape architects the Olmsted Brothers designed the campus site and Voorhees, Walker, Foley and Smith the building architecture.

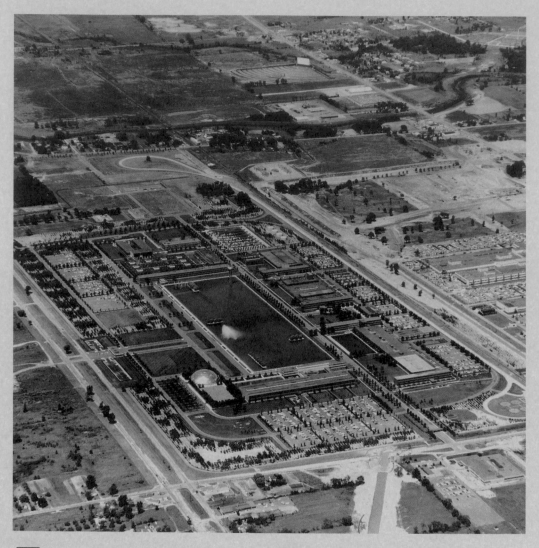

fig. 5 Aerial photo of the one-by-two mile site of the General
Motors Technical Center. Though distractingly spectacular, the
fundamental scheme is the same as the more modest versions
of the corporate campus. Instead of a grassy expanse, the
research facilities face the rectangular lake, an immense watery
quadrangle studded with jetting fountains, willow islands, and
a sculptural water tower. The glinting dome visible near the
lower right of the lake is where styling engineers show off new
models of GM cars.

fig. 6 (right): View from the interior open space to the hillsides
surrounding the IBM West Programming Center, Santa Teresa,
California, a corporate campus designed by the landscape
architects SWA Group.

still famous as the site where scientists, supposedly free of corporate constraints, invented both the transistor and the "bit" in 1948, revolutionizing electronics and computing.

The 1948 Johns-Manville Research Center, in Manville, New Jersey, and the contemporary General Electric Electronics Park further promoted the corporate campus.26 However, the 1956 General Motors Technical Center spectacularly refined the precepts of the corporate campus. On a grand one-by-two-mile property north of Detroit, the architect Eero Saarinen and the landscape architect Thomas Church designed a modernist manifesto comprised of long, low, glazed buildings, crisp planes of grass, sharply delineated bosques of trees, and, at the center, a vast rectangle of water fig.5 . The cutting-edge campus design emphasized and glorified the modernity of the corporate research enterprise. As a commentator observed, "Here is know-how; here is the vision of industry; here is tomorrow today—Wednesday on Tuesday." 27 Twelve years in the making and widely covered in the media, the GM Technical Center elicited a tide of superlative press. It cost at least $130 million (perhaps more),

an immense expense even with all its enduring public relations value. To date, no other corporate campus has bested the GM Technical Center.

Future corporate campuses reiterated the initial postwar models and imitated General Motors with more modest but nonetheless emphatically modernist designs. By 1960, corporations had also built campuses on the West Coast. IBM completed the first phase of its principal California operations base in 1958, a 190-acre complex in San Jose that helped to initiate the now mythic Silicon Valley. The 1960 Ramo-Wooldridge Laboratories in Southern California were lauded by the designers and critics Christopher Tunnard and Boris Pushkarev in *Man-Made America* as an exemplar of "industrial urban design."28

Since the 1950s, the corporate campus has continued to be a remarkably consistent landscape type, while accommodating circumstances of site, region, and business priorities. The 1977 IBM West Coast Programming Center, in Santa Teresa (near San Jose), displays a taut, crisp, high-style geometry within its campus, in contrast to a backdrop of grassland hillsides fig. 6 .29 The 1992 Boeing

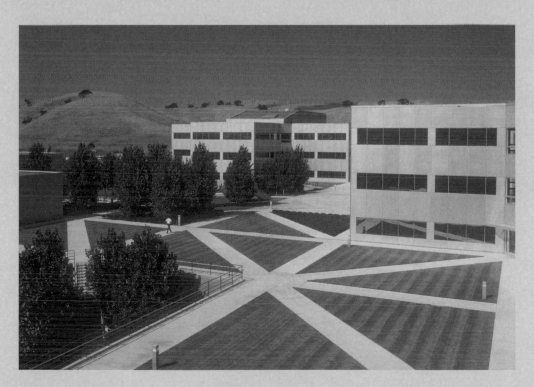

Longacres Park, outside Seattle, incorporates more recent environmental concerns. An orchard, its rows of trees angled toward a distant view of Mount Rainier, reflects the region's history of apple cultivation. Building on remnant wetlands protected by federal law, a large constructed wetland, surrounded by native woodland, forms the centerpiece of the corporate campus.30

The Corporate Estate

Corporate campus schemes used landscape design to reconceive the white-collar workplace, retain targeted employee groups, and signal eminent corporate standing. Indubitably successful in these goals, the setting sold the corporation. This lesson was absorbed and amplified in the idea of the corporate estate. For two seminal estate projects—the General Foods headquarters (the very first corporate estate) and the Deere & Company Administrative Center—corporations hired the designers of previous precedent-setting corporate campuses: for General Foods, the architect of Bell Labs; for Deere & Company, the architect of the GM Technical Center.

Built as the seat of the highest corporate echelons, the corporate estate provides the suburban alternative to the striking urban skyscraper. Ample pastoral sites, views unblemished by rude site utilities, and stylish architecture suitably reflect the elite status of top postwar executives. At the same time, corporate estates' extensive and generous landscape engenders popular approval, even civic pride, in much the same way that skyscrapers distinguish a city skyline.

Though predated by the 1954 General Foods Headquarters and the 1956 Connecticut General Life Insurance Corporation, the 1964 Deere & Company Administrative Center in Moline, Illinois, has commanded the most renown.31 It appears simple on the site plan, yet its circumnavigating driveway structures an elegantly dramatic series of views that visitors and employees experience as they enter the site ⌐fig. 7¬. The looping driveway lassoes the building complex, moving from the ravine bottom at the road intersection, then rising along embankments to reveal stunning views across the ponds to the rusty brown Cor-ten steel facades, then banking upward into the woodland groves, eventually arriving at the principal parking lot, disclosed at the last possible moment, and then dropping back down again to the rear of the building, to provide service access. In this way, the driveway is an active element in the experience of the landscape, orchestrating views to maximum effect ⌐fig. 8¬.

The award-winning Administrative Center garnered high praise from Deere's executives and employees, the local community, cultural critics, and other corporate leaders; it was a resounding success both inside and outside the company and remains a cornerstone of the corporation's public relations ⌐fig. 9¬. Images of the center are ubiquitous in Deere publications; the company encourages farmers and the general public to visit the site and invites particularly good customers to lunch in the executive dining room, which affords views out over the shimmering ponds. All subsequent corporate estates have recapitulated Deere's essential elements: low-rise, contemporary architecture set amid many sylvan acres, with grand entry drives, concealed parking and infrastructure, and verdant vistas.

Two high-profile corporate headquarters added refinements to the corporate estate idea: the 1970 PepsiCo World Headquarters, in Harrison, New York, and the 1972 Weyerhaeuser Corporate Headquarters, in Tacoma, Washington. PepsiCo

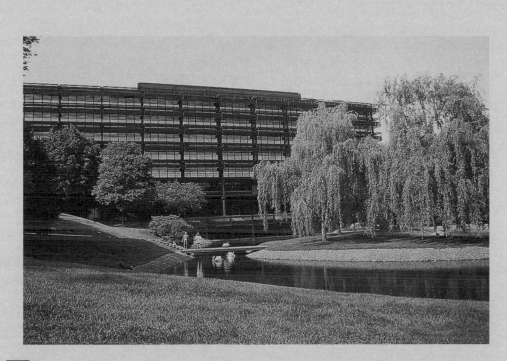

fig. 8 View from the drive at the Deere & Company Administrative Center, an example of the spectacular views of the corporate headquarters throughout the site.

fig. 9 Ad for the Deere & Company Administrative Center in *Destination Quad Cities*, the 1997 visitors' guide to the Moline area.

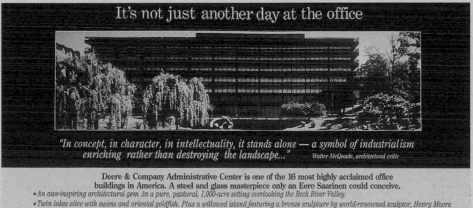

president Donald Kendall extended prestigious display to seigniorial patronage, surrounding his executive office building with a public sculpture garden of major twentieth-century works. George Weyerhaeuser particularly insisted on high visibility for his sumptuous building and landscape. He convinced the state highway authorities to modify their standard railing design to make the headquarters readily visible from both an adjoining interstate and a passing state highway.32

In marked contrast, perceived threats of anti-establishment activism and skeptical receptions in more affluent suburban communities during the early 1970s caused other corporations to obscure their presence in the suburban landscape. Wooded terrain completely enveloped the 1971 American Can headquarters in Greenwich, Connecticut, to create a kind of a corporate hideaway. Additional corporations wary of public attention followed suit, including Union Carbide, which built its Corporation World Headquarters in Danbury, Connecticut, buffered deep within 645 acres of forest in 1982.

By the late 1980s and into the 1990s, corporations had begun to confront highly motivated

and organized local resistance. The latest permutation of the corporate estate might thus be designated as Palladio meets the Prairie School: it combines historicist architecture with a regionalist landscape. The Codex World Headquarters, in Canton, Massachusetts, and the Becton Dickson Headquarters, in Franklin Lakes, New Jersey, attempted to appease local outcries with swank design solutions inspired by European villas and country houses.33 While certainly partly the result of architectural vogue, these constructions placed a cloak of genteel aristocratic leisure over the busy capitalism taking place within.

The Office Park

The developers of office parks built upon two precedents. One was the industrial park—a planned industrial district of warehousing and manufacturing uses first seen in the 1920s. Though quite bare-boned, industrial park development guidelines coordinated infrastructure systems, standardized ample traffic conduits, and set limits on building heights and footprints.34 The other precedent was the planned residential community, later regularized as the planned unit development, where restrictive

fig. 10 The site plan of the Cornell Oaks Corporate Center, an office park in a suburb of Portland, Oregon, prepared by the Mitchell Nelson Group, a division of Maul Foster Alongi, Inc. As typifies the office park, each office building is surrounded by a pool of parking delineated by landscape medians and verges. More generous landscape areas front the highway, connecting arterial and interior "parkway."

188

covenants controlled every aspect of development for predictable environmental results and assured real estate values. Planned unit developments adhered even more strictly to the suburban aesthetic than industrial parks. They usually included larger open spaces and extensive landscaping and restricted supporting uses other than single-family housing. In both of the first two office parks—the 1952 Office Park in Mountain Brook, Alabama, outside of Birmingham, and the 1955 Hobbs Brook Office Park in Waltham, Massachusetts, along Route 128—developers relied on the landscape to define an ambience desirable to both suburban communities and white-collar tenants.

In office parks, green borders surround structures and parking lots; narrow green strips, often bermed, break up large expanses of asphalt; and landscaped medians and verges outline interior roads. An ample, sometimes showy landscape expanse that usually includes a sign naming the office park fronts the principal road or highway that connects to the distant downtown fig. 10 . Cory Jackson, the developer of the Mountain Brook Office Park, identified this visual effect as "looking over the treetops instead of the car tops."35

For the local entrepreneurs who built them, landscaping was fundamental to the "definite asset" of office parks: "The attractiveness of a controlled environment."36 Quite unlike corporate campuses and estates, office parks can take a couple of decades to attain full occupancy. Therefore, as buildings are added, the landscape space provides coherence and organization within the development and consistency between it and surrounding residential areas.

Though they gathered far less notice than corporate campuses or estates, office parks were, and continue to be, the most common type of suburban corporate landscape, found in the peripheries of most cities. Early office parks appeared in regional business centers like Birmingham, as well as in major markets such as the Boston metropolitan area.37 By 1960, developers had begun to build office parks in the suburbs of Omaha, St. Paul, and Kansas City (Missouri), as well as additional ones in both Birmingham and Waltham. By 1965, office parks had opened in suburban Atlanta, Oklahoma City, Mobile, Tucson, Englewood (Colorado), Asheville (North Carolina), San Mateo (California), Kansas City, Chattanooga, Wellesley (Massachusetts), El Paso, Houston, and Dallas.38

In 1965, *Industrial Development and Manufacturers Record* reported that office parks housed "middle executives and their staffs" and "a sales force or regional administrative operation." They constituted the personnel of the expansion and decentralization of postwar corporations. Besides corporate tenants, the office park catered to insurance, accounting, architectural, and engineering firms—professional services expanding to meet growing corporate demand.39

By 1970, the term *business park* encompassed the emerging variations of the office park, such as the university research park.40 During the next decade, office parks expanded in size and often included supporting uses such as hotels, restaurants, and service, retail, and day care centers. Developers increasingly realized the marketing value of the landscape design, which in combination with emblematic graphics (the "signage system"), created a sought-after "address" for the business tenants. With relatively cheap land costs, office park designs could be even more ambitious. At Corporate Woods, outside of Kansas City, the main thoroughfare through the project became a "scenic parkway," and the site's amenities included three miles of trails, a golf course, and tennis courts. Office park developers, convening under professional organizations, agreed that landscape design was "second only to parking in importance." This was "a function of why people moved to the suburbs in the first place," they explained; "to enjoy a pastoral environment."41

During the heated speculation of the 1980s, office park plans were marked by an outlandish audacity: huge properties, square-footage targets in the millions, and "photo op" landscape design. The most ambitious was Solana, on the suburban edge of Dallas–Ft. Worth, straddling two towns (Westlake and Southlake) and developed by joint partnership between Maguire Thomas Partners and IBM, the lead tenant. The nine-hundred-acre site contained 7 million square feet of office space (3 million occupied by IBM), a two-hundred-room hotel, an athletic club, and several restaurants and retail and service businesses fig. 11 .42 A large team designed the complex, under the leadership of the landscape architects Peter Walker and Martha Schwartz, who devised the site concept and master plan. Dubbed "Vaux on the prairie" by one critic (a reference to the seventeenth-century splendor of Vaux-le-Vicomte, outside Paris),

Louise A. Mozingo

Solana received worldwide publicity, with coverage in the design press of Japan, Germany, Great Britain, and Italy.43

The Dissembling Pastoral Corporation

The most apparent significance of the corporate campus, corporate estate, and office park is their common role in the relocation of white-collar work. They were the means by which the leaders of postwar capitalism fled the urban core: a vivid abandonment of the city center by the powerful, self-interested parties that keep cities going. This is most heartbreakingly obvious in smaller cities dominated by single corporations, such as Moline, Illinois. There, Deere & Company's exit left a decimated downtown that dwindled for decades. The business leaders who built corporate campuses, corporate estates, and office parks powerfully shaped postwar American urbanism and locked into place the last keystone in the automobile landscape, with all its attendant difficulties. Complacent at the insulated suburban periphery are the people who, like Bill Gates, ensconced in the Microsoft Corporate Campus, run the world.

Beyond their role in reshaping the American city, the import of these landscapes lies in their cheerful reconception of the troubling corporate endeavor. What Richard Walker so aptly terms the American "well-honed taste for the Arcadian look" enabled corporations to mask the ugly results of managerial capitalism.44 This most useful corporate disguise was clearly enunciated by Gabriel Hauge, a New York business bank president, in a speech at the inauguration of the Deere & Company Administrative Center. He first conceded to the assembly of top industrial financiers and executives: "The creation of wealth is not necessarily a lovely process. People can get hurt, skills can be rendered obsolete, investment can lose value, natural resources have to be put to the uses of man, and in the process beautiful landscapes have to be scratched, trees have to be cut down." He countered that gloomy estimation with the assurance that the Administrative Center would attest to a progressive, public-minded institution: "[We] are witnessing an impressive manifestation of the business community thinking greatly of its functions. I speak now not only of all the efforts that businessmen contribute in their communities unrelated to their own activities, but also of pursuing and seeking excellence in the way this enterprise has achieved it in this great new nerve center for Deere & Company."45

At an extreme, the campus, estate, and office park became vehicles for out and out corporate duplicity. The reconstructed wetlands and restored woodlands of Boeing Longacres Park spin a tale of environmental responsibility, of abiding by, even extending beyond, environmental regulations for the public good, of literally having environmental concerns at the core of corporate life. Yet in the same year that construction began at Longacres, *Fortune* singled out Boeing as one of ten egregious corporate "environmental laggards," noting the company's beyond the norm increases in toxic, chemical, and solid waste production.46

In the 1951 essay "Ghosts at the Door," J. B. Jackson wrote of the American lawn: "in an indefinable way the lawn is . . . the background for conventionally correct behavior. . . . In America the lawn is more than essential, it is the heart and very soul of the front yard . . . that landscape element that every American values most."47 With a seductive, dissembling élan, the corporate campus, the corporate estate, and the office park gave corporate capitalism a front yard, with, as Jackson said, "its vague but nonetheless real social connotations."

Originally published in Everyday America: Cultural Landscape Studies after J. B. Jackson, edited by Chris Wilson and Paul Groth. ©2003 The University of California Press

Notes

The preparation of this article was supported by a Harvard University Dumbarton Oaks Fellowship for Studies in Landscape Architecture, a Humanities Research Fellowship of the University of California, Berkeley, and the Beatrix Farrand Fund of the Department of Landscape Architecture and Environmental Planning, University of California, Berkeley. Site visits were funded by a Committee on Research Junior Faculty Grant of the University of California, Berkeley.

1. Richard Walker, "A Theory of Suburbanization: Capitalism and the Construction of Urban Space in the United States," in *Urbanization and Urban Planning in Capitalist Society,* ed. Michael Dear and A. J. Scott (New York: Methuen, 1981), pp. 383–429; John R. Stilgoe, *Borderland: Origins of the American Suburb, 1920–1939* (New Haven: Yale University Press, 1988); and Kenneth T. Jackson, *Crabgrass Frontier* (New York: Oxford University Press, 1985).

2. Alfred Dupont Chandler, Jr., *The Visible Hand: The Managerial Revolution in American Business* (Cambridge: Harvard University Press, 1977), and Chandler, *Scale and Scope: The Dynamics of Industrial Capitalism* (Cambridge: Harvard University Press, Belknap Press, 1990).

3. J. B. Jackson, "The Popular Yard," *Places* 4, no. 3 (1987): 26, 30.

4. Wayne G. Broehl, *John Deere's Company: The Story of Deere and Company and Its Times* (New York: Doubleday, 1984), pp. 614–15.

5. "Should Management Move to the Country," *Fortune* 46, no. 6 (December 1952): 166.

6. L. Andrew Reinhard and Henry Hofmeister, "New Trends in Office Design," *Architectural Record* 97, no. 3 (March 1945): 99–101; Douglas Lathrop, "New Departures in Office Building Design," *Architectural Record* 102, no. 4 (October 1947): 119–23; Francis Bello, "The City and the Car," *Fortune* 56, no. 4 (October 1957): 192.

7. General Foods, *GF Moving Day and You* (New York: General Foods, 1952).

8. "Should Management Move to the Country," 166.

9. Employees of the former General Foods, now part of Kraft Foods, interviewed by the author, June 1997.

10. "Why Companies Are Fleeing the Cities," *Time,* April 26, 1971, pp. 86–88; Richard Reeves, "Loss of Major Companies Conceded by City Official," *New York Times,* February 5, 1971; J. Roger O'Meara, "Executive Suites in Suburbia," *Conference Board Report* 9, no. 8 (August 1972): 6–16; Herbert E. Meyer, "Why Corporations Are on the Move," *Fortune* 92, no. 5 (May 1976): 252–72.

11. "Offices Move to the Suburbs," *Business Week,* March 17, 1951, p. 82.

12. "Explains Plans of Laboratory," *Newark News,* August 1, 1930.

13. William Story, "Advertising the Site through Good Design," *Landscape Architecture* 49, no. 3 (spring 1959): 144.

14. "For Corporate Life '57," *Newsweek,* September 16, 1957, pp. 114–15; "Building with a Future," *Time,* September 16, 1957, p. 91; "Symposium in a Symbolic Setting," *Life,* October 21, 1957, pp. 49–54.

15. "Should Management Move to the Country," p. 116; O'Meara, "Executive Suites in Suburbia"; Meyer, "Why Corporations Are on the Move."

16. "Should Management Move to the Country," 168.

17. Philip Herrera, "That Manhattan Exodus," *Fortune* 75, no. 6 (June 1967): 144.

18. Reeves, "Loss of Major Companies," 39.

19. Robert Hewitt, quoted in "Administrative Center" video presentation at the Deere & Company Administrative Center, Moline, Illinois, viewed by the author June 1997.

20. Mildred Reed Hall and Edward T. Hall, *The Fourth Dimension in Architecture: The Impact of Building on Behavior* (Santa Fe: Sunstone Press, 1975), pp. 58, 61.

21. Edward H. Laird, "Electronics Park: An Industrial Center for the General Electric Company," *Landscape Architecture* 38, no. 1 (October 1946): 16.

22. Roland Marchand, *Advertising the American Dream: Making the Way for Modernity, 1920–1940* (Berkeley: University of California Press, 1998).

23. Kenneth A. Meade, "The Shortage of Scientific Personnel: What Industry Is Doing About It" (address to the National Association for the Advancement of Science) *Science* 105, no. 2731 (May 1947): 460.

24. "New View of Metals," *Business Week,* August 27, 1955, p. 158.

25. Francis Bello, "The World's Greatest Industrial Laboratory," *Fortune* 58, no. 5 (November 1958): 155.

26. Laird, "Electronics Park," pp. 14–16; "Electronics Park, Syracuse, New York," *Architectural Record* 105, no. 2 (February 1949): 96–103; "Large Corporation Builds a Research Campus in New Jersey," *Architectural Record* 106, no. 4 (October 1949): 108–14; Clifford F. Rassweiler, "The Johns-Manville Research Center Six Years Later," *Architectural Record* 118, no. 3 (September 1955): 222–24.

27. Russell Lynes, "After Hours: The Erosion of Detroit," *Harper's,* January 1960, pp. 24. Lynes is the author of *The Tastemakers* (New York: Grosset and Dunlap, 1949); Peirce Lewis commends him thus: "Nobody has written more perceptively and engagingly about [taste in America] than Russell Lynes." See Peirce Lewis, "American Landscape Tastes," in *Modern Landscape Architecture: A Critical Review,* ed. Marc Treib (Cambridge: MIT Press, 1993), pp. 2–18.

28. Christopher Tunnard and Boris Pushkarev, *Man-Made America: Chaos or Control* (New Haven: Yale University Press, 1964), p. 294.

29. "IBM West Coast Programming Center," *Process Architecture* 85 (October 1989): 74–77.

30. Philip Enquist, Skidmore, Owings and Merrill, interviewed by the author, June 1993.

31. Louise A. Mozingo, "The Corporate Estate in the USA, 1954–64: 'Thoroughly modern in concept, but . . . down to earth and rugged,'" *Studies in the History of Gardens and Designed Landscapes* 20, no. 1 (January–March 2000): 25–55.

32. *The Donald M. Kendall Sculpture Gardens* (Harrison, N.Y.: PepsiCo [1997?]); "Weyerhaeuser Corporate Headquarters," *Process Architecture* 85 (October 1989): 44–49; Peter Walker, interview with the author, November 1997.

33. Laurie Olin, "Regionalism and the Practice of Hanna/Olin, Ltd.," in *Regional Garden Design in the United States,* ed. Therese O'Malley and Marc Treib (Washington, D.C.: Dumbarton Oaks, 1995), pp. 243–69; Mildred Schmertz, "Recollection and Invention," *Architectural Record* 176, no. 1 (January 1988): 62–72; Robert Campbell, "Arts and Crafts Spirit Pervades Corporate Offices," *Architecture: AIA Journal* 77, no. 5 (May 1988): 139–43; Robert Campbell, "Intimations of Urbanity in a Bucolic

Setting," *Architecture: AIA Journal* 77, no. 1 (January 1988): 72–77; Ellen Posner, "Harmony Not Uniqueness," *Landscape Architecture* 79, no. 4 (May 1989): 43–49; Jory Johnson, "Codex World Headquarters: Regionalism and Invention," *Landscape Architecture* 78, no. 3 (April–May 1991): 155–63; Stephen Kliment, "Rooms with a View," *Architectural Record* 181, no. 11 (November 1993): 80–85.

34. "Wooing White Collars to Suburbia," *Business Week,* July 8, 1967, p. 97.

35. J. Ross McKeever, *Business Parks: Office Parks, Plazas, and Centers* (Washington, D.C.: Urban Land Institute, 1971), p. 18.

36. "The Office Park: A New Concept in Office Space," *Industrial Development and Manufacturers Record* 134, no. 9 (September 1965): 9–13.

37. "Wooing White Collars," 97.

38. McKeever, *Business Parks,* 45–67; "The Office Park," 13–14.

39. "The Office Park," 9–13.

40. McKeever, *Business Parks,* p. 8.

41. National Association of Industrial and Office Parks Education Foundation, *Office Park Development: Comprehensive Examination of Elements of Office Park Development* (Arlington, Va.: National Association of Industrial and Office Parks, 1984), p. 42.

42. Marita Thomas, "Superb Teamwork Forges 'Age-Proof' IBM Center," *Facilities and Management* 82, no. 2 (February 1989): 48–55.

43. David Dillon, "And Two in the Country," *Landscape Architecture* 80, no. 3 (March 1990): 62–63; "IBM Westlake/ Southlake," *Process: Architecture* 85 (October 1989): 106–13; "Solana," *Baumeister* 187, no. 4 (April 1990): 32–34; Alan Phillips, *The Best in Science, Office, and Business Park Design* (London: B.T. Batsford, 1993); "Solana, Texas," *Architettura* 36, no. 10 (October 1990): 224–26.

44. Richard Walker, "A Theory of Suburbanization," 391.

45. Gabriel Hauge, "Gabriel Hauge," in *Deere & Company Administrative Center* (Moline, Ill.: Deere & Company, 1964), p. 17.

46. Faye Rice, "Who Scores Best on the Environment," *Fortune* 128, no. 2 (July 1993): 122.

47. J. B. Jackson, "Ghosts at the Door," in Jackson, *Landscape in Sight: Looking at America,* ed. Helen Lefkowitz Horowitz (New Haven: Yale University Press, 1997), p. 113.

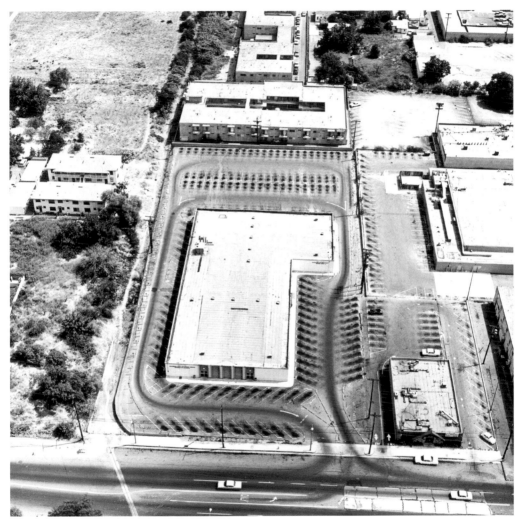

Edward Ruscha *State Dept of Employment, 14400 Sherman Way, Van Nuys* from the series *Parking Lots* 1993/1997 (cat. no. 60)

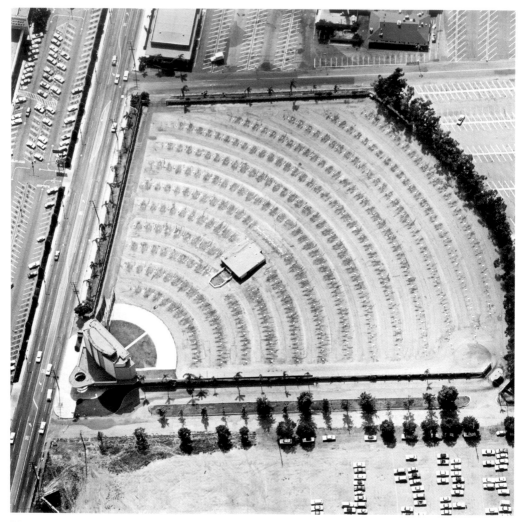

Edward Ruscha *Gilmore Drive-In Theatre, 6201 W. 3rd St* from the series *Parking Lots* 1993/1997 (cat. no. 55)

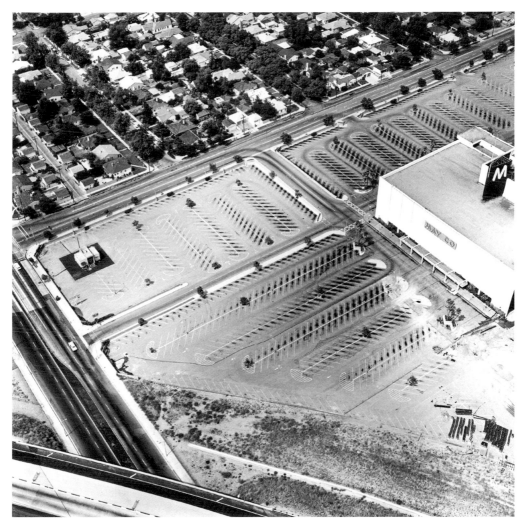

Edward Ruscha *May Company, 6150 Laurel Canyon, North Hollywood* from the series *Parking Lots* 1993/1997 (cat. no. 58)

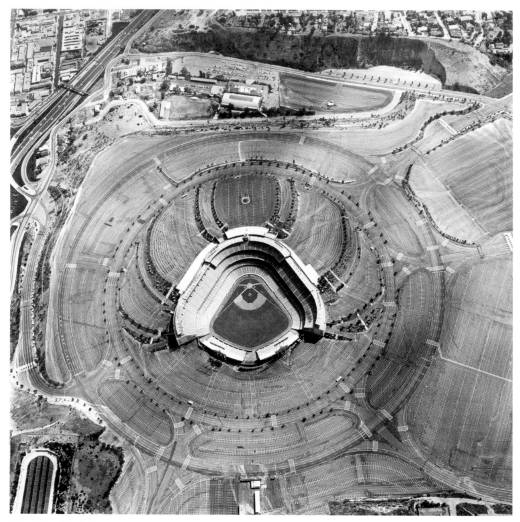

Edward Ruscha *Dodgers Stadium, 1000 Elysian Park Ave.* from the series *Parking Lots* 1993/1997 (cat. no. 54)

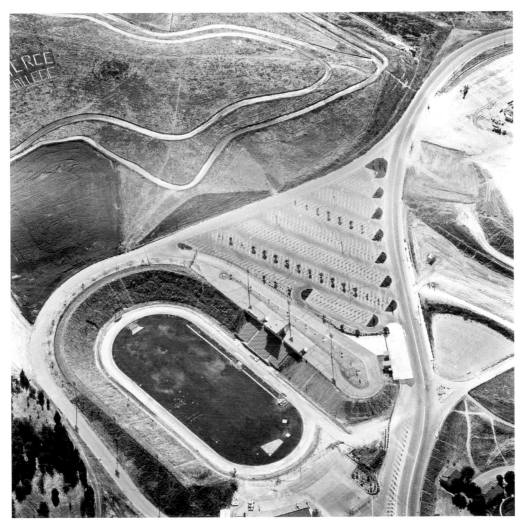

Edward Ruscha *Pierce College, Woodland Hills* from the series *Parking Lots* 1993/1997 (cat. no. 59)

Autotechnogeoglyphics
Vehicular Test Tracks in America

2006–2007

Center for Land Use Interpretation (CLUI)

Like the lines on the Plains of Nazca, automotive test tracks are earthen etchings on a huge scale, partly representative, partly enigmatic, pointing toward the future and the past. They represent the condition of America, land of the automobile, a syndrome that transformed the landscape of the nation, and the world, more than any other. They are the nurseries for the vehicular companions that we can't seem to live with, or without. Despite their vastness, often a few square miles in size, these track complexes are a condensation of space, a microcosm of the country, built for subjecting vehicles to all the types of terrain—from interstates to suburban stop-and-go traffic; from dirt roads to black ice—that the vehicle might encounter in the real world.

The need for space pushes them to the edge of the suburbs, and beyond, where land is cheaper and where visitors are less likely. These are famously secret places where new ideas in this competi-tive, capital-intensive industry are covertly aired. Despite their size, they are supremely surficial, nearly two-dimensional. Outside, on the ground, they are obscure horizontal bands of bermed earth, beyond a distant fence line. From the air, they are fully exposed, laid out like a diagram, hidden in plain sight and curious to behold.

The automotive test tracks of America are located mostly in the West and Midwest. Around Detroit, each of the "big three" automotive companies operates at least one major complex. Tracks are located around Phoenix to test in conditions of extreme heat, in addition to everything else. On the fringes of this city's sprawl are tracks for companies whose home terrain has no desert to work in, such as Volvo, Toyota, Volkswagen, and Nissan. Honda and Hyundai's tracks are in the desert north of Los Angeles. And Caterpillar, the global manufacturer of earth-moving equipment, tests its machines in a giant hilltop sandbox near Peoria, Illinois.

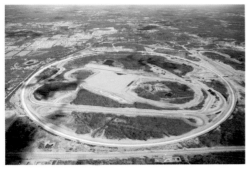

General Motors, Milford, Michigan

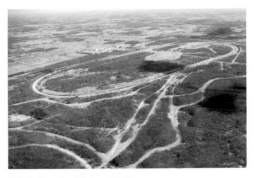

DaimlerChrysler, Chelsea, Michigan

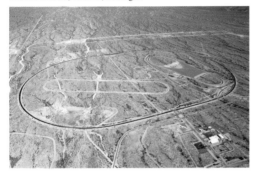

DaimlerChrysler, Wittmann, Arizona

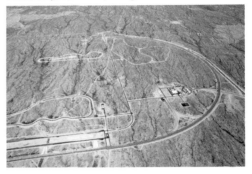

Toyota, Wittmann, Arizona

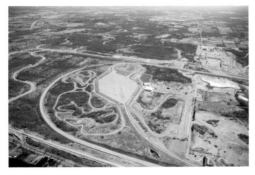

Ford, Romeo, Michigan

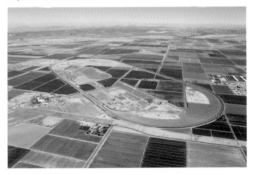

Nissan, Maricopa, Arizona

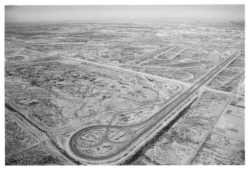

General Motors, Mesa, Arizona

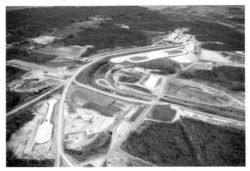

Caterpillar, Peoria, Illinois

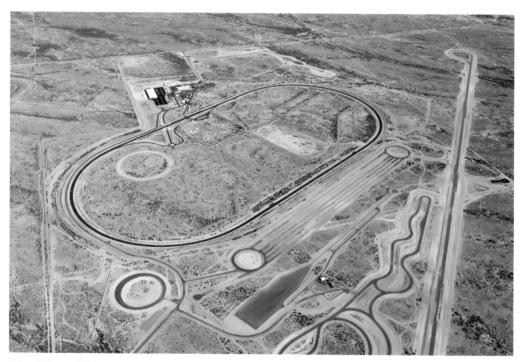

Volvo, Wittmann, Arizona

above (left to right) and previous page: Selections from the series *Autotechnogeoglyphics: Vehicular Test Tracks in America* 2006–2007 (cat. no. 7)

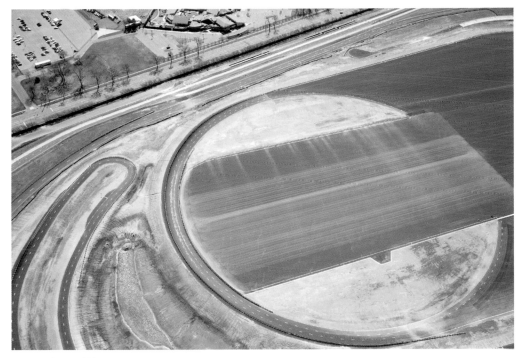

Ford, Dearborn, Michigan

Stefanie Nagorka *Wayne, NJ 2002* from the *Aisle Studio Project* 2002 chromogenic print

Stefanie Nagorka *Portland, OR 2005* from the *Aisle Studio Project* 2005 chromogenic print

203

Stefanie Nagorka *Topeka, KS 2006* from the *Aisle Studio Project* 2006 chromogenic print

Stefanie Nagorka *Shreveport, LA 2004* from the *Aisle Studio Project* 2004 chromogenic print

Julia Christensen *Big Box Reuse: Snowy Range Academy, Laramie, WY* 2005 (cat. no. 9)

Julia Christensen *Big Box Reuse: Head Start, Hastings, NE* 2005 (cat. no. 8)

Julia Christensen *Big Box Reuse: Spam Museum, Austin, MN* 2005 (cat. no. 10)

Julia Christensen *Big Box Reuse: Grace Gospel Church, Pinellas Park, FL* 2007 (cat. no. 11)

Julia Christensen top: *Big Box Reuse: Hong Kong Food Market (Exterior 1), Gretna, LA* 2007 (cat. no. 13)
bottom (left to right): *Big Box Reuse: Hong Kong Food Market (Thank You for Shopping), Gretna, LA* 2007 digital print
Big Box Reuse: Hong Kong Food Market (Aisle 5), Gretna, LA 2007 (cat. no. 12)

The Afterlife of Big Boxes

A Conversation with Julia Christensen

Andrew Blauvelt, July 11, 2007

Julia Christensen is an artist, musician, and writer whose work explores community, land use, and technology. She currently resides amidst the plains of northern Ohio, where she teaches interdisciplinary new media arts at Oberlin College and Conservatory. A book documenting Christensen's research on the reuse of big boxes is forthcoming from MIT Press.

Andrew Blauvelt: Perhaps we should begin with the most obvious question: Why did you become interested in the ways that people reuse empty big box stores?

Julia Christensen: The project started, fittingly enough, in my hometown. I grew up in a small town in central Kentucky called Bardstown, an idyllic, historic place. The buildings downtown are hundreds of years old, cobblestone streets are impeccably preserved, zoning laws are strict, and tourists come from all over just to experience the preserved age of the town. With a population of less than ten thousand people, the city has more than three hundred buildings on the National Register of Historic Places. Meanwhile, Wal-Mart has expanded twice in Bardstown, building new structures for operation, each within a mile or two of the last. So there are currently three sites in Bardstown that Wal-Mart developed—the building that is currently being used and the two that were abandoned before it. These buildings, obviously, stick out in the landscape. And yet, there they are, these big boxes.

AB: Were they reusing these former Wal-Marts?

JC: The city of Bardstown razed the first Wal-Mart site after a decade of vacancy—in order to make way for the new town courthouse. I was instantly transfixed. The courthouse had been in its original downtown location for over two hundred years! Using the old Wal-Mart site as the new courthouse lot was quite a compelling update for a town so invested in its historic integrity. I began asking questions around town about what made the reuse happen, how that decision was made. I was documenting this process in Bardstown, and I simultaneously began researching how other towns were dealing with the same situation, sensing that big box abandonment was a nationwide phenomenon. I learned that towns across the country are actually using the buildings themselves for unlikely

adaptive reuses. Each reuse that I discovered offered a plethora of questions about how our towns are changing due to these buildings and their infrastructure. That's how the project was born.

AB: It seems as though you occupy a kind of "blind spot" in suburban redevelopment. Do you have certain advantages as an artist over others, such as architects or planners, who might be studying the same phenomena?

JC: Absolutely. As an artist, I am not attached to a specific language, rhetoric, or research technique. I am not attached to a financial bottom line either, so I am not trying to dig up specific projected results for an institution or a corporation. I do not have a particular set of data that I am looking for at each site. Actually, when I first started the project, I did have a list of questions I wanted answered at each site I visited. I soon learned that each location actually had a very unique story to tell, and oftentimes my list of questions would be rendered entirely irrelevant at one site, when the same questions had made for great conversation one hundred miles east. I learned quickly that, as an artist, I have flexibility in this regard: I am able to go to a site and allow the creative process to take over, which for me not only borrows from traditional research techniques, but also employs intuition and sensory data while I am absorbing the site. (Although sometimes I do have to fight my own tendencies, because I am hopelessly obsessed with planning and organizing too!) But by working more intuitively on-site, I am able to cull the complexities and textures of the big box reuse phenomenon, rather than just securing answers to the same question again and again.

AB: The idea of research and documentation sounds very factual or technical—although, as you say, an artist can approach the subject in a very different way. Are people open to your inquiries?

JC: Yes, it is interesting. I'm not sure why, but I think people are more willing to share their story with an artist in a way that they would not with an academic, or a corporate entity, or a governmental agency, for instance. Throughout the big box research, I have recognized a freedom that the subjects feel in knowing they are part of an art project. In a way, taking part in an art project contextualizes what they have done as a creative act, which empowers them to think critically about reuse, and so they tell me all about it. Once a journalist went with me to a site to see how my process played out—it was a Kmart-turned-church, I think—and she was amazed at how much these people were telling me, just talking freely to me about religion and Kmart and their families and their homes. They just do not feel me judging them, or putting them in corners, in the way an academic study might.

Meanwhile, as an artist who works with technology, I am interested in exploring the use of typical communication channels to find creative means of distributing information and points of view too. Of course, a lot of technological tools like video cameras and digital still cameras—and indeed the Internet itself—are still very much in the hands of a relatively elite group of people (and constantly in danger of becoming more and more corporate). But utilizing these technological channels in new ways to fulfill part of a creative process is a great way of thinking about the means of making change. Activism is changing these days, just as the entities that are being protested are changing dramatically. And as artists, we are in a great position to experiment and explore technology to find new ways of provoking change. In this way, the work uses digital technology in order to connect people, giving them a platform on which to create discussion about the issue.

AB: Are there distinct reuse typologies that you've noticed across the country. Is there anything that connects these patterns of reuse?

JC: Clear across the board, the first thing that is mentioned in terms of what made the building attractive is the location. These buildings are basically inseparable from the infrastructure, and towns invest loads of money to make the big box accessible, often in order to bring the retailer to town in the first place. When the retailers move on to their next building, a lot of corporation-specific infrastructure is left behind in their wake. So when the reusers get into the buildings, they cite the location as key.

Secondly, reusers cite the space. A supersizing of civic institutions is happening here. People never really seemed to need preschools or churches or guitar stores this big before, but the space has somehow been cited to me over and over as "badly needed." There is a deeply rooted, seemingly unconscious merging of the United States' retail landscape and civic landscape going on.

Structurally, an interesting typology to note is the electrical structure of the buildings, which is, of course, built for aisles. Often this same electrical board is just revamped and reused, and then the hallways run along these same electrical lines—meaning the hallways reach clear from the front of the building to the back. The halls of the school, for instance, run directly along an aisle that perhaps used to move school supplies.

AB: Speaking of infrastructure, the big box seems inseparable from the vast amount of parking lot that supports it. In the reuses you've seen, have the new owners struggled with what to do with these spaces, or is there even such a thing as too much "ample parking"?

JC: Great question. The parking lot is also always cited as one of the most attractive things about the reuse, believe it or not. In fact, the big box is not only inseparable from the parking lot, but also from the infrastructure that supports the parking lot, which is what makes the location central. Big box reuse is definitely very much about "location reuse," not just the reuse of the building. Big box reuse is a reflection of the auto-centric culture that we live in—people want to be able to drive and park right at the doorstep. But I can think of one site, the Head Start preschool in Hastings, Nebraska, in a renovated Kmart store, which sees the parking lot as room to eventually expand their building. Their patrons generally only use a few rows and have about seven rows of parking in front of the building, so in the next decade they foresee the expansion of their preschool out over a few rows of parking.

AB: Is the defunct big box similar to the "dead mall" problem?

JC: The first major difference is that big boxes are not being vacated because the companies are going out of business or because the model does not work. They are abandoning buildings because they are *growing*, building *bigger* structures, and claiming more land. The dead mall phenomenon is associated more with failure. Meanwhile, shopping malls are usually built for multiuses, and big boxes are built for single-use purposes. There is one major entrance and exit to a big box. And of course with big boxes, as opposed to shopping malls, we are looking at a small handful of global corporations that are building all of these structures, so the big box is fairly corporation-specific.

AB: It's amazing to think that it must be cheaper to build new than to shut down or slow down business during a remodel. Do you look at reuse as part of a "natural" economic cycle of a building's life or more as an ad hoc reaction?

JC: Well, it is hard to separate our thinking about the retail sites of the twenty-first century from the term "ad hoc," simply because there seems to be so little planning happening across

the country in terms of retail construction. Driving across the United States, passing strip mall after strip mall, it is generally clear that not a lot of overall planning is going into the development of these sites in relation to one another. On the macro level, if you were to look at the United States from above and chart out the pockets of retail development, you would find that they generally happen in little vacuums, without much consideration of the next. Entire cities are emerging from this ad hoc development, cities that are practically lawless. No thoughtful zoning, no city officials, even. Developers and contractors rule the roost. In fact, this sort of development seems to almost somehow expand the meaning of the word "city," similar to your question's expansion of the word "natural"—what do we mean anymore by "city," or by "natural"? Big box reuse is happening in much the same way. When I go to a site, the renovators are generally unaware that what they are doing is happening all over the country, often right under their noses in the next town.

That said, the act of reuse has always been a natural part of the urban process. Maybe the real impetus for change is in shifting our perception of the big box phenomenon, so that we can understand it as systematic—people are probably going to reuse these structures. We need to place the big box phenomenon in the larger time line of the development of the United States, rather than think it is this ad hoc instance occurring wild and uncontrolled. It is important not only to think critically about where the big box development pattern came from, or how the cycle started, but also where it is *leading*, and what the *future* segment of the cycle has in store.

AB: The title of your project is "How Communities Are Reusing the Big Box," which is interesting to me in that the word "community" is invested with particular significance. Although a public structure, the big box is still private property. Do you find the reuse of these buildings to be more civically inclined than their retail predecessors?

JC: Well, that's the title at the top of my Web page, but I rarely think of the project as having a single title. I really feel like it has so many titles, with so many interrelated segments that are ongoing and for a diverse set of audiences. My forthcoming book is currently titled *Big Box Reuse*, which is the title I am used to at the moment, possibly because the book has taken up the better part of my attention for the past twelve months. But the community aspect is definitely important too, so I am glad to address that.

First of all, the project is definitely about people as much as it is about buildings or roads or stoplights, so the community aspect refers to the human stories that make up this research. The research focuses on communities and how they are absorbing this development. Land use issues are a wonderful indicator of larger cultural issues, and big box reuse has been a great conduit to those larger issues that often affect the "community."

So in that sense, the term "community" simply relates to a group of people with a shared interest, reusing a big box for something other than retail. This community aspect (along with the ownership of the boxes) definitely ranges within the wide spectrum of "private" and "public," the divisions of which are always questionable these days. This project has actually showed me over and over how private the public is, and how those two concepts are hardly dichotomous anymore.

In terms of actual community involvement in the reuse, this varies too. I have written a chapter in my book about a library in Missouri in a renovated Kmart, the Lebanon-Laclede County Library. In that case, the town seriously came out and worked on the structure. Everybody in town did something to adapt the building to its new use, from laying carpet

to designing sculptures for the hallway to donating money. And having the reuse be for the town's public library made the whole thing a very community-minded endeavor. Meanwhile, I have visited the Spam Museum in Austin, Minnesota, in a renovated Kmart building. There the situation is entirely corporate, since Hormel bought and renovated the building. They actually employed a LEED-certified firm out of Mankato, Minnesota [Paulsen Architects], that thought critically about how the reuse would play out over time. There are a lot of characteristics at the site that are adjustable according to the use of the community in the building, meaning the employee base. So this community is entirely private—a corporate community. It is questionable, I suppose, for me to even call them a community. But they call themselves a community!

This project is very much about documenting what I see and letting the audience make the call about what such a community means. Maybe the use of the word "community" to apply to this range of public and private groups of people is indicative of a change in the United States, despite my own feelings on the matter.

AB: A church is such a part of a community. What is the range of uses people have given to these spaces?

JC: The uses that this project has identified are primarily civic, or at least not retail. Part of this is because the corporations that build the structures have future-reaching stipulations on the deeds to ward off competition, so it is actually tougher for some retailers to get their hands on these buildings—especially competing big boxes! You can bet a Wal-Mart building will never become a Kmart building, for example. I have heard of such rules in the deeds reaching for up to a century in the future. For this reason, a lot of the sites that initially emerged in my study were civic-minded. A library offers less competition to a Kmart than a Big Lots or a Wal-Mart.

As I visited these sites, I just became fascinated with the ways in which communities adopt corporation-specific infrastructure for civic uses, which is really at the heart of the research. In terms of the range of these uses, I have seen churches, charter schools, senior resource centers, go-kart tracks, museums, libraries, preschools—all in abandoned Wal-Mart, Kmart, Home Depot buildings.

AB: Have you encountered strong resentment from the communities about these defunct buildings, feelings of abandonment?

JC: Sure, of course. People are sad, confused, angry, and mad about abandoned big box stores. I have never talked to anyone who is happy about it. Well, I take that back—I met a flea market owner who loves when Wal-Mart buildings are vacated because he snatches up the leases and makes flea markets out of them. In fact, he likes it when Wal-Mart moves right across the street because he loves the overflow of Wal-Mart business to his flea market in the abandoned Wal-Mart sites. Traffic overlap.

For the most part, though, people do not like empty big boxes, meaning the buildings themselves. This project has always focused on the *buildings*, and the *future* of the communities that have been dealt an empty building, rather than on the *corporations* who built the structures in the *past*. This focus on the future has been really effective in getting people to talk about their relationship to these buildings—and to the larger big box issues too—without feeling pigeonholed, categorized, or criticized. By framing this discussion in the productive act of reuse, figuring out what we should do about the empty buildings for the future, towns find empowerment and savvy. By

thinking critically about their landscape, they gain control over the development of future buildings too.

But the resentment about the buildings is generally inextricable from resentment about the retailers. The complexities of the big box issues are tough to get at. We are used to hearing about the extremities: the fights against big box retailers, and the struggle of rural poor dependence on big box retailers. I think it is crucial that we also consider the huge range in between those extremities. We rarely hear much about the people who have this love-hate relationship with the retailers, which is so present all over the country. This is definitely the attitude that I run into the most, the "I-hate-them-but-I-shop-there-anyway" attitude or the "I-know-about-the-sweatshops-but-I-still-buy-my-clothes-there" attitude. It is crucial to explore and try to understand this nonchalant awareness in figuring out how to make change.

Of course, this is a part of a feedback loop started by the retailers, since big box corporations have removed shopping alternatives in many towns and have created such powerful reliance on their stores. People feel as if they have no control over their town's landscape, or its economic state, because the companies have so much power. They shop there because they feel "there is nothing they can do about it." In this sense, it is important to note that activism needs to test new waters here—and indeed, lots of great thinkers are expanding how we think about activism, including the Yes Men and the Critical Art Ensemble—because we are faced with corporations that are operating differently from anything we have encountered in the past. Talking about big box issues has been a wonderful conduit to open up discussion about the larger cultural issues, including resentment and anger.

AB: Do you see your role with the project as a kind of neutral documentarian or as more of an agent for change? And why?

JC: In regard to this project, I do not see the difference, honestly. I think that I can document this phenomenon as it is emerging on the ground, and that in itself will indeed spark change. No matter how "neutral" the presentation remains, the subject matter is anything but neutral! It does not need *me* to render it political, because that is inherent. I mean, with the artwork, I just feel so strongly that the documents speak for themselves, and that the story is there. I am willing to take the risk that the audience will think critically about what this phenomenon is telling us about culture when they see the evidence of this land-use pattern. There are some really powerful messages about our culture embedded in these reuses, and it has been very effective to let audience members connect this to their own lives, reaching conclusions about how these corporations are altering the landscape. By asserting myself less, it has made room for the subjects and the audience to assert themselves more. Sometimes the most powerful realizations are the ones people come to themselves, without being told.

It is interesting—people are sometimes skeptical about such a stance, even though the project has existed like this for five years and has been effective in just that way. I have put the work out there with the idea that I can display the findings and trust the audience to make their own decisions about this landscape. Even more, I trust that people will take in the documents, and indeed make changes in their own communities as a result. I think it has worked. I have gone into towns to give these "neutral" talks, and then the city councils there have turned around and put moratoriums on big box buildings, or have put design

restrictions on future buildings. I have yet to go into a town and give a "neutral" talk to have them embrace and celebrate the big box!

AB: But I'm sure there is an expectation to take a clear stand—to deliver a verdict, not a discussion.

JC: I guess that is the fear—that if I don't make it polemically clear that the big box is harmful, nobody will be able to come to that conclusion on their own. As artists, I suppose it is easy to forget that we are rarely making our art pieces solo, on our own, since they would simply not be anything at all if it were not for the audience that receives them. I just happen to find a lot of excitement in creating on that line between the artist and the audience, and placing work on that line too. My work is really inseparable from the audience. We work in tandem, making the concepts live.

I was just at a dinner party in Oberlin, Ohio, where someone asked me to tell the group about the big box reuse project. I gave the usual first one-liner, a description of the project, and immediately a heated one-hour discussion ensued about the impact of these buildings. Everyone talked very candidly and openly about the complexities of their own community's reliance on these buildings, despite their hate of the retailers, how the shapes of their communities were changing, questioning how to fight effectively so that they might bend the direction of the future. And then finally, after this lively discussion with me taking it all in, someone turned to me and said, "Great project." I like to think I have discovered and cultivated a platform upon which people may work these things out themselves. In that way, the audience is just as responsible as I am, which is a really empowering way to think about the future.

The Terrazzo Jungle

Fifty years ago, the mall was born. America would never be the same.

Malcolm Gladwell

Malcolm Gladwell, a staff writer for <u>The New Yorker,</u> is the author of such books as <u>The Tipping Point: How Little Things Can Make a Big Difference</u> (2001) and <u>Blink: The Power of Thinking Without Thinking</u> (2005).

Victor Gruen was short, stout, and unstoppable, with a wild head of hair and eyebrows like unpruned hedgerows. According to a profile in *Fortune* (and people loved to profile Victor Gruen), he was a "torrential talker with eyes as bright as mica and a mind as fast as mercury." In the office, he was famous for keeping two or three secretaries working full time, as he moved from one to the next, dictating nonstop in his thick Viennese accent. He grew up in the well-to-do world of pre-war Jewish Vienna, studying architecture at the Vienna Academy of Fine Arts—the same school that, a few years previously, had turned down a fledgling artist named Adolf Hitler. At night, he performed satirical cabaret theatre in smoke-filled cafés. He emigrated in 1938, the same week as Freud, when one of his theatre friends dressed up as a Nazi Storm Trooper and drove him and his wife to the airport. They took the first plane they could catch to Zurich, made their way to England, and then boarded the S.S. Statendam for New York, landing, as Gruen later remembered, "with an architect's degree, eight dollars, and no English." On the voyage over, he was told by an American to set his sights high—"don't try to wash dishes or be a waiter, we have millions of them"—but Gruen scarcely needed the advice. He got together with some other German émigrés and formed the Refugee Artists Group. George S. Kaufman's wife was their biggest fan. Richard Rodgers and Al Jolson gave them money. Irving Berlin helped them with their music. Gruen got on the train to Princeton and came back with a letter of recommendation from Albert Einstein. By the summer of 1939, the group was on Broadway, playing eleven weeks at the Music Box. Then, as M. Jeffrey Hartwick recounts in *Mall Maker*, his new biography of Gruen, one day he went for a walk in midtown and ran into an old friend from Vienna, Ludwig Lederer, who wanted to open a leather-goods boutique on Fifth Avenue. Victor agreed to design it, and the result was a revolutionary storefront, with a kind of mini-arcade in the entranceway, roughly seventeen by fifteen feet: six exquisite glass cases, spotlights, and faux marble, with green corrugated glass on the ceiling. It was a "customer

trap." This was a brand-new idea in American retail design, particularly on Fifth Avenue, where all the carriage-trade storefronts were flush with the street. The critics raved. Gruen designed Ciro's on Fifth Avenue, Steckler's on Broadway, Paris Decorators on the Bronx Concourse, and eleven branches of the California clothing chain Grayson's. In the early fifties, he designed an outdoor shopping center called Northland outside Detroit for J. L. Hudson's. It covered a hundred and sixty-three acres and had nearly ten thousand parking spaces. This was little more than a decade and a half since he stepped off the boat, and when Gruen watched the bulldozers break ground he turned to his partner and said, "My God but we've got a lot of nerve."

But Gruen's most famous creation was his next project, in the town of Edina, just outside Minneapolis. He began work on it almost exactly fifty years ago. It was called Southdale. It cost twenty million dollars, and had seventy-two stores and two anchor department-store tenants, Donaldson's and Dayton's. Until then, most shopping centers had been what architects like to call "extroverted," meaning that store windows and entrances faced both the parking area and the interior pedestrian walkways. Southdale was introverted: the exterior walls were blank, and all the activity was focussed on the inside. Suburban shopping centers had always been in the open, with stores connected by outdoor passageways. Gruen had the idea of putting the whole complex under one roof, with air-conditioning for the summer and heat for the winter. Almost every other major shopping center had been built on a single level, which made for punishingly long walks. Gruen put stores on two levels, connected by escalators and fed by two-tiered parking. In the middle he put a kind of town square, a "garden court" under a skylight, with a fishpond, enormous sculpted trees, a twenty-one-foot cage filled with bright-colored birds, balconies with hanging plants, and a café. The result, Hardwick writes, was a sensation:

> Journalists from all of the country's top magazines came for the Minneapolis shopping center's opening. *Life, Fortune, Time, Women's Wear Daily,* the *New York Times, Business Week* and *Newsweek* all covered the event. The national and local press wore out superlatives attempting to capture the feeling of Southdale. "The Splashiest Center in the U. S.," *Life* sang. The glossy weekly praised the incongruous combination of a "goldfish pond, birds, art and 10 acres of stores all . . . under one Minnesota roof." A "pleasure-dome-with-parking," *Time* cheered. One journalist announced that overnight Southdale had become an integral "part of the American Way."

Southdale Mall still exists. It is situated off I-494, south of downtown Minneapolis and west of the airport—a big concrete box in a sea of parking. The anchor tenants are now J. C. Penney and Marshall Field's, and there is an Ann Taylor and a Sunglass Hut and a Foot Locker and just about every other chain store that you've ever seen in a mall. It does not seem like a historic building, which is precisely why it is one. Fifty years ago, Victor Gruen designed a fully enclosed, introverted, multitiered, double-anchor-tenant shopping complex with a garden court under a skylight—and today virtually every regional shopping center in America is a fully enclosed, introverted, multitiered, double-anchor-tenant complex with a garden court under a skylight. Victor Gruen didn't design a building; he designed an archetype. For a decade, he gave speeches about it and wrote books and met with one developer after another and waved his hands in the air excitedly, and over the past half century that archetype has been reproduced so faithfully on so many thousands of occasions that today virtually every suburban American goes shopping or wanders around or hangs out in a Southdale facsimile at least once or twice a

month. Victor Gruen may well have been the most influential architect of the twentieth century. He invented the mall.

One of Gruen's contemporaries in the early days of the mall was a man named A. Alfred Taubman, who also started out as a store designer. In 1950, when Taubman was still in his twenties, he borrowed five thousand dollars, founded his own development firm, and, three years later, put up a twenty-six-store open-air shopping center in Flint, Michigan. A few years after that, inspired by Gruen, he matched Southdale with an enclosed mall of his own in Hayward, California, and over the next half-century Taubman put together what is widely considered one of the finest collections of shopping malls in the world. The average American mall has annual sales of around three hundred and forty dollars per square foot. Taubman's malls average sales close to five hundred dollars per square foot. If Victor Gruen invented the mall, Alfred Taubman perfected it. One day not long ago, I asked Taubman to take me to one of his shopping centers and explain whatever it was that first drew people like him and Victor Gruen to the enclosed mall fifty years ago.

Taubman, who just turned eighty, is an imposing man with a wry sense of humor who wears bespoke three-piece suits and peers down at the world through half-closed eyes. He is the sort of old-fashioned man who refers to merchandise as "goods" and apparel as "soft goods" and who can glance at a couture gown from halfway across the room and come within a few dollars of its price. Recently, Taubman's fortunes took a turn for the worse when Sotheby's, which he bought in 1983, ran afoul of antitrust laws and he ended up serving a yearlong prison sentence on price-fixing charges. Then his company had to fend off a hostile takeover bid led by Taubman's archrival, the Indianapolis-based Simon Property Group. But, on a recent trip from his Manhattan offices to the Mall at Short Hills, a half hour's drive away in New Jersey, Taubman was in high spirits. Short Hills holds a special place in his heart. "When I bought that property in 1980, there were only seven stores that were still in business," Taubman said, sitting in the back of his limousine. "It was a disaster. It was done by a large commercial architect who didn't understand what he was doing." Turning it around took four renovations. Bonwit Teller and B. Altman—two of the original anchor tenants—were replaced by Neiman Marcus, Saks, Nordstrom, and Macy's. Today, Short Hills has average sales of nearly eight hundred dollars per square foot; according to the Greenberg Group, it is the third-most-successful covered mall in the country. When Taubman and I approached the mall, the first thing he did was peer out at the parking garage. It was just before noon on a rainy Thursday. The garage was almost full. "Look at all the cars!" he said, happily.

Taubman directed the driver to stop in front of Bloomingdale's, on the mall's north side. He walked through the short access corridor, paused, and pointed at the floor. It was made up of small stone tiles. "People used to use monolithic terrazzo in centers," he said. "But it cracked easily and was difficult to repair. Women, especially, tend to have thin soles. We found that they are very sensitive to the surface, and when they get on one of those terrazzo floors it's like a skating rink. They like to walk on the joints. The only direct contact you have with the building is through the floor. How you feel about it is very important." Then he looked up and pointed to the second floor of the mall. The handrails were transparent. "We don't want anything to disrupt the view," Taubman said. If you're walking on the first level, he explained, you have to be able, at all times, to have an unimpeded line of sight not just to the stores in front of you but also to the stores on the second level. The idea is to overcome what Taubman likes to call "threshold resistance," which is the physical and psychological barrier that stands between a shopper and the inside of a store. "You buy something because it is available and attractive," Taubman said. "You can't have any obstacles. The goods have to be all there." When Taubman was designing stores in Detroit, in the

nineteen-forties, he realized that even the best arcades, like those Gruen designed on Fifth Avenue, weren't nearly as good at overcoming threshold resistance as an enclosed mall, because with an arcade you still had to get the customer through the door. "People assume we enclose the space because of air-conditioning and the weather, and that's important," Taubman said. "But the main reason is that it allows us to open up the store to the customer."

Taubman began making his way down the mall. He likes the main corridors of his shopping malls to be no more than a thousand feet long—the equivalent of about three city blocks—because he believes that three blocks is about as far as peak shopping interest can be sustained, and as he walked he explained the logic behind what retailers like to call "adjacencies." There was Brooks Brothers, where a man might buy a six-hundred-dollar suit, right across from Johnston & Murphy, where the same man might buy a two-hundred-dollar pair of shoes. The Bose electronics store was next to Brookstone and across from the Sharper Image, so if you got excited about some electronic gizmo in one store you were steps away from getting even more excited by similar gizmos in two other stores. Gucci, Versace, and Chanel were placed near the highest-end department stores, Neiman Marcus and Saks. "Lots of developers just rent out their space like you'd cut a salami," Taubman explained. "They rent the space based on whether it fits, not necessarily on whether it makes any sense." Taubman shook his head. He gestured to a Legal Sea Foods restaurant, where he wanted to stop for lunch. It was off the main mall, at the far end of a short entry hallway, and it was down there for a reason. A woman about to spend five thousand dollars at Versace doesn't want to catch a whiff of sautéed grouper as she tries on an evening gown. More to the point, people eat at Legal Sea Foods only during the lunch and dinner hours—which means that if you put the restaurant in the thick of things, you'd have a dead spot in the middle of your mall for most of the day.

At the far end of the mall is Neiman Marcus, and Taubman wandered in, exclaimed over a tray of men's ties, and delicately examined the stitching in the women's evening gowns in the designer department. "Hi, my name is Alfred Taubman—I'm your landlord," he said, bending over to greet a somewhat startled sales assistant. Taubman plainly loves Neiman Marcus, and with good reason: well-run department stores are the engines of malls. They have powerful brand names, advertise heavily, and carry extensive cosmetics lines (shopping malls are, at bottom, delivery systems for lipstick)—all of which generate enormous shopping traffic. The point of a mall—the reason so many stores are clustered together in one building—is to allow smaller, less powerful retailers to share in that traffic. A shopping center is an exercise in cooperative capitalism. It is considered successful (and the mall owner makes the most money) when the maximum number of department-store customers are lured into the mall.

Why, for instance, are so many malls, like Short Hills, two stories? Back at his office, on Fifth Avenue, Taubman took a piece of paper and drew a simple cross-section of a two-story building. "You have two levels, all right? You have an escalator here and an escalator here." He drew escalators at both ends of the floors. "The customer comes into the mall, walks down the hall, gets on the escalator up to the second level. Goes back along the second floor, down the escalator, and now she's back where she started from. She's seen every store in the center, right? Now you put on a third level. Is there any reason to go up there? No." A full circuit of a two-level mall takes you back to the beginning. It encourages you to circulate through the whole building. A full circuit of a three-level mall leaves you at the opposite end of the mall from your car. Taubman was the first to put a ring road around the mall—which he did at his mall in Hayward—for the same reason: if you want to get shoppers into every part of the building, they should be distributed to as many different

entry points as possible. At Short Hills—and at most Taubman malls—the ring road rises gently as you drive around the building, so at least half of the mall entrances are on the second floor. "We put fifteen per cent more parking on the upper level than on the first level, because people flow like water," Taubman said. "They go down much easier than they go up. And we put our vertical transportation—the escalators—on the ends, so shoppers have to make the full loop."

This is the insight that drove the enthusiasm for the mall fifty years ago—that by putting everything under one roof, the retailer and the developer gained, for the first time, complete control over their environment. Taubman fusses about lighting, for instance: he believes that next to the skylights you have to put tiny lights that will go on when the natural light fades, so the dusk doesn't send an unwelcome signal to shoppers that it is time to go home; and you have to recess the skylights so that sunlight never reflects off the storefront glass, obscuring merchandise. Can you optimize lighting in a traditional downtown? The same goes for parking. Suppose that there was a downtown where the biggest draw was a major department store. Ideally, you ought to put the garage across the street and two blocks away, so shoppers, on their way from their cars and to their destination, would pass by the stores in between—dramatically increasing the traffic for all the intervening merchants. But in a downtown, obviously, you can't put a parking garage just anywhere, and even if you could, you couldn't insure that the stores in that high-traffic corridor had the optimal adjacencies, or that the sidewalk would feel right under the thin soles of women's shoes. And because the stores are arrayed along a road with cars on it, you don't really have a mall where customers can wander from side to side. And what happens when they get to the department store? It's four or five floors high, and shoppers are like water, remember: they flow downhill. So it's going to be hard to generate traffic on the upper levels. There is a tendency in America to wax nostalgic for the traditional downtown, but those who first believed in the mall—and understood its potential—found it hard to look at the old downtown with anything but frustration.

"In Detroit, prior to the nineteen-fifties, the large department stores, like Hudson's, controlled everything, like zoning," Taubman said. "They were generous to local politicians. They had enormous clout, and that's why when Sears wanted to locate in downtown Detroit they were told they couldn't. So Sears put a store in Highland Park and on Oakland Boulevard, and built a store on the East Side, and it was able to get some other stores to come with them, and before long there were three mini-downtowns in the suburbs. They used to call them hot spots." This happened more than half a century ago. But it was clear that Taubman has never quite got over how irrational the world outside the mall can be: downtown Detroit chased away traffic.

Planning and control were of even greater importance to Gruen. He was, after all, a socialist—and he was Viennese. In the middle of the nineteenth century, Vienna had demolished the walls and other fortifications that had ringed the city since medieval times, and in the resulting open space built the Ringstrasse—a meticulously articulated addition to the old city. Architects and urban planners solemnly outlined their ideas. There were apartment blocks, and public squares and government buildings, and shopping arcades, each executed in what was thought to be the historically appropriate style. The Rathaus was done in high Gothic; the Burgtheatre in early Baroque; the University was pure Renaissance; and the Parliament was classical Greek. It was all part of the official Viennese response to the populist uprisings of 1848: if Austria was to remake itself as a liberal democracy, Vienna had to be physically remade along democratic lines. The Parliament now faced directly onto the street. The walls that separated the élite of Vienna from the unwashed in the suburbs were torn down. And, most important, a ring road, or Ringstrasse—a grand mall—was built around the city, with wide sidewalks and expansive urban views, where

Viennese of all backgrounds could mingle freely on their Sunday afternoon stroll. To the Viennese reformers of the time, the quality of civic life was a function of the quality of the built environment, and Gruen thought that principle applied just as clearly to the American suburbs.

Not long after Southdale was built, Gruen gave the keynote address at a *Progressive Architecture* awards ceremony in New Orleans, and he took the occasion to lash out at American suburbia, whose roads, he said, were "avenues of horror," "flanked by the greatest collection of vulgarity—billboards, motels, gas stations, shanties, car lots, miscellaneous industrial equipment, hot dog stands, wayside stores—ever collected by mankind." American suburbia was chaos, and the only solution to chaos was planning. When Gruen first drew up the plans for Southdale, he placed the shopping center at the heart of a tidy four-hundred-and-sixty-three-acre development, complete with apartment buildings, houses, schools, a medical center, a park, and a lake. Southdale was not a suburban alternative to downtown Minneapolis. It was the Minneapolis downtown you would get if you started over and corrected all the mistakes that were made the first time around. "There is nothing suburban about Southdale except its location," *Architectural Record* stated when it reviewed Gruen's new creation. It is an imaginative distillation of what makes downtown magnetic: the variety, the individuality, the lights, the color, even the crowds— for Southdale's pedestrian-scale spaces insure a busyness and a bustle. Added to this essence of existing downtowns are all kinds of things that ought to be there if downtown weren't so noisy and dirty and chaotic—sidewalk cafés, art, islands of planting, pretty paving. Other shopping centers, however pleasant, seem provincial in contrast with the real thing—the city downtown. But in Minneapolis, it is the downtown that appears pokey and provincial in contrast with Southdale's metropolitan character.

One person who wasn't dazzled by Southdale was Frank Lloyd Wright. "What is this, a railroad station or a bus station?" he asked, when he came for a tour. "You've got a garden court that has all the evils of the village street and none of its charm." But no one much listened to Frank Lloyd Wright. When it came to malls, it was only Victor Gruen's vision that mattered.

Victor Gruen's grand plan for Southdale was never realized. There were no parks or schools or apartment buildings just that big box in a sea of parking. Nor, with a few exceptions, did anyone else plan the shopping mall as the centerpiece of a tidy, dense, multi-use development. Gruen was right about the transformative effect of the mall on retailing. But in thinking that he could reenact the lesson of the Ringstrasse in American suburbia he was wrong, and the reason was that in the mid-nineteen-fifties the economics of mall-building suddenly changed.

At the time of Southdale, big shopping centers were a delicate commercial proposition. One of the first big postwar shopping centers was Shopper's World, in Framingham, Massachusetts, designed by an old business partner of Gruen's from his Fifth Avenue storefront days. Shopper's World was an open center covering seventy acres, with forty-four stores, six thousand parking spaces, and a two-hundred-and-fifty-thousand-square-foot Jordan Marsh department store—and within two years of its opening, in 1951, the developer was bankrupt. A big shopping center simply cost too much money, and it took too long for a developer to make that money back. Gruen thought of the mall as the centerpiece of a carefully planned new downtown because he felt that that was the only way malls would ever get built: you planned because you had to plan. Then, in the mid-fifties, something happened that turned the dismal economics of the mall upside down: Congress made a radical change in the tax rules governing depreciation.

Under tax law, if you build an office building, or buy a piece of machinery for your factory, or make any capital purchase for your business, that investment is assumed to deteriorate and

lose some part of its value from wear and tear every year. As a result, a business is allowed to set aside some of its income, tax-free, to pay for the eventual cost of replacing capital investments. For tax purposes, in the early fifties the useful life of a building was held to be forty years, so a developer could deduct one-fortieth of the value of his building from his income every year. A new forty-million-dollar mall, then, had an annual depreciation deduction of a million dollars. What Congress did in 1954, in an attempt to stimulate investment in manufacturing, was to "accelerate" the depreciation process for new construction. Now, using this and other tax loopholes, a mall developer could recoup the cost of his investment in a fraction of the time. As the historian Thomas Hanchett argues, in a groundbreaking paper in *The American Historical Review*, the result was a "bonanza" for developers. In the first few years after a shopping center was built, the depreciation deductions were so large that the mall was almost certainly losing money, at least on paper—which brought with it enormous tax benefits. For instance, in a front-page article in 1961 on the effect of the depreciation changes, the *Wall Street Journal* described the finances of a real-estate investment company called Kratter Corp. Kratter's revenue from its real-estate operations in 1960 was $9,997,043. Deductions from operating expenses and mortgage interest came to $4,836,671, which left a healthy income of $5.16 million. Then came depreciation, which came to $6.9 million, so now Kratter's healthy profit had been magically turned into a "loss" of $1.76 million. Imagine that you were one of five investors in Kratter. The company's policy was to distribute nearly all of its pre-depreciation revenue to its investors, so your share of their earnings would be roughly a million dollars. Ordinarily, you'd pay a good chunk of that in taxes. But that million dollars wasn't income. After depreciation, Kratter didn't make any money. That million dollars was "return on capital," and it was tax-free.

Suddenly it was possible to make much more money investing in things like shopping centers than buying stocks, so money poured into real-estate investment companies. Prices rose dramatically. Investors were putting up buildings, taking out as much money from them as possible using accelerated depreciation, then selling them four or five years later at a huge profit—whereupon they built an even bigger building, because the more expensive the building was, the more the depreciation allowance was worth.

Under the circumstances, who cared whether the shopping center made economic sense for the venders? Shopping centers and strip malls became what urban planners call "catalytic," meaning that developers weren't building them to serve existing suburban communities; they were building them on the fringes of cities, beyond residential developments, where the land was cheapest. Hanchett points out, in fact, that in many cases the growth of malls appears to follow no demographic logic at all. Cortland, New York, for instance, barely grew at all between 1950 and 1970. Yet in those two decades Cortland gained six new shopping plazas, including the four-hundred-thousand-square-foot enclosed Cortlandville Mall. In the same twenty-year span, the Scranton area actually shrank by seventy-three thousand people while gaining thirty-one shopping centers, including three enclosed malls. In 1953, before accelerated depreciation was put in place, one major regional shopping center was built in the United States. Three years later, after the law was passed, that number was twenty-five. In 1953, new shopping-center construction of all kinds totalled six million square feet. By 1956, that figure had increased five hundred per cent. This was also the era that fast-food restaurants and Howard Johnsons and Holiday Inns and muffler shops and convenience stores began to multiply up and down the highways and boulevards of the American suburbs—and as these developments grew, others followed to share in the increased customer traffic. Malls led to malls, and in turn those malls led to the big stand-alone retailers like

Wal-Mart and Target, and then the "power centers" of three or four big-box retailers, like Circuit City, Staples, Barnes & Noble. Victor Gruen intended Southdale to be a dense, self-contained downtown. Today, fifteen minutes down an "avenue of horror" from Southdale is the Mall of America, the largest mall in the country, with five hundred and twenty stores, fifty restaurants, and twelve thousand parking spaces—and one can easily imagine that one day it, too, may give way to something newer and bigger.

Once, in the mid-fifties, Victor Gruen sat down with a writer from *The New Yorker's* Talk of the Town to give his thoughts on how to save New York City. The interview took place in Gruen's stylish offices on West Twelfth Street, in an old Stanford White building, and one can only imagine the reporter, rapt, as Gruen held forth, eyebrows bristling. First, Gruen said, Manhattan had to get rid of its warehouses and its light manufacturing. Then, all the surface traffic in midtown—the taxis, buses, and trucks—had to be directed into underground tunnels. He wanted to put super-highways around the perimeter of the island, buttressed by huge double-decker parking garages. The jumble of tenements and town houses and apartment blocks that make up Manhattan would be replaced by neat rows of hundred-and-fifty-story residential towers, arrayed along a ribbon of gardens, parks, walkways, theatres, and cafés.

Mr. G. lowered his brows and glared at us. "You are troubled by all those tunnels, are you not?" he inquired. "You wonder whether there is room for them in the present underground jungle of pipes and wires. Did you never think how absurd it is to bury beneath tons of solid pavement equipment that is bound to go on the blink from time to time?" He leaped from his chair and thrust an imaginary pneumatic drill against his polished study floor. "Rat-a-tat-tat!" he exclaimed. "Night and day! Tear up the streets! Then pave them! Then tear 'em up again!" Flinging aside the imaginary drill, he threw himself back in his chair. "In my New York of the future, all pipes and wires will be strung along the upper sides of those tunnels, above a catwalk, accessible to engineers and painted brilliant colors to delight rather than appall the eye."

Postwar America was an intellectually insecure place, and there was something intoxicating about Gruen's sophistication and confidence. That was what took him, so dramatically, from standing at New York Harbor with eight dollars in his pocket to Broadway, to Fifth Avenue, and to the heights of Northland and Southdale. He was a European intellectual, an émigré, and, in the popular mind, the European émigré represented vision, the gift of seeing something grand in the banality of postwar American life. When the European visionary confronted a drab and congested urban landscape, he didn't tinker and equivocate; he levelled warehouses and buried roadways and came up with a thrilling plan for making things right. "The chief means of travel will be walking," Gruen said, of his reimagined metropolis. "Nothing like walking for peace of mind." At Northland, he said, thousands of people would show up, even when the stores were closed, just to walk around. It was exactly like Sunday on the Ringstrasse. With the building of the mall, Old World Europe had come to suburban Detroit.

What Gruen had, as well, was an unshakable faith in the American marketplace. Malls teach us, he once said, that "it's the merchants who will save our urban civilization. 'Planning' isn't a dirty word to them; good planning means good business." He went on, "Sometimes self-interest has remarkable spiritual consequences." Gruen needed to believe this, as did so many European intellectuals from that period, dubbed by the historian Daniel Horowitz "celebratory émigrés." They had fled a place of chaos and anxiety, and in American consumer culture they sought a bulwark against the madness across the ocean. They wanted to find in the jumble of the American marketplace something as grand as the Vienna they had lost—the place where the unconscious was

meticulously dissected by Dr. Freud on Berggasse, and where shrines to European civilization—to the Gothic, the Baroque, the Renaissance, and the ancient Greek traditions—were erected on the Ringstrasse. To Americans, nothing was more flattering than this. Who didn't want to believe that the act of levelling warehouses and burying roadways had spiritual consequences? But it was, in the end, too good to be true. This wasn't the way America worked at all.

A few months ago, Alfred Taubman gave a speech to a real-estate trade association in Detroit, about the prospects for the city's downtown, and one of the things he talked about was Victor Gruen's Northland. It was simply too big, Taubman said. Hudson's, the Northland anchor tenant, already had a flagship store in downtown Detroit. So why did Gruen build a six-hundred-thousand-square-foot satellite at Northland, just a twenty-minute drive away? Satellites were best at a hundred and fifty thousand to two hundred thousand square feet. But at six hundred thousand square feet they were large enough to carry every merchandise line that the flagship store carried, which meant no one had any reason to make the trek to the flagship anymore. Victor Gruen said the lesson of Northland was that the merchants would save urban civilization. He didn't appreciate that it made a lot more sense, for his client, to save civilization at a hundred and fifty thousand square feet than at six hundred thousand square feet. The lesson of America was that the grandest of visions could be derailed by the most banal of details, like the size of the retail footprint, or whether Congress set the depreciation allowance at forty years or twenty years.

When, late in life, Gruen came to realize this, it was a powerfully disillusioning experience. He revisited one of his old shopping centers, and saw all the sprawling development around it, and pronounced himself in "severe emotional shock." Malls, he said, had been disfigured by "the ugliness and discomfort of the land-wasting seas of parking" around them. Developers were interested only in profit. "I refuse to pay alimony for those bastard developments," he said in a speech in London, in 1978. He turned away from his adopted country. He had fixed up a country house outside of Vienna, and soon he moved back home for good. But what did he find when he got there? Just south of old Vienna, a mall had been built—in his anguished words, a "gigantic shopping machine." It was putting the beloved independent shopkeepers of Vienna out of business. It was crushing the life of his city. He was devastated. Victor Gruen invented the shopping mall in order to make America more like Vienna. He ended up making Vienna more like America.

Originally published in <u>The New Yorker</u>, March 15, 2004, 120–127. ©2004 Malcolm Gladwell

In the Meantime, Life with Landbanking

2002/2007

Interboro
Tobias Armborst, Daniel D'Oca, Georgeen Theodore, Christine Williams

In the Meantime, Life with Landbanking is Interboro's proposal for the abandoned Dutchess Mall in Fishkill, New York.

A classic regional shopping center built in 1974, the Dutchess Mall had been situated at a seemingly perfect location at the time: the southeast corner of a major highway interchange in the heart of a county poised for growth. However, market nuances of a location can be hard to predict, and it turned out that this site was all wrong for a shopping center. The region around it has grown steadily over the past three decades, but Poughkeepsie was the magnet for that growth. Even as the Dutchess Mall was dying, this vital suburban strip evolved on a ten-mile stretch just north of the interchange. By the early 1990s, the mall was less than 50 percent occupied, and in 1998, it officially closed its doors.

But the mall didn't die. Detective work revealed that the Dutchess Mall is playing host organism to scores of different bacterial cultures that infuse the site with life. You don't need a microscope to see new growth on the weekends when the popular Dutchess Flea Market fills up the old Service Merchandise anchor store and parking lot with crafts, antiques, hardware, hair salons, specialty foods, heavy-metal memorabilia, and lots and lots of junk. Many other activities— formal and informal, scheduled and erratic, sanctioned and illicit— happen on the site, too: driver's license testing and practice, mobile food vendors, prostitutes meeting clients, truck and mobile home storage, carpool parking, and even the occasional motorcycle rally, political protest, or UFO sighting. Far from having died, the mall has merely transformed.

In the Meantime, Life with Landbanking stems from our suspicion that there is a logic to these faint signals, and that we might do well to emulate that logic. In the spirit of endogenous development—or development that identifies and takes inspiration from the urbanity that exists in a given place, however trivial it might seem—our programs (a nightclub, beer garden, outdoor summer stage, car wash, recycling center, business incubator, day-care center, recreation commons, bus stop, or sculpture garden) can be imagined out of cultures that have already started to grow around the property. The result is not a master plan, but a collection of small, cheap, feasible moves that come in over time and lead to many possible futures.

It may be the case that, with time, a cure will be found and Dutchess Mall will make a full recovery, probably reborn as a distribution, manufacturing, or research center. It's certainly what the developers— who freely admit to landbanking the property for future sale or redevelopment—are hoping for. We are not against the future possibility of such an invasive operation. But in the meantime, we wonder if there aren't options for some alternative therapies.

Interboro

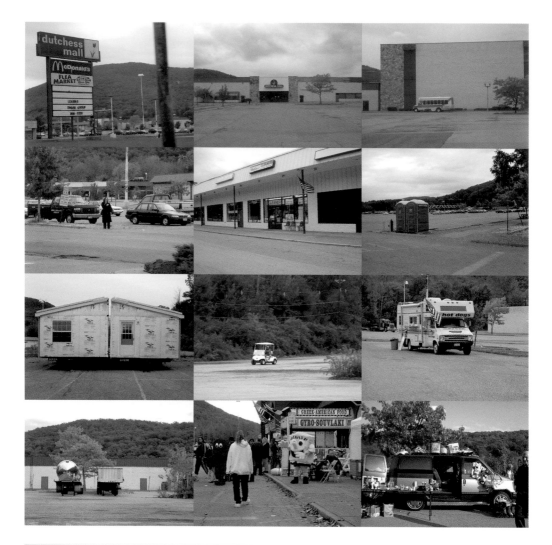

226

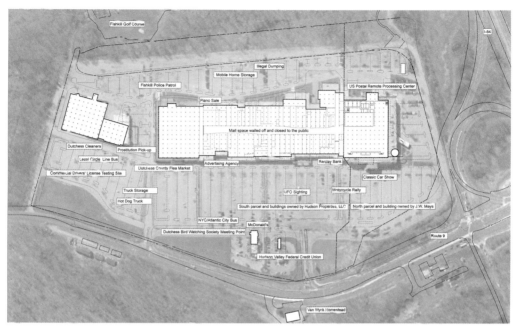

Site plan of Dutchess Mall noting existing uses

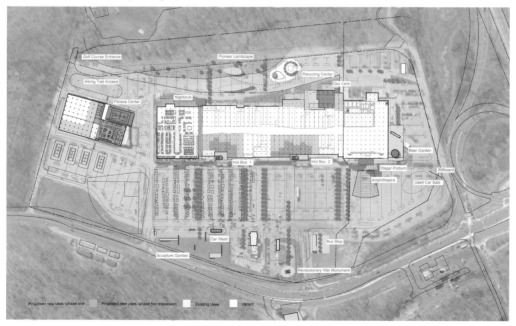

Site plan of Dutchess Mall noting proposed new uses

left: Photos documenting existing Dutchess Mall activities
following page (top to bottom): Rendering of proposed sculpture garden at Dutchess Mall; Rendering of proposed new business incubator at Dutchess Mall

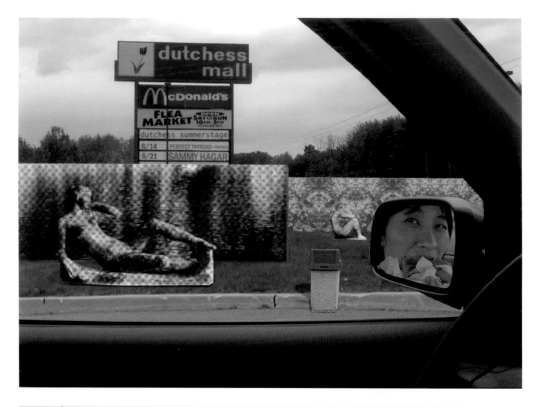

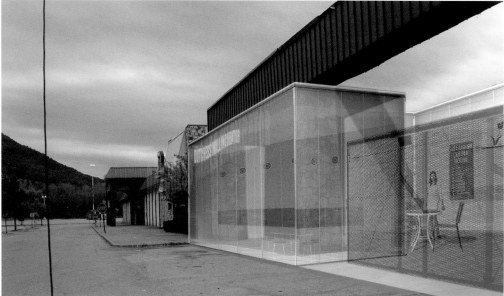

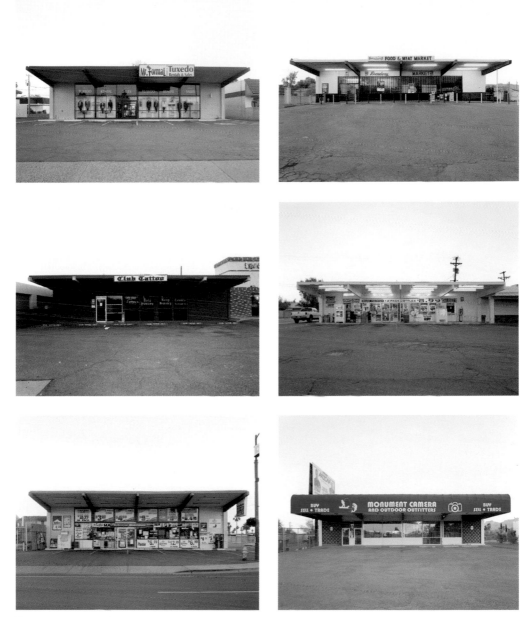

Paho Mann Selections from *Re-inhabited Circle Ks (Phoenix)* 2004–2006 (cat. no. 43)

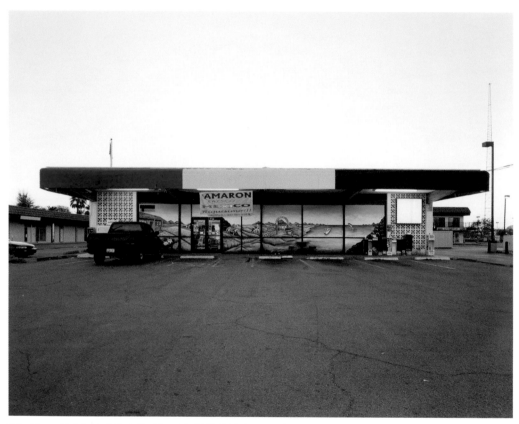

Paho Mann *Re-inhabited Circle Ks (Phoenix)* 2004–2006 (cat. no. 43)

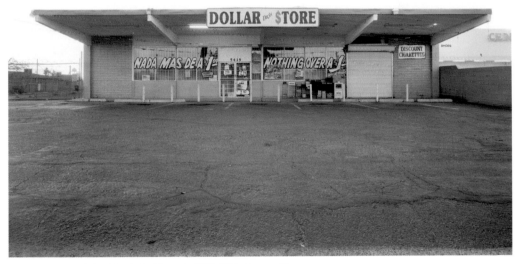

Paho Mann *Re-inhabited Circle Ks (Phoenix)* 2004–2006 (cat. no. 43)

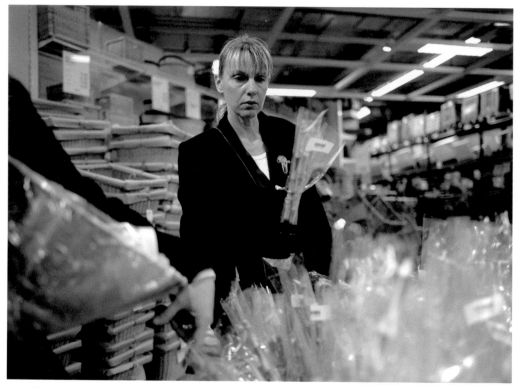

Brian Ulrich *Schaumburg, IL* from the series *Copia/Retail* 2002 (cat. no. 76)

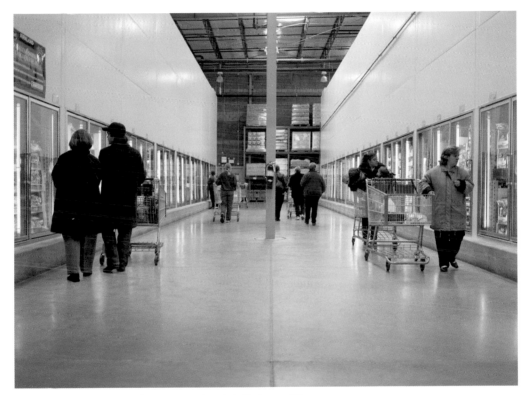

Brian Ulrich *Chicago, IL* from the series *Copia/Retail* 2003 (cat. no. 77)

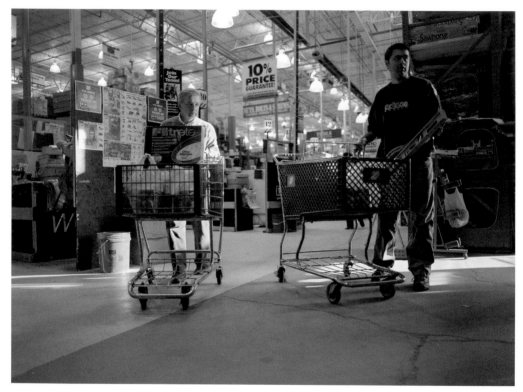

Brian Ulrich *Chicago, IL* from the series *Copia/Retail* 2002 chromogenic print

Flatspace
Resurfacing Contemporary Public Space

2003–2007

Lateral Architecture
Mason White, Lola Sheppard, Neeraj Bhatia, Chris Kupski

Traditional exurban settlement has been increasingly overtaken throughout the last two decades by massive retail corridors and their asphalt networks: big box stores clustered in power centers and their associated access roads, buffer zones, and parking lots. Whether we like it or not, this exurban condition represents our contemporary public realm as North Americans spend more and more time within these spaces negotiating a highly controlled, familiar, and homogeneous environment. The result is a flattened experience of place. The possibilities of intervening in this exurban condition, or what we call "flatspace," on its own terms remain overlooked.

Composed of entirely autonomous components—big box, parking lot, landscape lining—flatspaces are driven by economy and functionality, and lack any articulation of social, cultural, or material specificity. In their subordination to the car and the comfort of mobility, flatspaces are places of sterile transit, or what sociologist Marc Augé terms "non-places." The intent of our interventions, however, is not to make them contextual or regionally specific, but rather to invite more open-endedness and serendipity in people's encounters and to create indeterminate spaces that enhance the public

realm. Rather than reconfiguring the fundamental economic logic that determines and drives this type of environment, we thought it seemed more apt and opportune to concentrate on recalibrating the experience itself.

In its current format, public life in exurbia is composed of fleeting encounters of drivers jockeying for parking spaces, utilitarian dialogues at drive-thrus, and perfunctory exchanges. How can one transform this environment to respond to its unlikely status as an essential contemporary public space? This question inspired several design proposals that reconfigure the "ingredients" of these landscapes, forging new connections, experiences, and definitions of public space.

We selected three key elements of flatspace to modify: *program*, *parking*, and *landscape*. A generic case-study site—five hundred forty-five acres of retail corridor in Columbus, Ohio—was examined. Rather than introduce new elements, each scheme tests the modification of existing ones. With these strategies, we also seek to recognize elements of the absurd in the current conditions of exurbia—its size, efficiency, manicured landscape—and use these as a means for disrupting the uniformity of experience.

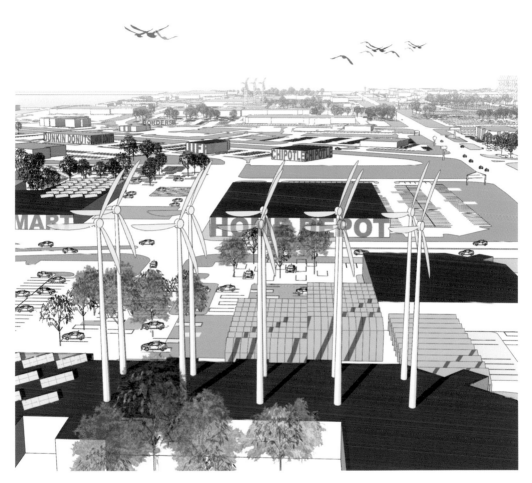

Pixelscape

A pixel in digital terms is composed of three colors that oscillate between varying degrees of purity. In our scheme, pixel types correspond to surface types of building, parking, and landscape. The pixel scheme begins by reading the current landscape as a series of pixels or surface types. Zones of pixel corruption are introduced where the potential exists to hybridize or cross-breed the surface of building, parking, and landscape. The resolution is then "turned up" again, revealing a new "impure" landscape of hybrid conditions, with a mixing of programs and landscapes such as orchard parking, parking-lot greenhouses and markets, rooftop solar panels and wind generators, and parking-lot play surfaces. These hybrids encourage unlikely encounters that contribute to the public sphere.

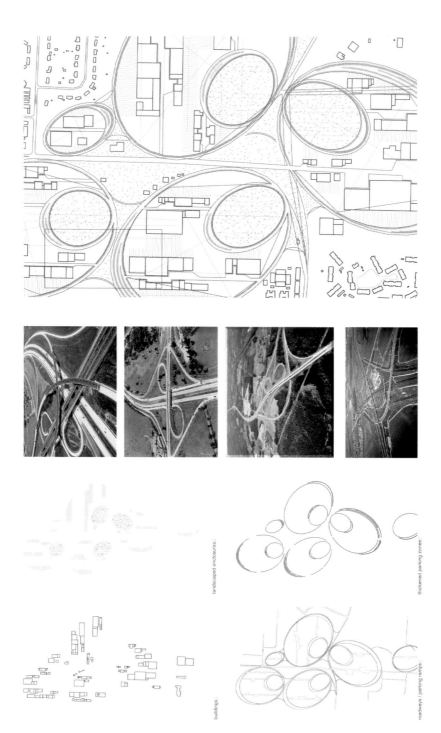

landscaped enclosures::

thickened parking zones::

buildings::

roadways / parking ramps::

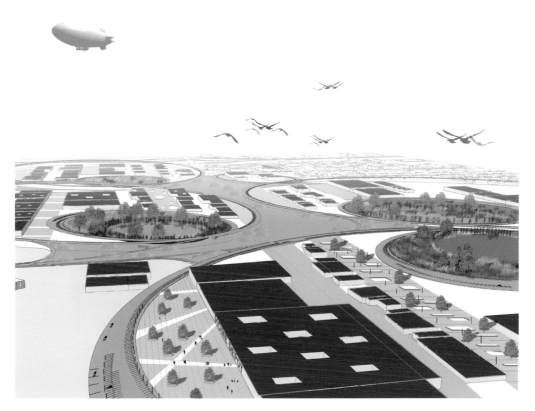

On Off-Ramps

The exurban condition is accessed by highway off-ramps; these threads allow directional change with a speed and smoothness not found at typical intersections. In this scheme, we have incorporated the search for a parking space with a secondary road that is inspired by the smoothness of the off-ramp. These tangentially linked loops offer circumferential parking and concentrate the typical dispersal of landscape buffers into larger wetland parks at the heart of each loop instead of parking lots. Shoppers and park-goers may intermingle in their search for a parking space. By collapsing the ritual for finding parking and road infrastructure into one system, buffer zones are eliminated. The vast area afforded by this synthesis is given over to public space.

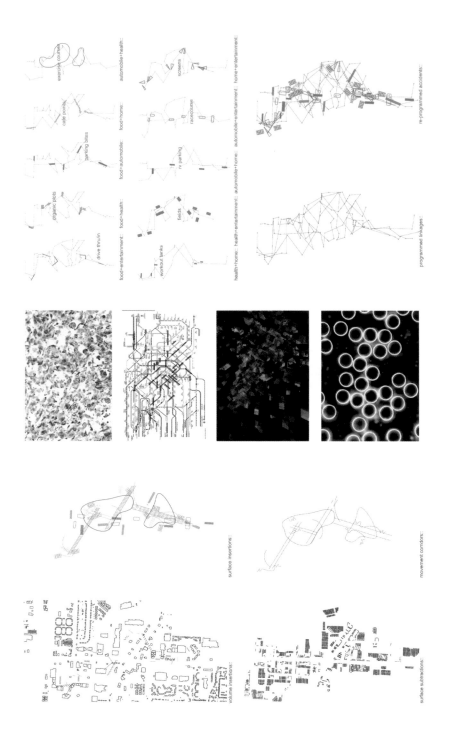

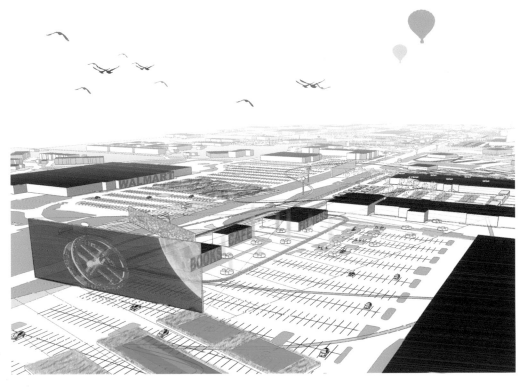

Confetti

The shopper seeking a haircut and the shopper in search of a quick bite may pass each other in their cars in search of closer parking spaces, but the space does not encourage their meeting or interaction. The confetti proposal intervenes in this system through the insertion of a new program generated by "cross-breeding" shopping activities. The new program, located at the intersection of these shopping-pattern movements, is made up of a blend of the programs: food and automobile merge to create parking-lot cafés; automobile and fitness combine to form exercise spaces in the parking lot; or automobile and home hybridize to provide overnight parking for recreational vehicles. By marking the space of collision, the confetti program allows an opportunity for connection among isolated citizens.

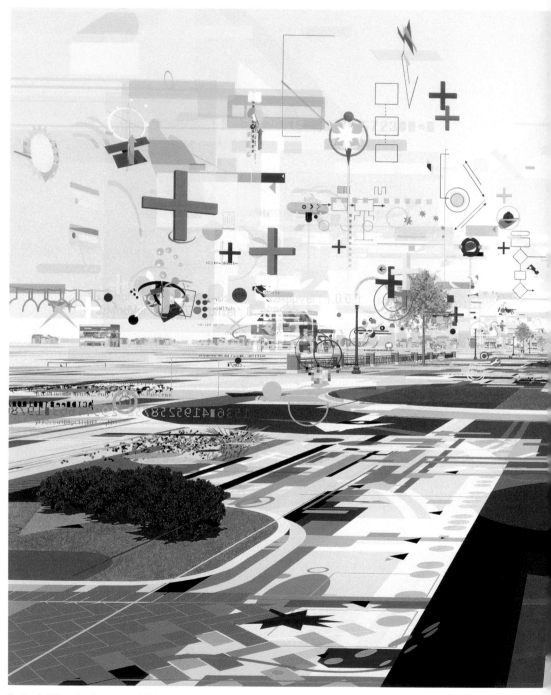

Benjamin Edwards *Immersion* 2004 (cat. no. 20)

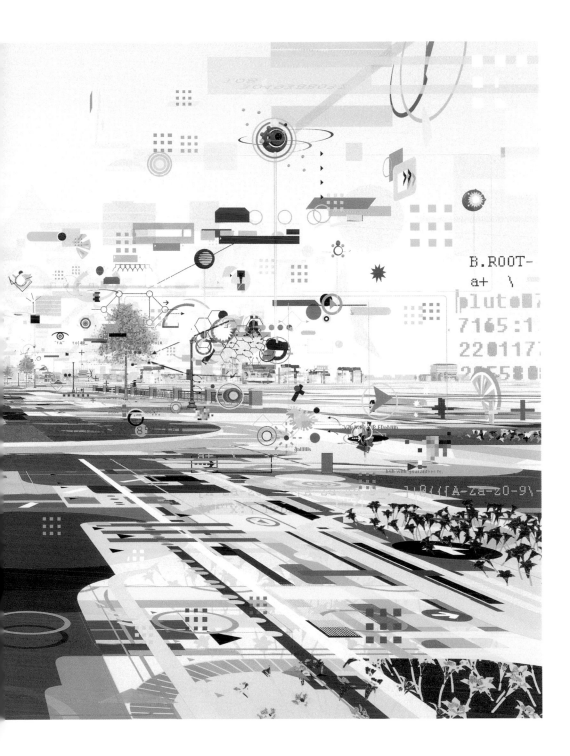

PLACE: K Mart

CATEGORY: megamart

LOCATIONS:

EXPERIENCE consumed
interior
exterior

1. 1500 Bald Hill Rd. Warwick RI (Providence, I-15) X X
2. 1130 Newport Av. S. Attleboro MA (Providence, 55) X X X
3. 1441 Elmwood Av. Cranston RI (Providence)
4. 1386 Atwood Av. Johnston RI (Providence, I-15) X
5. 622 G. Washington Hwy Lincoln RI (Providence, I-1) X

EXTERIOR NOTES:

"Garden Shop"
"Auto Service"
Little Caesars Pizza Station

INTERIOR NOTES:

No directory available
Departments are signified by banners

MISC. NOTES:

Stores open in Manhattan, call no ------ likened to a conquest (boldly going where no Kmart has gone before)
· advertisements frequent in prettimes showing celebrity appearances
· corner kiosks need to be modified to fit into tunnels, bridges

Benjamin Edwards *K-Mart Information Sheet* 1996 (cat. no. 18)

Benjamin Edwards *Starbucks Information Sheet* 1996 (cat. no. 19)

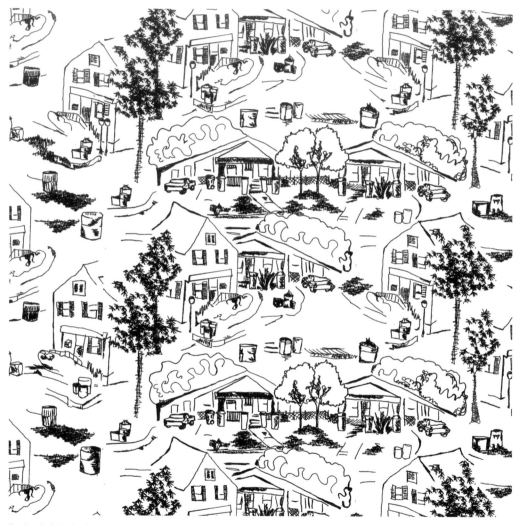

Jessica Smith *Trash Day* 2005/2007 (cat. no. 67)

Jessica Smith *Cloverleaf* 2006/2007 (cat. no. 68)

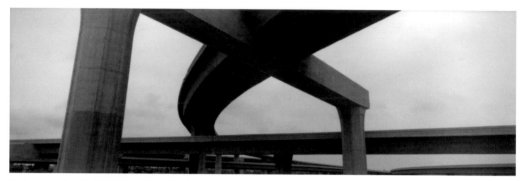

Catherine Opie *Untitled #7* from the series *Freeway* 1994 (cat. no. 52)

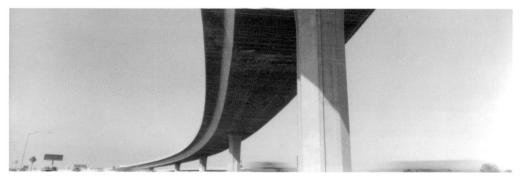

Catherine Opie *Untitled #20* from the series *Freeway* 1994 (cat. no. 53)

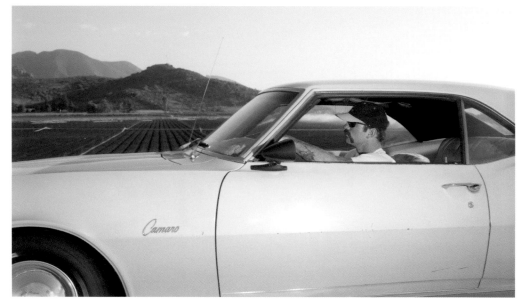

Andrew Bush *Man traveling southeast on U.S. Route 101 at approximately 71 mph somewhere around Camarillo, California, on a summer evening in 1994* 1994 (cat. no. 5)

Andrew Bush *Men heading south on Interstate 5 in San Joaquin Valley, California (no other information available)*
1998 (cat. no. 6)

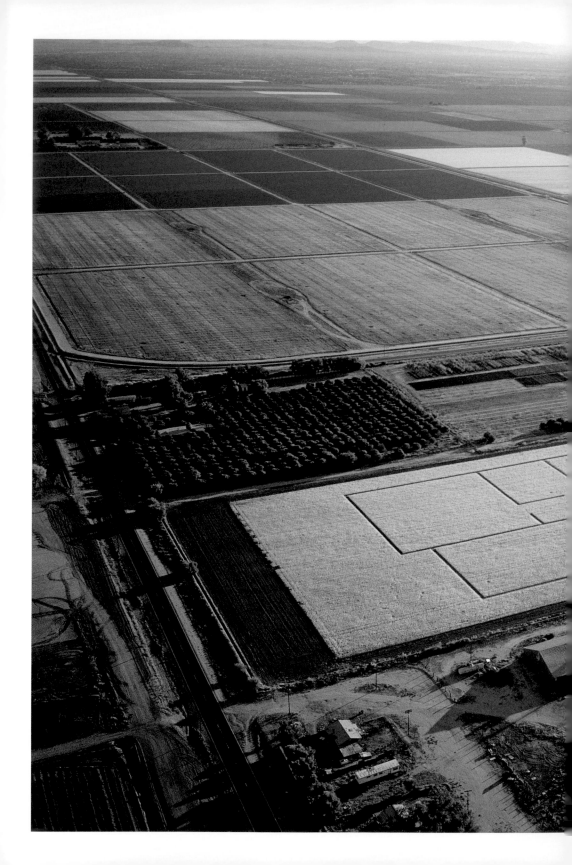

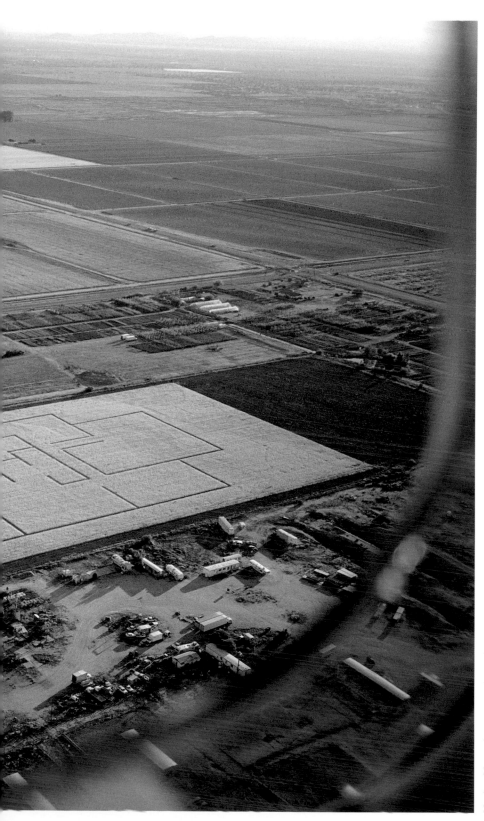

Matthew Moore *Rotations: Single Family Residence #5* 2003–2004 (cat. no. 48)

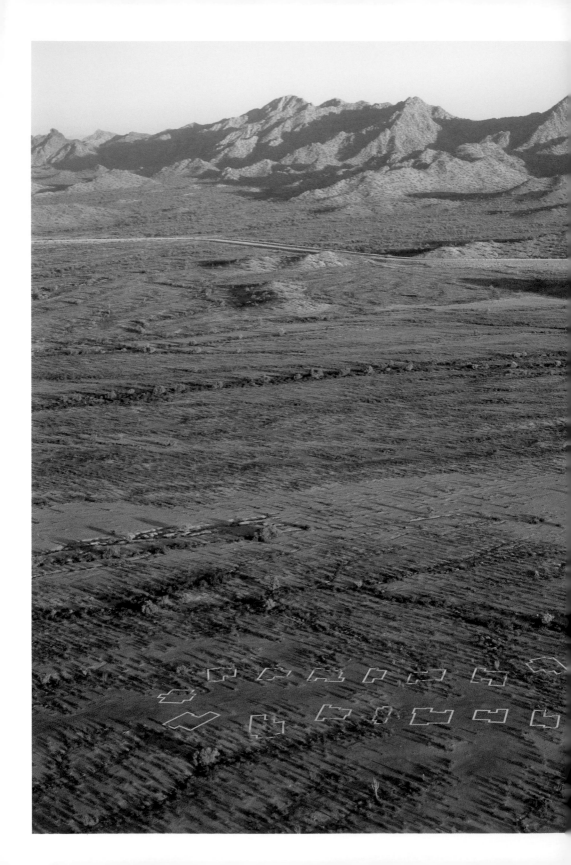

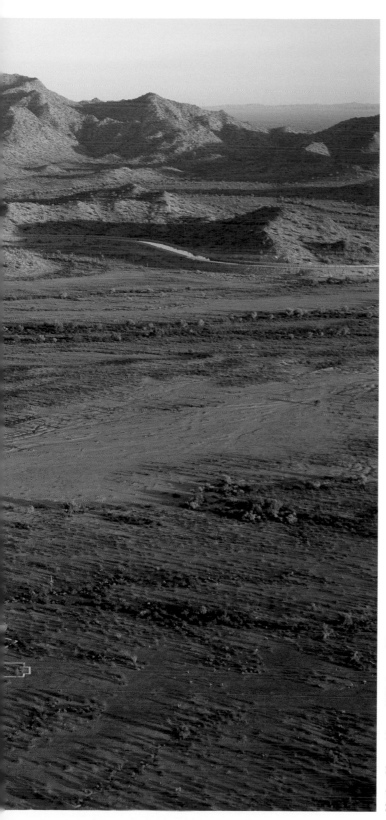

Matthew Moore *Mirage* 2007 (cat. no. 50)

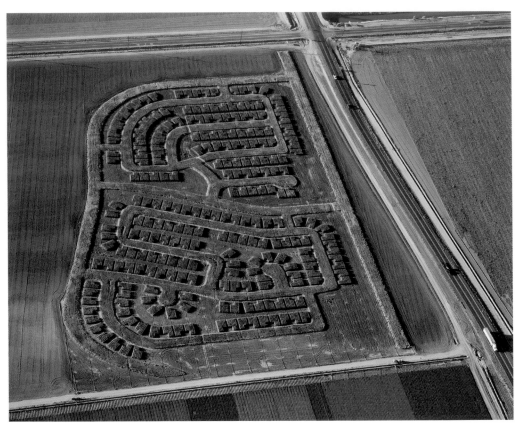

Matthew Moore *Rotations: Moore Estates #5* 2006 chromogenic print in plexiglass

Learning from Sprawl

Robert Bruegmann

Robert Bruegmann, professor of art history, architecture, and urban planning at the University of Illinois, is a historian of architecture, landscape, and the built environment. His most recent book, <u>Sprawl: A Compact History</u> (2005), has created a considerable stir.

It is curious that we still have sprawl. After all, for generations, "right-minded" individuals have savaged it; planners have advocated policies designed to counter it; and public agencies have succeeded in pushing through measures to stop it. With all this firepower directed against sprawl, one would think that by now it would be a thing of the past.

In fact, sprawl is more visible today than ever before. It can be found in Peoria and Paris, Boston and Bangkok— in fact, in every city in the world where ordinary citizens have a real choice either at the ballot box or in the real estate market. Even in places such as Moscow or Shanghai, where these conditions have not yet been fully met, sprawl is very much in evidence. It has become the middle-class settlement pattern of choice throughout the world. How has it been possible for anything so widely reviled to survive and thrive?

Why Has Sprawl Persisted?

I would like to suggest two answers to this question. The first involves the confusion surrounding the term "sprawl." There has never been an agreement on what it actually means. As a noun with something like its current meaning, the term first became popular in England immediately after World War I. However, just as the weed of one generation can become the prized native plant of the next, so too could the kind of development criticized as sprawl during the 1920s and 1930s in England later be considered quite compact and admirable.

This confusion has persisted for some very good reasons. One is that it has been essential to the anti-sprawl movement. After all, very few people who criticize sprawl believe they live in it. Sprawl is the kind of place inhabited by other people with less good sense and good taste than the person using the term. One person's sprawl has always been another's cherished neighborhood. Leaving the term vague has allowed for the creation of a massive coalition against sprawl, even

when many members of that coalition live in places that would be branded by the rest as perfect examples of it. For example, it allows the person living in the last house in a subdivision to join the anti-sprawl bandwagon to attack a new subdivision of houses exactly like her own in the fields behind her backyard.

One of the consequences of the lack of agreement on any clear definition of sprawl has been the disconcerting tendency of efforts directed at one kind of sprawl or another to backfire. The modern world's most famous attempt to stop sprawl was the one put in place in England immediately after World War II. It provided the legal framework for executing plans such as that created for Greater London in 1944 by architect and town planner Patrick Abercrombie. His solution was simple: he surrounded the city with a green belt, or urban-growth boundary. London could grow, but only up to the green belt. In one stroke, he believed, he had stopped sprawl and given a coherent shape to the city.

From one point of view, this plan succeeded. As visitors drive outward from central London, they are often impressed with the way the urban fabric abruptly stops at the inner edge of the green belt. If these visitors had traveled a little further, however, they would have found that the green belt did not actually halt sprawl. In fact, the postwar population of London grew much more quickly than Abercrombie had predicted and became more affluent than he had imagined. Within a few decades, growth in the London area jumped over the green belt and sprawled across much of southeast England, scattering the urban population much further than it would have without the belt.

The same thing has happened more recently in Portland, Oregon—another place that tried to use a boundary to direct urban growth. Even though the Portland growth boundary is legally mandated to move in order to accommodate growth (as the boundary has started to pinch in places in recent decades), much new development has simply been redirected even further out. The places that have grown most quickly in the Portland region have not been within the growth boundary but in towns outside the boundary, particularly in Vancouver, Washington, which is across the river from Portland and not part of the Oregon growth-management system.

Another classic way to stop sprawl has been to dictate large lot zoning. In the Portland region, for example, to stop the development of rural areas, particularly those in the Willamette Valley, legislators mandated large minimum lot sizes. This technique, which has been widely used across the United States, suggests that stopping the proliferation of subdivisions is a good way to stop the growth of suburbs, to contain the urban area and maintain a rural landscape beyond it. If there is a 40- or 80-acre minimum lot size, it obviously makes it impossible for developers to create standard subdivisions.

In some cases this technique has worked as planned, at least initially. It hasn't stopped the exodus of urban citizens to rural landscapes, though. If they are affluent enough, these families simply buy 20 or 80 acres, or whatever the minimum requirement happens to be, and build their dream house on that. In the near term, the insertion of a few houses is not likely to compromise the rural atmosphere. Of course, these regulations mean that many buyers purchase much more land than they really want. Over the years, moreover, as the urban population spreads outward toward these exurban communities, there is often an increasing demand for services that can only be provided economically at higher densities. In response, public officials rescind the large-lot zoning and put in, often at great cost, the roads and sewers that weren't necessary in the era of large-lot development. Both growth boundaries and large-lot zoning provide classic cases of the unintended consequences of regulations trying to curb something as hard to define as sprawl.

The second reason that sprawl persists is that it has brought a large number of important benefits to millions of people for many centuries. Since the birth of cities, whenever a group of citizens has gained enough wealth, many members of that group have chosen to move from congested city centers to lower-density settlements at the edge. This was just as true of the suburbs of ancient Rome and nineteenth-century Paris as it is of the extremely low-density exurbs of American cities today.

The reason that this happened is because, throughout urban history, living in city centers has been unpleasant, and often quite unhealthy, for many ordinary citizens. Although rich and powerful families have always been able to take advantage of all the cultural and social amenities that high density can offer and can mitigate its problems, many ordinary citizens had little interest in the opera or the court ball and instead were the ones who suffered most because of the noise, congestion, and dirt of city centers as well as the diseases that periodically swept through—and continue to sweep through—high-density poor neighborhoods. Moving to lower-cost and lower-density peripheral areas has typically allowed many of these ordinary citizens a way to own their own land and to enjoy far more space, more greenery, and more contact with the land than they would have had in an apartment in the city center.

In this century, in many affluent countries, a large percentage of the population has chosen the single-family suburban house on its own land, with an automobile at the ready in the driveway, as a way to obtain for itself the kind of privacy, mobility, and choice once possible only for the wealthiest urban dwellers. As society becomes more and more prosperous, it may become more attractive for families of relatively modest means to live at high density, but until very recently, there were extremely powerful reasons for ordinary people to want to sprawl outward from the city.

Why Has Anti-Sprawl Persisted?

If what I have said is true, then the more interesting question is no longer why cities have sprawled but why, despite the weight of evidence on the benefits of sprawl, have so many people fought so vigorously against it? I would again like to propose two answers to this question.

The first is that many people fight sprawl because it is in their own interest to do so. It is easy to see how this is the case for the resident of Manhattan with a country house in the Hamptons. For him, the burgeoning suburbs of Suffolk County are a double loss. Not only do they slow up his weekend drive to the country, but they also ruin the view that he used to enjoy on the way.

Even for individuals who don't appear to have a direct stake in the fight against sprawl, there are often considerable benefits. Throughout the affluent world, those urban areas that have instituted the toughest anti-sprawl measures—Los Angeles, Vancouver, London, Hong Kong, Sydney, or Perth, for example—have seen housing prices soar. None of this is surprising. It is hard to imagine how an urban area, all other things being equal, can implement significant restrictions on the land supply without raising prices. Of course, it is not just anti-sprawl measures that cause the pinch in supply. All kinds of environmental and heritage restrictions can do the same thing, and it is not so much the statute books as the way the regulations are enforced.

Not surprisingly, it is almost always the case that in the urban areas with the strictest anti-sprawl measures, there will also be found the greatest restrictions on what can be done within the already developed area. This is because the one thing that most citizens living near the center dislike more than low-density sprawl at the edge is higher density and more congestion near themselves. The result has been an impasse and an upward pressure on prices

that will inevitably occur when it becomes simultaneously harder to develop at the edge and to redevelop at the center.

This has obviously had very negative effects on housing affordability. However, for many current owners—what we can call the "incumbents' club," or people who are already happy with their current living situation—it has created a vast windfall. These individuals, even if they are worried about the loss of affordability for their own children or grandchildren, find it difficult to argue too strenuously against policies that not only deflect unwanted growth away from them but also simultaneously increase the value of their own house, in many cases today doubling or tripling their net worth over a relatively short number of years. For this reason, it is clear that in societies where the majority of voters are homeowners, there are powerful incentives to approve anti-sprawl policies and stringent environmental and preservation regulations, even when it hurts some part of the current population and most of the future residents of the area.

In the case of anti-sprawl measures, this has been particularly easy, because until the past few years there has been no concerted effort to show how harmful many of these policies have been. It is only now becoming clear how much less erosion in affordability has occurred in urban areas such as Atlanta or Houston, which may be growing as quickly as any highly regulated city but with more relaxed planning regulations.

The second reason for the persistence of the anti-sprawl campaign is more complex. It has to do with the way this debate, although apparently informed by reasoned arguments based on empirical data, has actually been fueled by a set of class-based assumptions that are primarily aesthetic and metaphysical, many of which rarely surface in the public debates about sprawl. To understand these, it is often easier to look back into history.

In the case of attacks on sprawl in the twentieth century, there have been three major campaigns. Not surprisingly, they correspond with the three great periods of economic and urban expansion—the 1920s, the post–World War II decades, and the interval starting in the 1980s that continues, in diminished fashion, today.

The First Campaign Against Sprawl: Britain in the 1920s

"And still the destruction spreads like a prairie fire. . . . Beauty is sacrificed on the altar of the speeding motorist. . . . A gimcrack civilization crawls like a gigantic slug over the country, leaving a foul trail of slime behind it."

A denunciation of suburban development around Los Angeles in the 1960s, or of sprawl in Atlanta today? Hardly. This was author Howard Marshall writing about England in the 1930s in the vehemently anti-suburban manifesto *Britain and the Beast*, published in London in 1937. It is difficult to resist quoting writers such as Marshall at length. In part, this is because of the perverse pleasure that any reader can take in the overheated language, which verges on self-parody. It is also in part because these words, which sound so much like the rhetoric one hears from disgruntled observers of contemporary suburban subdivisions and strip malls, were actually deployed against the modest, and to our eyes positively quaint, garden suburbs and semidetached houses of Britain between the two world wars.

Marshall's essay was hardly an anomaly. It was part of a flood of anti-suburban writing by architects, planners, and literary types in England in reaction to the massive suburbanization and urban sprawl that swept outward from London in the years after World War I. During this period, greater London grew in population by about 10 percent but more than doubled in land area. This was sprawl at a scale unsurpassed by anything in post–World War II America. Criticizing sprawl

and suburban growth was especially popular among a privileged class of people watching an old social and urban order in the throes of profound change. As the world economy modernized and political processes democratized, the gains made by a newly affluent middle and working class threatened many entrenched interests.

The comments of prominent urban planner Thomas Sharp, writing in his 1932 book *Town and Countryside*, are in some ways even more revealing:

Tradition has broken down. Taste is utterly debased. There is no enlightened guidance or correction from authority. The town, long since degraded, is being annihilated by a flabby, shoddy, romantic nature-worship. That romantic nature-worship is destroying also the object of its adoration, the countryside. Both are being destroyed. The one age-long certainty, the antithesis of town and country is already breaking down. Two diametrically opposed, dramatically contrasting, inevitable types of beauty are being displaced by one drab, revolting neutrality. Rural influences neutralize the town. Urban influences neutralize the country. In a few years all will be neutrality. The strong, masculine virility of the town, the softer beauty, the richness, the fruitfulness of that mother of men, the countryside, will be debased into one sterile, hermaphroditic beastliness.

Three-quarters of a century later, most readers will find these comments curious relics of a previous era. Few people today would be comfortable believing that, at some point in the distant past, Nature laid down once and for all such hard and fast distinctions either between the role of men and women in society or between the city and the country on the land. We are much more likely to accept the notion that these categories are fluid and changeable. It should remind us, though, that we are likewise trapped in a system of thought based on our own assumptions, temperament, and position in society, and that our own views will inevitably seem outmoded, even dangerous, at some point in the future. This should serve as a reminder about the danger of succumbing to the tempting idea that any individual should have the right or duty to impose his or her own ideas of the good urban life on everyone else.

In this passage, Sharp's objections are largely aesthetic, which has been the most persistent and perhaps most fundamental objection to sprawl. Other members of the anti-sprawl coalition in Britain between the wars attacked it for an entire array of other reasons. Attacks on sprawl from Sharp's time to our own have tended to fall roughly into four categories. The first is economic efficiency, or the idea that building at high densities is more economical than building at low densities. The second is social, the notion that sprawl has produced socially weakened communities. The third is environmental, the idea that sprawl and low-density settlement require more energy, create more pollution, and do more damage to animal habitat than higher-density settlement. The fourth is aesthetic, that sprawl is ugly.

Anti-sprawl advocates have used all these arguments in each of the three campaigns against sprawl. When it came time to make public policy, however, it was the more objective economic, social, and environmental arguments that came to the fore. Still, what Sharp's comments suggest is that underneath the widely varying charges against sprawl, there exists a fundamental core of class-based aesthetic ideas and metaphysical assumptions about man and nature and the proper way to live in cities.

We have already considered the way the British government acted after World War II to institute an urban boundary to stop sprawl around London. In order to put plans like this into

effect, the Labour Government instituted a draconian new policy of nationalizing, by compulsory purchase, all development rights. No longer would any owner be able to build anything on his or her land without getting specific approval from the government. This gave the government almost complete control of development. Government planners, rather than individuals or the collective action of the real estate market, could determine what ought to be built and where.

Perhaps the most conspicuous of these policies was the green belt. The land set aside for the belt was neither the most productive farmland nor even the most scenic open space, however. Its primary purpose was to give a definite shape to the city and prevent any more of the allegedly "formless" sprawl of the prewar years. For Abercrombie and his colleagues, a simple geometric form such as the circle was obviously more aesthetically pleasing than the tentacles of growth along London's roads and railroads that had been the norm for centuries.

Aesthetic considerations were reinforced by class-based social and political assumptions. Abercrombie imagined a place where the government would control all major decisions about what development should take place and where it should go. In fact, he displayed a marked disdain for the private real estate market and the choices that individual families made within it. He assumed that government itself would eventually not only do the planning, but also most of the building, meaning that the role of the private developer would fade into insignificance.

This was at once a radical political solution and a very conservative one. It was radical in its desire to abolish the traditional rights of private property and eliminate the inequities that were supposedly caused by the real estate market. Coming as it did on the heels of the disenchantment fostered by the economic crisis of the 1930s, the British planning system was widely heralded across the Western world as a free-world solution to the problems caused by the period's so-called excesses and inequalities inherent in the market economy. It was part of an upsurge in interest in a progressive "third way," somewhere between capitalism and socialism, which led to intense policy experimentation in many of the most affluent nations of northern Europe after World War II. Although some private-market activities were allowed to continue, the presumption was that they would be firmly subservient to stringent top-down governmental planning intended to protect the interests of the citizenry as a whole.

However, like many of the policies instituted during this era in the name of progressive ideals, the most important effect of the British postwar town-planning system may have been to preserve the status quo. It was very conservative in its belief that many major decisions should be taken away from ordinary citizens and placed in the hands of well-trained government planners. It was also very conservative in its assumption that this planning was a "final solution," which, once made, would endure indefinitely with only small adjustments to maintain the system.

Already by the 1960s, however, it was clear that there were problems with the system. Both population and economic growth were much greater than the planners had expected, and the green belt did not stop sprawl. In fact, rather than contain London, the green belt could be seen as actually dispersing it further when families chose to jump out beyond the belt. In addition, because many of the families beyond the belt had to commute back to jobs that remained within, it lengthened travel times and increased congestion. Finally, because of the land supply constraints caused by the green belt and the bureaucratic hurdles to obtaining permission to build anywhere, prices for land in the London area both within and outside the belt started a steep upward climb that would soon make the price of the average house in the southeast of England—on average, the oldest, smallest, and most poorly equipped among affluent Western nations—the highest in Europe.

The Second Campaign Against Sprawl: The United States in the Postwar Years

While some individuals in the United States paid close attention to the British attacks on suburban growth and sprawl, criticism of U.S. suburbs was much more muted before World War II. Because the cost of the commuter railroad remained fairly high during the nineteenth and early twentieth centuries, the most conspicuous suburbs were often upper-middle-class in character. And given the fact that the attack on the suburbs and sprawl has usually spared the enclaves of the wealthy and powerful, no matter how low in density, but has targeted the places where working- and middle-middle class families live, there were relatively few complaints in the United States about railroad suburbs and sprawl before World War II.

The postwar situation changed rapidly as peripheral development spread out beyond the boundaries of central cities, and much of it was middle- and working-class. American observers such as social and architectural critic Lewis Mumford brought the kind of rhetoric used by highbrow British writers to the United States. Mumford, like many of the British elite, split his life between residences in the city and the country—in his case, the Upper West Side of Manhattan and the small town of Amenia in Dutchess County, New York. He was horrified by the sprawl he saw out the window of the train as it roared past the suburbs en route to or from his country house.

This passage from his famous 1961 book, *The City in History*, gives a good indication of Mumford's disdain for this landscape and the people who lived in it:

> Whilst the suburb served only a favored minority it neither spoiled the countryside nor threatened the city. But now that the drift to the outer ring has become a mass movement, it tends to destroy the value of both environments without producing anything but a dreary substitute, devoid of form and even more devoid of the original suburban values. . . . A new kind of community was produced which caricatured both the historic city and the archetypal suburban refuge: a multitude of uniform unidentifiable houses, lined up inflexibly, at uniform distances, on uniform roads, in a treeless communal waste, inhabited by people of the same class, the same income, the same age group, witnessing the same television performances, eating the same tasteless prefabricated foods, from the same freezers, conforming in every respect to a common mold.

In other words, for Mumford, what was perfectly acceptable for a few people of his own class became intolerable when it related to a large number of people whose lifestyle he could neither understand nor appreciate.

Another individual who popularized criticism of the suburbs and sprawl was journalist William H. Whyte, who had earned a reputation as an astute observer of suburbia with his 1956 book *The Organization Man*. About a year later, he organized what was probably the first conference on sprawl in the United States. He invited a group of individuals, almost all from large cities on the East Coast of the United States, and from it he published a volume of anti-sprawl polemics entitled *The Exploding City*.

On the first page of his essay in the book, Whyte sounded the alarm: "Already huge patches of once green countryside have been turned into vast, smog-filled deserts that are neither city, suburb, nor country, and each day—at a rate of some 3,000 acres a day—more countryside is being bull-dozed under." On the same page, he also attacked what would quickly become the standard target of American critics of suburbia and sprawl—Los Angeles. He described the flight from Los Angeles to San Bernardino as "an unnerving lesson in man's infinite capacity to

mess up his environment." Other writers in the same volume chimed in, excoriating Los Angeles for everything from its apparent formlessness to its alleged crime problems. Many of these complaints appear to have been completely unwarranted, but they were perhaps not surprising given that most of the urban experts assembled by Whyte lived in places such as Manhattan, and they simply did not know or understand the fast-growing cities of the American South and West. They were comfortable with their own place in the social order of the large industrial cities of the nineteenth century and were unable to comprehend the new physical, geographical, and social order that Los Angeles represented.

Perhaps the most important statistical foundation on which the edifice of postwar American anti-sprawl was built was that of economic efficiency. It was based on the apparently common-sense observation that low-density living must require more roads and sewers, longer travel times, and a greater use of energy. There developed an entire body of literature devoted to proving these contentions. The most famous early example of this literature was the "Costs of Sprawl" report issued by the Real Estate Research Corporation in 1974 at the very end of the postwar campaign against sprawl. As soon as it was issued, however, there was a quick counterattack by critics demonstrating that the computer simulations designed to show that high-density "planned" development was more economically efficient than low-density "unplanned" development were fundamentally flawed.

In the first place, as critics of the report noted, the "Costs of Sprawl" researchers had failed to factor in the larger living areas and household sizes of homes compared to apartments. Second, many of the conclusions reached by the authors of the report were based on computer models that did not hold up in actual practice on the ground. In fact, many of the large-scale mixed-use developments thought to be more cost effective often turned out to be highly inefficient because they required massive investment up front for infrastructure and were difficult to adapt when market conditions changed. One result was that two of the largest and most highly praised master-planned developments of those years—Reston, Virginia, and Columbia, Maryland—eventually went bankrupt and had to be reorganized. Finally, the supposed savings to the public purse from building fewer miles of road, which was the largest additional expense involved in lower-density development, were not very large considering the total cost of government. Moreover, any savings to the government by building fewer miles of roads could easily be dwarfed by the private costs of increased congestion caused by more cars on these roads.

The second line of argument during these years was connected with the supposed negative social effects of suburban expansion. An entire bookshelf of treatises with titles such as *The Crack in the Picture Window* (John Keats, 1957) or *The Split-Level Trap* (Richard E. Gordon, et al., 1961) claimed to show that middle-class suburban families were more conformist, more homogenous, and more selfish than their urban counterparts. These books were typically written by upper-middle-class individuals living in large cities in the American Northeast, people who often had little firsthand contact with middle-class suburban life. These authors, according to the scathing analysis of sociologist Herbert Gans in his classic 1967 book *The Levittowners*, believed that the suburbs were filled with "an uneducated, gullible, petty 'mass' which rejects the culture that would make it fully human, the good government that would create the better community and the proper planning that would do away with the landscape-despoiling little boxes in which they live." On the other hand, he concluded that social life in the suburbs was just as rich and as intricate as in the city, and he vigorously defended the right of citizens to live where and how they wished.

Other observers claimed that the move to the suburbs sapped the vitality of the central city, and that affluent people who moved to the suburbs not only took their tax dollars with them, but also turned their backs on urban problems. Many claimed that the suburban exodus was the cause of the woes of the central cities, many of which were undoubtedly in terrible shape in the 1960s and 1970s. But these observations failed to account for the fact that city centers were already showing signs of acute distress long before World War II, or that sprawl was at least as powerful in cities such as Paris or San Francisco, where the center stayed vibrant, as in places such as Detroit or St. Louis. In fact, in numerous U.S. cities in the 1960s, at exactly the same time that sprawl was reaching its supposed zenith, there was a conspicuous trend of gentrification in many older inner neighborhoods.

There were also important environmental objections to sprawl during the second campaign. Anti-sprawl activists blamed the suburbs and sprawl for more air pollution caused by rising automobile use and more water pollution caused by the runoff from an increased amount of impervious paving surface. However, it is conspicuous that a huge number of people moved to the suburbs specifically because they wanted a better, less polluted environment for themselves and their children and a closer connection with the land. Suburbanites swelled the ranks of the Sierra Club and other environmental groups after World War II, and they were a major force in the barrage of environmental legislation passed in the late 1960s and early 1970s, the majority of it during the Nixon administration. This legislation signaled a new national readiness to curb every kind of pollution and, indeed, most kinds of pollution did decline substantially over the next few decades, even with significant suburban growth.

As usual, during the second anti-sprawl campaign, by far the most persistent and greatest volume of attacks came on aesthetic grounds. Architectural critic Peter Blake issued one of the era's most conspicuous manifestos with his 1964 book *God's Own Junkyard: The Planned Deterioration of America's Landscape*. During this campaign, the aesthetics of anti-sprawl even made their way into popular culture with a song about "little boxes on the hillside" and one saying "They paved paradise/And put up a parking lot."

As was the case with all of the other attacks on sprawl, these aesthetic forays did not go unanswered. British architectural critic Reyner Banham took some of them on in his now-classic 1971 book *Los Angeles: The Architecture of Four Ecologies*. Instead of seeing the city as the formless, inchoate mass described by Mumford or Whyte, he outlined the ways in which Los Angeles was just as coherent as older cities. He demonstrated that it was built with a similar attention to topography, climate, and transportation, but simply updated for new technologies and new economic and social conditions. Banham also celebrated Los Angeles' vitality in the creation of new and more democratic artistic traditions.

American architects Robert Venturi and Denise Scott Brown performed a similar operation. Looking through the pictures in Blake's book, they decided that these images, which were meant to show the ugliest man-made landscapes in America, were actually a lot more interesting to them than much of the work of the most tasteful architects of their own day. They were fascinated by the Las Vegas strip, Levittown (page 49), and the freeway—all objects of scorn for most aesthetes of the period.

The Third Campaign Against Sprawl: 1980s until Today
If anything, the onslaught against sprawl and the suburbs is even more virulent today, as evidenced by the titles of such recent books as Wolch, Pastor, and Dreier's 2004 *Up Against the*

Robert Bruegmann

Sprawl: Public Policy and the Making of Southern California or Joel S. Hirschhorn's 2005 *Sprawl Kills: How Blandburbs Steal Your Time, Health and Money.* The withering descriptions of suburbia in a book such as James Howard Kunstler's 1994 *Geography of Nowhere: The Rise and Decline of America's Man-Made Landscape* or the paranoid, dystopian views of Los Angeles in Mike Davis' 1990 *City of Quartz: Excavating the Future in Los Angeles* carry on the tradition.

There have been continued attempts to prove that low-density suburban growth is economically inefficient and social inequitable. These studies have proven to be no more persuasive or rigorous than the ones in previous campaigns. In fact, as so many American city centers are fast becoming enclaves of the affluent and the suburbs have become much more diverse and more like city centers, many of the old arguments have faded away. The crusade against sprawl might have nearly disappeared by now if it had not been for a set of new environmental arguments in general and two in particular.

The first concerns climate change. There is no doubt that global warming is a major problem that will need to be solved. The connection with sprawl and suburban growth, however, is not strong. According to much conventional thinking, low-density suburban living inevitably leads to increased energy use, more driving, and thus greater pollution, greenhouse emissions, and global warming. However, it is far from certain that people in high-density cities necessarily consume less energy and produce fewer greenhouse gases than those who live in low-density suburbs. As a number of recent studies have suggested, if we measure all of the energy used by city dwellers—counting energy used in elevators, taxis, rental cars, and commuting to country houses—it is quite possible that families living in apartments in city centers use more energy and create more emissions per capita than people living in low-density suburbs. In fact, the biggest variable in energy use and greenhouse emissions is not density but affluence. On average, when people become more affluent they use more energy and emit more greenhouse gases, whether they live in the city or the suburbs.

Suburban houses, for example, when constructed primarily of natural wood, shaded by trees in the summer, and surrounded by a mature landscape, may well offer, from the most complete accounting, a more energy-efficient and environmentally friendly way to live than the typical nineteenth-century industrial city with its tall apartment buildings and its elevators, lights burning twenty-four hours a day, and huge air-conditioning loads. With sufficient land, moreover, the residents of low-density settlements could tap vast amounts of renewable energy in the form of power from solar, wind, geothermal, or biomass sources. It is quite possible that it might be easier for suburbanites to get to a point of zero carbon emissions and complete self-sufficiency in energy or water supply than their counterparts in apartments in the city.

Or, looked at from the other side of the coin, even if everyone in the urban world was forced into high-density cities and required to use public transportation for all travel, greenhouse emissions would not be reduced unless the bulk of the urban population remained in poverty. Bringing them up to even minimal middle-class standards in the cities we have now would cause a vast increase in energy and emissions. We will eventually have to find ways to cut down dramatically on greenhouse gases, probably involving major changes to the ways we create energy. There is little evidence that forcing people into denser settlement patterns will solve the problem.

Another charge against sprawl is that it is destroying habitat and causing species extinction. In many ways, this is the most direct challenge to sprawl because it is clear that some urban development is indeed destroying habitat. A major problem here is that we know so little about

species extinction. We have only a vague understanding of how many species are becoming extinct each decade or, even more importantly, which are becoming extinct because of urban development. Given this uncertainty about even the most basic scientific issues involved, indiscriminate attempts to stop sprawl and suburban development on the grounds that it will help endangered species could actually do more harm than good.

These calls are usually based on assumptions such as this: Nature is a benign and purposeful force; Man is upsetting Nature's balance; and for this reason, Man must be excluded from large territories in order for Nature to operate effectively. Of course, this assumes that Man is separate from Nature and that the cities that men build are somehow less natural than most of the rest of our landscape. In reality, though, most of the landscape anywhere near our cities, whether we are talking about cropland or forests that have been repeatedly logged over, has been thoroughly remade over the centuries by human hands. Many of these landscapes, particularly cropland, would actually provide better habitat if they were redeveloped as low-density exurban development with more varied vegetation. For many anti-sprawl activists, however, this observation is entirely beside the point. For them, sprawl violates their most basic sense of the way the world ought to be and the roles of Man and Nature in the landscape.

This seems to be where most debates about sprawl ultimately end—in a cul-de-sac of disagreement over basic moral and aesthetic judgments. No matter how much we start out with objective, quantifiable criteria, arguments about sprawl almost always depend, in the end, on the most highly abstract and unquantifiable assumptions about nature, man, and the purposes of urban life. And this brings us inevitably back to the class-based aesthetic assumptions about sprawl at the heart and soul of the case against it, which have generated the most persistent and loudest objections over the course of the last century.

As we have seen, middle-class and working-class suburbs—whether London's brick nineteenth-century row houses and the semidetached houses of the 1920s and 1930s, the ranch houses of the San Fernando Valley of Los Angeles in the 1950s or 1960s, or today's newest suburbs—have evoked a similar response from tastemakers at the time they were built. Their verdict: irredeemably ugly. Of course, as we have already seen, most of these "ugly" buildings survived to become the accepted urban fabric of the next generation and often the cherished historic landmark of the generation following. The row houses are now considered the very essence of central London, and the semidetached houses built between the wars, like the bungalows of American cities, have also gained at least grudging respect. The 1950s ranch houses are clearly on their way back into fashion with hip young buyers who see them as a great investment and, undoubtedly, tomorrow's historic landmarks.

However, even though every generation in history has witnessed this kind of revolution in aesthetic judgment, many people in each new generation seem sure that their judgment will be final. Today, even many of the most broad-minded individuals seem to be unable to imagine that the strip malls, McDonald's restaurants, and Wal-Mart stores that they find so unappealing might one day be considered fine examples of a historical, vernacular building type worth preserving and celebrating. So, a great many otherwise intelligent people are trapped in the notion that they live in the ugliest of all ages of the world, and that the worst part of this ugliness—the suburbs and exurbs—constitute the largest part of our urban system, house the majority of the population, and are growing much faster than central cities or rural areas.

What a discouraging prospect! Fortunately, this is where the artists and critics have played a key role in the past and can continue to play an important role today, because it is obviously

far easier to change our aesthetic sensibilities and learn to come to terms with sprawl than it is to tear down the majority of places we live today and build something else. For decades, artists such as David Hockney and Ed Ruscha have been looking at Los Angeles, for example, and seeing there not an ugly, incoherent landscape but instead a new kind of aesthetic sensibility and energy. Hockney's suburban swimming pools and Ruscha's gas stations or parking lots provide an alternative way to view much of the ordinary landscape around us, allowing us to see the extraordinary and beautiful in what might otherwise appear unworthy of consideration.

In a similar way, many artists, architects, and critics today are trying to see beyond the conventional reigning wisdom so they can decipher the hidden order behind the apparent chaos of our urban built environment and learn new ways of considering its aesthetic qualities. Venturi and Scott Brown provide an excellent precedent in their 1973 article "The Highway." In it they argue that the sheer scale of the freeway made it almost impossible to judge by conventional aesthetic standards. They decided that perhaps it wasn't the freeway, but those standards that were the problem:

> When a going architectural credo finds itself overturned on the freeway, the artists should be around interpreting. This has been a role of the artist in the past, transmitting folk art into fine art, fertilizing one culture from another and in the process making our own culture acceptable to and usable by ourselves. Although, as Tom Wolfe suggests, the artists came late to the mass-pop scene and can still learn from the verve of the neon and hot rod, folk and commercial artists; it is they who, by putting the highway in an art gallery, help us to see it in a new context as part of a continuing artistic tradition and, by creatively elaborating its reality, jolt our aesthetic ruts and enable us to learn from its vitality.

Similarly, contemporary architectural critic and curator Aaron Betsky talks about finding what is beautiful in sprawl, which we don't recognize because we can't evaluate its forms. German artist Boris Sieverts organizes tours through the empty lots and industrial wastelands at the periphery of Cologne, trying to cast off conventional aesthetic judgments and find new ways of appreciating these vistas. A great many artists are now looking at the suburbs and exurbs and finding there, if not unalloyed beauty, at least a highly complex and interesting landscape, one that can't be dismissed with the easy and lazy label of sprawl.

We have had generations of high-minded, cultured individuals attacking middle- and working-class suburbs for their middle-brow banality. But now, after so much avant-garde searching for the furthest aesthetic horizon of antibourgeois outrage, it may be the moment when artists can finally turn back to reexamine the very thing that was always the greatest horror of the avant-garde: the everyday middle-class world. If they do, it will inevitably involve dealing with that bête noire of generations of upper-middle-class tastemakers—sprawl.

A Lexicon of Suburban Neologisms

Rachel Hooper and Jayme Yen

Rachel Hooper is the Cynthia Woods Mitchell Curatorial Fellow, Blaffer Gallery, the Art Museum of the University of Houston, Texas. Prior to that she was a 2006–2007 curatorial fellow at the Walker Art Center, Minneapolis. Jayme Yen is a researcher in the design department at the Jan van Eyck Academie, Maastricht, the Netherlands. She was a 2006–2007 design fellow at the Walker Art Center.

A

adaptive reuse: To use or redevelop an older structure or site that no longer serves its original purpose

This process usually involves significant remodeling and restoration, but is considered an ecological alternative to new construction or developing a greenfield location.

See also: cluster zoning, compact land use, infill, mixed-use development, smart growth

alligator

1: A real estate investment producing negative cash flow

This occurs when land is purchased by a developer, then divided into more subdivisions than are actually developed: "An alligator investment 'eats' equity because it lives on a diet of principal, interest, and property tax payments but does not produce income."[1]

2: A strip of tire tread found on the roadside

Trucker lingo for blown tires or retreads scattered on the road.

3: A broad-snouted crocodilian that occasionally plagues suburban areas

As suburban areas encroach on wetlands in cities such as Tampa and Houston, alligators have wandered into these new developments. Gators have also been found in the suburbs of Los Angeles, and Washington, D.C., and Cleveland, where police suspect they were once kept as pets.

1. Dolores Hayden, *A Field Guide to Sprawl* (New York: W.W. Norton & Company, Inc., 2004).

anchor store: The major store of a shopping center, typically located on the corner or end of a group of stores

Supermarkets generally anchor community centers; department stores in excess of one hundred thousand square feet anchor regional malls; and superregional shopping centers may have three or more anchors. Initially, the broad appeal of department stores and supermarkets attracted a high volume of consumers, who would then patronize smaller stores that surrounded the anchors. With the gradual decline of department stores' popularity over the past ten to fifteen years and the concurrent success of the big box retail model, malls and other shopping centers have had to be re-anchored or risk becoming a dead mall.

See also: outparcel

asphalt nation: A synonym for the United States that emphasizes the degree to which automobiles and the paving, pollution, and congestion that accompany them are intrinsic to the American way of life

In the book *Asphalt Nation*, Jane Holtz Kay assesses the auto age and examines ways that lob-

bies, policies, and trends have led to America's car culture. Kay believes the end of an era of reliance on cars approaches and that "we can find, create, and the revive the remedies, and that planning solutions depend, in the end, on land-use solutions—on mobility based on human movement and transportation beyond the private automobile."[1]

1. Jane Holtz Kay, *Asphalt Nation: How the Automobile Took Over America, and How We Can Take It Back* (New York: Crown Publishers, Inc., 1997), 8.

auto park

1: A retail development with multiple car dealerships in one central location

Gathering car sales lots in one central location offers automobile dealers a visible location usually off of a major highway, enables consumers to comparison shop, and concentrates the impact of expansive pavement and advertising related to auto sales away from the city proper.

2: A megasite suitable for major automotive manufacturing

The Tennessee Valley Authority (TVA) has encouraged towns in the Southeast to run utilities to large open areas located near interstates, rail lines, and airports in order to lure major auto manufacturers to build plants. The TVA then certifies these spaces as suitable megasites for future development.

3: A parking lot (British)

B

baby boomer: A person born during a marked rise in the birthrate

In the United States, this term applies to those born during the period following the end of World War II from about 1945 to 1965.

ball pork: A stadium hosting privately owned sports teams and built primarily with public funds

A contraction of the words "ball park" and "pork barrel," ball pork results from the appropriation of government funds for projects that benefit a relatively small constituency.

See also: growth machine

BANANA (Build Absolutely Nothing Anywhere Near Anything): An acronym for a person or organization opposing a proposed structure or operation on a site

and unwilling to compromise on the issue

The term, a variation of which is "Build Absolutely Nothing Anywhere Near Anyone," is often used pejoratively against groups opposing land development.

See also: LULU, NIMBY, NOTE

bedroom community: A typically suburban, largely residential area offering few employment opportunities and from which residents commute to work; also known as a commuter town

Bedroom communities often evolve out of their residential status as places of work and expand in suburban settings, enabling more people to both live and work in these areas. Early patterns of relocation witnessed a shift of businesses out of cities and into new suburbs, whether into office or industrial parks. Business economies, particularly in the retail sector, also develop in bedroom communities, providing new sources of jobs to support expansive new residential settlement.

See also: edge city

berm: A raised mound of earth, usually covered in sod, separating two areas and typically used as sound or visual barriers

See also: noise barrier

big box: A large retail store, typically with 75,000 to 250,000 square feet of space, distinguished by its rectangular plan; concrete-block construction; windowless, standardized exteriors; and single-story structure with a three-story height of about 30 feet

The big box model, with expansive parking lots and rapid construction in areas often insufficiently prepared to accommodate such enterprises, has been blamed for traffic congestion and sprawl.

See also: category killer, chain store, discount department store, outlet store, power center, superstore, value retailer, warehouse club

blandburb: A term coined by author Joel S. Hirschhorn for a suburban location characterized by extreme homogeneity and monotony that causes its residents to become depressed[1]

1. Joel S. Hirschhorn, *Sprawl Kills: How Blandburbs Steal Your Time, Health, and Money* (New York: Sterling & Ross Publishers, Inc., 2005).

boomburb: A city with more than one hundred thousand residents, although not the largest city in its metropolitan area, maintaining double-digit or higher

rates of population growth in recent decades[1]
See also: edge city, megaburb, sprinkler city, zoomburb

> **1.** This type of fast-growing city was identified by Robert E. Lang and Patrick A. Simmons in a report for the Fannie Mae Foundation in 2001.

brownfield: Real estate property of which the expansion, redevelopment, or reuse may be complicated by the presence or potential presence of a hazardous substance, pollutant, or contaminant
See also: drosscape, greenfield, greyfield

burbed-out: Having qualities stereotypically associated with suburbia, such as cookie-cutter houses, SUVs, chain-store shopping areas

C

carchitecture

1: Buildings that respond to the automobile in society
"Carchitecture has been a long, slow evolutionary response to the problem of accommodating the inherent contradiction of the car; the car will set society free, an automotive society creates traffic, traffic enslaves society."[1]
2: Buildings designed to be seen from cars
"We are living in a carchitecture age, an era in which most buildings are designed to be seen and appreciated from moving vehicles."[2]
See also: drive-thru, duck, logo building

> **1.** Jonathan Bell, ed., *Carchitecture* (London: August Media, 2001).
> **2.** Charlene Rooke, "Scenic Drive," *enRoute* (July 2004), http://www.enroutemag.com/e/archives/july04/index.html.

category killer: A product, service, brand, or company that has an enormous competitive advantage
Originating in marketing and strategic management, this term has become synonymous with big box retailers such as Wal-Mart or Home Depot that dominate the market and drive smaller stores representing specific product and service categories out of business.
See also: big box, chain store, discount department store, outlet store, power center, superstore, value retailer, warehouse club

centaur: A gay man who lives openly in a predominantly heterosexual suburb
In the book *Peacocks, Chameleons, Centaurs: Gay Suburbia and the Grammar of Social Identity*, Wayne Brekhus studies three identity types: lifestylers, commuters, and integrators. Being gay is a central to the identity of a lifestyler, or peacock, who lives openly in gay-specific ghettos in urban areas. Centaurs, on the other hand, are integrators who live openly in the heterosexual space of the suburbs and "integrate their gay identity into living in a heterosexualized world." They see their gay identity as an adjective that describes part of their life all of the time. Brekhus sees the open integration of gay men into suburban spaces as a relatively recent phenomenon that coincides with the social acceptance of gay identity in the culture at large.[1]
See also: chameleon

> **1.** Wayne Brekhus, *Peacocks, Chameleons, Centaurs: Gay Suburbia and the Grammar of Social Identity* (Chicago: University of Chicago Press, 2003), 29, 216.

chain store: One of a group of retail stores that share a brand and common merchandising policy, usually owned and franchised by a single corporate entity
See also: big box, category killer, discount department store, outlet store, power center, superstore, value retailer, warehouse club

chameleon: A gay man who lives in the suburbs and travels to "identity-specific spaces to be his 'gay self,' " often in the evenings or on weekends[1]
In the book *Peacocks, Chameleons, Centaurs*, Brekhus describes chameleons as using their gay identity as a mobile verb that they can turn on or off at will. Some structural factors that he believes affect gay suburban identity are that "oppression truncates against integrating and in favor of commuting" and "visible minority status truncates against commuting and in favor of lifestyling."[2]
See also: centaur

> **1.** Wayne Brekhus, *Peacocks, Chameleons, Centaurs: Gay Suburbia and the Grammar of Social Identity* (Chicago: University of Chicago Press, 2003), 28.
> **2.** Ibid., 216–217.

Claritas: A marketing information resources company established in 1971 that specializes in identifying target markets based on U.S. Census data and consumptive patterns

Claritas describes markets primarily as "social groups" that roughly classify people by location and income. Each is further segmented into "lifestyle clusters" that match demographics to consumption patterns. Claritas clusters have been used not only for consumer research, but also to identify potential voters in elections.

Claritas' urbanization measures fall into four classes: Urban Areas, Second Cities, Suburbs, Town and Country. The company further divides U.S. consumers into fourteen different groups and sixty-six different segments ordered according to socioeconomic rank, which consider various characteristics such as income, education, occupation, and home value. According to Claritas PRIZM NE, the definitions and segments of the four suburbs groups are:[1]

Group S1 – Elite Suburbs
The most affluent suburban social group, Elite Suburbs is a world of six-figure incomes, post-graduate degrees, single-family homes and managerial and professional occupations. The segments here are predominantly white with significant concentrations of well-off Asian Americans. Befitting their lofty salaries, S1 members are big consumers of large homes, expensive clothes, luxury cars and foreign travel. Despite representing a small portion of the U.S. population, they hold a large share of the nation's personal net worth. [The Elite Suburbs group consists of the following segments: Upper Crust; Blue Blood Estates; Movers & Shakers; and Winner's Circle.]

Group S2 – The Affluentials
The six segments in The Affluentials are one socioeconomic rung down from the Elite Suburbs—with a 25 percent drop in median income—but their residents still enjoy comfortable, suburban lifestyles. The median income in S2 is nearly $60,000, the median home value is about $200,000, and the mostly couples in this social group tend to have college degrees and white-collar jobs. Asian Americans make up an important minority in these predominantly white segments. As consumers, The Affluentials are big fans of health foods, computer equipment, consumer electronics and the full range of big-box retailers. [The Affluentials group consists of the segments: Executive Suites; New Empty Nests; Pools & Patios; Beltway Boomers; Kids & Cul-de-Sacs; and Home Sweet Home.]

Group S3 – Middleburbs
The five segments that comprise Middleburbs share a middle-class, suburban perspective, but there the similarity ends. Two groups are filled with very young residents, two are filled with seniors and one is middle-aged. In addition, S3 includes a mix of both, homeowners and renters as well as high school graduates and college alums. With good jobs and money in their jeans, the members of Middleburbs tend to have plenty of discretionary income to visit nightclubs and casual-dining restaurants, shop at midscale department stores, buy dance and easy listening CDs by the dozen and travel across the U.S. and Canada. [The Middleburbs group consists of the segments: Gray Power; Young Influentials; Suburban Sprawl; Blue-Chip Blues; and Domestic Duos.]

Group S4 – Inner Suburbs
The four segments in the Inner Suburbs social group are concentrated in the inner-ring suburbs of major metros–areas where residents tend to be high school educated, unmarried and lower-middle class. There's diversity in this group, with segments that are racially mixed, divided evenly between homeowners and renters and filled with households that are either young or aging in place. However, the consumer behavior of the S4 segments are dominated by older Americans who enjoy social activities at veterans clubs and fraternal orders, TV news and talk shows, and shopping at discount department stores. [The Inner Suburbs group consists of the segments: New Beginnings; Old Glories; American Classics; and Suburban Pioneers.]

See also: clustered world

1. Excerpted from *PRIZM NE Marketing Segments*, Claritas Customer Segmentation, http://www.claritas.com/claritas/Default.jsp?ci=3&si=4&pn=prizmne_segments.

cloverleaf: An interchange at which two crossing highways form a series of curving entrance and exit ramps resembling, from an aerial view, the shape of a four-leaf clover

One of the first types of interchanges developed, the cloverleaf allows vehicles to proceed in either direction on either highway without stopping at any traffic lights. However, it creates congestion due to the fact that vehicles are both entering and exiting traffic from the same lane. A cloverleaf takes up more land than almost any other type of interchange.

cluster

1: cluster subdivision

A traditional form of suburban development composed of groupings of similar houses sold at similar prices to families that purchase similar types of household goods, which results in geographic divisions between socioeconomic classes.[1]

2: cluster zoning

A type of development that increases the overall density of housing by reducing each home's lot size, which in turn allows large areas of open space to be used for parks, preservation of environmentally sensitive areas, or agriculture. In addition to being a more ecologically sound alternative to a traditional development, cluster zoning reduces construction and maintenance costs by having shorter streets and utility lines.

See also: high density, smart growth

3: clustered world

Refers to the findings of marketer Michael J. Weiss, who divided the United States into forty marketing clusters named after residential stereotypes in the books *The Clustering of America*[2] and *The Clustered World: How We Live, What We Buy, and What It All Means About Who We Are*[3]

Weiss' data is based primarily on the market research done by Claritas.

See also: Claritas, SOHO

4: fast-food cluster

A collection of fast-food restaurants in a small geographic area

1. Dolores Hayden, *A Field Guide to Sprawl* (New York: W.W. Norton & Company, 2004), 32.
2. Michael J. Weiss, *The Clustering of America* (New York: Harper & Row, 1988).
3. Michael J. Weiss, *The Clustered World : How We Live, What We Buy, and What It All Means About Who We Are* (London: Little, Brown, & Co., 2000).

collector road: A street with no more than four lanes that collects traffic from small local roads and delivers it to major roadways with faster speed limits (exceeding 35 mph) and additional lanes

New developments, which often do not include enough collector roads, lead to increases in traffic congestion, driving time, and stress on existing streets.

Community Interest Development (CID): Any development with private ownership of buildings, or units, but common ownership of land and communal elements; also known as Common Interest Development

CIDs are usually governed by a community association, such as a homeowner association (HOA) or property owner association (POA). Increasingly popular in newer residential areas, CIDs enforce covenants, codes, and restrictions (CC&R) that function as zoning ordinances governing a variety of issues for an entire development—everything from domestic animals and exterior appearances to home occupancy and infrastructure maintenance—under the premise of preserving overall property values in the community.

See also: deeded community, gated community, homeowners association

compact land use: A development strategy that focuses growth around existing population centers

An urban-growth boundary, mixed-use development, and infill construction are important components of compact land use, which is seen as an antidote to sprawl and a way to encourage the use of public transportation.

See also: cluster zoning, infill, mixed-use development, smart growth

crunchy suburb: A typically inner-ring suburb characterized as progressive, anticommercial, or countercultural, particularly found in cities located in the northern rim of the United States through Vermont, Massachusetts, Wisconsin, Oregon, and Washington

Satirized by David Brooks as a "progressive suburb dominated by urban exiles who consider themselves city folks at heart but moved out to suburbia because they needed more space," a crunchy suburb is populated by countercultural urbanites with kids as well as businesses that cater to these families, such as food co-ops. Brooks sees crunchy suburbanites as open-minded, inclusive,

and in possession of the last truly anticommercial lifestyle.[1]

1. David Brooks, *On Paradise Drive: How We Live Now (And Always Have) in the Future Tense* (New York: Simon & Schuster, 2005).

cul-de-sac: A dead-end street with a bulb-shaped turn-around

By limiting access through one inlet/outlet and reducing speed limits, cul-de-sac communities are thought to be one of the safest places to live. They command typically higher premiums in resale, and are popular with developers because they allow more houses onto irregularly shaped plots of land. However, recent studies have pointed out that cul-de-sacs discourage pedestrians and public transportation. They also have some of the highest rates of traffic accidents involving young children.[1] "In cities such as Charlotte, N.C., Portland, Ore., and Austin, Texas, construction of cul-de-sac–based suburbs has basically been banned. In other places, cul-de-sac communities have been retrofitted with cross streets."[2]

1. William H. Lucy and David L. Phillips, *Tomorrow's Cities, Tomorrow's Suburbs* (Chicago: American Planning Association, 2006).
2. John Nielsen, "Cul-de-Sacs: Suburban Dream or Dead End?," *Morning Edition* (June 7, 2006), http://www.npr.org/templates/story/story.php?storyId=5455743.

cup-holder cuisine: Food meant to be consumed on the go while driving or walking, often in a package designed to fit in a car's cup-holder
See also: drive-thru, fast food

curb appeal: A first impression of a house when seen from the street

Positive curb appeal—through such things as a well-groomed and designed landscape, an attractive exterior paint color, and a well-maintained house exterior—is thought to sell a house faster and for a higher price.

D

dead mall: A shopping center that has fallen into distress, decay, or decline through disuse, a deteriorating structure, and/or abandonment

Often a mall becomes unfavorable because it is out of fashion, has a high vacancy rate, or draws very little consumer traffic. Dead malls usually occur when surrounding neighborhoods go into socioeconomic decline, when there is competition with another larger shopping center, or when the anchor stores leave or close. As consumer trends have shifted over the past twenty years and more malls have become vacant, a number of architects, scholars, and governmental agencies have attempted to reinvent the indoor, enclosed shopping mall and consider new ways to use the greyfields created by dead malls.[1]
See also: greyfield

1. For a description of a project by the National Endowment for the Arts, see David J Smiley, ed., *Sprawl and Public Space: Redressing the Mall* (New York: Princeton University Press, 2002).

deeded community: A group of properties that each carry deed restrictions outlined in a Deed of Conveyance that must be followed by the property owner

Deed restrictions can limit everything from the type of business that can be run from the home to choices for the house's exterior paint color.
See also: Community Interest Development (CID)

discount department store: A large retail store, usually between 75,000 and 250,000 square feet, offering a wide variety of merchandise at low prices

Target, Wal-Mart, and Kmart are prime examples of U.S. discount department stores.
See also: big box, category killer, chain store, outlet store, power center, superstore, value retailer, warehouse club

Disneyfication: The stripping of a real or historical place or event of its original character in order to repackage it in an ersatz, simplified, and sentimentalized form

The term, derived from the name of the Walt Disney Company, describes what some see as the expanding influence of the principles behind the Disney theme parks, particularly for suburban development.[1] The Walt Disney Company became directly involved in suburban development when it built a planned community named Celebration just south of Walt Disney World in Orlando, Florida.[2]
See also: theme park, theming

1. See Sharon Zukin, *The Cultures of Cities* (Boston: Blackwell, 1996). For the related term Disneyization, see Alan Bryman, *The Disneyization of Society* (London: Sage, 2004).

2. For more information on Celebration and suburban planning, see Andrew Ross, *The Celebration Chronicles: Life, Liberty, and the Pursuit of Property Value in Disney's New Town* (New York: Ballantine Books, 1999) and Bettina Drew, "Celebration: A New Kind of American Town" in *Crossing the Expendable Landscape* (St. Paul, Minnesota: Graywolf Press, 1998).

drive 'til you qualify: A phrase used by real estate agents whereby potential homebuyers travel away from the workplace until they reach a community in which they can afford to buy a home that meets their standards

"The size of the wallet determines that of the mortgage, and therefore the length of the commute. Although there are other variables (schools, spouse, status, climate, race, religion, taxes, taste) and occasional exceptions (inner cities, Princeton), in this equation you're trading time for space, miles for square feet."[1]

1. Nick Paumgarten, "There and Back Again," *The New Yorker* (April 16, 2007).

drive-thru: An establishment, such as a fast-food restaurant or a bank, where customers drive to a window to conduct business while remaining in the car

Popular since the 1920s for its convenience, the drive-thru has recently been banned in some American cities because curb cuts for automobiles disrupt the sidewalk, endanger pedestrians, and take up more space than a standard parking lot.
See also: carchitecture, cup-holder cuisine

drosscape: A term created by Alan Berger "to describe a design pedagogy that emphasizes the productive integration and reuse of waste landscapes throughout the urban world. . . .The term drosscape implies that dross, or waste, is scaped, or resurfaced, and reprogrammed by human intensions."[1]
See also: brownfield, greenfield, greyfield

1. Alan Berger *Drosscape: Wasting Land in Urban America* (New York: Princeton Architectural Press, 2006), 236.

duck: A type of architecture in which the shape of the structure is symbolic, often literally so

Long Island's Big Duck—an 18-by-30-by-20-foot duck-shaped concrete structure built in 1931 by duck farmer Martin Maurer to promote his business—was the inspiration for this term coined by Robert Venturi, Denise Scott Brown, and Steven Izenour. "Where the architectural systems of space, structure, and program are submerged and distorted by an overall symbolic form. This kind of building-becoming-sculpture we call the duck in honor of the duck-shaped drive-in, 'The Long Island Duckling,' illustrated in *God's Own Junkyard* by Peter Blake.[1] The duck is the special building that is a symbol."[2]
See also: carchitecture, logo building

1. Peter Blake, *God's Own Junkyard: The Planned Deterioration of America's Landscape* (New York: Holt, Rinehart and Winston, 1964), 101. See also Denise Scott Brown and Robert Venturi, "On Ducks and Decoration," *Architecture Canada* (October 1968).
2. Robert Venturi, Denise Scott Brown, and Steven Izenour, *Learning from Las Vegas: The Forgotten Symbolism of Architectural Form* (Cambridge, Massachusetts: MIT Press, 1977), 89.

E

edge city: An area on the outskirts of a city with a high density of office buildings, retail centers, and businesses, and thus a political, economic, and commercial base independent of the central city

Journalist Joel Garreau coined this term to refer to a suburb with more jobs than bedrooms.[1]
See also: bedroom community

1. Joel Garreau, *Edge City: Life on the New Frontier* (New York: Anchor Books, 1992).

Edifice rex: An extremely large new house, often built in an older suburb of smaller homes, characterized by an ostentatious, over-size facade
See also: McMansion, monster home, starter castle, tract mansion

empty nester: A parent whose children have grown up and moved away from home

Empty nesters are often residents of suburbs, where they once moved to raise their families.

ethnoburb: A "suburban ethnic cluster of residential areas and business districts in large metropolitan areas"[1]

The term was coined by Wei Li in a 1998 article about Los Angeles. While the community remains multiethnic, the ethnoburb has a high concentration (although not necessarily a majority) of one particular ethnic group.[2]

1. Wei Li, "Ethnoburb versus Chinatown: Two Types of Urban Ethnic Communities in Los Angeles," *Cybergeo* 10 (1998).
2. Vincent Miller, "Mobile Chinatowns: The Future of Community in a Global Space of Flows," *The Journal of Social Issues* 2 (2004).

exurb: A semirural suburban area, beyond densely settled subdivisions, featuring widely separated, large, expensive homes often surrounded by woods, creeks, or ponds and populated by upper and upper-middle-class residents

A. C. Spectorsky coined the term in his 1955 satirical book *The Exurbanites* to describe displaced successful New Yorkers who move away from the city to establish an ideal home on a large plot of land.[1] More recently, exurbanites have become a sought-after political demographic and the subject of many growth debates and studies.

See also: leapfrog, sprinkler city

1. A. C. Spectorsky, *The Exurbanites* (Philadelphia: J. B. Lippincott Company, 1955).

F

family room: An informal living area or recreation room in a residence
See also: media room

fast food

1: of, relating to, or specializing in food prepared in quantity by a standardized method and served quickly in a ready-to-eat state
2: designed for ready availability, use, or consumption and with little consideration given to quality or significance
See also: cup-holder cuisine, drive-thru

first ring: An area directly adjacent to a central metropolitan area that represents the first phase of suburban development, chronologically and geo-graphically, beyond the city; also known as first tier
See also: inner ring

food court druid: A satirical term coined by author Robert Lanham to described a teenage goth or mall rat obsessed with fantasy role-playing games[1]
See also: mall rat

1. Robert Lanham, *Food Court Druids, Cherohonkees, and Other Creatures Unique to the Republic* (New York: Plume, 2004).

G

garage

1: A space primarily for parking or storing motor vehicles but also unused possessions, equipment, and tools

The successor to the carriage house, the detached garage was seen as a safer environment for storing automobiles, which contained volatile gasoline. Since the postwar period, the suburban garage structure is more typically integrated into the house itself and has grown in size and complexity.
2: A commercial establishment for repairing and servicing motor vehicles
See also: garage band, Garage Mahal, snout house

garage band: An amateur rock band typically holding its rehearsals in a garage

Some of the earliest garage bands appeared in the United States in the 1960s. A significant influence on U.S. punk, such groups often emphasized their amateur qualities by, for instance, playing simple chords or using the garage as a studio to make low-cost recordings.

Garage Mahal: A large or opulent garage or parking structure

gated community: A community or common-interest development with controlled entrances, typically staffed by private security guards, to regulate access by pedestrians, bicycles, and automobiles
See also: Community Interest Development (CID), privatopia

greenfield: Land undeveloped except for agricultural use, especially that considered for new industrial or residential development
See also: brownfield, drosscape, greyfield

greenway

1: Land converted for recreational use; particularly a trail or linear open space established along a natural corridor, such as a riverfront, stream, or ridge line, or along a railroad right-of-way
2: A trail or bike path; any natural or landscaped course for pedestrian or bicycle passage
3: Open space that links parks and rural land; a belt of interconnected parks or rural land surrounding a town or city

greyfield:
Economically obsolete, outdated, failing, moribund, and/or underutilized real estate assets, such as formerly industrial waterfront sites or dead malls; alternate spelling: grayfield

The term, coined by Pricewaterhouse Coopers and the Congress for New Urbanism in 2001, refers to the color of the extensive asphalt pavement that occupies these sites. Unlike brownfields, greyfields do not have high levels of pollution and are equipped with an infrastructure that makes them ripe for redevelopment.
See also: brownfield, drosscape, greenfield

gridlock

1: A traffic jam; a high density of vehicles on a grid of intersecting streets such that movement is stopped or extremely slowed
2: A situation resembling gridlock; frustrating stagnation, a complete lack of movement or progress resulting in standstill

growth machine:
A characterization of local governments, particularly municipalities that produce wealth for those in power by encouraging real estate development at the taxpayers' expense

Sociologist Harvey Molotch observed in 1976 that a common interest in growth is one of the few issues that unites and politically mobilizes those in the upper echelons of the social hierarchy.[1] To this day, the basic issues that Molotch's thesis addressed, such as growth, local economic development, and who promotes these, remain central to the politics of cities.[2]
See also: ball pork

1. Harvey Molotch, "The City as Growth Machine" in *The American Journal of Sociology*, 1976, http://www.nw-ar.com/face/molotch.html.
2. Andrew E. G. Jonas and David Wilson, eds., *The Urban Growth Machine: Critical Perspectives Two Decades Later* (Albany: State University of New York Press, 1999).

H

high density:
Having a large number of families, individuals, dwelling units, households, or housing structures per unit of land

High-density housing has historically carried a stigma due to its association with poverty, crime, and other social problems. For this reason, ordinances have been passed in many areas limiting the density of development. However, planners and developers have argued that high-density housing helps curb sprawl, allows residents to walk to the supermarket or local schools, offers residents more direct access to public transportation, and costs less for the developer in terms of infrastructure and land use. Row houses, townhomes, and apartment buildings have therefore increasingly become a part of cluster zoning and infill development.
See also: cluster, infill, low density

home office

1: Headquarters or main office of a company
2: A work or office space in an individual's private residence

Since the advent of the personal computer and breakthroughs in communication technologies in the 1990s, more workers have decentralized, creating an office in their living space and working from home. A significant tax deduction for home offices makes this way of working financially advantageous, if you qualify according to the IRS's stringent criteria. A Community or Common Interest Development (CID) often restricts homeowners from operating an independent business from their residence.
See also: SOHO, telecommute

homeowners association (HOA):
An organization established to govern a private community; specifically, a group of homeowners, elected by fellow members, that determines the covenants, conditions, and restrictions (CC&Rs) owners, tenants, and guests must obey according to a set of rules or bylaws

The HOA protects and preserves the value of the property and may also be responsible for repairs and maintenance of the community's common areas, including swimming pools, health club facilities, and landscaping. Generally, the developer initially controls the association, then transfers control to the individual owners some years later. Usually the governing board of directors has an annual budget prepared, and then assesses each member a share of the costs.
See also: Community Interest Development (CID)

HOV (High Occupancy Vehicle) lane: A designated express lane on highways for use exclusively by vehicles with two or more passengers

Commonly marked with diamonds painted on the pavement, the HOV lane is less congested than other lanes on the highway and therefore meant to encourage carpooling. Some cities have recently experimented with charging single occupancy vehicles a toll to use the HOV lane during peak traffic periods.

I

infill: The development of new housing or other buildings on scattered vacant sites in a built-up area; also called "odd-lot development"
See also: compact land use, mixed-use development

inner ring: Suburban areas that are adjacent or in close proximity to city centers

Inner-ring suburbs were usually among the first areas in a metropolitan region, built during the boom that followed World War II, and frequently located within a three-digit interstate highway. Many inner-ring suburbs have been in decline due to new suburban-growth competition and have experienced increasing rates of poverty and crime.
See also: exurb, first ring, leapfrog

L

landfill: A disposal site in which solid waste is compacted and covered with earth in alternate layers of specified depth according to an approved plan

Hazardous waste is not permitted, and landfill sites are regulated so they can be reused for another purpose in the future. Nonetheless, a landfill is usually considered to a LULU (locally unwanted or undesirable land use).
See also: BANANA, LULU, NIMBY, NOTE

leapfrog: To bypasses empty land for development in order to build in a remote location

A condition of sprawl, leapfrogging was encouraged in the late twentieth century by tax policies that favored greenfield development and still occurs when developers want to move beyond city boundaries to avoid its land-use regulations.
See also: exurb, first ring

lifestyle commuter: Someone who works in the city but lives outside an urban area, usually in an exurb, because a more rural lifestyle is preferred

light rail: A rapid-transit public transportation system, sometimes referred to as a contemporary version of the streetcar

logo building: A building with a prominent trademark sign, or whose design is distinctive and easily recognizable from the road

Some communities find this architecture distasteful and have worked together with franchises to design buildings better integrated with their specific surroundings.
See also: carchitecture, duck

low density: Having a lesser number of families, individuals, dwelling units, households, or housing structures per units of land

Americans often prefer low-density housing and believe that generous lots make for safer neighborhoods and higher property values. However, low-density development contributes to sprawl and encourages residents to be more dependent on their automobiles.
See also: compact land use, high density, infill, mixed-use development, sprawl

LULU (Locally Unwanted Land Use or Locally Undesirable Land Use): An acronym for a nuisance or detriment to local sites and neighboring land

LULUs can be anything from parking lots to nuclear power plants, landfills, prisons, or psychiatric hospitals. Environmental justice observers point out that LULUs are disproportionately located in poor or minority neighborhoods. However, this observation is the topic of much debate as others claim employment and other benefits that may compensate for their detrimental aspects.
See also: BANANA, NIMBY, NOTE

M

mall rat: A young person who spends much of his or her leisure time at a shopping center primarily for socializing and entertainment, rather than shopping
See also: food court druid

media room: One of the many activity-specific rooms associated with newer suburban homes and dedicated to accommodating new electronic tech-

279

nologies such as large-screen televisions, home theaters with stereo sound systems, computers, and video games

According to a 2005 study by the National Association of Home Builders (NAHB), 85 percent of Americans want walk-in pantries, 77 percent want separate shower stalls in their bathrooms, 95 percent want laundry rooms, 64 percent want home offices, and more than a third want media rooms.[1]
See also: family room

1. Les Christie, "Die, die, monster home!," CNNMoney.com (August 18, 2005).

megachurch:
A church with a congregation of two thousand or more worshippers at each weekly service and characterized, in part, through the use of nontraditional music, theatrical lighting, sophisticated audio systems, and display technologies

Although Protestant in origin, more than half of U.S. megachurches are nondenominational. Unlike that of traditional churches, the architectural language of megachurches tends toward the secular. One of the largest such congregations in the United States is the Lakewood Church in Houston, Texas, which uses a converted sports arena (once home to the Houston Rockets) to seat sixteen thousand worshippers. Though extreme in size, they tend not to be as ornate as the cathedrals of an earlier era. Architectural critic Witold Rybczynski notes that megachurches often resemble performing arts centers, community colleges, or corporate headquarters.[1] They also tend to include a variety of spaces for the benefit of their congregation: the Willow Creek Community Church of Chicago, situated on a 155-acre site, features two sanctuaries, a gym and recreation center, a bookstore, a food court, and a cappuccino bar. "Megachurches celebrate comfort, ease and the very idea of contemporary suburban life."[2]

1. Witold Rybczynski, "An Anatomy of Megachurches: The New Look for Places of Worship," *Slate* magazine (October 20, 2005).
2. Paul Goldberger, "The Gospel of Church Architecture, Revised," *New York Times*, April 20, 1995.

megaschool:
A high school with a population of two thousand or more students

Megaschools most often come into being when two or more smaller high schools merge. Critics of the model often site its lack of intimacy, security, guidance, and support. A Western Michigan study suggested that the most effective size at which a high school can operate is between six hundred to nine hundred students.[1]

1. Sue Robertson, "Is Bigger Always Better?," *School Planning and Management* (November 2001).

megasite:
A large parcel of land of more than 1,000 acres, typically a greenfield, ideal for heavy industrial development and offering easy access to highways and railroads

McMansion:
A large, hastily built, cookie-cutter house with a footprint of greater proportion to its lot size, constructed with details simulating a hodge-podge of architectural styles and numerous modern, high-tech features

The term, derived from the fast-food restaurant McDonald's, was coined in the 1980s by architects and architecture critics in response to the many oversize, poorly designed homes being built in American suburbs. McMansion also refers to a new, large house that stands out from the surrounding homes because of its garishness, especially those built in established neighborhoods of smaller homes.
See also: Edifice rex, monster home, ranchburger, tract mansion

megaburb:
A suburban area with an accelerated growth rate that continues to climb; an "economically integrated, wealth producing and consuming machine"[1]
See also: boomburb, zoomburb

1. James S. Russell, "When Suburbs Become Megaburbs," *Architectural Record* (August 2003), http://www.jsrussellwriter.com/megaburbs.html.

middle landscape
1: A historic notion of suburbia as idealized by the upper-middle classes of the first industrial revolution

Middle landscape originates with Leo Marx, a professor of American Studies at the Massachusetts Institute of Technology, who described it as situated somewhere between the "chaos, garbage, and immigrant-dense metropolis" and the "uncivilized, provincial, and poor countryside."[1]
2: The area between the city and the countryside

Peter Rowe popularized the term in his book

Making a Middle Landscape (MIT Press, 1991), in which he examines the factors that have shaped modern suburban development and its ameliorative possibilities.

1. Cory Dolgon, "Suburbia," *Chronicle of Higher Education* (July 8, 2005).

minivan: A small passenger van

Popularized in the United States beginning in the 1980s, the American minivan was originally intended to appeal to families living in suburban areas. Minivans are typically taller than a station wagon, but smaller than a utility van.
See also: soccer mom

mixed-use development: The practice of allowing multiple uses (any combination of residential, commercial, industrial, office, or institutional) in a building or set of buildings
See also: adaptive reuse, cluster zoning, compact land use, infill, smart growth

monster home: An extremely large new house built in a neighborhood of smaller homes

Monster homes typically come into being as "teardowns," a term that describes the process of demolishing an existing, functional house and replacing it with a larger, more expensive home. In recent years, cities have begun to enact legislation that restricts the size of new homes in older neighborhoods. Some of these laws take the form of limiting new buildings to a certain percentage of its lot size.

According to the National Association of Home Builders (NAHB), in 1950 an average new house was 963 square feet and in 1970 it was 1,500 square feet. The 2005 average was 2,400 square feet, with one in five having more than 3,000 square feet. However, since 1971 average household size has shrunk from 3.1 people to 2.6 people in 2005. The average lot size also contracted from 9,000 square feet in the 1980s to 8,000 in 2005.[1] Thus, the trend points to bigger houses being constructed for fewer people on smaller plots of land.
See also: Edifice rex, McMansion, starter castle, tract mansion

1. Les Christie, "Die, die, monster home!," CNNMoney.com (August 18, 2005).

N

NASCAR dad: Euphemism for a white, working-class father believed to enjoy stock-car racing

During the presidential election of 2004, the term NASCAR dad was coined by the media in reference to the key demographic the candidates needed to win over in order to secure the presidency.
See also: soccer mom

nerdistan: An upscale suburb or suburban city in which a large percentage of the population is employed by nearby high-tech industries

The term first came into use in a 1997 *Washington Post* essay titled "Escape from Nerdistan," written by urban scholar and author Joel Kotkin. Kotkin identified five prime examples of nerdistans: Orange County, California; North Dallas, Texas; Northern Virginia; Raleigh-Durham, North Carolina; and the area surrounding Redmond, Washington (headquarters for Microsoft): "South Orange County is a classic nerdistan—largely newly built, almost entirely upscale office parks, connected by a network of toll roads and superhighways to planned, often gated communities inhabited almost entirely by college educated professionals and technicians."[1]
See also: technoburb

1. Joel Kotkin, "Avoiding Excesses Has Buoyed L.A.'s Tech Sector," *Los Angeles Business Journal* (August 20, 2001).

New Suburbanism: An architectural and city planning movement that describes an approach to developing suburban communities based on the principles of Smart Growth and New Urbanism

The basic concepts of New Suburbanism predate the Smart Growth and New Urbanism movements, as exemplified in older suburbs such as the Woodlands, outside of Houston, Texas; Irvine, California; Columbia, Maryland; and Reston, Virginia.[1] This term came into broad use through urban scholar and author Joel Kotkin, who wrote a report titled "The New Suburbanism: A Realist's Guide to the American Future" (The Planning Center, 2005). Kotkin credits Randall Jackson, the president of the Planning Center, with coining the name.[2] However, the term probably surfaced in 1999 with Bob Lembke, then-managing partner of Bromley Cos. LLC, developers of Bromley Park, a 16,000-acre master-planned community in Brighton, Colorado. Lembke spoke about his plans to combine

the amenities of suburban life with the principles of New Urbanism in order to create a development that didn't shun the car, but still offered ways for people to connect as a community as they would in denser environments.[3]

A principal idea of New Suburbanism is "suburban villages," which behave more like small towns and are less reliant on central cities: "In contrast to New Urbanism, new suburbanism tries to work within sprawl rather than fight it. Promoters seek not a return to the dense urban paradigm of Jane Jacobs but instead the creation of an archipelago of villages connected not only by roads (and sometimes trains) but also by new communications technology. While it may sometimes follow the design principles created by New Urbanists, the suburban village embraces the reality of dispersion and encourages less dependence on long-range commuting, including to the urban core. It looks less to the urban past of the industrial era and more to the postindustrial future of a new village-dominated epoch."[4]

See also: New Urbanism

1. Joel Kotkin, "What Is the New Suburbanism?," Planetizen.com (April 24, 2006).
2. Kotkin, "The New Suburbanism," *Architecture* (June 2005).
3. Pete Lewis, "The New Suburbanism," *ColoradoBiz* (January 1999).
4. Kotkin, "What Is the New Suburbanism?," 2006.

New Urbanism: An architectural and city planning movement that opposes sprawl and seeks to develop neighborhoods that mimic successful aspects of city life

New Urbanist projects focus on pedestrian-friendly and transit-oriented designs as well as sustainable growth that is "sensitive to environmental quality, economy, and social equity."[1] It has become known as traditional neighborhood design, neo-traditional design, and transit-oriented development. A further idealistic branch of New Urbanism was founded by Michael E. Arth in 1999 and is known as New Pedestrianism. New Urbanism's most famous proponents are architects Andrés Duany and Elizabeth Plater-Zyberk, two of the founders of the Congress for the New Urbanism, established in 1993.

Further reading: Congress for the New Urbanism, http://www.cnu.org/. See the Duany Plater-Zyberk (DPZ) site for a list of New Urbanist readings, http://www.dpz.com/research.aspx.

See also: New Suburbanism

1. Ajay Garde, "Designing and Developing New Urbanist Projects in the United States: Insights and Implications," *Journal of Urban Design* (February 2006).

NIMBY (Not In My Backyard): An acronym used to express opposition to the location of an unwanted and undesirable facility in the neighborhood, usually because they are considered unsightly, dangerous, or will lead to decreased property values

Prime subjects of NIMBY protests include jails, garbage dumps, and drug or convict rehabilitation centers.

See also: BANANA, LULU, NOTE

no growth: A city planning movement that opposes new developments of any sort

See also: slow growth, smart growth

node: A suburban enclave on the periphery of cities

Nodes are part of an auto-centric landscape of suburban destinations connected by highways and roads.

noise barrier: A wall or other solid obstruction alongside a highway, typically made of concrete or wood, designed to reduce roadway noise into an adjacent neighborhood; also known as noise wall

According to urban historian and architect Dolores Hayden, noise walls rarely work well because on wide highways the noise will go over the wall and bounce back from it.[1]

See also: berm

1. Dolores Hayden, *A Field Guide to Sprawl* (New York: W.W. Norton & Company, 2004).

non-place: Spaces of such temporary, transient activity as to not have the significance to be regarded as "places"; also called non-space

The term "non-place" was coined by French anthropologist Marc Augé, who wrote *Non-Places: Introduction to an Anthropology of Supermodernity* (1995). Examples of non-places include airports, supermarkets, hotel rooms, and highways.

"Marc Augé coined the term *non-lieux* [non-places] to describe specific kinds of spaces, chiefly architectural and technological, designed to be passed through or consumed rather than appropriated, and retaining little or no trace of our engagement with them. These spaces, principally associated with transit and communication, are for Augé the defining charac-

teristics of the contemporary period he calls 'supermodernity,' the product and agent of a contemporary crisis in social relations and consequently in the construction of individual identities through such relations."[1]

1. Emer O'Beirne, "Mapping the Non-Lieu in Marc Augé's Writings," *Forum for Modern Language Studies* 42, no. 1 (2006).

NORC (Naturally Occurring Retirement Community):
A building, complex, or neighborhood in which a majority of residents are seniors (over age 60)

The State of New York defines a NORC as a community in which 40 to 50 percent of the heads of households are at least sixty years old. A high concentration of the elderly may occur due to those who want to "age in place" or who are "stay puts" (both phrases refer to people who want to live in their homes as long as possible). In some areas, NORCs are officially recognized by city and state governments. Both New York City and Chicago provide some funding to NORCs. New York has a NORC-Supportive Service Program (SSP) that certain groups are proposing should be rolled out to the rest of the nation.[1]

1. Anita Altman, "The New York NORC-Supportive Service Program," *Journal of Jewish Communal Service* (Spring 2006).

NOTE (Not Over There Either): A person or local
organization that opposes an unwanted or undesirable land-use proposal, but does not want it built elsewhere, either
See also: BANANA, LULU, NIMBY

O

office park: A commercial complex consisting of
one or more office buildings set in a parklike landscape; also referred to as a business park, executive park, or office plaza

The office park may also contain gyms, restaurants, child-care facilities, and recreational areas. The buildings and grounds of an office park are often referred to collectively as a "campus."

outer-ring suburb: Newer suburban devel-
opments further from the urban core than first- or inner-ring suburbs

Traditionally, metropolitan geographic space is divided into three classifications: central city, sub-

urbs (as a donut-shaped ring surrounding the city center), and the rural area/countryside lying beyond the suburbs. (The metropolitan region is classified as the combination of the central city and the suburbs.) However, as the suburbs themselves become increasingly differentiated, scholars parse new classifications that take into account a specific time of development or imply rates of growth and distance away from the urban core. Examples of newer naming conventions include: first suburbs, streetcar suburbs, post–World War II suburbs, inner-ring suburbs, outer-ring suburbs, exurbs, boomburbs, zoomburbs, subcenters, and satellite cities.[1]
See also: boomburb, exurb, first ring, zoomburb

1. Nancey Green Leigh and Sugie Lee, "Philadelphia's Space In Between: Inner-Ring Suburb Evolution," *Opolis: An International Journal of Suburban and Metropolitan Studies* 1, Issue 1 (2005).

outlet store: A large store, usually with 75,000 to
250,000 square feet of space, serving as a discount arm of a major department store or a manufacturer, such as Nike or Levi's

Outlet stores are typically located in the metropolitan periphery or in exurban locations to avoid direct competition with department stores. They are typically clustered together with other discount stores to form outlet malls.
See also: discount department store, value retailer, warehouse club

outparcel: A store not physically connected to a
mall, but located on its premises; also called an outlot tenant or pad tenant
See also: anchor store

ozoner: Slang for an outdoor or drive-in movie
theater

Primarily built during the 1950s, these theaters now tend to be abandoned, replaced in popularity by television and multiplex cinemas. Ozoners are a prime example of a TOAD (temporary, obsolete, abandoned, derelict).
See also: TOAD

P

park and ride: A municipal system that allows
suburban commuters to park free and use public transit to travel to their destinations

Physically the system calls for large parking lots to be adjacent to a bus or rail station. While park and ride is intended to reduce urban traffic congestion, their own parking lots can become so congested as to require commuters to organize a carpool to the park-and-ride lot.

Patio Man: A satirical term coined by David Brooks to describe a suburban Republican man who lives with his wife (dubbed Realtor Mom) and is obsessed with backyard leisurely pursuits and the latest in outdoor grilling technology[1]
See also: Realtor Mom

1. David Brooks, "Patio Man and the Sprawl People," *The Weekly Standard*, August 12, 2002.

pedestrian-friendly: A term to describe designs that favor walking as the primary mode of transportation and the rights of pedestrians in general, championed by the New Urbanists, among others
See also: New Urbanism

Peter Pan suburb: A suburban area with no planning for the elderly

picture window

1: A large window, or grouping of windows, designed to frame an exterior view in a house

A picture window dominates the wall or the room in which it is located.
2: A metaphor for suburbia

The term gained in popularity during the postwar period when it was used by author John Keats in his 1957 novel, *The Crack in the Picture Window*. Writes William S. Saunders, "Keats' novel so railed against the disfunctionalities of suburban lifestyles that he compared suburbia to the urban nightmare of George Orwell's *1984*."[1]

"His characters were John and Mary Drone, who lived in Rolling Knolls, where 'For literally nothing down, you too can find a box of your own in one of the fresh-air slums we're building around the edges of American cities . . . inhabited by people whose age, income, number of children, problems, habits, conversations, dress, possessions, perhaps even blood types are almost precisely like yours.'"[2]

The picture window as literary device makes another appearance in Benjamin Cheever's novel *The Good Nanny* (2004). Aileen Panetta writes, "The reference to the picture window is telling. Critics of

the suburbs were ready to assert that the physical environment, the house itself, could have a debilitating effect on the inhabitants—destroy their personalities. The picture window became a contested object. Builders maintained that, besides being cheap to install, it allowed maximum access to light and to nature; critics decried its ubiquity, its charmlessness, its negation of privacy, and its enforcement of the display of virtually identical status objects. For its detractors, the picture window became synonymous with the ills of suburbia itself."[3]

1. William S. Saunders, *Sprawl and Suburbia: A Harvard Design Magazine Reader* (Minneapolis: University of Minnesota Press, 2005).
2. Rosalynn Baxandall and Elizabeth Ewen, *Picture Windows: How Suburbs Happened* (New York: Basic Books, 2001).
3. Aileen Panetta, "Westchester: The Suburb in Fiction" from *Westchester: The American Suburb*, ed. Roger G. Panetta (Bronx, New York: Fordham University Press, 2006).

pod: An area of single-use zoning (such as a shopping center or residential subdivision) located off a major road

"The term may have derived from peas in a pod or from the pod people in the classic film *Invasion of the Body Snatchers*. Long, winding roads that go nowhere characterize dead-worm subdivisions, places with multiple pods. Pods are often a cul-de-sac . . . or a group of them."[1]

1. Dolores Hayden, *A Field Guide to Sprawl* (New York: W.W. Norton & Company, 2004).

pork chop: A term used to describe a residential lot that requires a long driveway to reach the house

"Pork chop lots indicate sprawl because they indicate pressure to sell farmland."[1] When owners come under pressure to meet rising taxes, they may sell large lots off existing farmland, one or two at a time. This process is referred to as "nickel and dime housing," a phrase used by planner Tom Daniels. The first lots to be sold are those fronting the road; the second set to go are pork chop lots.

1. Dolores Hayden, *A Field Guide to Sprawl* (New York: W.W. Norton & Company, 2004).

privatopia: A verbal contraction of "private utopia" referring to a planned or gated community in

which a homeowner's association establishes and enforces rules pertaining to such aspects as property appearance and resident behavior

Such associations, when formed in the absence of an official municipality, may also maintain and operate their own basic infrastructure, including water, sewer, trash, and fire department.
See also: Community Interest Development (CID), gated community, homeowners association, property owner association (POA)

power center: A large retail shopping center consisting primarily of big box stores

Power centers have risen in popularity as the regional mall has been in decline.
See also: big box, category killer, chain store, discount department store, outlet store, superstore, value retailer, warehouse club

property owner association (POA): An association created by the developer that determines the covenants, conditions, and restrictions (CC&Rs) owners, tenants, and guests must obey according to the bylaws

Various amenities run by the association are generally offered to its members, such as pools, parks, and tennis courts.
See also: homeowners association, Community Interest Development (CID)

Q

quality of life (QOL): A term used to describe the personal satisfaction or dissatisfaction one finds with nonmaterial comforts, such as the cultural, intellectual, or safety conditions under which one lives

A perceived improvement of quality of life is one reason why people may prefer suburban communities more than urban centers. The phrase is often abbreviated as QOL in academic studies.

R

ranchburger: A one-story ranch house in a subdivision of similar homes

Ranchburgers are mass-produced and "consumed" like fast-food hamburgers.

Realtor Mom: A satirical term coined by David Brooks to describe a suburban Republican woman

who lives in sprinkler city with her husband, dubbed Patio Man[1]
See also: Patio Man, sprinkler city

1. David Brooks, "Patio Man and the Sprawl People," *The Weekly Standard*, August 12, 2002.

ring road: A higher-speed road, such as an interstate highway, that encircles a central city and passes between it and the first- or inner-ring suburbs

The design is meant to relieve traffic congestion in the urban core, although it often leads to heavy traffic just beyond. It is also referred to as a beltway.

roundabout: A circular intersection, or junction, of two or more roads where traffic flows in one direction around a central island; also called a rotary

It is considered a traffic-calming device designed to slow traffic, particularly in residential areas. Also known as a traffic circle. The first roundabout in the United States was Columbus Circle in New York City, built in 1905 and designed by William Phelps Eno, a pioneer in traffic control and regulation known as the "Father of Public Safety."

S

SLAPP suit (Strategic Lawsuit Against Public Participation): A lawsuit in which a corporation or developer sues an organization in an attempt to force it to drop protests against a corporate initiative

A common scenario is one where local residents, petitioning to change zoning laws to prevent a real estate development, are served with a SLAPP suit for interfering with a developer's business interests. Many states now have anti-SLAPP suit legislation to protect citizens' rights.

slow growth: An urban planning and transportation movement intended to slow down the pace of new housing and commercial development

Slow growth began as a grassroots movement in California in the 1970s. Not to be confused with the "slow city" movement whose proponents are not necessarily opposed to city growth.
See also: no growth

smart growth: An urban-planning and transportation movement that advocates sustainable land use through compact, mixed-use, transit-oriented,

pedestrian-friendly, and environmentally conscious development

Smart growth focuses on concentrating growth in the central city and older suburbs as opposed to developments on the edges.
See also: adaptive reuse, cluster zoning, compact land use, high density, infill, mixed-use development

snout house: A house from which the garage protrudes like a nose from the main residence toward the street

Common criticisms of this layout include the fact that the garage dominates street frontage, children cannot be watched at play, and the front door is hidden from view.

soccer mom: A typical suburban mom with children whom she ferries around (most likely in a minivan) to various after-school activities

During the presidential election of 1996, the media used the term to denote that portion of the demographic that candidates needed to woo in order to win the presidency.
See also: NASCAR dad

SOHO (Small Office Home Office): A marketing term that describes the small business and business-at-home worker
See also: home office, telecommute

speed bump or speed table: A traffic-calming device in the form of a rounded ridge (bump) or flat, raised plane (table) across a road or driveway designed to slow traffic

While speed bumps are designed to reduce or discourage vehicle through-traffic, the speed table can also serve as a pedestrian crossing.

sprawl: The spread of settlements extending beyond the outskirts of a city on undeveloped land

Sprawl is characterized as haphazard or unchecked growth with a dependency on the automobile, low population densities, fragmented open spaces between real estate developments, frequent lack of public spaces and community centers, single-use zoning, and commercial developments surrounded by extensive parking lots.

sprawl stress syndrome: A condition of worsening health for residents living in low-density suburbs

The term was coined by Joel S. Hirschhorn in the book *Sprawl Kills*: "Sprawl stress syndrome is

not just plain or acute stress that comes and goes in unusual situations, but is chronic stress. Chronic sprawl lifestyle stress results from a steady stream of frustrations and heartaches over long periods, like daily stress from driving in heavy traffic and never having enough time."[1]

1. Joel S. Hirschhorn, *Sprawl Kills: How Blandburbs Steal Your Time, Health, and Money* (New York: Sterling & Ross Publishers, 2005), 212.

sprinkler city: A fast-growing outer suburb or exurb

The term, which references the irrigation systems necessary to maintain manicured lawns, was coined by David Brooks to describe the locus of the Republican party's base in "Patio Man and the Sprawl People," *Weekly Standard*, August 12, 2002.
See also: boomburb, exurb, Patio Man, Realtor Mom, zoomburb

starter castle: An extremely large, ostentatious new house

The term is a play on "starter home," a house for a first-time buyer. A starter castle may be built on the site of a teardown, when an existing, functional house is demolished to make room for a new, often much larger structure.
See also: Edifice rex, McMansion, monster home, tract mansion

streetcar suburb: Early suburbs, built between 1870 and 1910, constructed along horse carriage and later electric streetcar lines

The property of a streetcar suburb was often owned by the transit companies. Developments could occur within city boundaries as well as in adjacent industrial cities and suburbs. Because they were not designed for the automobile, streetcar suburbs are typically denser than the suburban developments that followed.

strip mall: A long, single-story retail complex housing adjacent stores, businesses, and restaurants

Usually a common parking lot is situated in front edged by a sidewalk, and the entire development faces the road with stores aligned in a row. Also referred to as a shopping plaza or mini-mall.

subdivision: A housing development created by partitioning land into individual lots for sale or lease

suburban plantation: A migrant labor camp situated in or near a suburban location and typically composed of makeshift structures that house workers employed in service industries supporting neighboring suburbs

In the documentary *Rancho California (Por Favor)* (2003), professor John Caldwell documented migrant farmworker camps such as Rancho de los Diablos, Kelly Camp, Porterville, and McGonigle Canyon, each located in suburban southern California where homeless, indigenous Mixteco workers coexist with gated communities in Carlsbad, La Costa, Encinitas, and Del Mar.

superstore: An over-size retail store that sells many kinds of merchandise or a wide variety of products in a specific category, such as electronics or recreational sporting goods
See also: big box

SUV (Sport Utility Vehicle): A large passenger automobile with a roomy interior and a higher driving position built on a truck chassis, typically capable of four-wheel drive

Descended from commercial and military vehicles such as the Jeep, the SUV gained popularity in the 1990s and early 2000s. Although intended for off-road travel, it is more commonly a status symbol and alternative to the minivan. SUVs have also been negatively referred to as "urban assault vehicles."

T

tank farm: A site with a large collection of storage containers for oil or liquid natural gas; also known as an oil depot

Tank farms are often located in or near ports with easy access to pipelines and shipping channels.

technoburb: An exurb that has organically morphed into a city with an infrastructure, industries, and services spread throughout the area

The term was coined by Robert Fishman in his 1987 book *Bourgeois Utopias*. Although a technoburb may be dominated by a large number of technology-based businesses, they are so named as a result of the rise of advanced technology and telecommunications. "By 'technoburb' I mean a peripheral zone that has emerged as a viable socioeconomic unit. Spread out along its highway growth corridors are shopping malls, industrial parks, campus-like office complexes, hospitals, schools and a full range of housing types. Its residents look to their immediate surroundings rather than to the city for their jobs and other needs, and its industries find not only the employees they need but also the specialized services."[1]
See also: nerdistan

1. Robert Fishman, *Bourgeois Utopias: The Rise and Fall of Suburbia* (New York: Basic Books, 1987).

telecommute: To work at home by the use of computers and other electronic devices

The commute to work is replaced by a telecommunications link with a central office.
See also: home office, SOHO

theme park

1: An entertainment complex, typically outdoors, containing a collection of attractions that share an overarching narrative or theme

Descended from traveling fairs and carnivals, early amusement parks offered rides and attractions to visitors in one location. Modern approaches to theme parks are believed to originate with Disneyland and Walt Disney World, beginning in the 1950s in the United States.
2: A type of urban/suburban planning that combines history, architecture, entertainment, and retail to create a simulation of an idealized, citylike space

Examples include megamalls such as the Mall of America in Bloomington, Minnesota, Faneuil Hall in Boston, and Universal Studios' City Walk in Los Angeles. The term came into broader use through the book *Variations on a Theme Park: The New American City and the End of Public Space* (1992), edited by Michael Sorkin. He writes that these new "theme park" urban environments are also notable for their consumption of imagery, obsession with security and surveillance, and lack of public space.
See also: Disneyfication, theming

theming: The technique of creating restaurants, hotels, shopping malls, casinos, or even entire towns to simulate other, typically historic, places (Venetian Hotel in Las Vegas, for example) or cultural experiences (such as the concept of an Irish pub)
See also: Disneyfication, theme park

TOAD (Temporary, Obsolete, Abandoned, Derelict): A term coined by lawyers and planners to describe places such as abandoned shopping malls, empty big

box stores, drive-in theaters, or closed industrial sites
See also: dead mall, greyfield, ozoner

tower farm: A cluster of broadcast antennae and transmitting towers, including cellular phone towers

The Federal Telecommunications Act of 1996 (section 704) guaranteed companies the right to erect cell towers, overriding local zoning laws.

tract mansion: A large, expensive, ostentatious house erected among similar-looking homes by a developer who builds on speculation

These homes are usually more than 4,000 square feet, and often combine a dizzying array of architectural styles (for instance, Baroque meets Greek Revivalist meets Cape Cod) in order to quickly impress potential buyers. Also referred to as a McMansion or a "twenty-minute house," referring to the time it takes a realtor to show it to potential buyers.
See also: Edifice rex, McMansion, monster home, starter castle

trailer park: An area equipped to accommodate mobile homes

Parking space for house trailers is rented, and the trailer park provides residents with utilities and services.

V

value retailer: A large store, usually with 75,000 to 250,000 square feet of space, that makes a profit from a high volume of items sold, rather than an inventory mark-up
See also: big box, category killer, chain store, discount department store, outlet store, power center, superstore, warehouse club

W

Walmartization: To become like or have an effect similar to Wal-Mart, the world's largest retailer known for discount priced goods

The phrase is pejoratively used to describe the rise and economic impact of large, outer-suburb shopping outlets and big box stores over smaller commercial districts and locally owned businesses.

warehouse club: A large store, usually with 75,000 to 250,000 square feet of space, offering a limited number of product items (five thousand or less) in bulk at discounted prices

Examples of warehouse clubs include Costco, Pace, and Sam's Club.
See also: big box, category killer, chain store, discount department store, outlet store, power center, superstore, value retailer

weekend home: A second home, often in the suburbs, exurbs, or rural countryside, used on weekends or during vacations

weekend warrior: A homeowner who attempts do-it-yourself home-improvement projects over the weekend, often without extensive experience

white flight: A demographic characteristic in which Caucasian residents leave neighborhoods increasingly or predominantly inhabited by nonwhites

The most commonly cited example of white flight is the situation that occurred in the United States during the 1950s through 1970s as whites left the central cities for new suburban developments.

wigger: A derogatory slang term for a white person (typically a young suburban male) who affects the speech, dress, and behavior stereotypically associated with urban African Americans in general and hip-hop culture in particular; also known as wigga

Z

Zillow: An online real estate service company offering real estate valuations

Rich Barton and Lloyd Frink, both former Microsoft executives and founders of the travel company Expedia, launched the site zillow.com in 2006. Zillow offers free real estate information and home-value estimates, called "Zestimates," which have been criticized by some real estate agents as inaccurate.

zoomburb: A suburb growing even faster than a boomburb[1]
See also: boomburb

1. Dolores Hayden, *A Field Guide to Sprawl* (New York: W.W. Norton & Company, 2004).

Trash

2008

INABA/C-Lab
Jeffrey Inaba, Benedict Clouette, Matthew Clarke, Yi-han Cao, Jesse Seegers, Andrew Shimomura

It is said that a good way to understand a society is by studying its trash. In trash, it is believed, one can find exemplary evidence of the way a society lives: the things it consumes, the manner it consumes, and the means by which it consumes—an essential cross section of everyday life. But we think there is as much to be said for the form used to contain trash as for the contents of trash.

The common suburban trash can says much about culture in the suburbs. Its size is telling of the quantity of trash that is disposed. The inclusion of well-designed wheels is a response to its context. They accommodate the relatively long distances the trash can travels from backyard to curbside in the world of low-density, single-family residential communities. The material of the trash

can reflects the priority given to durability over sustainability, since the hard plastic takes decades to biodegrade. The profile of its sides is optimized for large-scale waste management infrastructure. It can be quickly lifted and emptied by the automated arms of garbage trucks, speeding up the collection process and thereby enabling faster waste collection over a greater territory.

In this project, the trash can has been redesigned, and mostly over-designed, to celebrate the taste of suburban culture and to give a form to the can that describes the processes of use, disposal, and management of the things we trash. *Trash* draws connections between the infrastructures of consumption, waste, and land management in suburbia.

wood

grass

**bulletproof
glass**

trash

luggage

chocolate

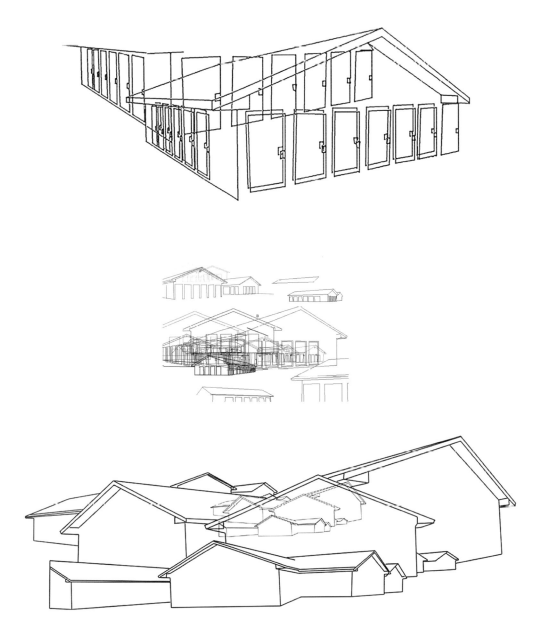

Kim Beck Stills from *Ideal City* 2004–2006 (cat. no. 3)

Kim Beck *Self-Storage* 2004 (cat. no. 4)

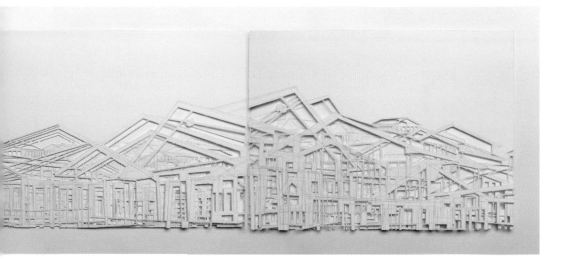

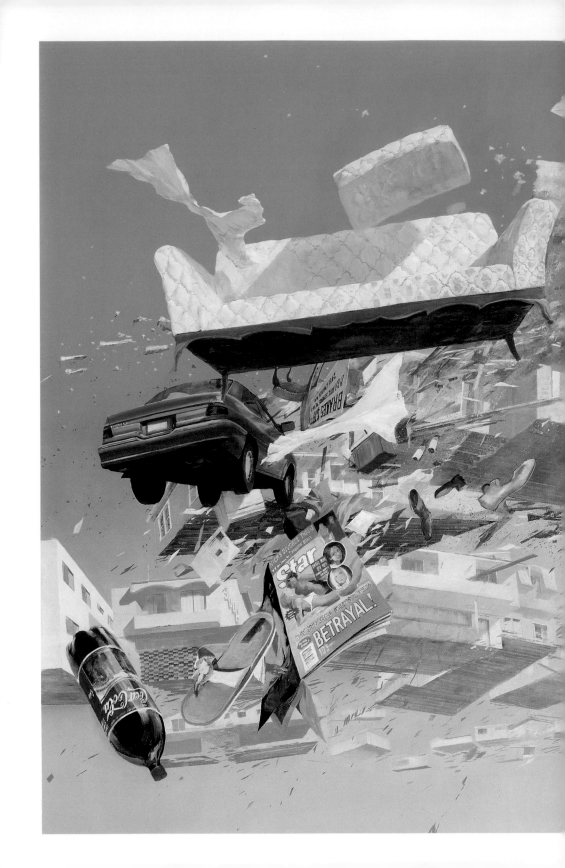

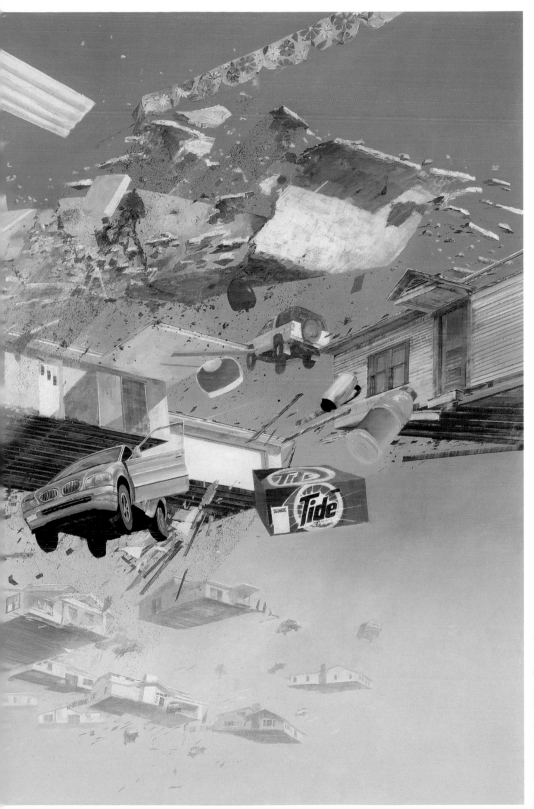

Adam Cvijanovic *Star* 2005 oil on panel

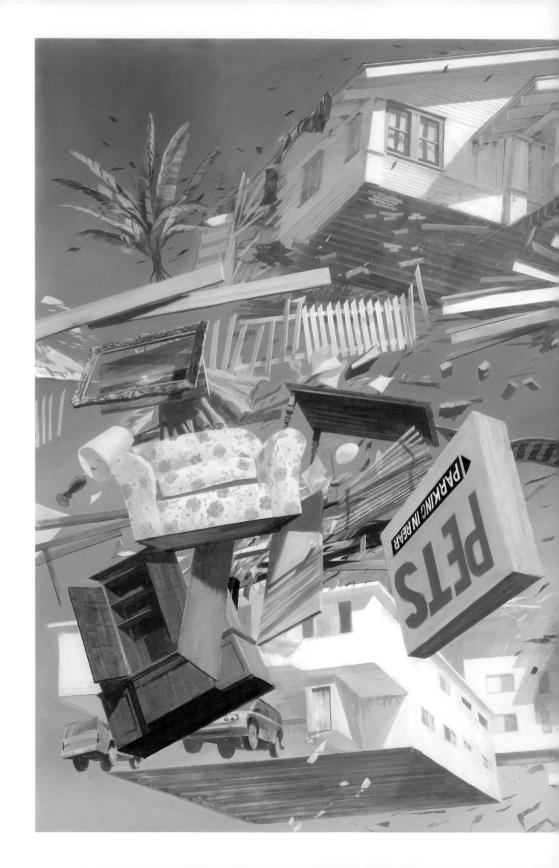

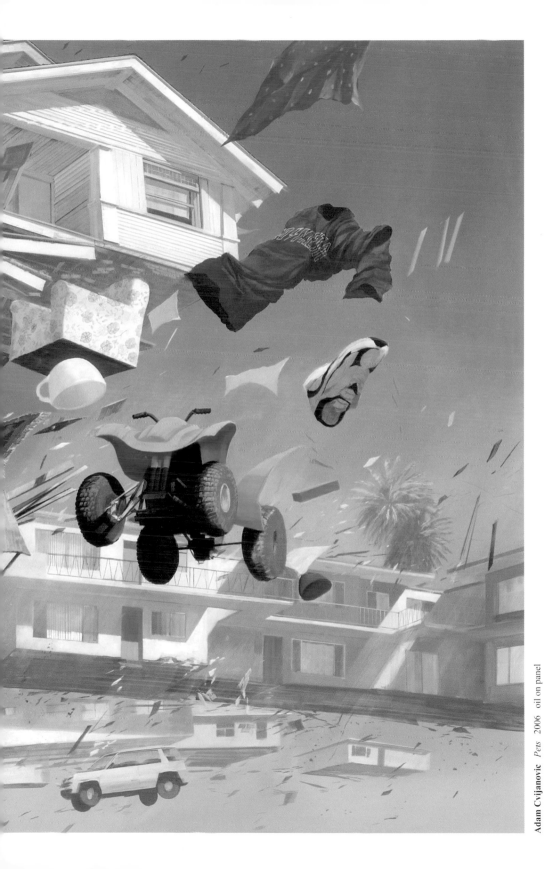

Adam Cvijanovic *Pets* 2006 oil on panel

Lee Stoetzel *McMansion 2* 2005 (cat. no. 71)

Angela Strassheim *Untitled (Elsa)* 2004 (cat. no. 72)

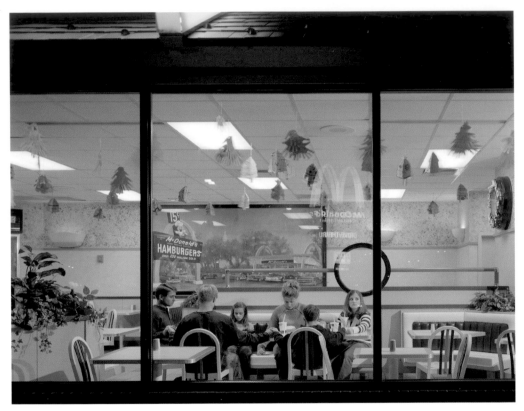

Angela Strassheim *Untitled (McDonald's)* 2004 (cat. no. 73)

Artist Biographies

Chris Ballantyne American, b. 1972, Mobile, Alabama; lives and works in New York

Chris Ballantyne's landscape paintings and prints often take a bird's-eye view of man-made forms set in expansive planes of grass or ocean. Jetties, swimming pools, fences, parking lots, and tract homes are common subjects; and although these constructions are so ubiquitous in our everyday lives as to be mundane, the artist subtly twists the logic of their forms, rendering them as entirely uncanny. Pools are surrounded by mounds of dirt instead of homes, fences dead-end without enclosing a yard, parking lots exist autonomously without linking to roads, and houses grow into multiple wings that connect with each other at improbable angles. The familiar geometries of rooftops and parking lines are thus rendered abstract—their flat planes of color appear as both a diagram and a dream. Ballantyne's aesthetic was influenced by his family's many moves during his childhood across the southern coast of the United States for his father's work with the U.S. Coast Guard. His experience living in various suburban areas gave him a sense of the homogeneity of residential development across the country as well as an awareness of expanding urban areas gradually encroaching on the natural landscape and ways that suburban development is primarily determined by emphatic borders around private property. Since earning his MFA from the San Francisco Art Institute in 2002, the artist has been interested in creating an "uneasy sense of quiet" through paintings, prints, drawings, sculptures, and murals in which an uninhabited architecture is arranged to interrogate the balance between nature and culture.

Kim Beck American, b. 1970, Redbank, New Jersey; lives and works in Pittsburgh and New York

Kim Beck grew up in suburban Denver and found her inspiration there to explore, as she says, "peripheral and suburban spaces [and] bring the banal and everyday into focus." Since receiving her MFA from the Rhode Island School of Design in 1999, Beck has concentrated on engaging the architecture of the suburban landscape: shopping malls, office buildings, highway signage, billboards, street lamps, tract homes, and self-storage facilities. A recent strand of work takes the latter as its subject matter; by showing these storage units simultaneously from multiple angles and densely layering them, Beck creates geometries of dizzying effect. In a related project titled Ideal Cities (2004), the artist melded her delicate and precise drawing skills with commercial die-cutting techniques to create a palimpsest of forms rendered in cut-paper constructions, cardboard models, and hand-drawn animations. Such works bring into relief the dichotomy between these generic and repetitive structures designed to both contain and conceal and the specific and personal nature of the contents, which remain a mystery. Beck's work has been shown at such venues as Printed Matter, New York; the Pittsburgh Center for the Arts; and Hallwalls Contemporary Art Center, Buffalo, New York.

Andrew Bush American, b. 1957, St. Louis, Missouri; lives and works in Los Angeles

From early on in his practice, Andrew Bush has been interested in photographing people in quiet stillness and letting the objects that surround them subtly tell their story. His first series, which began as his master's thesis at Yale University in the early 1980s, consisted of large-format color pictures of Bonnettstown Hall, where an Irish family that he met while traveling in Europe had lived for generations. Although only peripheral details of the house were shown, such as the thermostat or a lamp cord, the residents' presence could be seen in the worn markings throughout the home. When the artist moved to Los Angeles in 1985, he began a new series of Vector Portraits, close-ups of drivers on Southwest freeways framed by their car windows and the surrounding landscape. The pictures were taken between 1985 and 1998 using photographic equipment mounted to the passenger side of Bush's car, which allowed him to take in-focus pictures while traveling fifty to seventy miles per hour. For the most part, the subjects are engrossed in their driving and alone in their vehicles. The resulting images provide an intimate view of a very public act. Bush's work is in the collection of institutions such as the Metropolitan Museum of Art, New York; the Victoria and Albert Museum,

London; Bibliothèque Nationale de France, Paris; the Los Angeles County Museum of Art; and the Museum of Modern Art, New York.

Center for Land Use Interpretation (CLUI)
Established 1994; based in Culver City, California, with offices in Troy, New York; Wendover, Utah; and the Mojave Desert
Matthew Coolidge, founder and director; Sarah Simons, associate director

The Center for Land Use Interpretation (CLUI) is a nonprofit organization that studies, interprets, and educates the public about the human impact on the earth's surface. Reflecting the multidisciplinary perspective of its founder, who studied environmental science, contemporary art, and film at Boston University, CLUI aims to integrate the variety of approaches to and attitudes toward the landscape into "a single vision that illustrates the common ground in land use debates." Through formal and informal research carried out by both its staff and volunteers, as well as aerial photography, CLUI documents all manner of intentional and accidental interventions in the landscape, from missile silos to cornfield mazes and landfills to show caves. Studies typically explore a geographical region, a particular theme or landscape condition, or a combination of the two. The massive amount of information that CLUI collects on an ongoing basis is captured in its Land Use Database and a photographic archive and is disseminated to the public through programs that range from exhibitions to field trips. CLUI also is the lead organization in the development of the American Land Museum, a national network of landscape exhibition sites. Its nearly two dozen books and pamphlets include Overlook: Exploring the Internal Fringes of America with the Center for Land Use Interpretation (2006) and Pavement Paradise: American Parking Space (2007). In 2006, the Smithsonian American Art Museum awarded Matthew Coolidge its Lucelia Artist Award for the unique point of view CLUI brings to understanding American culture through its landscape.

Julia Christensen American, b. 1976, Bardstown, Kentucky; lives and works in Oberlin, Ohio

Julia Christensen watched the local Wal-Mart change locations three times in her hometown of Bardstown—and each time the community had to find a new way to use the old building. This conundrum stuck in her mind, and while she was a graduate student in electronic arts at Rensselaer Polytechnic Institute, New York, in 2003, she decided to do more research on the reuse of abandoned big box buildings. As part of her ongoing project, Big Box Reuse, Christensen has traveled more than 75,000 miles across the United States in her car to take photographs of reinvented big boxes and interview nearby residents. Her findings have been presented on her Web site (www.bigboxreuse.com) as well as in a video installation, a photographic study, a multimedia presentation, and a forthcoming book from MIT Press. Her dynamic approach to the project comes from her interdisciplinary training in electronic music, performance, and art. She has lectured widely, performed with the Yes Men, and is currently working on a time-based map of New Orleans in which users are allowed to view land uses in the city over a period of several centuries. Ultimately, Christensen hopes that her integrative methodology will spur communities where she presents her Big Box Reuse project to think of creative solutions when big box retailers leave empty buildings in their wake.

Coen+Partners
Established 1993; based in Minneapolis, with offices in New York
Shane Coen, principal

Coen+Partners, a nationally recognized landscape architecture practice, combines a light hand, a subdued palette, and sensitivity to site to produce environments that simultaneously highlight the relationship between the natural and the man-made and seamlessly integrate the two. Working collaboratively with architects on a portfolio of projects ranging from an intimate courtyard for a small residence to a planned community for one hundred families, the firm designs environments that define or reinforce the connections between built elements without compromising the local ecology. Coen+Partners' deference to the landscape is manifest on a grand scale in its master plan for Jackson Meadow (Marine on St. Croix, Minnesota, 1998), a planned community that is an early example of compact development. In this pattern of land planning, houses are clustered on only a portion of a large site, leaving the majority of the site as open space. In many cases, such as Jackson Meadow, the public space is permanently protected by conservation easements. Like the Mayo Woodlands project featured in the exhibition, Jackson Meadow is organized topographically, exploiting rather than neutralizing the site's natural features. Recipients of

awards from the American Institute of Architects, the American Society of Landscape Architects, and Progressive Architecture, these projects reflect Coen+Partners' desire to create interventions that are specific to place, environment, and client.

Gregory Crewdson American, b. 1962, New York; lives and works in New York

Gregory Crewdson stages his photographs in much the same way that a film would be shot, using elaborately built sets, dramatic lighting, cranes, props, and professional actors. He uses these grand productions to tell stories about small-town American life, which are both strange and familiar. In Lee, Massachusetts, where his parents had a cabin, Crewdson began his Natural Wonder series (1992–1997) that depicts birds, insects, and torn body parts in brightly colored, surreal, domestic settings. In Hover (1996–1997), the artist took aerial black-and-white photographs of strange events set in the streets and lawns of Lee, from an inexplicable circle in a family's backyard to rows of flowers being planted in the middle of a road. Dream House (2002) delves even further into the darker side of suburban life. This ambitious project was made in Rutland, Vermont, in a home where a woman had died four years earlier but in which all of the family's possessions remained intact. He used more recognizable actors in this series than in earlier works—Gwyneth Paltrow, Tilda Swinton, Philip Seymour Hoffman, Julianne Moore, and William H. Macy—but that celebrity is used to confound our expectations of the characters they portray. Although the work conveys the voyeurism associated with photography, the carefully posed photographs also reference a tradition of Realist painting in America by artists such as Grant Wood and Edward Hopper. Crewdson's work has been exhibited widely and is in the collections of the Museum of Modern Art, New York; the Broad Family Collection, Santa Monica, California; the Art Institute of Chicago; the Brooklyn Museum of Art; the Los Angeles County Museum of Art; the Metropolitan Museum of Art, New York; the San Francisco Museum of Modern Art; and the Whitney Museum of American Art, New York.

Adam Cvijanovic American, b. 1960, Cambridge, Massachusetts; lives and works in New York

Adam Cvijanovic's large-scale mural paintings evoke the sublime grandeur of nineteenth-century landscape painters such as Frederic Edwin Church and Caspar David Friedrich as well as the German muralists who crafted the vast cyclorama canvases of the Franco-Prussian War. Often painted on sheets of Tyvek—the synthetic material used for products ranging from waterproof FedEx envelopes to the vapor-permeable barrier or "house wrap" in new home construction—his work takes on architectural proportions. But unlike traditional murals and frescoes, his canvases are easily transported and can be adhered to walls and ceilings much like wallpaper, capturing the monumental quality of the subject matter in an immersive scale—from scenes of transcendent nature such as Niagara Falls, deserts of the American West, and the glaciers of Greenland to the ruptured landscapes of suburban America. In 2005, he began a series of works that capture the detritus of modern suburban life: tract houses ripped from their foundations, cars flung into the air along with all sorts of debris, including soda bottles, detergent packages, furniture, signs, and clothing. Cvijanovic's work has been shown in numerous exhibitions at organizations such as MASS MoCA, Massachusetts, North Adams; the Hammer Museum, Los Angeles; the Pennsylvania Academy of Fine Arts, Philadelphia; Creative Time, New York; and Bellwether, New York.

Benjamin Edwards American, b. 1970, Iowa City, Iowa; lives and works in Washington, D.C.

The work of Benjamin Edwards is situated in the imagined space between utopia and dystopia, the dream and the nightmare. His visually complex, layered, and colorful canvases are the result of meticulously selecting, collaging, and composing the signs and symbols of contemporary society. Drawing upon the architecture of suburbia, the artist recognizes the social effects of ever newer and faster technologies and denser, more integrated and branded global economies and their inevitable endpoint: the mass saturation of our lives and what he describes as the "monocultural leveling which spreads with the goal of perfect uniformity." The artist received his master's degree from the Rhode Island School of Design and also studied at the San Francisco Art Institute and the University of California, Los Angeles. His work has been shown at the Greenberg Van Doren Gallery, New York; Galerie Jean-Luc & Takako Richard, Paris; Tomio Koyama Gallery, Tokyo; and included in exhibitions at institutions such as Kunsthaus Graz, Austria; the Cranbrook Art Museum, Bloomfield Hills, Michigan; the Cleveland Art Museum; Artist Space, New York;

and P.S. 1/MoMA Center for Contemporary Art, Long Island City, New York.

Estudio Teddy Cruz
Established 1994; based in San Diego, California
Teddy Cruz, principal

Born and reared in Guatemala, Teddy Cruz moved to San Diego with his mother and American stepfather in the early 1980s, after a military coup in his home country. Cruz's ideas about architecture and urbanism have been profoundly influenced by the experience of living in proximity to the United States–Mexico border, and by the border's physical consolidation and growing symbolic presence as issues about security and immigration figure ever larger in public discourse. His work is the dialectical product of several interests or lines of thought inspired by the economic and social dichotomies of the bicultural border territory. More broadly, the work emerges out of an inquiry into the sociocultural implications of constructing space, and the relationships between architecture and various aspects of contemporary life. These two intellectual interests converge in a process-oriented practice that is grounded in community engagement, acknowledges existing physical and urban conditions, and seeks reconciliation of patterns of spatial occupation and social interaction with often unsympathetic zoning and planning regulations. Cruz cherishes the density of habitation and activity in the immigrant enclaves of San Diego as well as the informal and improvisational nature of social interactions there, and believes that rather than neutralizing this vitality, policymakers should embrace and accommodate it. He argues for a public policy that recognizes the particularity of real situations, opening the way for more imaginative and inclusive approaches to architecture and planning. Cruz was awarded the Rome Prize in Architecture in 1991 and in 1997 received his master's degree at the Harvard Graduate School of Design. He presented the inaugural James Stirling Memorial Lecture on the City in 2004.

FAT (Fashion Architecture Taste)
Established 1995; based in London
Sean Griffiths, Charles Holland, and Sam Jacob, principals

Although FAT describes itself as "purveyors of architecture of character and distinction," it might more accurately be described as the perpetrator of an architecture of wit and guileless accessibility that challenges the profession's notions of acceptable taste. Operating from the premise that architecture is a form of communication and that it should speak the language of its users, FAT has developed a reputation for making buildings that are memorable, engaging, and responsive to contemporary culture. FAT seeks to avoid what it considers the elitist attitude of many architects toward the creation of space with a capital S in favor of a populist sensibility that is manifest in easily recognizable forms and a vibrant palette. The now-iconic Blue House (London, 2002), with its billboardlike expression of the building's home and office components, exemplifies this approach. FAT's design for the Sint Lucas Art Academy (Boxtel, the Netherlands, 2006) received the prestigious European Award from the Royal Institute of British Architects and was also nominated for the Mies van der Rohe Award. In 2003, FAT was unanimously chosen by the future inhabitants of Woodward Place Social Housing (New Islington, Manchester) in a competition sponsored by the Royal Institute of British Architects, and its proposal for refurbishment and expansion of a 1960s high-rise housing block was selected in a competition sponsored by the London Borough of Newham. The firm was awarded second place in Building Design's Architect of the Year program in 2003 and was included in the Architects' Journal's 40 Under 40 exhibition in 2005.

Chris Faust
American, b. 1955, Fort Riley, Kansas; lives and works in St. Paul, Minnesota

Chris Faust is best known for his black-and-white panoramic landscapes that document ways that cities and rural communities are changing the land according to their own needs. Taken with a specialized banquet-format camera, Faust's photographs investigate geographic expressions of contemporary environmental values and priorities. Architecture and the natural landscape stand frozen in time in his pictures, which often depict quiet places where people cannot be found. Following projects on rural landscapes, grain elevators, and ore boats, the photographer collaborated with writer and landscape historian Frank Edgerton Martin on the Suburban Documentation Project from 1990 to 1996. The series included images of shopping malls, homes, and office parks, focusing especially on the edges of development where landscaped yards, parking lots, and buildings meet undeveloped fields and

farmland. Throughout his work, Faust asks us to consider these common subjects in and of themselves as spaces that both reflect and determine our relationship to the land that surrounds them. A book of Faust's nighttime tritone photographs, Nocturnes (2007), was recently published. The artist received his master's degree from the University of Wisconsin, La Crosse. His work has been shown at institutions such as the Tacoma Art Museum; the Walker Art Center, Minneapolis; the Minneapolis Institute of Arts; the National Building Museum, Washington, D.C.; the Weisman Art Museum, Minneapolis; and the San Francisco Museum of Modern Art. He is the recipient of numerous awards, including a McKnight Foundation Fellowship for Photography, a Bush Fellowship, and a Minnesota State Arts Board Fellowship.

Floto+Warner

Jeremy Floto American, b. 1976, Mountain Home, Idaho; lives and works in New York
Cassandra Warner American, b. 1975, New York; lives and works in New York

Jeremy Floto and Cassandra Warner are principals in the New York–based photography studio Floto+Warner. The husband-and-wife team has received critical acclaim for their architectural photography. Their striking images capture not only the spatial dynamics of their architectural subjects but also the human and social energy and spirit of the place. They have photographed some of today's most celebrated new buildings and interiors, including Rem Koolhaas' Seattle Public Library and Prada Epicenter store in SoHo, Frank Gehry's Disney Concert Hall in Los Angeles, Santiago Calatrava's Milwaukee Art Museum expansion, and Marcel Wanders' Hotel on Rivington in New York. They began the Inflatable series as an extension of a photography project documenting holiday yard installations. "Captivated by the simultaneous joy and sadness of these homemade environs," they ventured to Kmart to create their own renditions. The series consists of large-scale, inflatable lawn ornaments—ranging from Christmas holiday staples such as Santas, snowmen, and reindeer to sports-team mascots increasingly common in yards across America. The resulting works, while recalling the soft sculptures of Claes Oldenburg and the readymade artwork tradition first formulated by Marcel Duchamp, display a more decidedly abstract, occasionally grotesque, and frequently humorous transfiguration.

Dan Graham American, b. 1942, Urbana, Illinois; lives and works in New York

Working in a variety of media, Dan Graham began in the 1960s to reflect on the artistic system, focusing particularly on the mechanism of perception offered by works in different contexts. Since the early 1970s, the ideology that underpins social phenomena such as rock music and architecture has been at the center of his work. Inquisitorial ads in newspapers, revealing contributions to magazines, antirational architectural works, and exterior and interior pavilions that combine formal simplicity with visual complexity are some of the many means through which Graham has explored his ideas. In 1965, while living in New Jersey, Graham recorded the homes around him in a series of photographs. Making use of a cheap Kodak camera, he intended to make images that anyone could produce. He originally presented the photographs as a slide show and eventually published the images in Arts magazine, accompanied by a text that compared the serial qualities of suburban architecture with those of Minimalism. In Alteration to a Suburban House (1978/1992), clear glass replaces the facade of a suburban home while the interior space is bisected by a mirror. By exposing the home's inhabitants and reflecting the environment it faces, the artist investigates the boundaries of public and private, providing an ironic commentary on the utopian ideal of suburban life, its atmosphere of voyeurism and surveillance, and social conformity. Graham's work has been widely exhibited and published; selected publications include Rock My Religion: Writings and Projects 1965–1990 (1994), Dan Graham Interviews (1995), Dan Graham: Catalogue Raisonné (2001), and Dan Graham: Half Square and Half Crazy (2005).

INABA
Founded 2006; based in Los Angeles
Jeffrey Inaba, founder and principal

INABA is an architecture/design firm and cultural consultancy that develops new opportunities in the fields of architecture, urbanism, strategic planning, and design. INABA brings to its work a distinctively rich vision amalgamating modes of analysis and action that transcend the boundaries of conventional architectural thought. Jeffrey Inaba received master's degrees in architecture and design studies from Harvard University's Graduate School of Design, where he subsequently was

codirector, with Rem Koolhaas, of the Project on the City, a research group that examines the impact of modernization on the contemporary city. Inaba also was a partner in AMO, the research counterpart to Koolhaas' firm in Rotterdam, OMA (Office for Metropolitan Architecture). Commissions at that time ranged from strategic development and in-store technology for Prada to urban-planning studies for the European Union, demonstrating the elasticity of the firm's intellectual perspective. INABA serves a similarly wide clientele, including the University of Miami, Axe Body Spray, Coca-Cola, and the Chicago Loop Alliance in the areas of identity, planning, and new product consulting, as well as undertaking architecture and design projects for the New Museum of Contemporary Art, New York, and Debra Rodman Couture. As codirector of the Southern California Institute for Future Initiatives (SCIFI), a postgraduate program at the Southern California Institute of Architecture (SCI-Arc), and director of C-Lab, an architecture and communication group at Columbia University's Graduate School of Architecture, Planning, and Preservation, Inaba continues to cultivate innovative ideas about design in its widest possible sense and to investigate architecture's influence on globalization, politics, and people.

Interboro

Established 2002; based in Brooklyn, New York, and Düsseldorf, Germany
Tobias Armborst, Daniel D'Oca, and Georgeen Theodore, founders and principals

Like many young, progressive architecture firms, Interboro occupies the part of the professional terrain at which practice, research, and teaching converge. With experience that collectively encompasses architectural and urban design, planning in the private, public, and nonprofit sectors, and marketing, publishing, and scholarly research, the firm brings to its projects an inventive pragmatism. Interboro's working process combines expertise in global development trends with sensitive and rigorous analyses of local dynamics, in the belief that innovative proposals engage the full range of a place's economic, social, and environmental dimensions. Although the firm works across the spectrum of scales, with projects ranging from urban feasibility studies to an interactive computer exhibit on the development of New York City's Lincoln Center, its métier is the small gesture that acknowledges existing conditions and sees possibilities in incremental change. This non-normative attitude,

complemented by respect for individual autonomy, drives projects such as Deploy the Devoider!, a competition submission for vacant land in Philadelphia that proposes not a grand program, but a line of cheap modular components that would allow individuals to colonize and repurpose these sites. Interboro was awarded the Architectural League of New York's Young Architects Award in 2005 and, in 2006, the New Practices Award from the American Institute of Architects New York Chapter. It has won first prizes in the Dead Malls Competition, sponsored by the LA Forum for Architecture and Urban Design in 2003; the Shrinking Cities Competition, sponsored by Archplus magazine and the German Federal Cultural Foundation in 2004; and the Columbus Rewired exhibition, sponsored by the American Institute of Architects Columbus Chapter in 2007.

Lateral Architecture

Established 2002; based in Toronto, Canada
Lola Sheppard and Mason White, founders and principals

Lateral Architecture's practice is centered on the belief that architecture is an exercise in lateral thinking, and design an empirical process operating across seemingly disparate disciplines and phenomena. The firm's design work and research presuppose that architecture and public space are defined less through form than through what it calls "formatting." Formatting establishes an organization for program, interactivity, and change to occur, and it is from this ordering that a project emerges. Working at the intersection of architecture, landscape, and urbanism, Lateral is particularly interested in marginal urban and postindustrial sites where the systems and codes that determine these environments must be uncovered and rethought. Generally eschewing the heroic gesture, Lateral instead recalibrates existing programmatic, environmental, or physical elements through strategies of inversion, amplification, hybridity, and transfer. Fundamentally, Lateral Architecture's work is about questioning and conflating hierarchies, whether at the scale of American exurbs, as in Flatspace, or a single-family home. In its competition-winning inside/out house (Pilkington Glasshouse Competition, 2002), transparent storage walls around the perimeter of the house display the owner's possessions to the world, upending the hierarchy established by the house's iconic predecessors and, in Lateral's parlance, reformatting

its program. Lateral was awarded the Howard E. LeFevre Emerging Practitioner Fellowship by Ohio State University in 2003; received the Architectural League of New York's Young Architects Award in 2005; and was unanimously chosen the winner of the Orphan Spaces charrette competition in Toronto in 2006.

John Lehr American, b. 1975, Baltimore, Maryland; lives and works in Brooklyn, New York

Since graduating with his MFA from Yale in 2005, photographer John Lehr has been working on the series Sound and Fury, which captures commercial signage from unlikely angles. Lehr's imagery denies the viewer the signs' primary surface and message space, thus negating their communicative function. Emptied of their references, they become totemlike forms that bisect the image and draw us into non-places we rarely notice, such as medians separating traffic lanes or shoulders of roadways where such signage is anchored. A concurrent series, Mirage, documents scenes in the suburban landscape where the commonplace is revealed as both familiar and sublime. Mounds of gravel, mulch, and dirt are so perfectly arranged that they look like earthworks, and stacks of garbage and an electrical box stand as minimalist sculptures. Poughkeepsie, NY (2005) depicts a strange scene where a small set of concrete stairs leads to nowhere, or rather to the edge of a wooded development. The absent focal point—a future home or a missing sidewalk—is left as conjecture. Lehr's work has been shown at Yancey Richardson Gallery, New York; Corcoran Gallery of Art, Washington, D.C.; and Yale University School of Art, New Haven, Connecticut.

LTL Architects
Established 1997; based in New York
Paul Lewis, Marc Tsurumaki, and David J. Lewis, founders and principals

In a decade of practice, LTL Architects (formerly Lewis.Tsurumaki.Lewis) has assembled a diverse body of work that includes built projects, installations, and speculations that consistently pose the question, "What if . . . ?" LTL describes its work as "opportunistic architecture," by which they mean an approach in which such constraints as budget, schedule, zoning, and site are viewed as opportunities to explore overlaps between space, program, form, budget, and materials that generate imaginative solutions. The scale and range of the firm's projects vary from large institutional buildings, such as a residence hall at the College of Wooster, to a light fixture commissioned by Ivalo Lighting Incorporated and a wall-covering collection for Knoll Textiles. A key element in the success, surprise, and pleasure of LTL's work is its inventive use of materials, particularly in smaller projects: a wall relief of cast-plaster coffee cups at a coffee shop, for example, or walls and ceiling composed of industrial felt in a restaurant. The firm's probing intellect is in equal evidence in its speculations, which, in addition to New Suburbanism, include the reimagining of a typical parking garage as a "drive-up skyscraper" that combines parking with a mix of other uses. Academia provides important intellectual fuel for LTL, and all three partners teach at universities in the New York region. The firm was one of six that represented the United States at the Venice Architecture Biennale in 2004, and it received the National Design Award for Interior Architecture from Cooper-Hewitt, National Design Museum in 2007. Opportunistic Architecture, LTL's first monograph, was published in 2007.

Paho Mann American, b. 1978, Snowflake, Arizona; lives and works in Denton, Texas

Since 2001, Paho Mann has observed that mass-produced buildings and containers such as medicine cabinets and junk drawers are unique to their owners. From 2004 to 2006, he put together one of his most ambitious projects to date entitled Re-inhabited Circle Ks. While pursuing his master's degree from Arizona State University in Tempe, Mann noticed how defunct Circle K stores across the city had been reused for various new businesses. Researching telephone directories from the 1970s, before the Circle K company had fallen on hard times and had to divest many of its properties, he visited all of the listed locations and photographed each from the same vantage point and time of day. These systematic portraits are reminiscent of the typologies of Bernd and Hilla Becher, who photographed industrial architecture such as water towers, mining operations, and grain elevators. However, Mann, who is currently an assistant professor of photography at the University of North Texas, is interested in the specificity of individual customization rather than the anonymous structures of the Bechers. The artist has said that he was motivated to undertake this project because "these buildings do not show a linear progression of the corporatization

and homogenization of suburbia, but rather serve as evidence of a more circular system—a system driven by a delicate negation between same and different, between complicated sets of actions and choices that shape our built environment." Mann's work has been shown at institutions such as the Arizona State University Art Museum, Tempe; the Tucson Museum of Art; and the Albuquerque Center for Contemporary Art.

Sarah McKenzie American, b. 1971, Greenwich, Connecticut; lives and works in Boulder, Colorado

Since 2000, Sarah McKenzie has made the construction of new suburban homes the primary subject matter for her paintings. She began the series while living in the Front Range in Colorado, and her early works were aerial views of suburban development transforming farmland on the edges of cities. She moved to Cleveland in 2001 to take a position as a professor at the Cleveland Institute of Art. There her aerial views of suburbia showed the land being blanketed with subdivisions. Gradually, she has shifted away from these views and for the past two years has been working on a series of oil paintings showing partially built suburban homes. Wood-frame construction, houses wrapped in Tyvek, and freshly poured concrete establish the formal structure of McKenzie's canvases and panels, which are part realism and part geometric abstract. Her keen sense of light and vibrant colors bring out the beauty of their strict geometries and recall American Precisionist painting of the 1920s and 1930s. In her latest paintings, such as Site (2007), the artist delves into "the process of construction itself and, in it, find[s] a metaphor for the activity of painting." Thus she hopes to "draw a connection between the construction of a building out of raw materials (lumber, steel, and concrete) and the construction of a painting out of raw materials (paint, canvas, wood)." McKenzie's work has been shown at institutions such as Miami University, Oxford, Ohio; the University of Akron; Katonah Museum of Art, New York; Bemis Center for Contemporary Art, Omaha, Nebraska; and the Boulder Museum of Contemporary Art, Colorado.

Laura E. Migliorino American, b. 1959, Cleveland, Ohio; lives and works in Minneapolis, Minnesota

Laura Migliorino's series The Hidden Suburbs: A Portrait seeks to reveal the obscured diversity that exists in the outer-ring suburbs of Minneapolis

and St. Paul, Minnesota. The idea for the project emerged over the course of eighteen years as the artist commuted from her home in Minneapolis to work in Coon Rapids, a rapidly growing part of the Twin Cities. During that time, Migliorino witnessed the conversion of farmlands into residential subdivisions. She photographs residents of these subdivisions, posing them in front of their homes and superimposing their surroundings. The images dispel the stereotype of the white, heterosexual family typically associated with suburbia: a biracial family poses at the edge of a development's lake; a family from Africa poses in front of their garage. Such scenes suggest that although the visual landscape of suburbia has been constructed in favor of homogeneity, this blanket of sameness cannot hide the intrinsic diversity of its inhabitants or the powerful lure of the American suburb as a seemingly transcendent ideal. Migliorino's work has been exhibited at the Metropolitan Museum, New York; Phipps Center for the Arts, Hudson, Wisconsin; and Artists Space, New York.

Matthew Moore American, b. 1976, San Jose, California; lives and works in Goodyear, Arizona

Matthew Moore has reinvented the legacy of earthworks to comment on the loss of farmland to urban growth since earning his MFA in sculpture from San Francisco State University in 2003. The artist's belief that today "the urban and rural do not meet; they collide" comes from personal experience. His family has farmed the same land outside of Phoenix, Arizona, for four generations, and they have gradually sold acres of their land over the past several years as development has moved closer to their home. The artist's first response was Moore Rotations: Single Family Residence (2003–2004), a twenty-acre field of barley next to newly built suburban homes on which Moore carved out an enlarged plan of a typical single-family tract home. The lines on the floor plan were actually six-foot-wide rows of overturned earth that the artist hoed by hand, laboriously marking the banal patterns of homes that would soon overtake the field. In 2005, Moore began the next work in his Rotations series, Moore Estates. He attained the blueprints for a developer's planned community on land purchased from the artist's family, and re-created it at one-third scale in sorghum and wheat on 35 adjacent acres. The artist used a computer-aided-design program and a global-positioning satellite system to plot the roads and rows of homes on the field,

and this first step allowed him to visualize how suburbanization would change his land. However, over the next two years, as the sorghum "houses" grew thick and strong and the black-beard wheat "roads" were allowed to run their full cycle and turn brown for harvest, their organic growth stood in marked contrast to the rapid, unsustainable suburban growth happening next to it. Moore's work has been exhibited at the Arizona State University Art Museum, Tempe; Sonoma County Museum, Santa Rosa, California; the University of Southern Mississippi, Hattiesburg; and MASS MoCA, North Adams, Massachusetts.

Stefanie Nagorka American, b. 1954, Munich, Germany; lives and works in Montclair, New Jersey

For years, Stefanie Nagorka has created work with readymade materials such as concrete masonry units and prefabricated bricks purchased from home-supply stores, but it wasn't until 2002 that she began using the store itself as her studio. In these artistic actions, she creates sculptures directly on the warehouse floor or in garden-center aisles that are made from pavers, concrete blocks, and patio stones. Working without official permission, she photographs the resulting works before they are dismantled. By substituting her artist's studio for potentially any Home Depot or Lowe's store, Nagorka has adroitly expanded her artistic practice using the vernacular materials of suburbia while converting the retail site of consumption into her own productive venue. She has traveled the country, visiting stores in more than twenty-seven states as part of her Aisle Studio Project. Her temporary sculptures and performative actions question the status of the art object, raising issues of value and temporality. Nagorka's work is included in the collections of institutions such as the Brooklyn Museum; the Drawing Center, New York; the Fogg Art Museum of Harvard University, Cambridge, Massachusetts; the Yale University Art Gallery, New Haven, Connecticut; and the Fields Sculpture Park, Ghent, New York.

Catherine Opie American, b. 1961, Sandusky, Ohio; lives and works in Los Angeles

Catherine Opie's humanistic portraits of both architecture and people trace the diverse, shifting contours of the American community from the West Coast to the East. An early series from 1993 consisted of color portraits of friends in the lesbian and gay leather community in Los Angeles. She eventually extended this series across America to New York, Oklahoma, North Carolina, and Minnesota, documenting lesbian couples, friends, and families in her series Domestic. The artist has also captured the individual character of vernacular architecture in her studies of Beverly Hills homes, Los Angeles mini-malls, and Minnesota ice-fishing houses. In 1994, she photographed highway overpasses in Los Angeles for her Freeway series. Shot with a banquet-format camera, Opie's panoramas capture mysteriously empty highways that cut bold paths across the frame or stand as majestic testaments to one of America's largest infrastructural ventures rendered in stark shadow and light. The artist has said that she was inspired by photographs of the Old West and ways that they helped form this country's identity. In the Freeway series, she wanted to capture the contemporary landscape in the same expansive, grandiose way that conveyed a similar sense of place. Opie's work has been widely exhibited and is included in the collections of institutions such as the Albright Knox Gallery, Buffalo, New York; the Solomon R. Guggenheim Museum, New York; the Museum of Contemporary Art, Los Angeles; the Museum of Contemporary Art, Chicago; the Museum of Fine Arts, Boston; the Museum of Modern Art, New York; the Walker Art Center, Minneapolis; and the Whitney Museum of American Art, New York.

Edward Ruscha American, b. 1937, Omaha, Nebraska; lives and works in Los Angeles

Edward Ruscha moved to Los Angeles in 1956 to study commercial art, and his artwork has been tied to the city's landscape and culture ever since. He is probably best known for his drawings, paintings, and prints of emotive words. These text-based works gained attention in the early 1960s by drawing associations with the Pop Art movement of the period. At the same time, the artist was working on a series of artist's books that would have an enormous influence on conceptual art and photography, such as Twenty-six Gasoline Stations and Every Building on the Sunset Strip, which featured collected series of no-frills photographs that Ruscha was taking of banal sites in and around Los Angeles. The artist revisited his 1967 book Thirtyfour Parking Lots in Los Angeles in 1999 and released a set of editioned photographs based on the volume. The

aerial photographs depict mostly vacant parking lots in places such as shopping malls, stadiums, and drive-in theaters; their parallel lines form beautiful geometric patterns, while oil stains and skid marks appear like gestural marks on the black-top surface—signs of automobile activity and drivers' proclivities. Ruscha's work has been widely exhibited, collected, and published.

SITE (Sculpture in the Environment)
Established 1968 and chartered in 1970; based in New York City
James Wines, cofounder, president, and creative director

SITE is a multidisciplinary architecture and environmental arts organization that aims to create architecture and public spaces through an integration of structure and context that responds to social, psychological, cultural, and ecological information. Reacting in its early years to modernism's hegemony, SITE challenged traditional distinctions between visual art, architecture, and landscape, advocating instead a fusion that would make it difficult to determine where one art form ends and another begins. Exemplars of this approach were the nine showrooms it built between 1972 and 1984 for Best Products, an appliance and housewares catalogue showroom merchandiser and one of the country's first suburban big box stores. These projects—the sole survivor of which is the Indeterminate Facade (Houston, 1975)—not only elided the boundary between art and architecture, but also achieved SITE's polemical goal of bringing art out of the museum and into the public realm. Since the early 1990s, SITE has become increasingly engaged with sustainable architecture and environmental research. It believes that a truly sustainable architecture for the future must provide an expanded definition of green design and a higher level of communication with the public. Reflecting SITE's integrative approach, recent works have been based on inspirational sources found in communications systems, the natural sciences, and energy conservation technology. SITE has been the author or subject of dozens of monographs, exhibition catalogues, and journal articles and was included in the Venice Architecture Biennale in 2002. James Wines has received some twenty-five art and design awards to date, including the 1995 Chrysler Award for Design Innovation and a Pulitzer Prize for graphics.

Jessica Smith American, b. 1971, Ithaca, New York; lives and works in Savannah, Georgia

Jessica Smith produces a limited-edition line of textiles under the name Domestic Element. Using a digital textile printer, she creates patterns of cloverleaf highway ramps that resemble Celtic knots, bold cul-de-sac mazes, and houses from Levittown that are as ubiquitous as polka dots. Her interest in merging historical decorative traditions with contemporary themes comes from her belief in "the house as a symbol of self and the notion that how we decorate relates directly to our personal and communal beliefs, aspirations and values." Her pattern Trash Day (2005/2007) was inspired by the French toile de Jouy tradition. Smith adapted the quaint pastoral scenes shown in outline on a white background to the suburbs because "I wanted to make my own pastoral countryside, and the countryside of America is the suburbs." The inherent repetition of the houses in Trash Day and the cans stacked by the curb is an ironic commentary on the homogeneity of suburbia. Her inspiration came from a childhood spent in such subdivisions. "Each Sunday families spend hours sprucing up their homes. . . . The second part of this ritual comes later in the week, when curbsides become overwhelmed with trash. . . . For those few hours while our rubbish waits, we have reversed our earlier act, and instead of sweeping up our unwanted goods, [we're] leaving them out for all to see." Smith's work has been exhibited at the Cooper-Hewitt, National Design Museum, New York; Atlanta Design Museum; and School of Visual Arts, New York. Her work has been featured in such publications as the New York Times, The Times of London; GQ magazine, and I.D. Magazine.

Greg Stimac American, b. 1976, Euclid, Ohio; lives and works in Chicago

Greg Stimac's photographic series explore quotidian typologies that include campfires, melting snowmen, roadside memorials to deceased loved ones, bottles of urine littered on the roadside, unregulated outdoor firing ranges, and the rituals of mowing the lawn. The repetition of a particular subject in unique contexts draws our eye to the comparative differences between images. For the series Mowing the Lawn, Stimac photographed various practices of lawn maintenance across the country, capturing the diversity of this most suburban of activities. The images disclose the variety of approaches to this quintessential American pastime: prideful seniors

to bored teenagers, methodical precision to haphazard determination, riding mowers to electric mowers, lush manicured greens to dry xeriscapes. In 2005, Stimac received his bachelor's degree in photography from Columbia College, Chicago, where he was awarded an Albert P. Weisman Memorial Fellowship. His photographs have been shown at Bucket Rider Gallery, Chicago; Crocker Art Museum Sacramento, California; Minnesota Center for Photography, Minneapolis; the Museum of Contemporary Photography, Chicago; and the Museum of Contemporary Art, Chicago.

Lee Stoetzel American, b. 1968, Tallahassee, Florida; lives and works in Chester Springs, Pennsylvania

Lee Stoetzel's works explore the interplay between the natural and the man-made with a particular attraction to detritus and decay. In a recent collection of sculptures, the artist uses "pecky" cypress wood, its characteristic holes produced by a fungus, to form life-size versions of the Harley Davidson chopper of Easy Rider fame, the classic Macintosh Plus computer from Apple, and even a Volkswagen bus. For his McMansion series, he created and photographed scale models of the kinds of homes under construction near his home in Chester Springs. Playing on the very origin of the term McMansion and the ersatz nature of the subject, Stoetzel references the speedy but shoddy construction of such houses using raw materials derived from a typical fast-food meal. Utilizing McDonald's food and its packaging, he fashioned cladding for the houses from Filet-of-Fish sandwiches in lieu of stucco, layered cheese slices in place of vinyl clapboard, and composed the requisite treeless, featureless lots from crumbled ground beef. The artist received his master's degree in painting and printmaking from Southern Methodist University, and his work has been exhibited at Mixed Greens, New York; Tricia Collins Contemporary Art, New York; the Katonah Museum of Art, New York; and the Islip Art Museum, East Islip, New York.

Angela Strassheim American, b. 1969, Bloomfield, Iowa; lives and works in Minneapolis and New York

Angela Strassheim's photographic subject matter encompasses both life and death—its reality, finality, and promises. Her series Left Behind, which refers to the "unsaved" souls after the Rapture, draws upon the mythology of American domestic life with arresting color photographs that include members of her Apostolic Christian family. The artist's images display an intimacy that is at once disarming and transgressive, drawing you into a familiar yet unsettling world. The banal surroundings often depicted in her work belie a strong compositional eye that invites further inspection and speculation. Drawing upon her experience as a forensic photographer, Strassheim's scenes offer a unique vision of unusual sharpness and attention to detail, while capturing an atmosphere in which religious faith, suburban lifestyles, and personal memories converge. Her work was featured in the 2006 Whitney Biennial and has been shown at the Marvelli Gallery, New York; Musée de L'Elysée, Lausanne, Switzerland; the National Museum of Women in the Arts, Washington, D.C.; the DeCordova Museum and Sculpture Park, Lincoln, Massachusetts; Falcouner Gallery at Grinnell College, Grinnell, Iowa; the Des Moines Art Center; and the Minnesota Center for Photography, Minneapolis.

Larry Sultan American, b. 1946, New York; lives and works in Greenbrae, California

Larry Sultan grew up in California's San Fernando Valley, which has become a source of inspiration for a number of the artist's works. Sultan's Pictures from Home (1992) is a decade-long project that features his own mother and father as its primary subjects, exploring photography's role in creating familial mythologies. Using the same suburban setting, his next project, The Valley (2001), examined the adult-film industry and the area's middle-class tract homes that serve as pornographic film sets. The artist's focus is not the sex act per se, but the peripheral surroundings and pedestrian details—photographic backdrops and props, the homeowners' memorabilia, and actors waiting between shots or relaxing off-screen. His images negotiate between reality and fantasy, domesticity and desire, as the mundane qualities of the domestic surroundings become loaded cultural symbols. Sultan's work has been exhibited and published widely and is included in the collections of the Art Institute of Chicago; Bibliothèque Nationale, Paris; Center for Creative Photography, Tucson, Arizona; National Gallery of Art, Washington, D.C.; the Solomon R. Guggenheim Museum, New York; the Museum of Modern Art, New York; the San Francisco Museum of Modern Art; and the Whitney Museum of American Art, New York.

Brian Ulrich American, b. 1971, Northport, New York; lives and works in Chicago

In 2001, in the wake of the events of September 11, President George W. Bush encouraged American citizens to keep shopping to help boost the U.S. economy, thereby conflating consumerism and patriotism. Brian Ulrich's Copia project is a direct response to that advice—a long-term photographic examination of the peculiarities and complexities of a consumer-dominated culture. Through large-scale color photographs inconspicuously taken within big box stores, shopping malls, and thrift shops, Copia explores not only the everyday activities of shopping, but also the economic, cultural, social, and political implications of commercialism in general and the roles we play in overconsumption and as targets of marketing and advertising in particular. Ulrich explores the economies of excess found in both the bountiful displays of consumer goods at retail stores as well as the abundant remnants of our discarded consumer culture on offer at thrift stores. Ulrich's work is included in the collections of the Art Institute of Chicago; the Cleveland Museum of Art; the Museum of Fine Arts Houston; the Museum of Contemporary Art San Diego; and the Museum of Contemporary Photography, Chicago.

Michael Vahrenwald American, b. 1977, Davenport, Iowa; lives and works in New York

The large-scale color photographs of Michael Vahrenwald's Universal Default series are taken in the desolate, outlying landscapes of newly constructed big box stores across the United States, illuminated only by the glow of parking-lot lights. Vahrenwald faithfully documents these spaces without digital manipulation, using a large-format camera to capture the tactile details. Evidence of man's hand in the creation and maintenance of these artificial landscapes can be seen in the browning sod, scattered straw, and patterns of a freshly mowed lawn. Such spaces—the undulating berms, sad islands of parking-lot trees, and the indeterminate places that mark the boundary at the property's edges—exist as a buffer zone between the arterial roadways and the retail structures that increasingly dominate the exurban landscape. As the title indicates, these photographs present a universal phenomenon, a by-product of new retail development. This residual element, a leftover landscape, can be gleaned in an earlier body of work, Vahrenwald's Corporate Town (2004–2005).

The series explored the incongruous juxtapositions of ill-fated modern corporate offices inserted into historic New England communities—the ruins of an experiment in urban renewal. Vahrenwald's artistic practice has been informed by the work of American photographers of the 1960s and 1970s who examined the new American landscape in a time of political, economic, and cultural crisis. The artist studied photography at Yale University School of Art, where he received his MFA in 2003. His work has been exhibited at such venues as the Whitney Museum of American Art, New York; Mary Boone Gallery, New York; Galerie Alain LeGalliard, Paris; and D'Amelio Terras Gallery, New York.

Exhibition Checklist

1.
Chris Ballantyne
Untitled (Berm) 2003
acrylic on birch panel
36 x 48 in. (91.44 x 121.92 cm)
Collection Beth Rudin DeWoody

2.
Chris Ballantyne
Untitled (Additions) 2004
acrylic on birch panel
36 x 48 in. (91.44 x 121.92 cm)
Collection Anthony Terrana, Wellesley,
Massachusetts

3.
Kim Beck
Ideal City 2004–2006
DVD animation (black and white, silent);
3 minutes
Courtesy the artist

4.
Kim Beck
Self-Storage 2004
graphite on cut paper
22 x 120 in. (55.88 x 304.8 cm)
Courtesy the artist

5.
Andrew Bush
Man traveling southeast on U.S. Route 101 at
approximately 71 mph somewhere around
Camarillo, California, on a summer evening in 1994
1994
chromogenic print
30 x 40 in. (76.2 x 101.6 cm)
Courtesy The West Collection, Oaks, Pennsylvania

6.
Andrew Bush
Men heading south on Interstate 5 in San Joaquin
Valley, California (no other information available)
1998
chromogenic print
30 x 40 in. (76.2 x 101.6 cm)
Courtesy The West Collection, Oaks, Pennsylvania

7.
Center for Land Use Interpretation (CLUI)
Autotechnogeoglyphics: Vehicular Test Tracks
in America 2006–2007
archival ink-jet prints
16 x 20 in. (40.64 x 50.8 cm) each of 12
Courtesy the Center for Land Use Interpretation,
Culver City, California, and Carnegie Museum of Art,
Pittsburgh

8.
Julia Christensen
Big Box Reuse: Head Start, Hastings, NE 2005
digital print
18 x 24 in. (45.72 x 60.96 cm)
Courtesy the artist

9.
Julia Christensen
Big Box Reuse: Snowy Range Academy, Laramie, WY
2005
digital print
18 x 24 in. (45.72 x 60.96 cm)
Courtesy the artist

10.
Julia Christensen
Big Box Reuse: Spam Museum, Austin, MN 2005
digital print
18 x 24 in. (45.72 x 60.96 cm)
Courtesy the artist

11.
Julia Christensen
Big Box Reuse: Grace Gospel Church, Pinellas
Park, FL 2007
digital print
18 x 24 in. (45.72 x 60.96 cm)
Courtesy the artist

12.
Julia Christensen
Big Box Reuse: Hong Kong Food Market
(Aisle 5), Gretna, LA 2007
digital print
18 x 24 in. (45.72 x 60.96 cm)
Courtesy the artist

13.
Julia Christensen
Big Box Reuse: Hong Kong Food Market
(Exterior 1), Gretna, LA 2007
digital print
18 x 24 in. (45.72 x 60.96 cm)
Courtesy the artist

14.
Coen+Partners
Mayo Plan #1: Reinventing a Midwestern Suburb
2002/2007
3-D animation (color, sound)
Courtesy Carnegie Museum on Art, Pittsburgh

15.
Gregory Crewdson
Untitled from the series Dream House 2002
digital chromogenic print
29 x 44 in. (73.66 x 111.76 cm)
Collection Peggy and Ralph Burnet, Wayzata,
Minnesota

16.
Gregory Crewdson
Untitled from the series Dream House 2002
digital chromogenic print
29 x 44 in. (73.66 x 111.76 cm)
Collection Peggy and Ralph Burnet, Wayzata,
Minnesota

17.
Adam Cvijanovic
Same Day Delivery 2007/2008
Flashe, latex on Tyvek
192 $^1/_2$ x 161 $^5/_8$ in. (488.95 x 410.53 cm)
Courtesy Bellwether, New York

18.
Benjamin Edwards
K-Mart Information Sheet 1996
mixed media on paper
12 x 9 in. (30.48 x 22.86 cm)
Collection Peter and Annie Remes,
Wayzata, Minnesota

19.
Benjamin Edwards
Starbucks Information Sheet 1996
mixed media on paper
12 x 9 in. (30.48 x 22.86 cm)
Collection Peter and Annie Remes,
Wayzata, Minnesota

20.
Benjamin Edwards
Immersion 2004
acrylic, textured media, landscaping foam on canvas
75 x 125 in. (190.5 x 317.5 cm)
Collection Peter and Annie Remes, Wayzata,
Minnesota

21.
Estudio Teddy Cruz
Living Rooms at the Border: San Ysidro, California
2000/2007
mixed-media installation
dimensions variable
Courtesy the architect and Carnegie Museum
of Art, Pittsburgh

22.
Estudio Teddy Cruz
Manufactured Sites: Tijuana, Mexico 2000/2007
mixed-media installation
dimensions variable
Courtesy the architect and Carnegie Museum
of Art, Pittsburgh

23.
FAT (Fashion Architecture Taste)
Hoogvliet Heerlijkheid: Hoogvliet, Rotterdam,
The Netherlands 2001 to the present
mixed-media installation
dimensions variable
Courtesy Carnegie Museum of Art, Pittsburgh

24.
Chris Faust
The Edge, Eden Prairie, MN 1990
black-and-white photograph
15 $^5/_8$ x 41 $^1/_2$ in. (39.69 x 105.41 cm)
Collection Walker Art Center, Minneapolis
Justin Smith Purchase Fund, 1999

25.
Chris Faust
Bankrupt Developer Homes, Apple Valley, MN 1991
black-and-white photograph
15 $^1/_2$ x 41 $^7/_8$ in. (39.37 x 106.36 cm)
Collection Walker Art Center, Minneapolis
Justin Smith Purchase Fund, 1999

26.
Chris Faust
Veneer of Greenness, Woodbury, MN
1992/2007
black-and-white photograph
16 x 42 in. (40.64 x 106.68 cm)
Courtesy the artist

27.
Chris Faust
Community Center, Near Lincoln, NE
1993/2007
black-and-white photograph
16 x 42 in. (40.64 x 106.68 cm)
Courtesy the artist

28.
Chris Faust
Golf Community for Living, Chaska, MN 1991
black-and-white photograph
16 x 42 in. (40.64 x 106.68 cm)
Courtesy the artist

29.
Chris Faust
The Edge, Lincoln, NE 1993/2007
black-and-white photograph
16 x 42 in. (40.64 x 106.68 cm)
Courtesy the artist

30.
Floto+Warner
(Reindeer) 2004
nylon
79 x 50 in. (200.66 x 127 cm)
Courtesy Floto+Warner, New York

31.
Floto+Warner
(Santa Claus) 2004
nylon
72 x 54 in. (182.88 x 137.16 cm)
Courtesy Floto+Warner, New York

32.
Floto+Warner
(Snowman) 2004
nylon
72 x 60 in. (182.88 x 152.4 cm)
Courtesy Floto+Warner, New York

33.
Dan Graham
Homes for America 1966–1967
chromogenic print
34 1/2 x 25 in. (87.63 x 63.5 cm)
Collection Walker Art Center, Minneapolis
Justin Smith Purchase Fund, 1993

34.
Dan Graham
Alteration to a Suburban House 1978/1992
wood, felt, plexiglass
11 x 43 x 48 in. (27.94 x 109.22 x 121.92 cm)
Collection Walker Art Center, Minneapolis
Justin Smith Purchase Fund, 1993

35.
INABA/C-Lab
Trash 2008
mixed-media installation
dimensions variable
Courtesy Carnegie Museum of Art, Pittsburgh

36.
Interboro
In the Meantime, Life with Landbanking 2002/2007
model with projected animation
dimensions variable
Courtesy Carnegie Museum of Art, Pittsburgh

37.
Lateral Architecture
Flatspace: Resurfacing Contemporary Public Space
2003–2007
6 acrylic models, 3 DVD animations
dimensions variable
Courtesy the architects and Carnegie Museum
of Art, Pittsburgh

38.
John Lehr
Poughkeepsie, NY 2005
pigmented ink-jet print
27 x 34 in. (68.58 x 86.36 cm)
Courtesy MARCH, New York

39.
LTL Architects
New Suburbanism; dissected oblique projections
2000
digital lambda chromogenic color print on
photographic paper
14 x 48 in. (35.56 x 121.92 cm)
Collection Carnegie Museum of Art, Pittsburgh
The Drue Heinz Trust, 2002

40.
LTL Architects
New Suburbanism; sectioned perspective (aerial)
2000
digital lambda chromogenic color print on
photographic paper
15 x 20 in. (38.1 x 50.8 cm)
Collection Carnegie Museum of Art, Pittsburgh
The Drue Heinz Trust, 2002

41.
LTL Architects
New Suburbanism; sectioned perspective (street)
2000
digital lambda chromogenic color print on
photographic paper
14 x 20 in. (35.56 x 50.8 cm)
Collection Carnegie Museum of Art, Pittsburgh
The Drue Heinz Trust, 2002

42.
LTL Architects
New Suburbanism 2000/2004
model
9 x 30 ¹/₂ x 10 in. (22.86 x 77.47 x 25.4 cm)
Courtesy the architects

43.
Paho Mann
Re-inhabited Circle Ks (Phoenix) 2004–2006
ink-jet prints
20 x 24 in. (50.8 x 60.96 cm) each of 16
Courtesy the artist

44.
Sarah McKenzie
Site 2007
oil on canvas
48 x 72 in. (121.92 x 182.88 cm)
Courtesy the artist and Robischon Gallery, Denver

45.
Laura E. Migliorino
Egret Street 2006
pigmented ink-jet on canvas
22 x 22 in. (55.88 x 55.88 cm)
Collection Walker Art Center, Minneapolis
Justin Smith Purchase Fund, 2007

46.
Laura E. Migliorino
Chicago Avenue 2007
pigmented ink-jet on canvas
22 x 22 in. (55.88 x 55.88 cm)
Courtesy the artist

47.
Laura E. Migliorino
Goodhue Street 2007
pigmented ink-jet on canvas
22 x 22 in. (55.88 x 55.88 cm)
Courtesy the artist

48.
Matthew Moore
Rotations: Single Family Residence #5 2003–2004
chromogenic print in plexiglass
52 x 60 in. (132.08 x 152.4 cm) framed
Courtesy the artist and Lisa Sette Gallery,
Scottsdale, Arizona

49.
Matthew Moore
Single Family Residence: Hoe Cam Video 2003–2004
DVD (color, sound); 5 minutes
Courtesy the artist and Lisa Sette Gallery,
Scottsdale, Arizona

50.
Matthew Moore
Mirage 2007
chromogenic print in plexiglass
52 x 60 in. (132.08 x 152.4 cm) framed
Courtesy the artist and Lisa Sette Gallery,
Scottsdale, Arizona
Photo: Tim Lanterman

51.
Stefanie Nagorka
Minneapolis, MN 2008 from the
Aisle Studio Project 2008
prefabricated masonry components
dimensions variable
Courtesy the artist

52.
Catherine Opie
Untitled #7 from the series Freeway 1994
platinum print
2 1/4 x 6 3/4 in. (5.72 x 17.15 cm)
Collection Kimberly and Tim Montgomery

53.
Catherine Opie
Untitled #20 from the series Freeway 1994
platinum print
2 1/4 x 6 3/4 in. (5.72 x 17.15 cm)
Collection Jennifer and Charlie Phelps,
Maple Plain, Minnesota

54.
Edward Ruscha
Dodgers Stadium, 1000 Elysian Park Ave.
from the series Parking Lots 1993/1997
gelatin silver print mounted to mat board
21 5/16 x 21 5/16 in. (54.13 x 54.13 cm) matted
Collection Walker Art Center, Minneapolis
T. B. Walker Acquisition Fund, McKnight Acquisition
Fund, 2002

55.
Edward Ruscha
Gilmore Drive-In Theatre, 6201 W. 3rd St
from the series Parking Lots 1993/1997
gelatin silver print mounted to mat board
21 5/16 x 21 5/16 in. (54.13 x 54.13 cm) matted
Collection Walker Art Center, Minneapolis
T. B. Walker Acquisition Fund, McKnight Acquisition
Fund, 2002

56.
Edward Ruscha
Hollywood Bowl, 2301 N. Highland
from the series Parking Lots 1993/1997
gelatin silver print mounted to mat board
21 5/16 x 21 5/16 in. (54.13 x 54.13 cm) matted
Collection Walker Art Center, Minneapolis
T. B. Walker Acquisition Fund, McKnight Acquisition
Fund, 2002

57.
Edward Ruscha
Lockheed Air Terminal, 2627 N. Hollywood Way,
Burbank from the series Parking Lots 1993/1997
gelatin silver print mounted to mat board
21 5/16 x 21 5/16 in. (54.13 x 54.13 cm) matted
Collection Walker Art Center, Minneapolis
T. B. Walker Acquisition Fund, McKnight Acquisition
Fund, 2002

58.
Edward Ruscha
May Company, 6150 Laurel Canyon, North Hollywood
from the series Parking Lots 1993/1997
gelatin silver print mounted to mat board
21 5/16 x 21 5/16 in. (54.13 x 54.13 cm) matted
Collection Walker Art Center, Minneapolis
T. B. Walker Acquisition Fund, McKnight Acquisition
Fund, 2002

59.
Edward Ruscha
Pierce College, Woodland Hills from the
series Parking Lots 1993/1997
gelatin silver print mounted to mat board
21 5/16 x 21 5/16 in. (54.13 x 54.13 cm) matted
Collection Walker Art Center, Minneapolis
T. B. Walker Acquisition Fund, McKnight Acquisition
Fund, 2002

60.
Edward Ruscha
State Dept. of Employment, 14400 Sherman Way,
Van Nuys from the series Parking Lots 1993/1997
gelatin silver print mounted to mat board
21 5/16 x 21 5/16 in. (54.13 x 54.13 cm) matted
Collection Walker Art Center, Minneapolis
T. B. Walker Acquisition Fund, McKnight Acquisition
Fund, 2002

61.
Edward Ruscha
Universal Studios, Universal City from the
series Parking Lots 1993/1997
gelatin silver print mounted to mat board
21 5/16 x 21 5/16 in. (54.13 x 54.13 cm) each, matted
Collection Walker Art Center, Minneapolis
T. B. Walker Acquisition Fund, McKnight Acquisition
Fund, 2002

62.
SITE
Parking Lot Showroom, Best Products,
Inc., Dallas, TX 1976
model
6 1/4 x 25 x 25 in. (15.88 x 63.5 x 63.5 cm)
Courtesy SITE Environmental Design, Inc., and
Max Protetch Gallery, New York

63.
SITE
Ghost Houses 1979
pencil on paper
12 ³/₈ x 28 ¹/₈ x 1 ¹/₈ in. (31.43 x 71.44 x 2.86 cm)
framed
Courtesy SITE Environmental Design, Inc., and
Max Protetch Gallery, New York

64.
SITE
Ghost Houses 1979
pencil on paper
14 ³/₈ x 23 x 1 ¹/₈ in. (36.51 x 58.42 x 2.86 cm) framed
Courtesy SITE Environmental Design, Inc., and
Max Protetch Gallery, New York

65.
SITE
Grand Openings by Howard Silver from
Best Showrooms 1980s
DVD (color, sound); 28:38 minutes
Courtesy SITE Environmental Design, Inc., and
Max Protetch Gallery, New York

66.
SITE
Public Spaces by Howard Silver from
Best Showrooms 1980s
DVD (color, sound); 17 minutes
Courtesy SITE Environmental Design, Inc., and
Max Protetch Gallery, New York

67.
Jessica Smith
Trash Day 2005/2007
digital print and screenprint on linen
240 x 40 in. (609.6 x 101.6 cm)
Courtesy the artist

68.
Jessica Smith
Cloverleaf 2006/2007
digital print on silk dupioni
240 x 40 in. (609.6 x 101.6 cm)
Courtesy the artist

69.
Greg Stimac
Mowing the Lawn (Chandler, AZ) 2005/2006
ink-jet print
41 x 30 in. (104.14 x 76.2 cm)
Courtesy the artist

70.
Greg Stimac
Mowing the Lawn (Mentor, OH) 2005/2006
ink-jet print
41 x 30 in. (104.14 x 76.2 cm)
Courtesy the artist

71.
Lee Stoetzel
McMansion 2 2005
lambda print
27 x 62 in. (68.58 x 157.48 cm)
Courtesy the artist and Mixed Greens, New York

72.
Angela Strassheim
Untitled (Elsa) 2004
chromogenic print
30 x 40 in. (76.2 x 101.6 cm)
Courtesy the artist and Marvelli Gallery, New York

73.
Angela Strassheim
Untitled (McDonald's) 2004
chromogenic print
40 x 50 in. (101.6 x 127 cm)
Courtesy the artist and Marvelli Gallery, New York

74.
Larry Sultan
Tasha's Third Film 1998
chromogenic print
50 x 60 in. (127 x 152.4 cm)
Courtesy the artist and Stephen Wirtz Gallery,
San Francisco

75.
Larry Sultan
Boxers, Mission Hills 1999
chromogenic print
40 x 50 in. (101.6 x 127 cm)
Courtesy the artist and Stephen Wirtz Gallery,
San Francisco

76.
Brian Ulrich
Schaumburg, IL from the series Copia/Retail 2002
chromogenic print
30 x 40 in. (76.2 x 101.6 cm)
Courtesy the artist and Rhona Hoffman Gallery,
Chicago

77.
Brian Ulrich
Chicago, IL from the series Copia/Retail 2003
chromogenic print
30 x 40 in. (76.2 x 101.6 cm)
Courtesy the artist and Rhona Hoffman Gallery,
Chicago

78.
Michael Vahrenwald
Straw Hill, Wal-Mart, Bloomsburg, PA
from the series Universal Default 2005
chromogenic print
48 x 60 in. (121.92 x 152.4 cm)
Courtesy the artist

Index

Lenders to the Exhibition

Kim Beck, Pittsburgh and New York
Bellwether, New York
Peggy and Ralph Burnet, Wayzata, Minnesota
Carnegie Museum of Art, Pittsburgh
Center for Land Use Interpretation (CLUI),
 Culver City, California
Julia Christensen, Oberlin, Ohio
Beth Rudin DeWoody, New York
Estudio Teddy Cruz, San Diego
Chris Faust, St. Paul, Minnesota
Jeremy Floto and Cassandra Warner, New York
Lateral Architecture, Toronto
Lisa Sette Gallery, Scottsdale, Arizona
LTL Architects, New York
Paho Mann, Denton, Texas
MARCH, New York
Marvelli Gallery, New York
Max Protetch Gallery, New York
Sarah McKenzie, Boulder, Colorado
Laura E. Migliorino, Minneapolis
Mixed Greens, New York
Kimberly and Tim Montgomery
Matthew Moore, Goodyear, Arizona
Stefanie Nagorka, Montclair, New Jersey
Jennifer and Charlie Phelps, Maple Plain, Minnesota
Peter and Annie Remes, Wayzata, Minnesota
Rhona Hoffman Gallery, Chicago
Robischon Gallery, Denver
SITE Environmental Design, Inc., New York
Jessica Smith, Savannah, Georgia
Stephen Wirtz Gallery, San Francisco
Greg Stimac, Chicago
Lee Stoetzel, Chester Springs, Pennsylvania
Angela Strassheim, Minneapolis and New York
Larry Sultan, Greenbrae, California
Anthony Terrana, Wellesley, Massachusetts
Brian Ulrich, Chicago
Michael Vahrenwald, New York
Walker Art Center, Minneapolis
The West Collection, Oaks, Pennsylvania

Reproduction Credits

Board of Trustees

PRECEDENTS OF SUBURBAN SYMBOLS

Venturi, Scott Brown and Associates Analytic drawing from Yale architecture studio, "Remedial Housing for Architects or Learning from Levittown"